ROCK'N'ROLL PHOTOGRAPHY IS THE NEW TRAINSPOTTING

WELCOME TO "ROCK'N'ROLL PHOTOGRAPHY IS THE NEW TRAINSPOTTING". STRANGE TITLE? WELL, I CAME TO THE CONCLUSION THAT THAT'S EXACTLY WHAT IT HAD BECOME TO ME. IN MY YOUTH I WAS, IN FACT, A TRAINSPOTTER (AND I'M NOT EMBARRASSED ABOUT IT). THE OBJECT BEING TO COLLECT AS MANY LOCOMOTIVES' NUMBERS AS POSSIBLE AND, APART FROM ROCK'N'ROLL PHOTOGRAPHY BEING A CAREER, IT IS VERY MUCH A QUEST TO COLLECT AS MANY PHOTOS OF ROCK STARS AS I CAN. I STILL GET A THRILL WHEN PHOTOGRAPHING A NEW ARTIST, AND AM NOT HAPPY TILL I'VE GOT WHAT I CONSIDER A GREAT SHOT. I'VE BEEN CHASING PAUL KELLY FOR TWENTY YEARS NOW, TRYING TO GET THE ULTIMATE SHOT. I'VE FAILED MANY TIMES. IN FACT, THE FIRST PHOTO I TOOK OF HIM BACK IN 1985 STILL STANDS AS THE BEST I'VE EVER GOT OF HIM. NOT HIS FAULT. ANYWAY, THIS COLLECTION IS WHAT I CONSIDER MY BEST PHOTOGRAPHS, PICKED FROM DIFFERENT POINTS OF VIEW, A COMBINATION OF CAPTURING THE ESSENCE OF THE ARTIST AND PHOTOGRAPHIC QUALITIES.

A RETROSPECTIVE OF WORK FROM THE LAST 30 YEARS
BY TONY MOTT

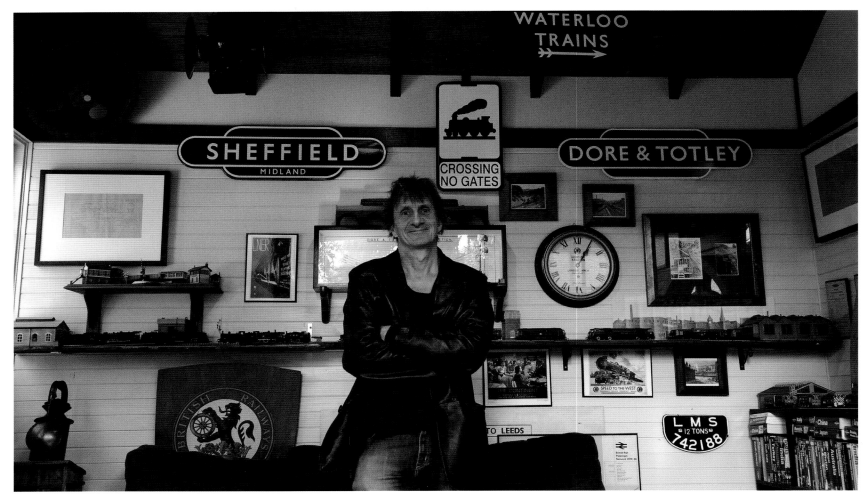

I was born in April 1956 (that makes me sort of old) and raised in Sheffield, England, quite normally by mum and dad, Mary and Brian Moulds. I was trained as a chef at Sheffield Polytechnic and in 1976 I left England, arriving in Australia for the first time. Using my training I worked in Sydney at the Opera House and the Gazebo before helping a friend open a restaurant in Armidale, New South Wales, called The Blackboard Menu, but I had to leave after six months because I only had a limited working visa. It was at this point that I realised I wanted to live in Australia permanently. I returned to England with the intention of securing a permanent visa, which didn't eventuate. Refusing to allow a little thing like a visa to stand in the way of escaping the UK, I managed to get a job on the SS *Oriana* as a chef, a wonderful job that lasted two years and took me to over 60 countries as diverse and interesting as Puerto Rico, Egypt, Panama, India, the Caribbean Islands, all around the Mediterranean, Nordkapp (where the sun never goes down and all its inhabitants are bonkers) and elsewhere. It was during this time I developed a strong sense of wanderlust, an affliction which has taken me to India seven times and helped me traverse the Himalayas on a number of occasions. In fact, to celebrate my 40th birthday I had to make a choice between getting pissed in Redfern and walking the Annapurna Circuit with my best friend Steve: I chose the latter.

Eventually my job on the ship came to an end and brought me back to Australia and in 1981 I finally managed to settle here permanently. I got my old job back at the Gazebo Hotel in King Cross, which, as it turns out, was a perfect location to embark on the next stage of my life.

I've often thought about my penchant for travel and train spotting (that's a whole other story right there!) and always go back to my childhood in Sheffield. When I was about eight or nine years old my mum and dad used to visit the local pubs, including one called the Castle Inn. My sister and I used to sit on the wall outside with our crisps and fizzy pop watching the trains go by. From this point we could see the trains disappear into a tunnel and I always wanted to know what was on the other side of that tunnel. Eventually I got to the other side of the tunnel and just kept on going!! Finally I got to and settled in Sydney.

In the early 1980s Sydney had a brilliant live music scene. Every night of the week you could see any number of excellent bands at any number of excellent venues, right across the city. Working as a chef meant I usually finished work around midnight, not a bad situation for somebody like me who loved music. I'd leave work and hop into any given venue. On Monday nights I used to go to the Piccadilly Hotel in the Cross to see the Divinyls play. They had a residency at the venue and at this stage they were unsigned and largely unknown. Singer Chrissy Amphlett didn't do a lot in those days. The stage persona she later became famous for was non-existent but, suddenly it seemed, she became a loony on stage wearing the schoolgirl uniform and gyrating about. I didn't know it at the time but I was learning my art of rock n roll photography on one of the world's greatest female performers.

During my days sailing the seven seas I'd developed a strong desire to document photographically the amazing places I saw. So every Monday night after work at the Gazebo I used to hone my fledgling skills by snapping away at the Divinyls. A lot of crap shots were taken but after four months the band's manager, Vince Lovegrove, who'd obviously seen me shooting away, asked to see the shots, one of which he chose and used as a tour poster. I was well chuffed! To top it off he paid me 20 bucks – my first foray into professional photography.

I was very green in those days, typified when Vince told me that my name was on the door for the band's next gig. I had no idea what this expression meant and for the next two months I continued to pay my way into their shows. One night he saw me and said, "You know your name's on the door, don't you?" Not wishing to appear unsophisticated, I replied, "Yeah, I know. Isn't that great," thinking that somewhere – perhaps the band's rehearsal studio – there was a door on which they'd written my name as a mark of respect. Just shows you how much I had to learn about the music industry.

By 1983 the Divinyls tour poster had had a snowball effect on my career and before long other bands were asking me to shoot their gigs. One day I walked into the offices of the free paper *On The Street*, then in its infancy and long before the term street press had ever been coined. I started getting work through the paper.

About a week before I went to *On The Street*, Margaret Cott had just started as a layout girl and so began a professional relationship with her, which lasts to this day. Within a year Margaret had become editor and I was photographing anything that moved, anywhere, anytime. All this and I was still working full-time at the Gazebo.

It was 1985 and for a short period of time during that year I got married. My wife was Swedish (and to the best of my knowledge still is) but I won't go into the topic any further other than to say she now lives in Sweden and I still live

in Sydney and we remain good friends. Anyway, she had suggested I head back to England and so I did, and with my few contacts in the industry I spent the summer of 1986 drinking a lot and generally having a good time going to music festivals. I went to Reading, Milton Keynes and so on, seeing tons of bands. I haven't managed to work out how to this day, but I managed to photograph Queen at Knebworth, which was a hell of an experience. I also went to Paris and New York that summer, purely as a drunken wanderlust thing as opposed to seriously pursuing anything professionally.

When I got back to Australia, Mick Jagger was touring to promote his first solo album. While I was away, and unbeknownst to me, Jagger's manager, Tony King, had been trying to track me down wanting to hire me as Jagger's tour photographer. To this day I have no idea who recommended me for the job but I'm extremely grateful. Eventually I made contact with Tony King and as it turned out they were not happy with whoever it was they had hired instead of me. By this stage the tour was in Melbourne so I went down and met Tony in his hotel room. I don't think I would be giving anything away when I say that Tony King is what you would describe as an effervescent gay man and when I met him he enthusiastically expounded the virtues of Sydney. "Oh I love Sydney," he said, "so many sailors in the one city." I thought, what have I got to do to get this gig? Tony King, it should be pointed out, is a lovely man and I have always gotten on extremely well with him on a professional basis. But that was the start of my relationship with Mick Jagger and eventually the Rolling Stones. It was an enormous break which has resulted in me touring with the Stones three times. As I've said, I have no idea how I got the gig because I was only reasonably well-known as a live photographer in Sydney at that point. And to think I nearly missed out because I was getting legless overseas!!

To illustrate how absurd the music industry can be at times, at the end of tour party I could hear people behind me talking about the tour photographer and how "he's just come back from working in London, Paris and New York, don't you know". I suddenly realised they were talking about me! Little did they know I was basically having a good time in these places and not doing the glamorous jobs they imagined.

As a consequence of the Jagger gig I toured in the same year with Bob Dylan and Fleetwood Mac. I wasn't any better as a photographer but once I had gigs of that calibre in my CV I looked so much better. That period was the beginning of my first break.

It was 1988 and with these three enormous gigs under my belt I was going out at least five nights a week just to see bands. I'd worked out by now what having my name on the door actually meant so I was saving myself a small fortune. The Sydney scene during this time was fertile. There were great bands in great venues happening every night of the week, a favorable environment in which to grow as a rock'n'roll photographer.

More breaks came my way in the early 1990s. I did a book called *Still Noise* with four other photographers, the album cover photography for Tommy Emmanuel's 'Dare To Be Different' and the Beasts of Bourbon's 'Black Milk'. It was all moving along quite nicely in a relatively short period of time. I'm proud of both those album covers because they're so radically different. Tommy Emmanuel's album was so obviously mainstream and commercial while the Beasts of Bourbon was very inner city and independent, and that's one of the things I love about working in the music industry – one minute you can be working with somebody like Lucinda Williams and the next minute working with the likes of Slipknot. They're vastly different performers with vastly different personalities to be captured through the lens. But I digress.

I guess the next major event that boosted my career was the start of the Big Day Out in 1992. In the late 80s and early 90s I'd been regularly heading over to Europe and the US every couple of years to check out the summer music festivals. I really couldn't understand why Australia didn't have its own version of the UK's Reading or Glastonbury festivals. Being staged in the UK, when those festivals take place, it's an added bonus when it doesn't rain, so why, with our weather and talented bands, why should we miss out??

Enter Ken West. Obviously Ken had been to these festivals, too, and had some thoughts about doing an Australian festival, and so began the Big Day Out. He's now one of the most respected promoters in the country and the Big Day Out is highly regarded both here and overseas. It became very successful very quickly and in the space of four years was at the same level as the festivals in the UK. So the Big Day Out was a valuable break for me. Every year I go on the road with the Big Day Out as it tours around Australia. This means I get to build a rapport with the bands I shoot, which is a luxury not often afforded a photographer.

It's always easier to work with people who you feel relaxed with and vice versa.

I don't work like a fashion photographer – I've never treated a musician as a model. A lot of photographers do because they presume there's a lot of glamour involved. Musicians are not thespians and they're not models so you need to build a rapport with them. Musicians can often feel uncomfortable in front of the camera, so relaxing them is an imperative. Obviously I'm referring to session work here. Live is a completely different kettle of fish. The disadvantage of doing sessions is that the artist is doing something that doesn't come naturally to them. The advantage is that you as the photographer have complete control over the environment, things like lighting. The difficulty is getting the artist comfortable. The live situation is the opposite, the artist is in their natural environment but the photographer is not, you have no control over the lighting and so on. The quality of your shots is reliant on the lighting guy and the movement of the artist.

Eye contact is vital in photography. If you take a photo of someone and their eyes are out of focus the whole shot lacks impact. That's how people look at photos, through the eyes of the subject. The eye is all important. In a live situation the subject is more than likely not looking at you, and there's also the bloody ever present microphone getting in the way.

In 2002 I put out the book *Every Picture Tells A Story* through ABC Books to very kind reviews. It was a very enjoyable experience putting the book together and coming to the realisation that I've been around a fair amount of time.

In 2005 I was employed as a stills photographer on my friend Paul Goldman's feature film 'Suburban Mayhem'. This was a new experience and very different from music photography, very unlike a photo shoot with a rock band, on the film set you're not so important, the film crew have other things to worry about, on the other hand the actors want to be photographed and a whole crew is there to assist with lighting and props. It was on this film set that I met Libby Sharpe, production manager who I fell in love with and eventually married – hurrah!!! Big lifestyle change. I've now done stills on 4 films, 'Cactus', 'Animal Kingdom' and 'Tomorrow When The War Began' but my first love still remains rock'n'roll photography.

The years 2007 and 2008 were quite amazing for very different reasons on a personal level; a very long story short: I got married twice and I lost both my mother and father; losing your parents is beyond explanation, an empty feeling, as much as I always knew I loved them both very much I never realised how much I would miss them, but I do appreciate how much they did for me and how lucky I was to have such a fantastic upbringing. Just to add to the drama of these 2 years I met my birth mother for the first time in my life(I was adopted) and discovered I had a full blood brother Keith, that I didn't know about. Quite a period: by the end of 2008 I had met my brother and his family and hope to have a lasting relationship with them and I'm happily married to Libby and all is well with the world.

In total I've had over 30,000 photographs published, the result of some 3,000 sessions and countless live shows, which have become 400 posters, 500 CD or vinyl covers and over 850 magazine front covers, and I'm still counting. It seems an age has passed since Vince Lovegrove used my shot of Chrissy Amphlett as a tour poster. I guess it has been a long time. Certainly much has happened and I've managed to collect some stories that I think are vaguely interesting along the way – some are downright bizarre and I hope you enjoy them.

Oh, and why did I change my name from Moulds to Mott? Well, when I first got a photo credit Moulds didn't look so groovy so I had to come up with an alternative. I looked to the most influential band in my life, Mott the Hoople. The next decision was Tony Mott or Tony Hoople. I went for the former.

Everyone should have a Mott the Hoople. In my formative years in college they were the only band that I related to lyrically. They delved into social, political and more general matters, not to mention being a dynamic live act. They were punks before punk had happened, all that and glam rock as well.

I've always felt music is an important medium: it can be a sanctuary when things are not so rosy, and a celebration of the joys of life, the two extremes of emotion. And that is why Mott the Hoople have been so important to me. A couple of examples of that are in 1976, when I first left England for Australia, I related to the Ian Hunter album 'All American Alien Boy', an album about an Englishman arriving in the US, feeling alien and yet loving it. I totally related to the sentiments. Thirty years later, when I lost my best friend who died at an early age and I was finding grief very difficult to deal with, I found solace in the Ian Hunter song 'Michael Picasso', a song about the death of his long-time best friend and David Bowie guitarist Mick Ronson. That's why I believe music is so powerful and important. Everyone should have a Mott the Hoople.

In 2009 Mott the Hoople reformed after a 34-year break. I flew back to England in October of that year to shoot and witness the band live. What an experience, they were everything I wanted and more. ROCK'N'ROLL!!

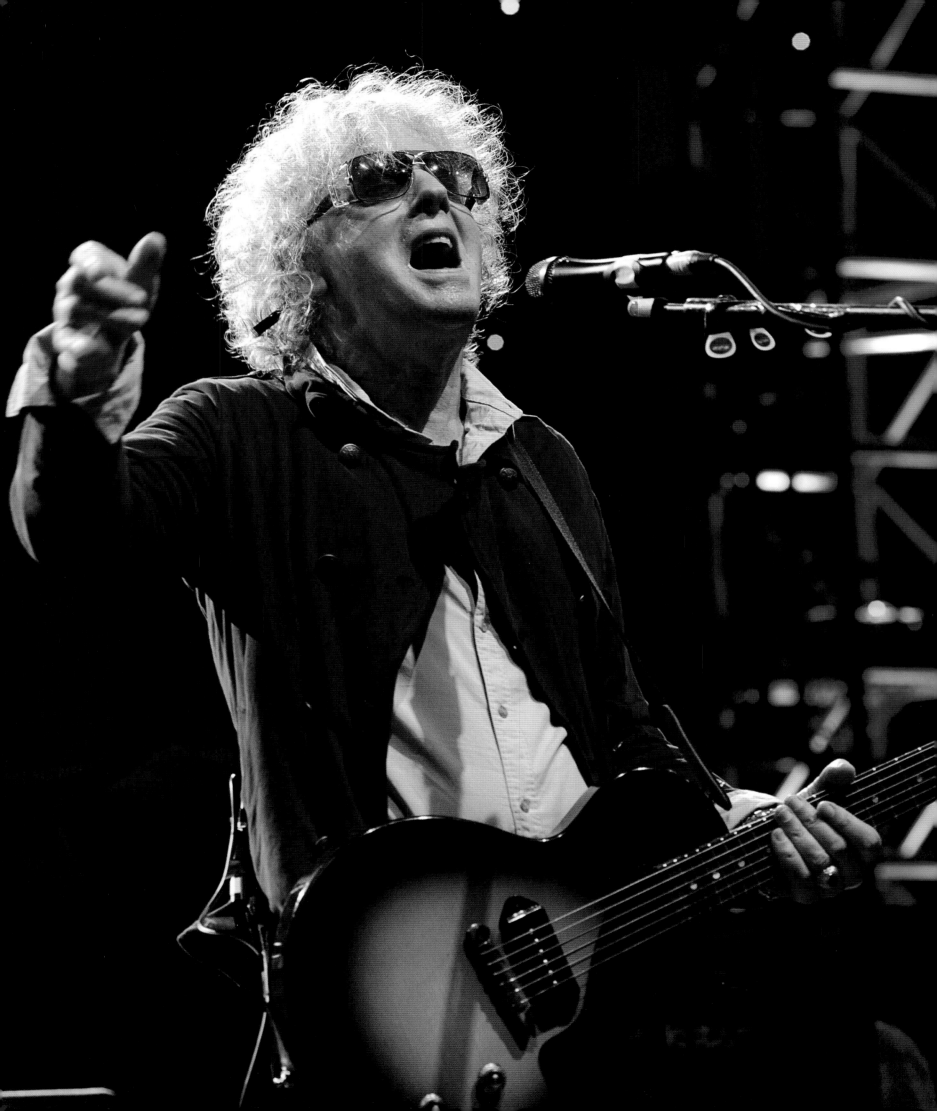

BALLAD OF MOTT

I changed my name in search of fame to find the Midas touch,
I wish I'd never wanted then what I want now twice as much,
I've crossed the mighty oceans and I've had a few divides,
But you never lose in emotion, because you find too much inside
You know the tales we tell, you know the bands so well
And still I feel they let you down

Rock'n'Roll's a loser's game, it mesmerises and I can't explain
The reasons for the sights and for the sounds
The grease paint still sticks to their face
So what the hell I cannot erase
The Rock'n'Roll feeling from my mind

[Kindly reproduced with permission from Universal Music.]

MOTT THE HOOPLE
DEATH MAY BE YOUR SANTA CLAUS

After 34 years the greatest rock band in the world got back together for a reunion at the Hammersmith Odeon, London, in October 2009. I flew back to the UK for the occasion. I went to their shows for three nights, twice to shoot and once for pleasure, and what a pleasure it was. I, and three old friends from college days, drank and rocked the night away. This band started my infatuation with rock'n'roll. By the time they hit the stage, Ian Hunter the lead singer was 70 – rock'n'roll really has grown up.

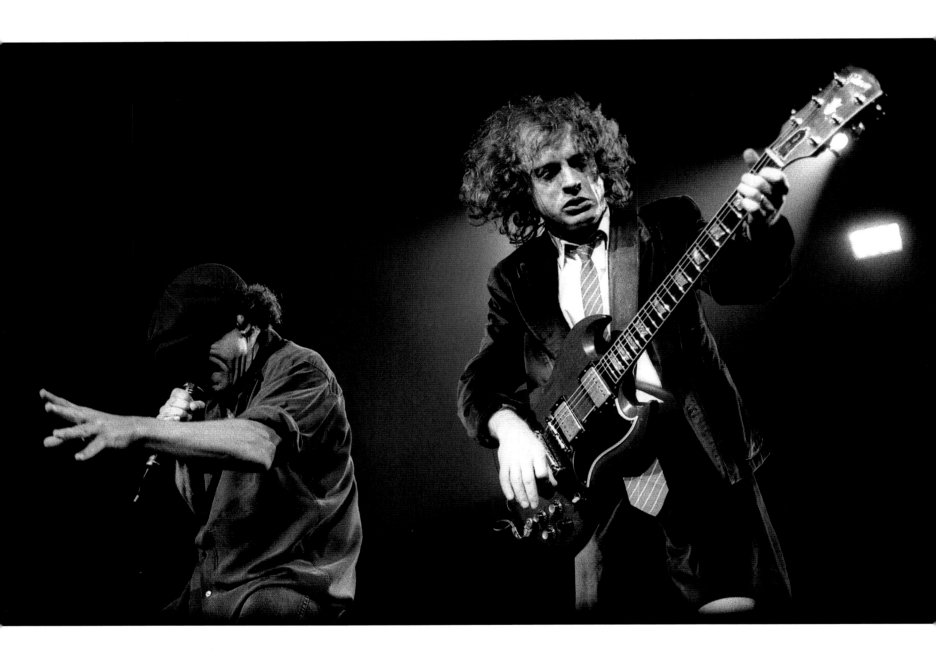

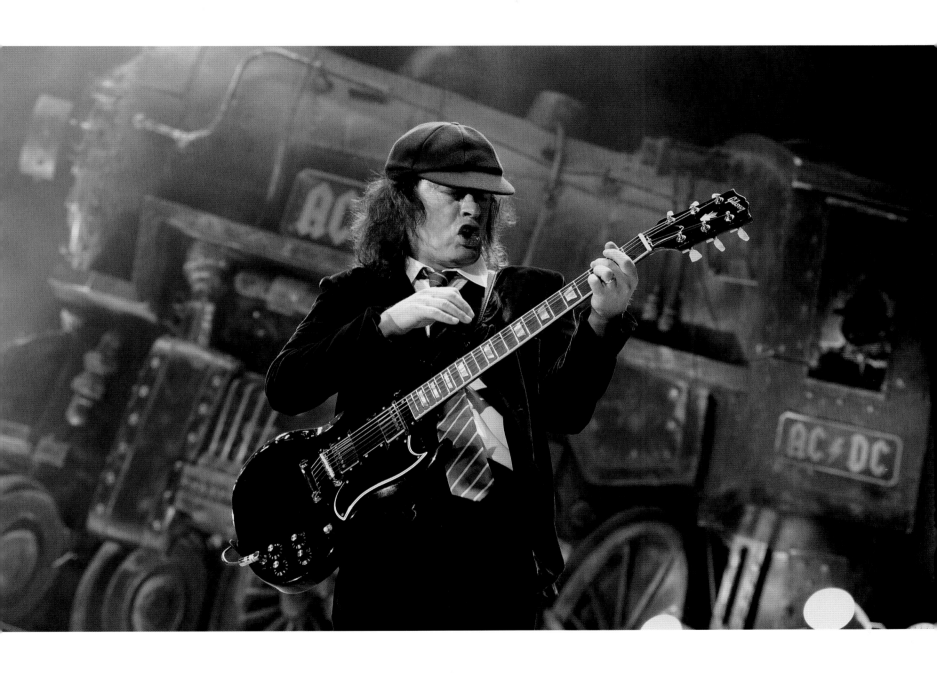

AC/DC
IT'S A LONG WAY TO THE TOP IF YOU
WANNA ROCK'N'ROLL

You cannot help but smile when a 57-year-old man walks on stage in a school uniform and proceeds to duck walk and play 20 minute guitar solos – the fans love it!! The music remains the same and these two shots, taken close to 20 years apart, are much the same, aside from the extensive stage props that now appear. A bloody locomotive on stage! Bloody brilliant.

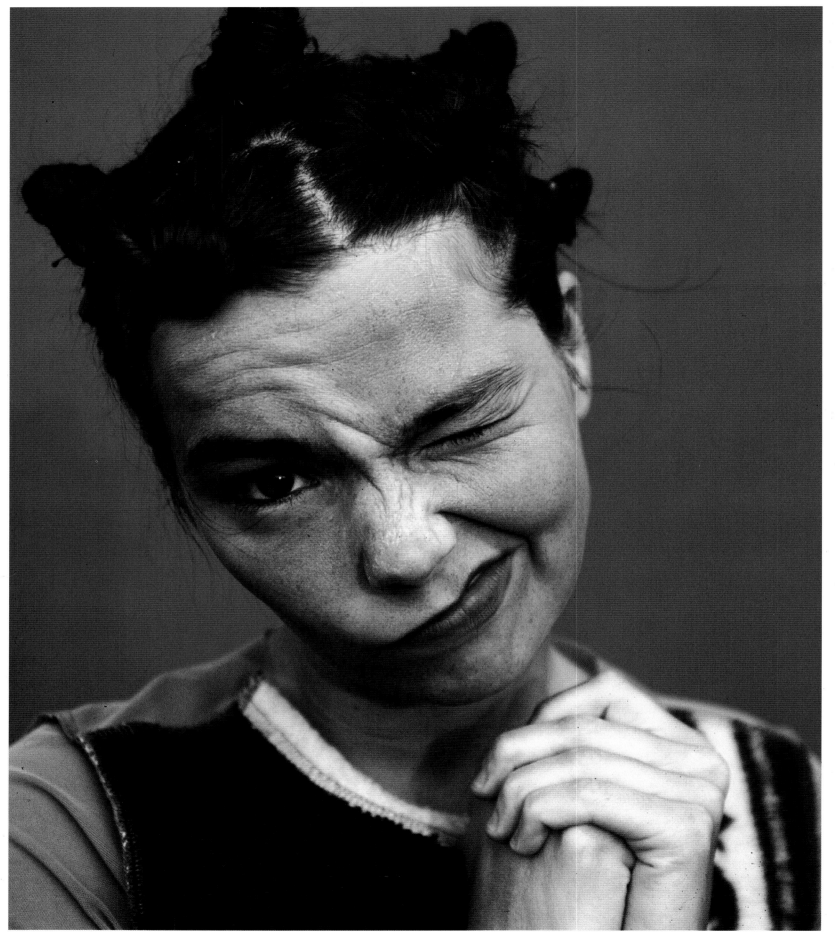

BJÖRK
NOD'S AS GOOD AS A WINK

Björk taken at the Big Day Out in 1995; this is one of my most published photos. First published in *Q* magazine in the UK and *Juice* magazine in Australia, it became very popular, so much so it ended up on Björk's autobiography cover. It's difficult to let go of a photo when you love it and I still submit it for publication whenever a Björk story is being published. She was as eccentric as you would expect and I spent a flight between Melbourne and Adelaide sitting next to her. She spoke in Icelandic to me and cared not that I understood nothing she said. Years later I had the pleasure of watching her sing ABBA songs around the piano of the Adelaide Hilton bar at post Big Day Out drinks.

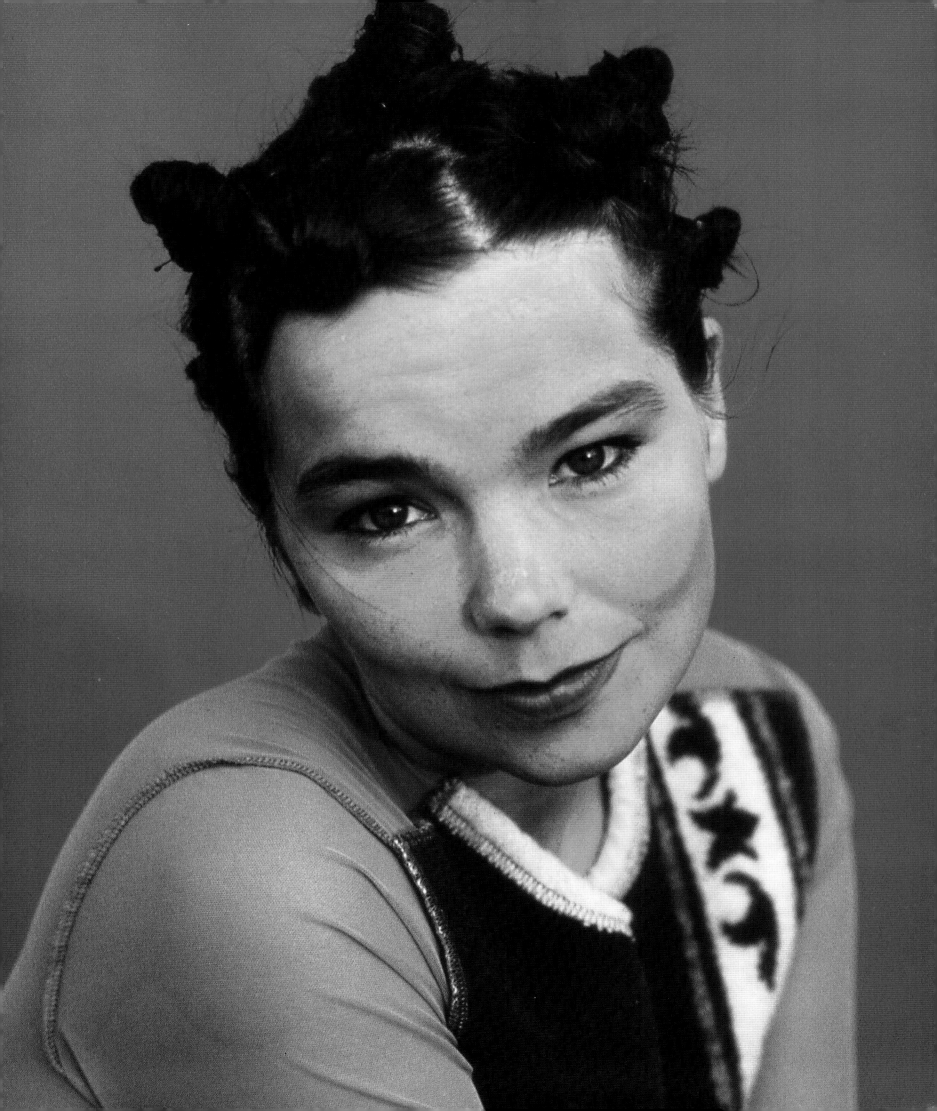

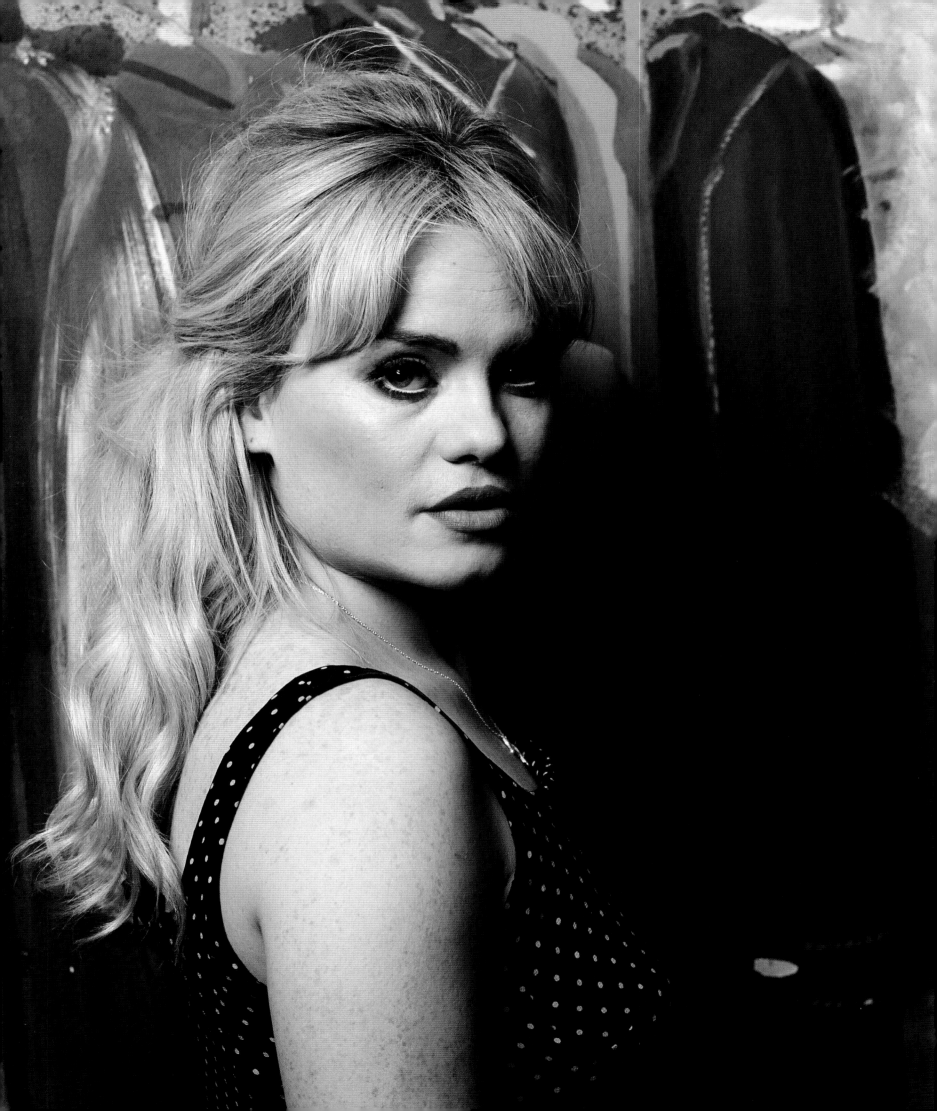

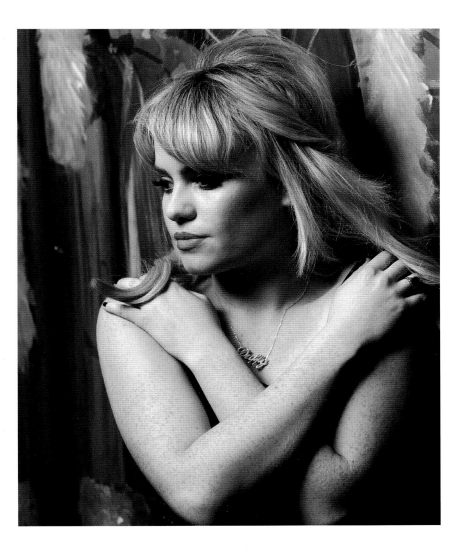
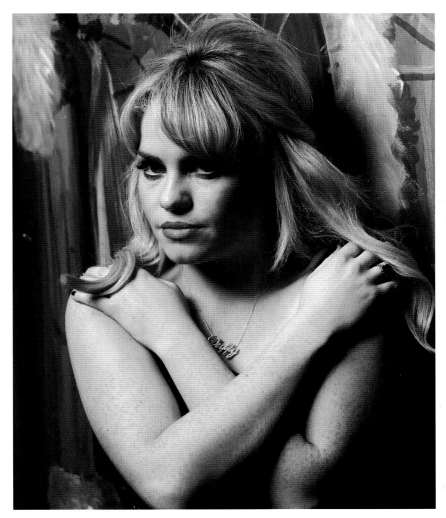

DUFFY
BIG THINGS IN SMALL PACKAGES

Taken at the Metro Theatre, Sydney, in 2008. This was taken just before the soundcheck. She was very sweet and obliging in the shoot and was desperate to do photos outside so she could have a cigarette. She couldn't have been sweeter. Small in stature, it was a gob smacking experience when the petite young girl finished the photos, casually walked onto the stage for the soundcheck with an experienced band (as in not her age group, great players) and produced such a powerful voice. An absolutely brilliant voice, great material; Dusty would have been proud.

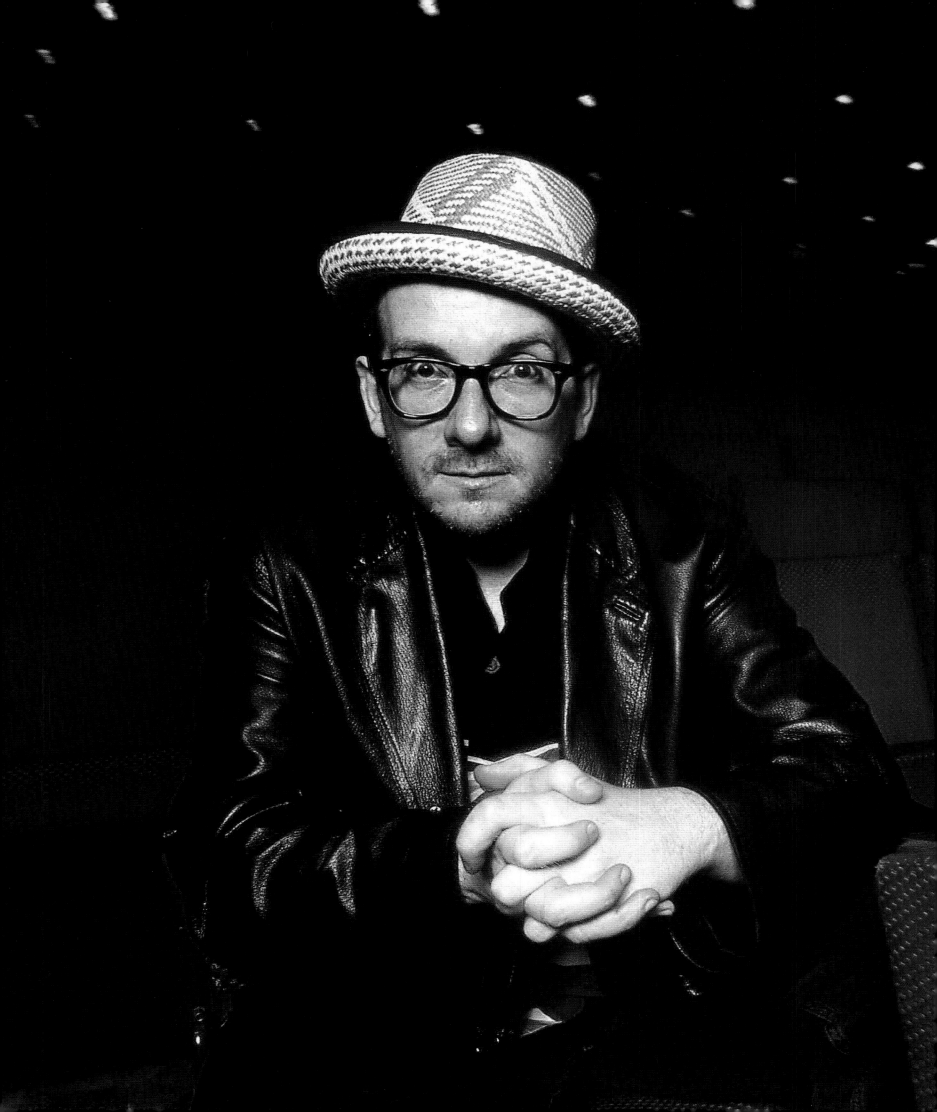

ELVIS COSTELLO
MY AIM IS TRUE

Lots of artists find photo sessions a necessary evil so as a consequence it's often an advantage to make it as convenient as possible to do the photo shoot. This was taken at the soundcheck to Elvis's concert at the now defunct Her Majesty's Theatre in Chinatown, Sydney. The gig part of the Burt Bacharach Painted From Memory tour was record by Triple J, with only Steve Nieve as accompaniment. It was one of the the greatest concerts I've witnessed. I have a feeling Elvis is one of those musicians who only relates to other musicians.

MARTHA WAINWRIGHT
WEDDING ENVY

Photographed in the back streets of Surry Hills. After the photo shoot
we retired to the Hopetoun pub for a quick refreshment that turned into
not so quick refreshment. I couldn't help myself and asked Martha about
her wedding and who played, as she comes from a sort of rock royalty
background. Much to my envy, Richard Thompson played at the wedding.
Martha asked who played at my wedding, and when I humbly said the
Killjoys she gushed what a fan she was and the envy was reversed.

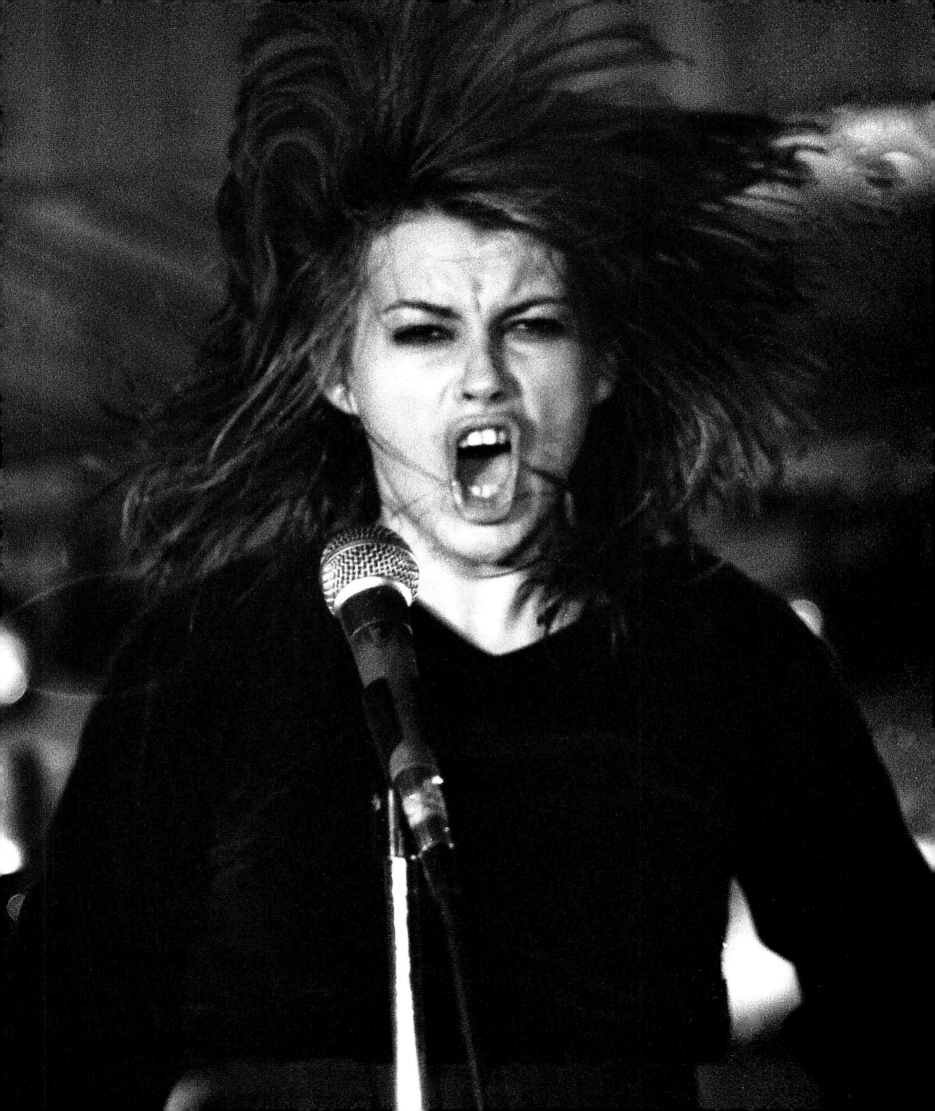

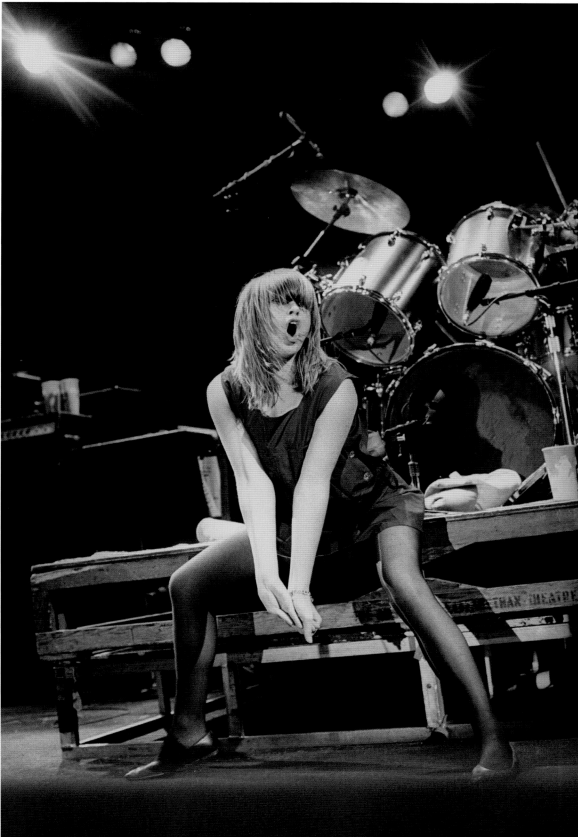

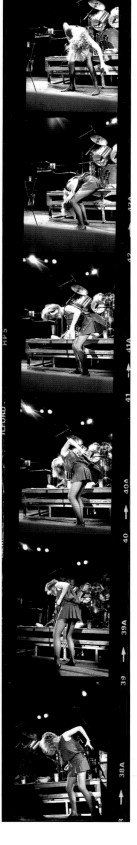

DIVINYLS
MOTT'S DEBUT
The first photo I ever sold, (left) taken at the Piccadilly Hotel Kings Cross, Sydney
during the band's Monday night residence, couldn't have been prouder when the band
used it for a tour poster; the fact they paid was a bonus and so started a career for which
I'm eternally grateful. Without Chrissy I wouldn't have a career. I sort of stalked her with
my camera to learn the art of rock photography. What a pleasure and pain it was.

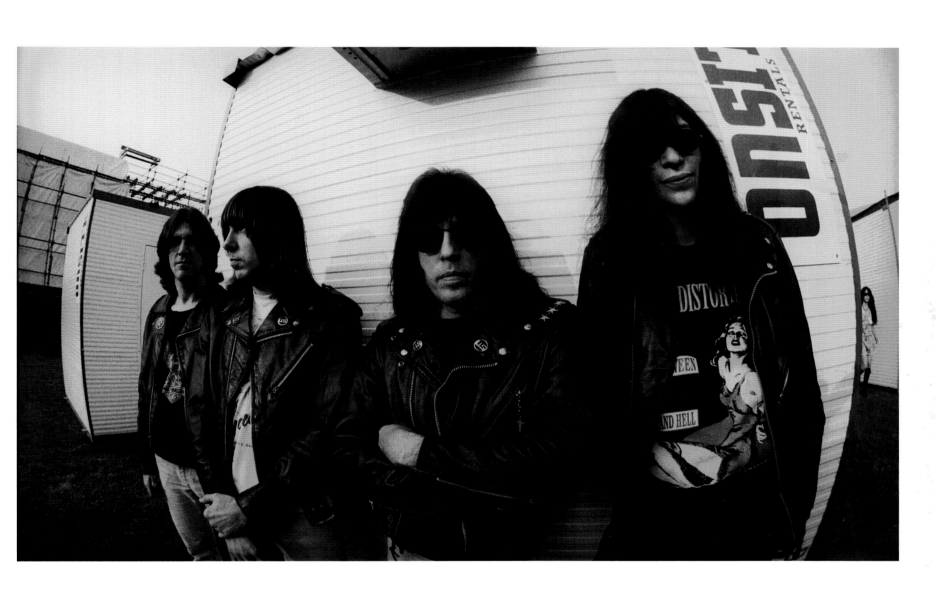

RAMONES
SOME THINGS ARE WRONG
Some things are wrong and the late great Joey Ramone being photographed
in daylight just seems sort of awkward and rare, and, hence, I like this
photograph for all the wrong reasons. I've done six Ramones sessions over the
years and always the same: just line up against whatever wall is convenient.
For variety, I tried the much-loved fisheye lens.

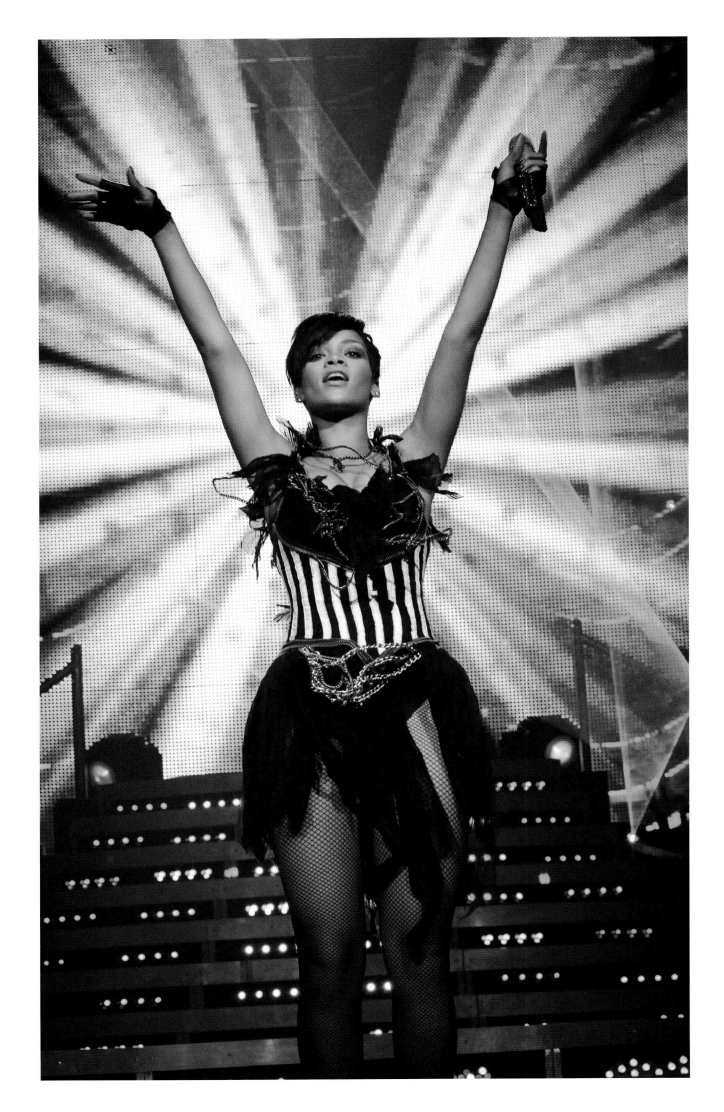

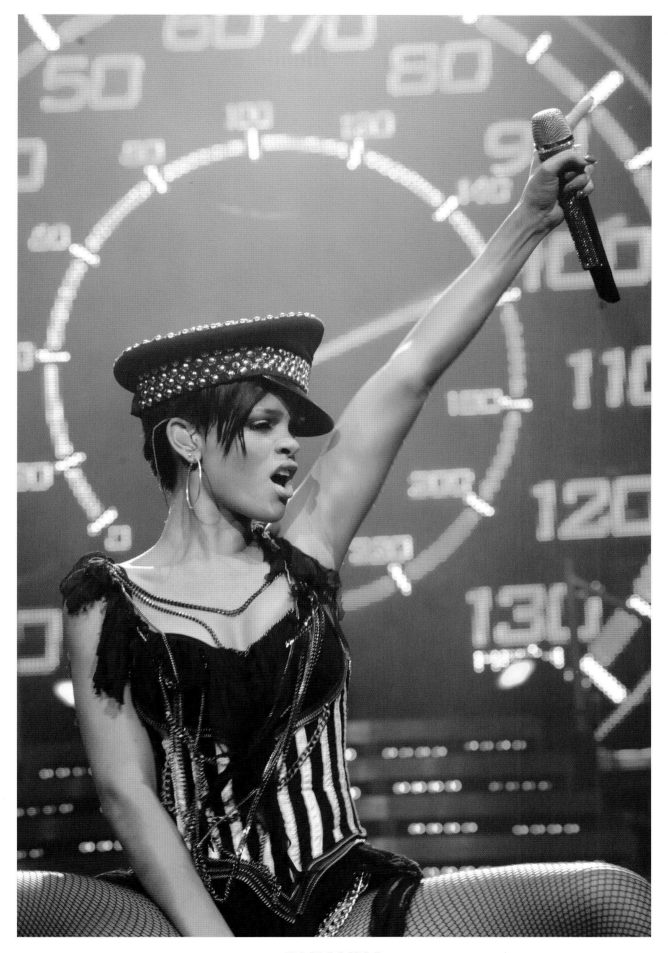

RHIANNA
SUNDAY BLOODY SUNDAY

Hired to shoot two nights with Rhianna at the Acer stadium in Sydney. The management wanted live concert and casual shots backstage. Consequently I was introduced to Rhianna so she'd be comfortable having shots taken in and around the dressing room. It's always best to keep this to a minimum so as not to annoy. Anyway, on the second night I went into the dressing room and noticed Rhianna in a sort of prayer pose and I immediately said, "Don't move an inch, it looks great." I noticed a sort of perplexed look on her face, only to turn around and see a vicar and small group of people doing Sunday prayers. Most embarrassing on my part. It was a Sunday and she being a Christian, ooops. Just to confuse I picked a live shot, go figure.

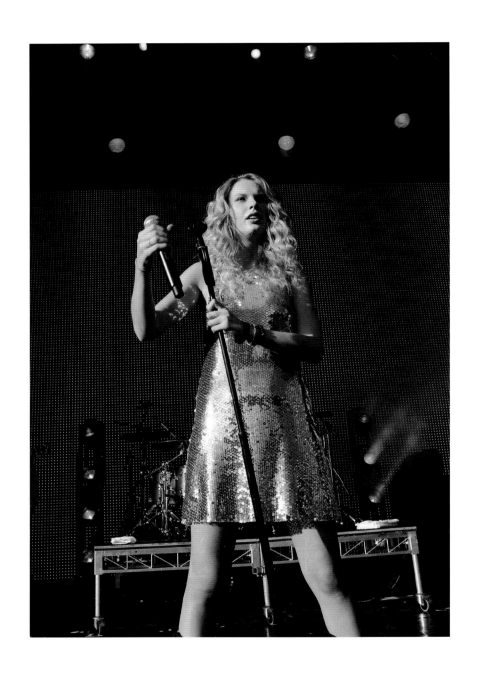
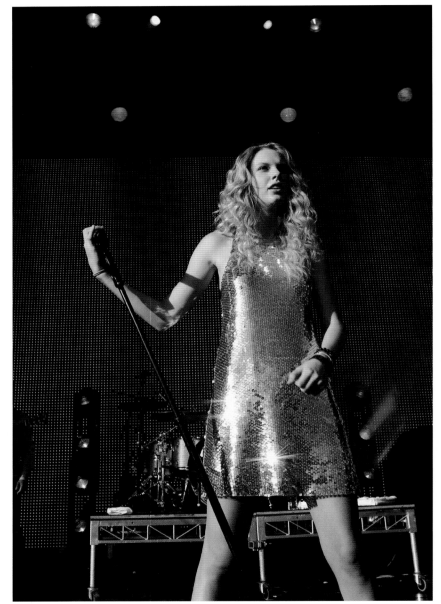

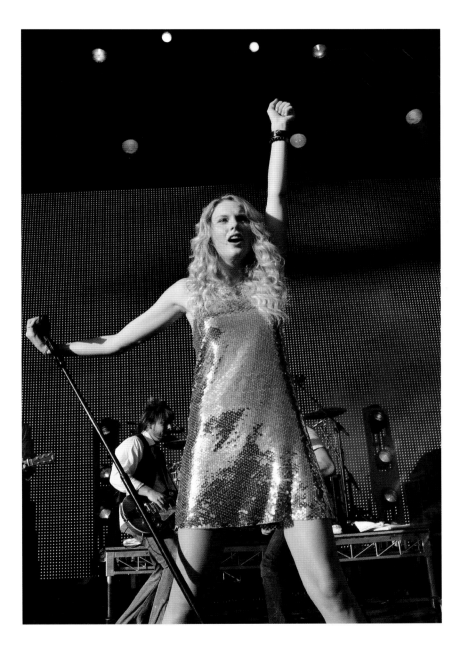

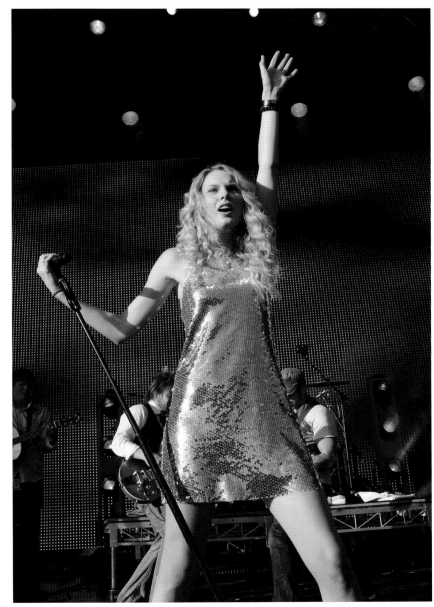

TAYLOR SWIFT
ON TIME EVERY TIME
Taken at the Sound Relief concerts for the Victorian bushfire appeal at the Sydney Cricket Ground. I'd witnessed Taylor three times and was amazed at the choreography of the show. She did the same jokes and had the same stage moves at exactly the same time every show. I found this disconcerting, so much for spontaneity.

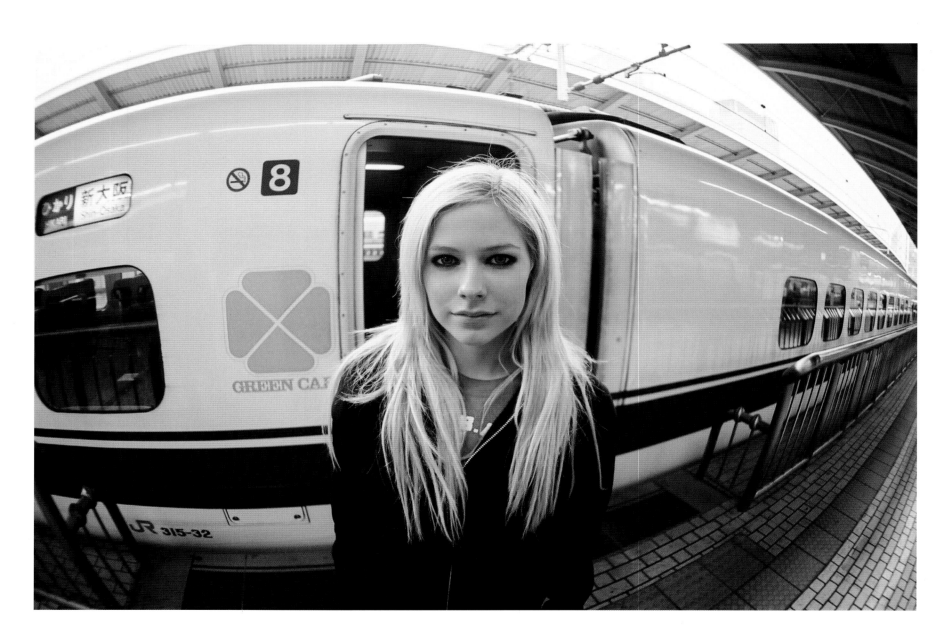

AVRIL LAVIGNE
LOST IN TRANSLATION

In 2005 I was flown to Japan to shoot Avril for a *Live At Budokan* DVD
release. The brief from the mangement was to have a Japanese background.
It was a strange and surreal week. In fact, it was like living in the film *Lost In
Translation*. The rep from the Japanese record company was horrified that
I wanted to shoot in the old quarter of Tokyo; the hotel was bizarre; I could
never stop the toilet from shooting warm water up my backside; and Avril was
mobbed by excited fans everywhere she went. We ended up shooting on the
railway station with the bullet train in the background. To finish off the surreal
feeling of the tour, the record company took us to a brothel for a post show
party. Not really the sort of place Avril wanted to be at. Lost in translation?

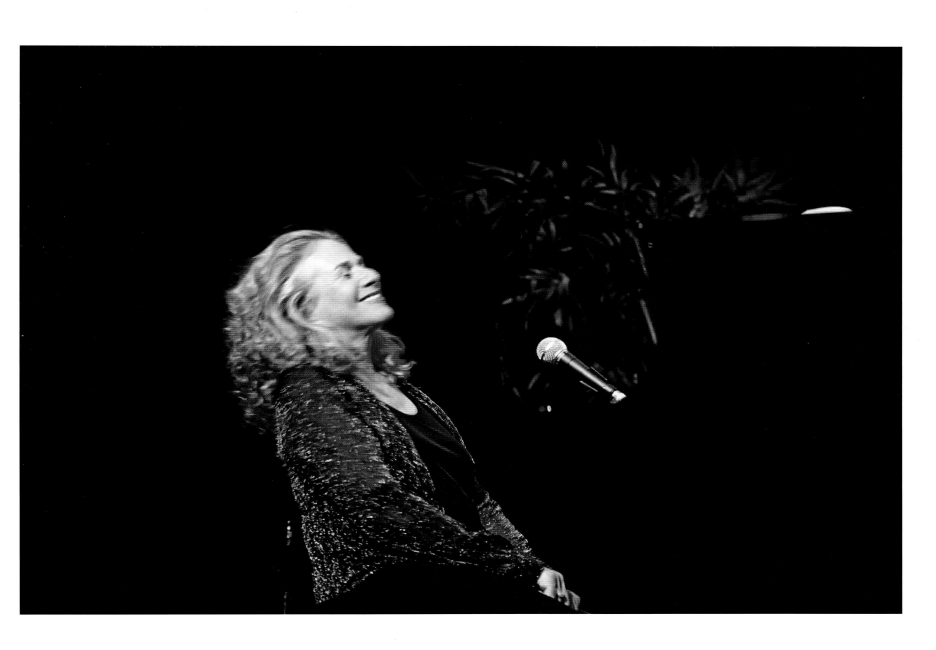

CAROLE KING
YOU'VE GOT A FRIEND

I spent my teen years listening to Carole King's *Tapestry* (I wasn't alone) so it was a surreal experience to photograph and witness her concert 30 years later. Her songwriting is beyond belief; over 50 top ten hits had been written by her even before *Tapestry* had been released. *Tapestry* was the biggest selling female album of all time until the 90s. Meeting Carole King is the only time I've suffered from star-struck. I was invited backstage post gig at the entertainment centre Sydney, when she entered the room I panicked, thinking to myself I have no idea what to say to her my hero, consequently I made a quick exit, I believe it was John Lennon who said "never meet your heroes". Good advice.

BON JOVI
HE'S GOT THE LOOK
Difficult to take a bad photo of this guy, couldn't be more
obliging, seems to be an all round nice guy. Sickening.

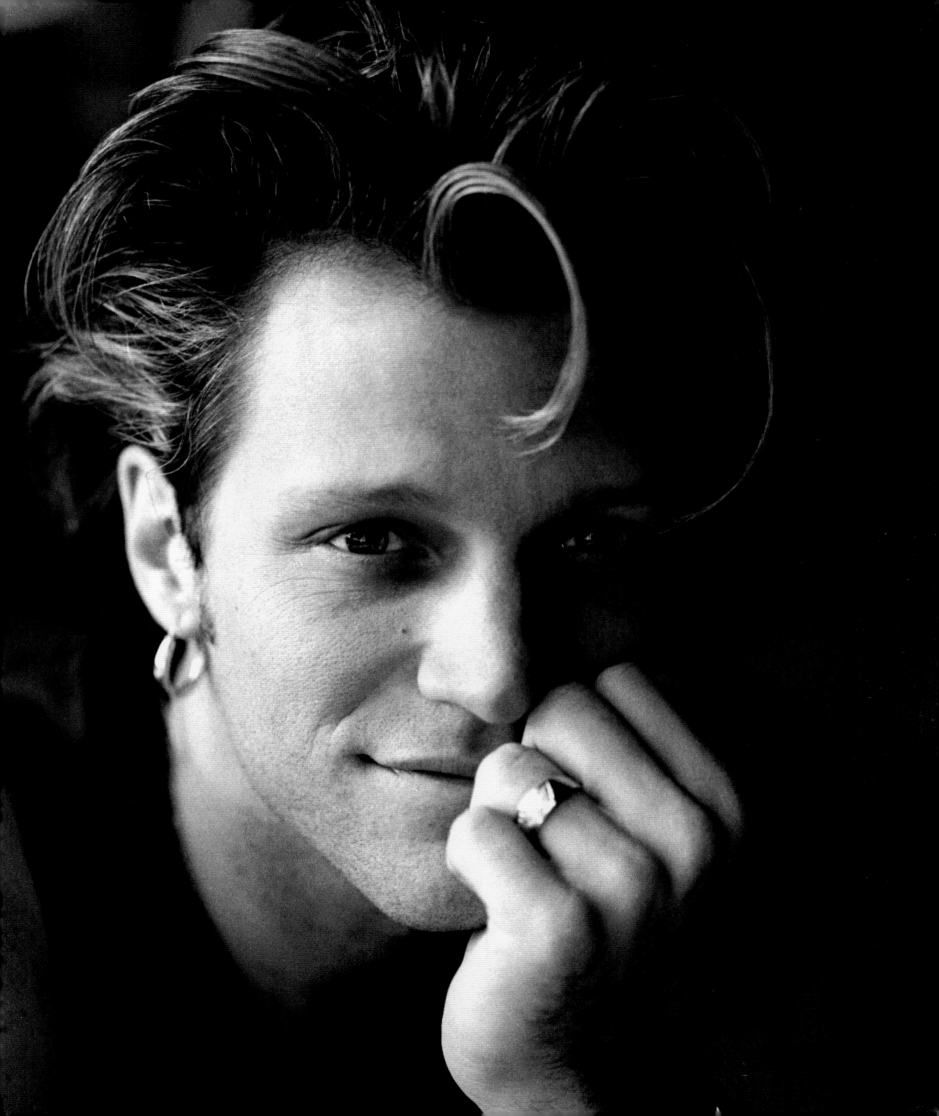

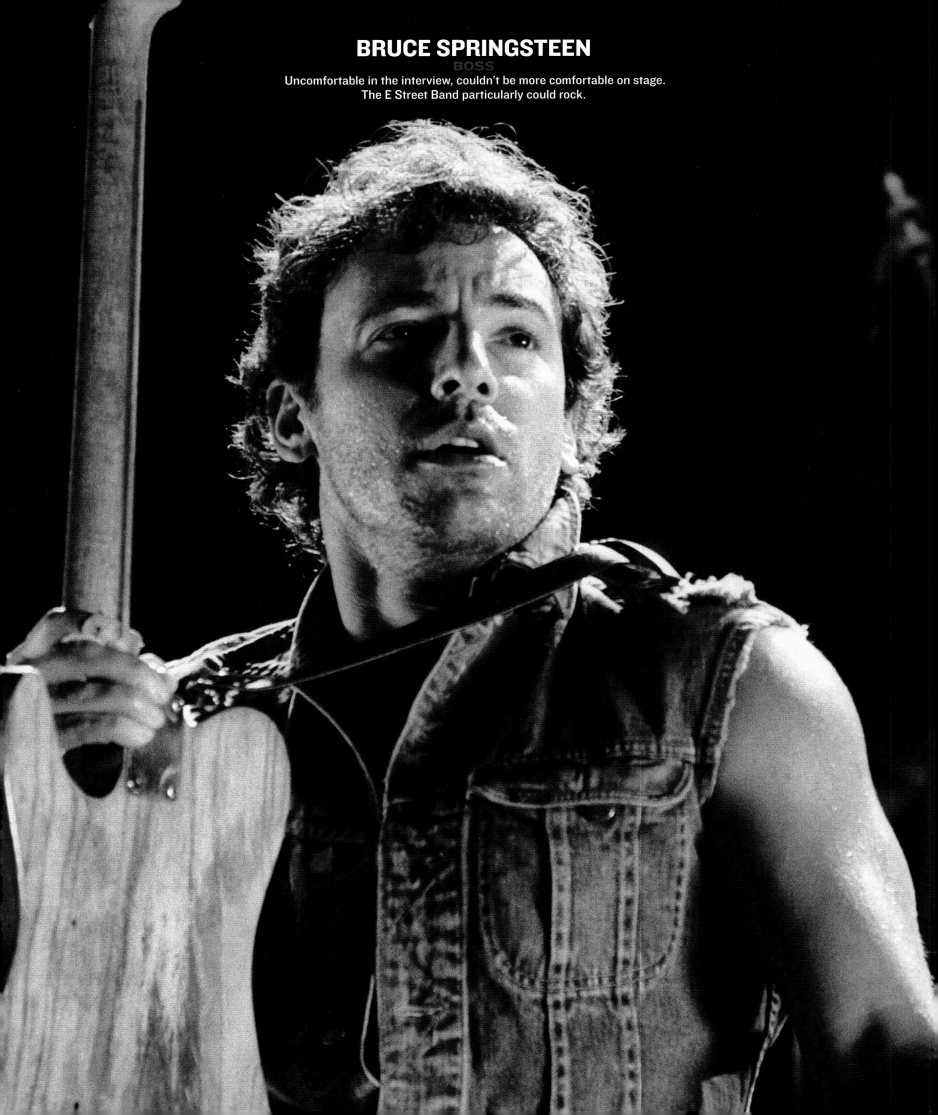

BRUCE SPRINGSTEEN
BOSS
Uncomfortable in the interview, couldn't be more comfortable on stage.
The E Street Band particularly could rock.

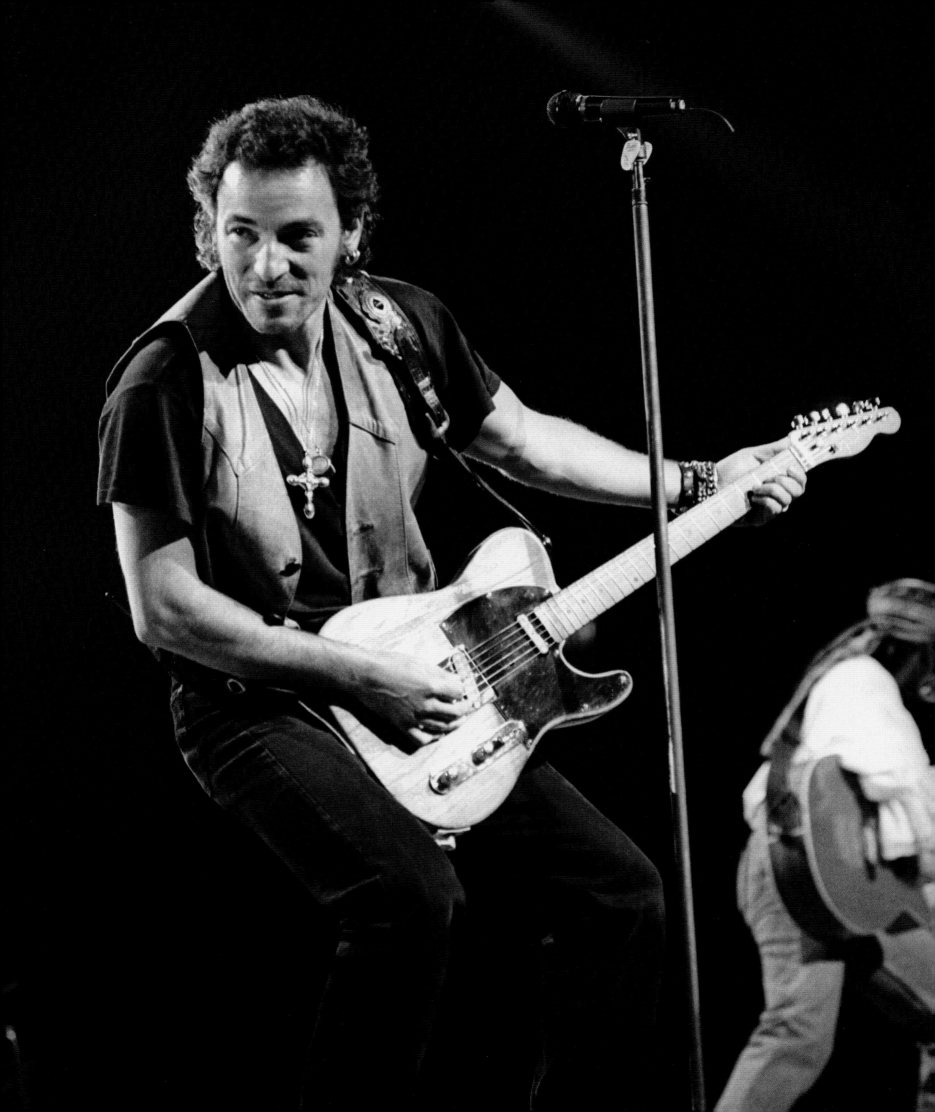

KEEF
GLIMMER TWIN

Unlike Mick, Keith moves less than five metres from his amp in the entire show and has a fag either attached to his guitar or in his gob during the entire set. The mosh pit resembles an ashtray by the end of the gig. Without a doubt the man who most resembles and stinks of rock'n'roll.

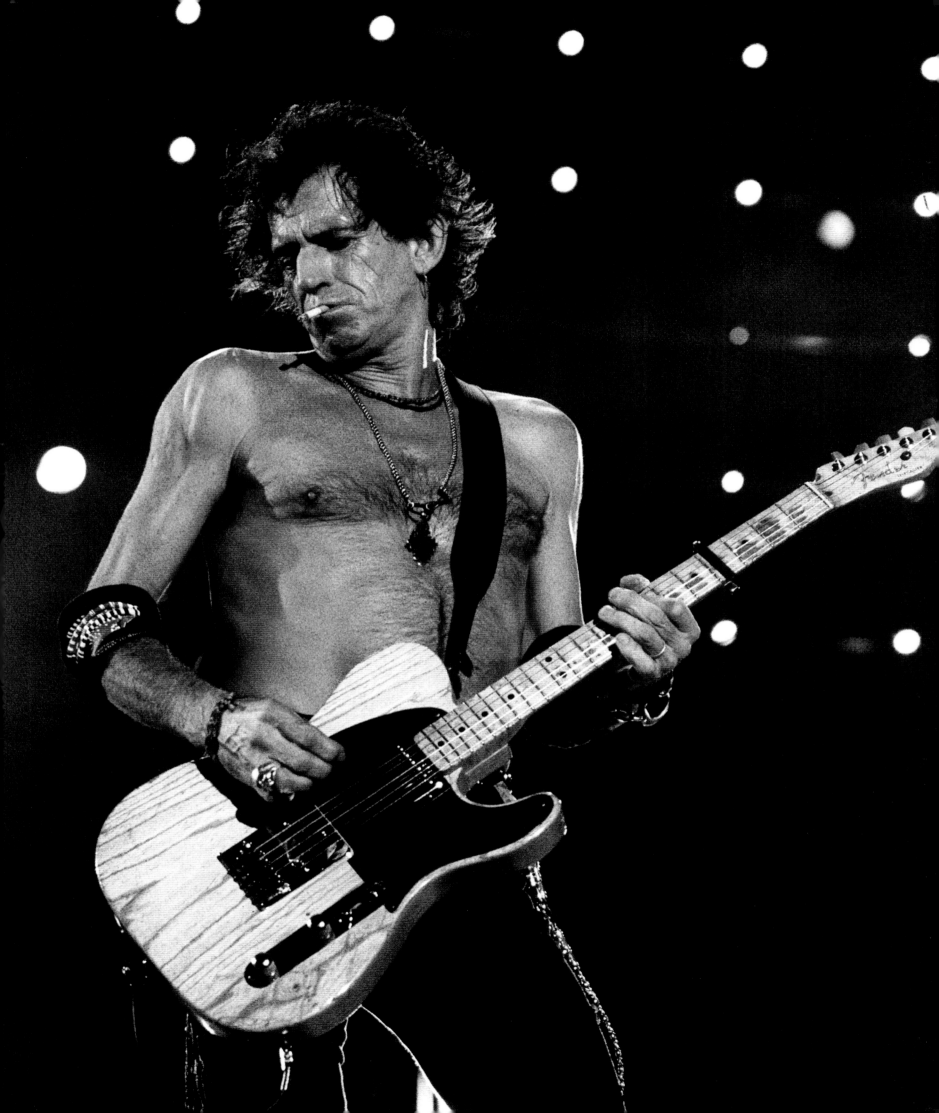

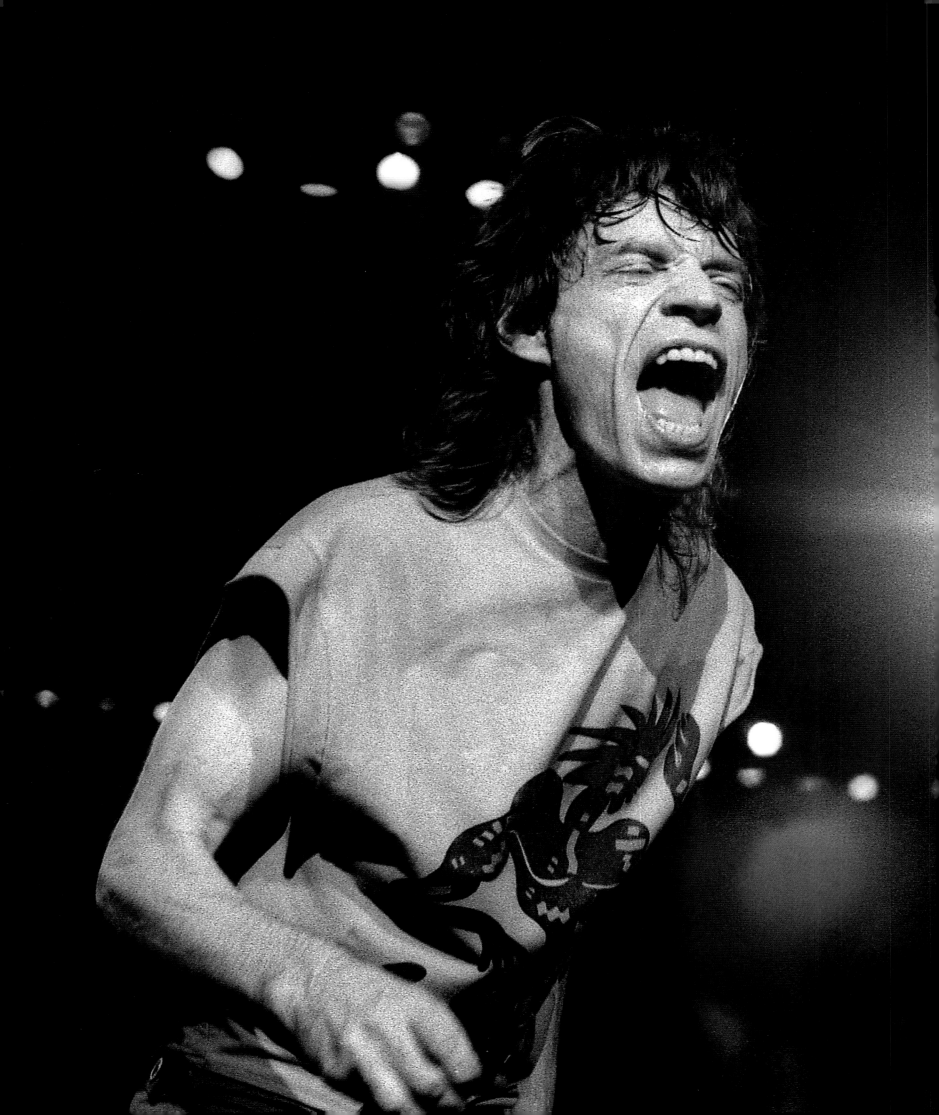

MICK JAGGER
GLIMMER TWIN

Travels around 25 kilometres on stage per night. His mother lived most of her life on the Parramatta Road in Petersham, and was 4th generation Australian, does this make him half Oz?

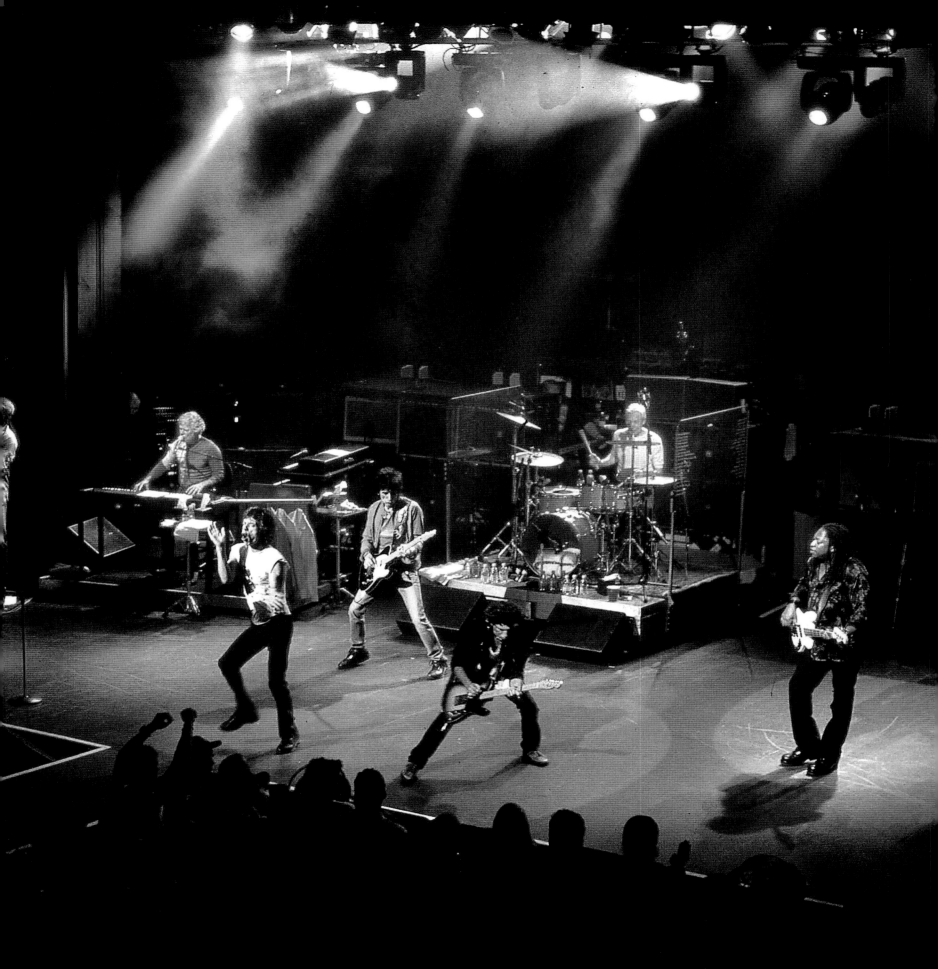

ROLLING STONES
EXILE AT ENMORE
Stones did a one off at the Enmore theatre, Newtown, very intimate and
completely different set list from their stadium shows, bluesier, brilliant.

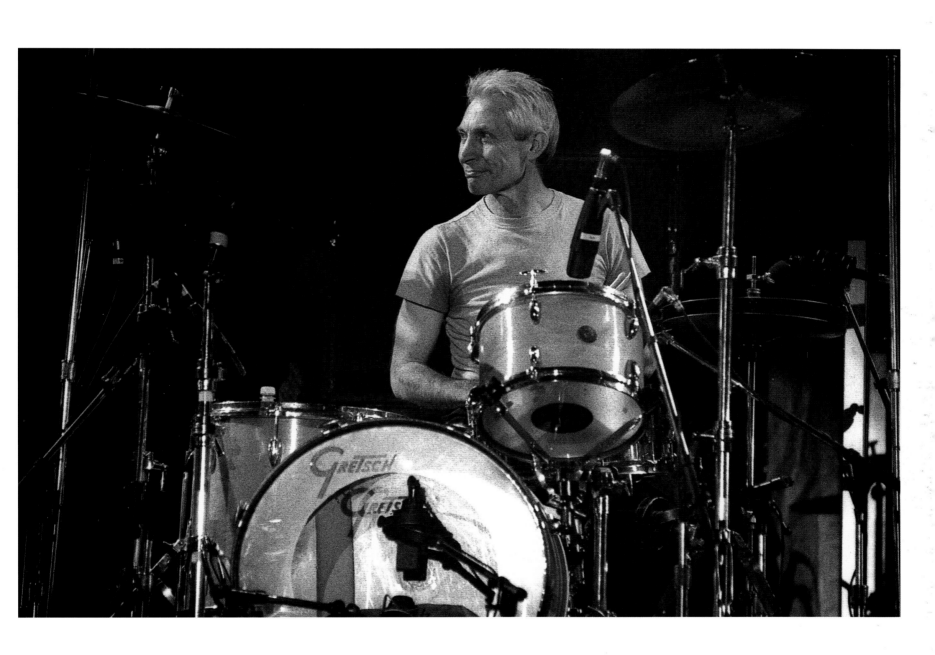

CHARLIE WATTS
A MAN BEHIND
Charlie's conversations backstage after the Sydney shows in 95 consisted
of a very excited Charlie telling anybody who would listen about the bargains
he got in the southern highlands spending millions on horses; not the
conversation I would have expected.

BOB DYLAN
POSITIVELY DIFFICULT
Not the easiest subject to shoot, hates having his photo taken either
live or session which really isn't what you need to hear before being
hired to photograph his 1986 tour. Told me to fuck off in front of 12,000
at the Sydney Entertainment Centre. I proceeded to do just that.

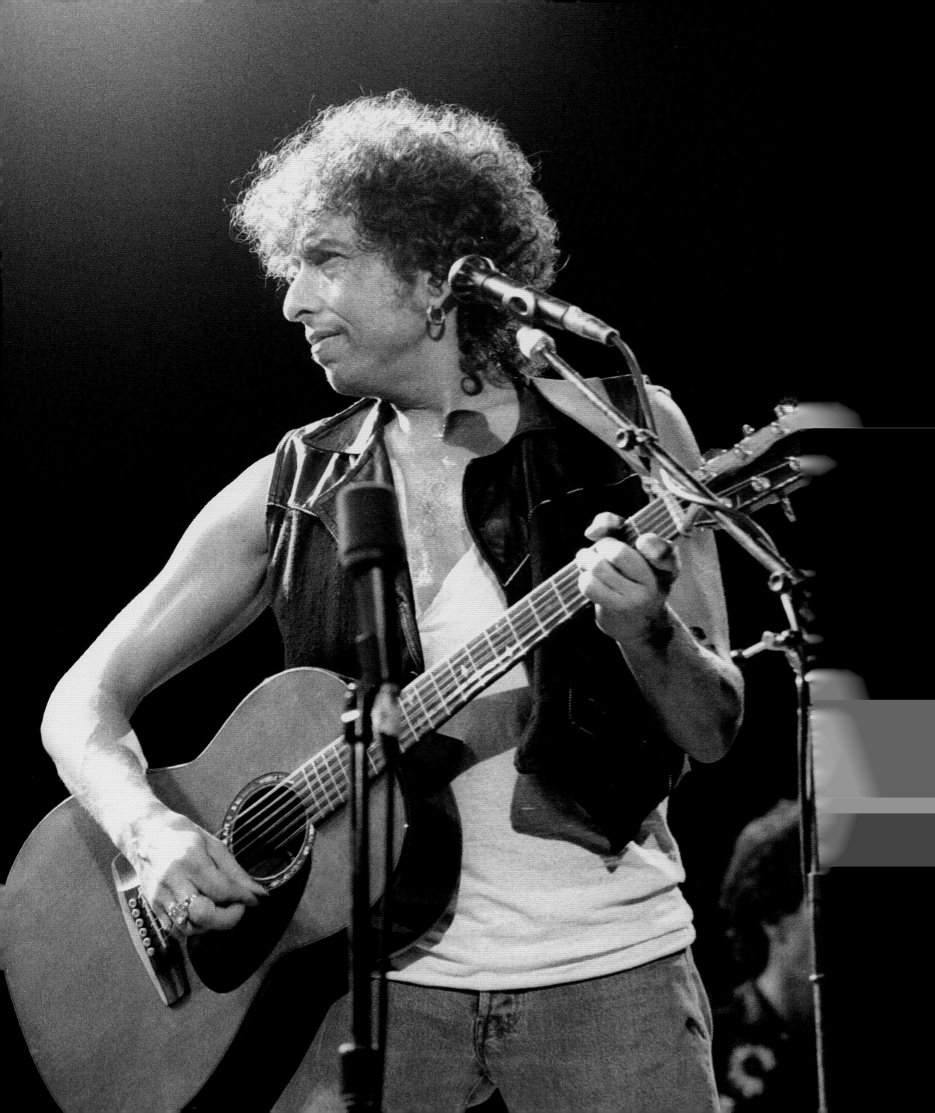

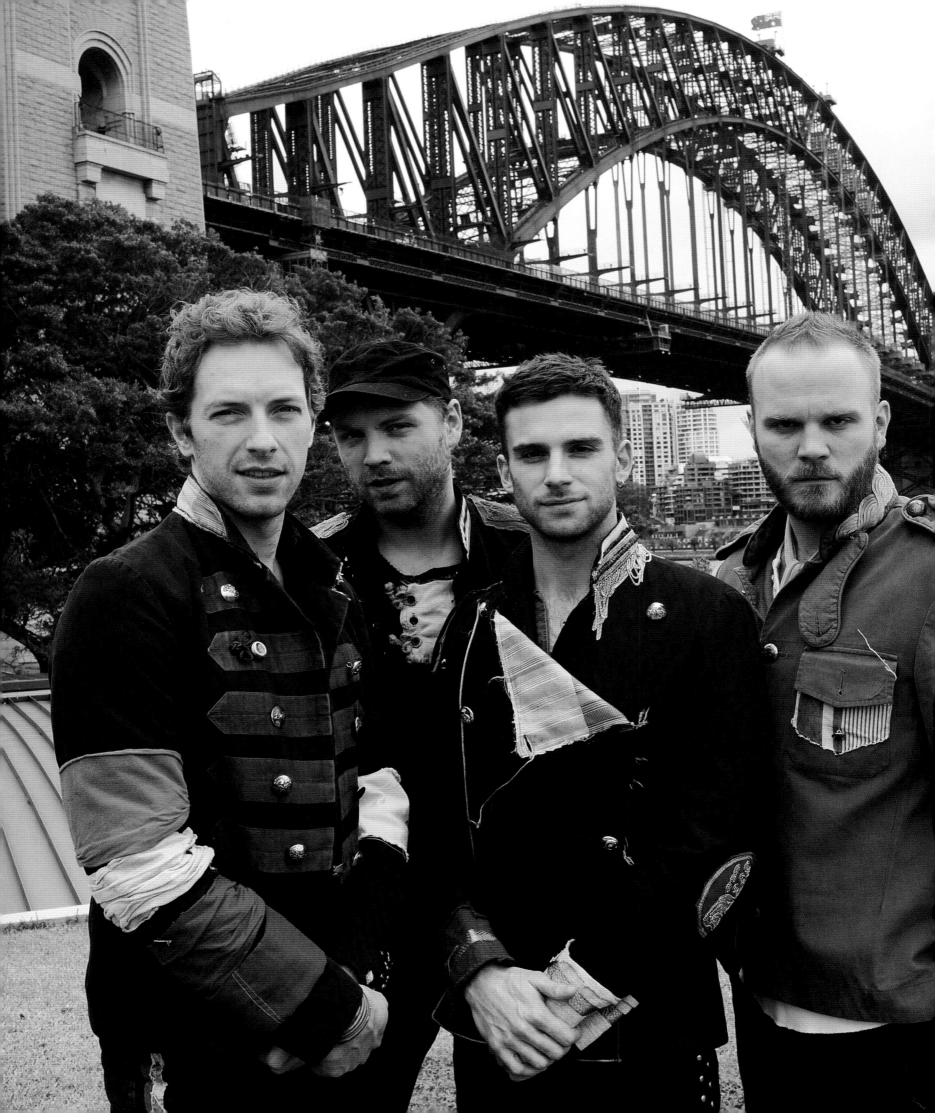

COLDPLAY
STEEL STRUCTURE BACKDROP

When overseas bands tour Australia the obligatory tourist photo is often called for. Overseas press love the Opera House, the Harbour Bridge or even a koala!! This Coldplay shoot is taken at the often-used rooftop of the Park Hyatt Hotel, on the edge of Sydney Harbour. I opened the conversation with the band announcing that I'd met them before on the Big Day Out when I took some of the worst photos I've ever taken – it happens. They thought this was very funny.

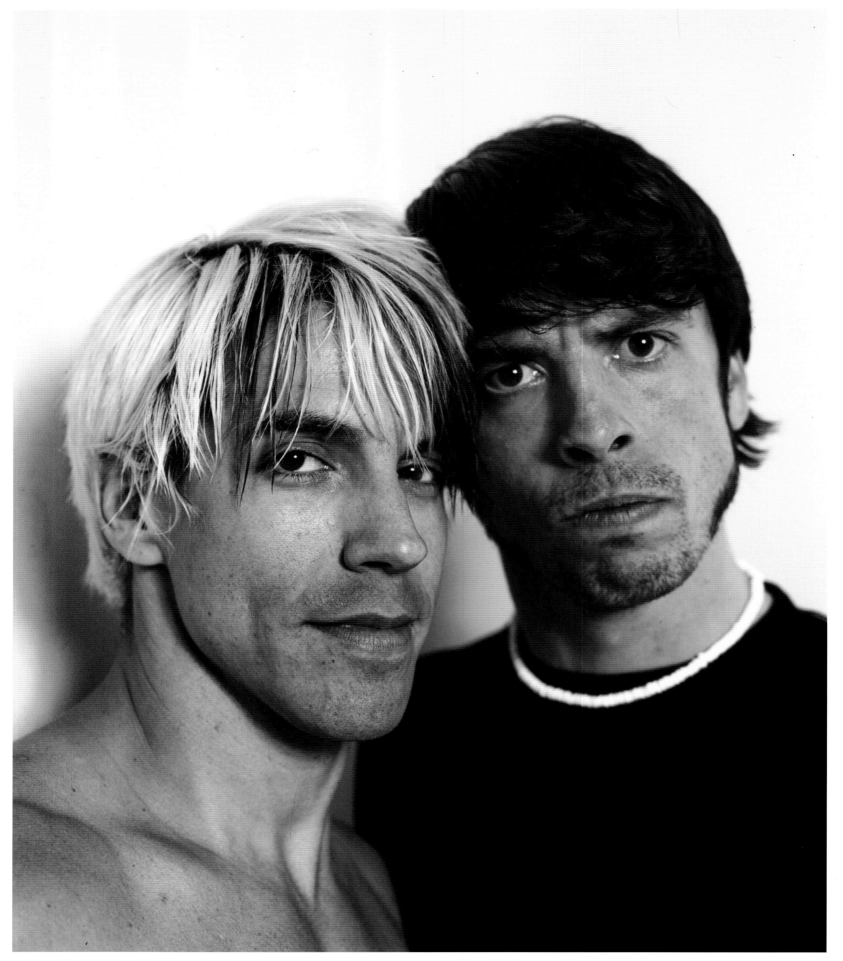

FOO FIGHTERS & RHCP
ANTHONY & DAVE
Red Hot Chili Peppers' Anthony Kiedis & Foo Fighters' Dave Grohl pose for
a front cover of UK metal bible *Kerrang!*, taken very quickly backstage at
Melbourne's Big Day Out. The fact that they knew each other helped make it
an easier shoot.

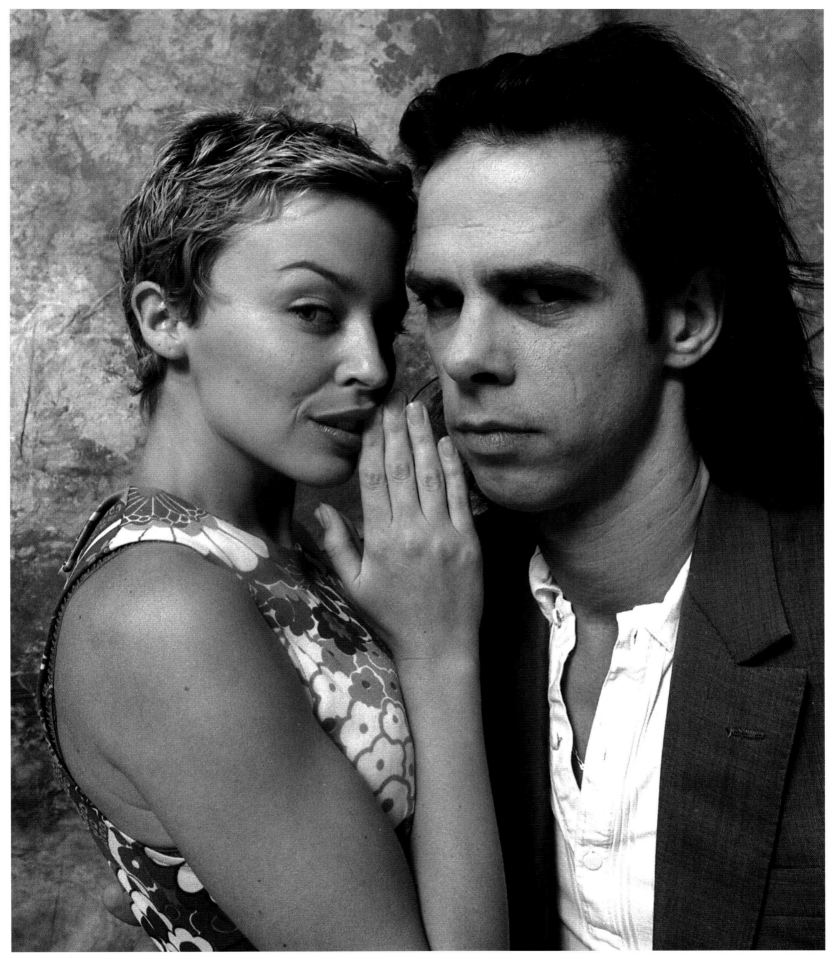

NICK CAVE & KYLIE MINOGUE
THE ODD COUPLE

Both Melbourne icons in their own field but hardly the same fields. This oddest of combinations sort of worked. For a quick shoot of possibly less than 10 minutes it couldn't have been better. I do believe Kylie was praying to Nick, and why not?

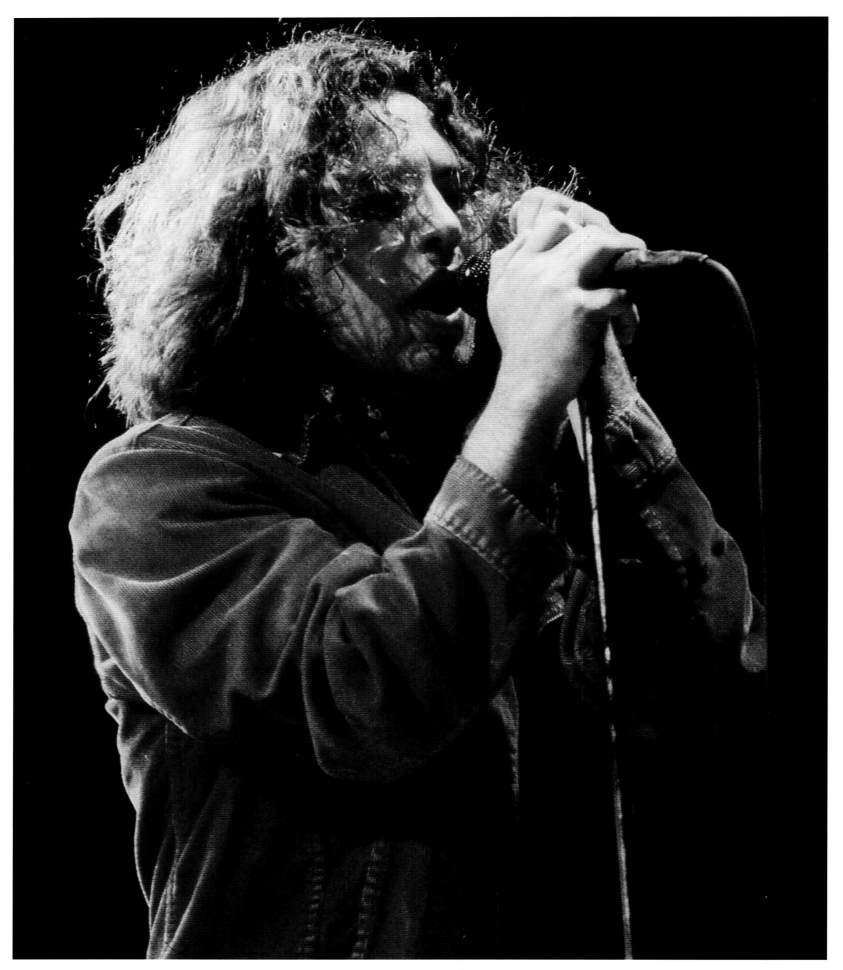

PEARL JAM
WHAT IS ALL THE FUSS ABOUT?
Music is subjective and everybody is allowed to like whatever they like, for the life of me I never got the Pearl Jam hysteria, possibly because I'd witnessed Nirvana earlier. I just didn't get Eddie Vedder or maybe I did and just didn't like what I heard, however as a rock'n'roll photographer I couldn't ignore them.

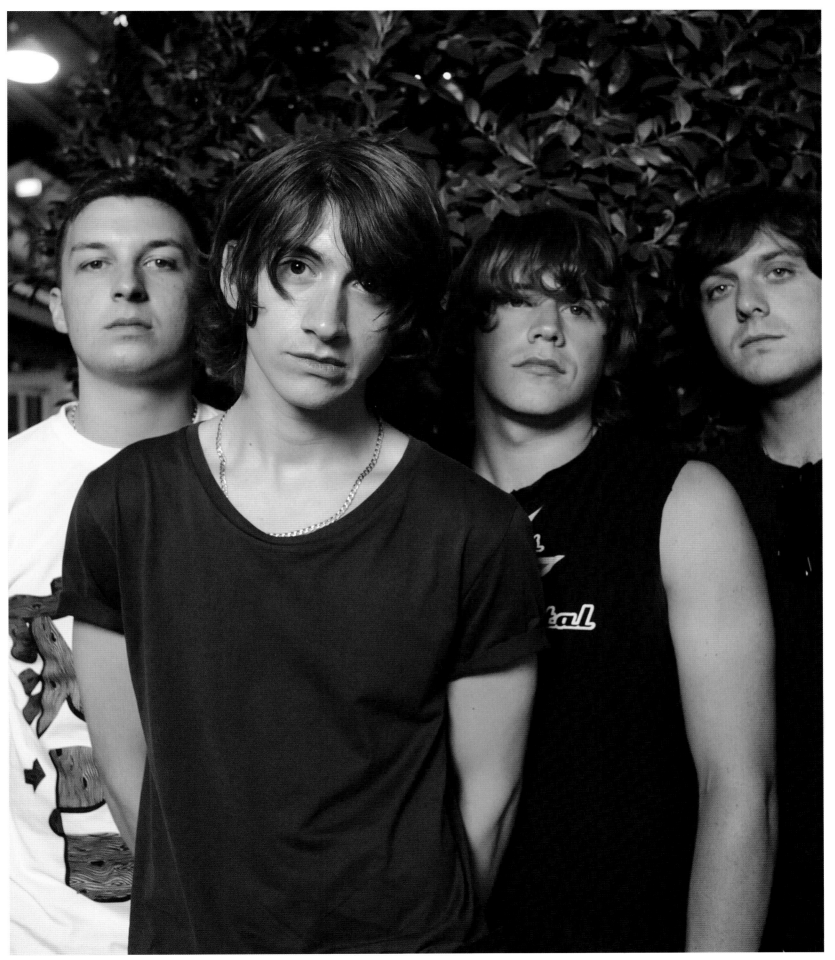

ARCTIC MONKEYS
SHEFFIELD LADS MAKE GOOD
I have something in common with the Arctic Monkeys: we are both from
Sheffield, Yorkshire. However, as they support Sheff Wed and I'm a Sheff United fan, we'll never be
great friends – it's an English football thing!! Taken outside their dressing room at the Big Day Out in
Sydney in 2008. Despite the overhype they received when they started, this band is the real deal.

PERRY FARRELL
TRUST!

Taken in a hotel room in Auckland prior to the Big Day Out, this was for a front cover of *The Age* to promote the BDO festival. On arriving in the makeshift studio, Perry introduced himself and said for us to work together we had to develop trust. He asked me to close my eyes and trust him, which I did. After 10 seconds or so I opened them to have Perry chastise me for lack of trust and to close them again, which I did. This time after about 10 seconds he gave my private parts a fine squeeze!! Now, apparently, there was trust. An eccentric gentleman.

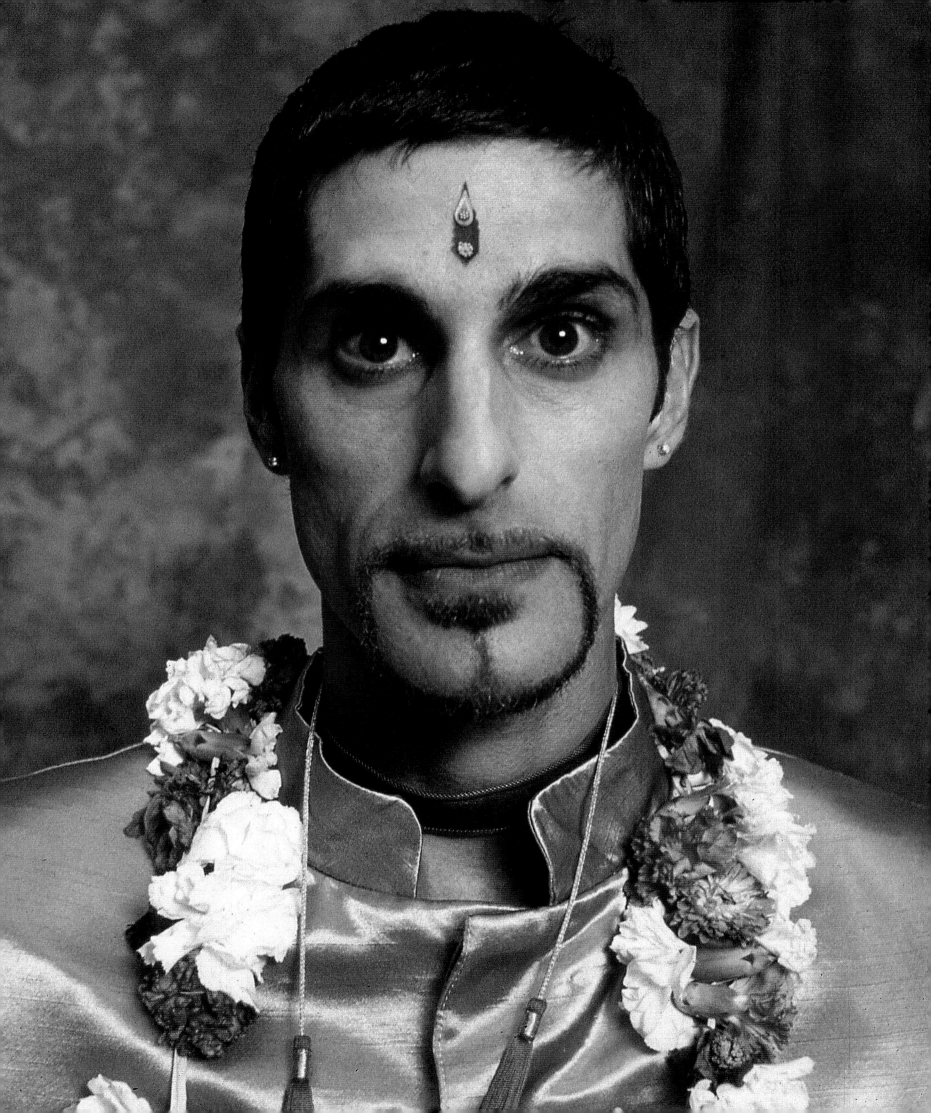

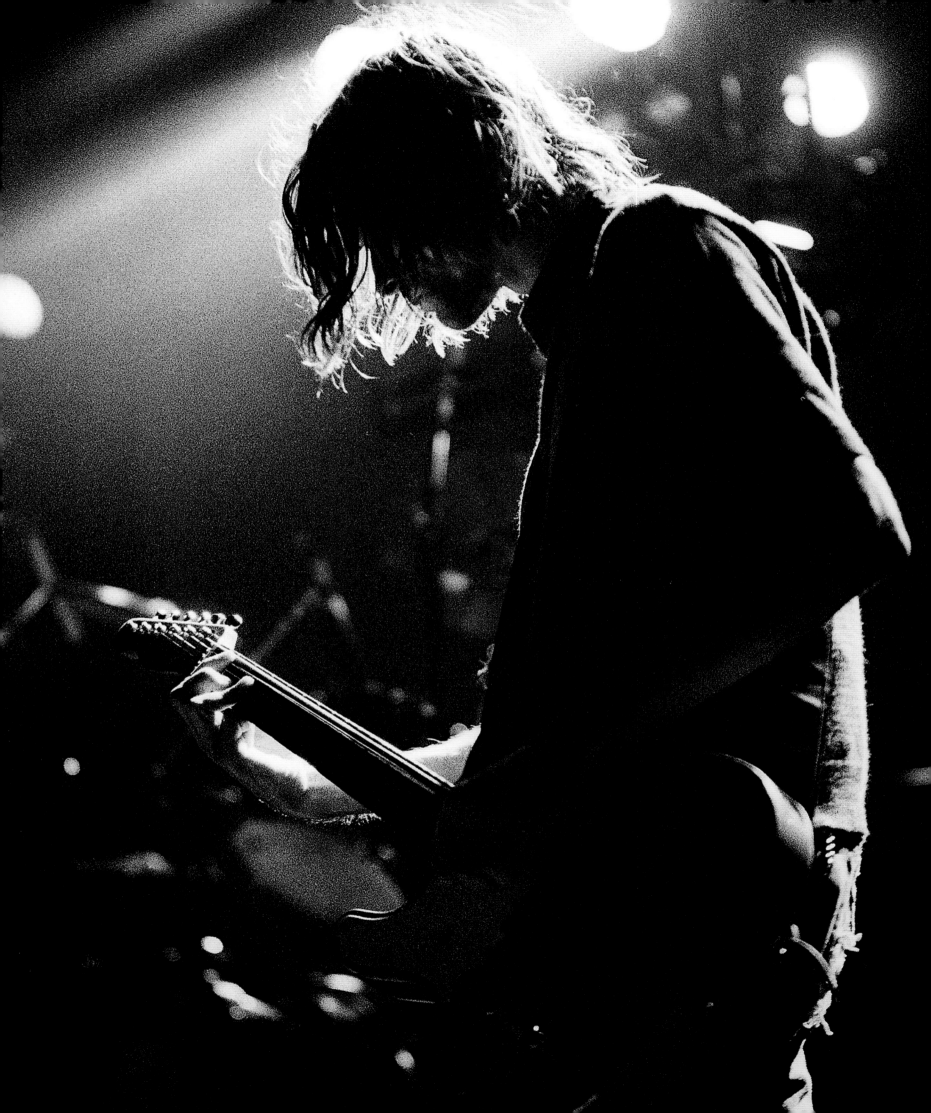

NIRVANA
SMELLS LIKE BDO
Shot at the inaugural BDO festival, by the time Nirvana hit the stage the entire festival audience had deserted the side stages to witness the Nirvana storm. Despite the vibe, this was not one of their better performances. However, The Phoenician Club show a few days later was awesome, and possibly my biggest professional regret as I witnessed it with alcohol rather than the camera. What a fool!!

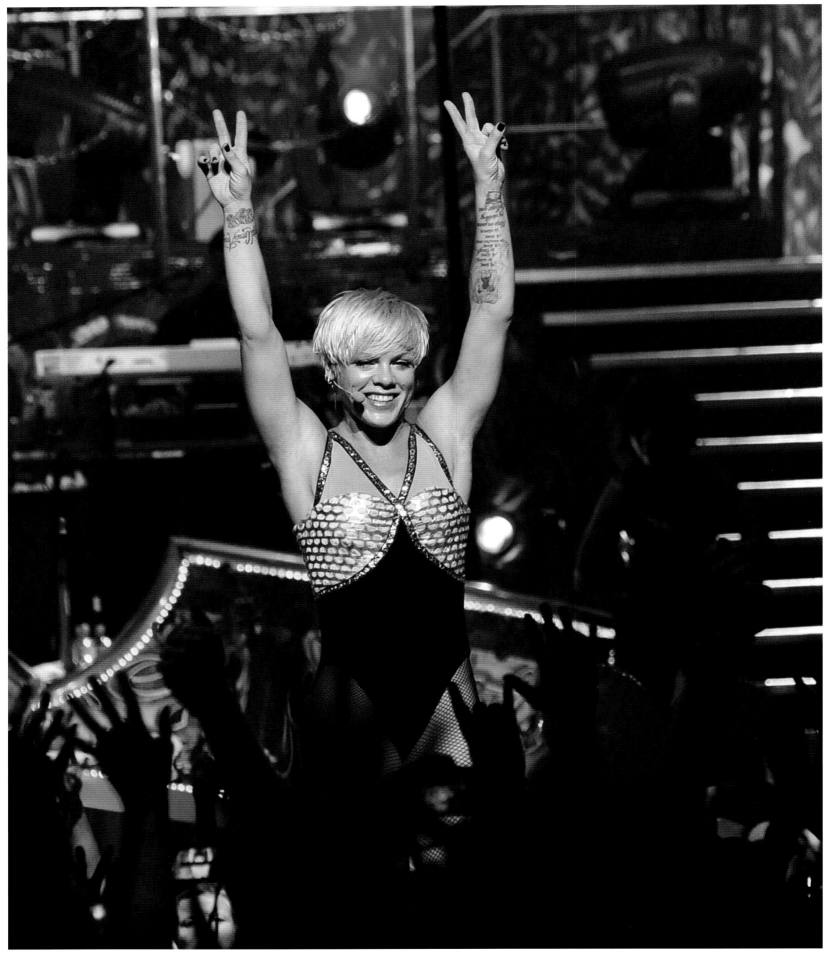

PINK
ROCK'N'ROLL CIRCUS IS IN TOWN
Taken from the back of the venue at the end of the final song of the final concert of
the marathon 2009 Australian tour. More theatre than rock'n'roll, Pink proved she
could sing and perform in just about every position, and spent an inordinate amount
of time upside down. I kid you not.

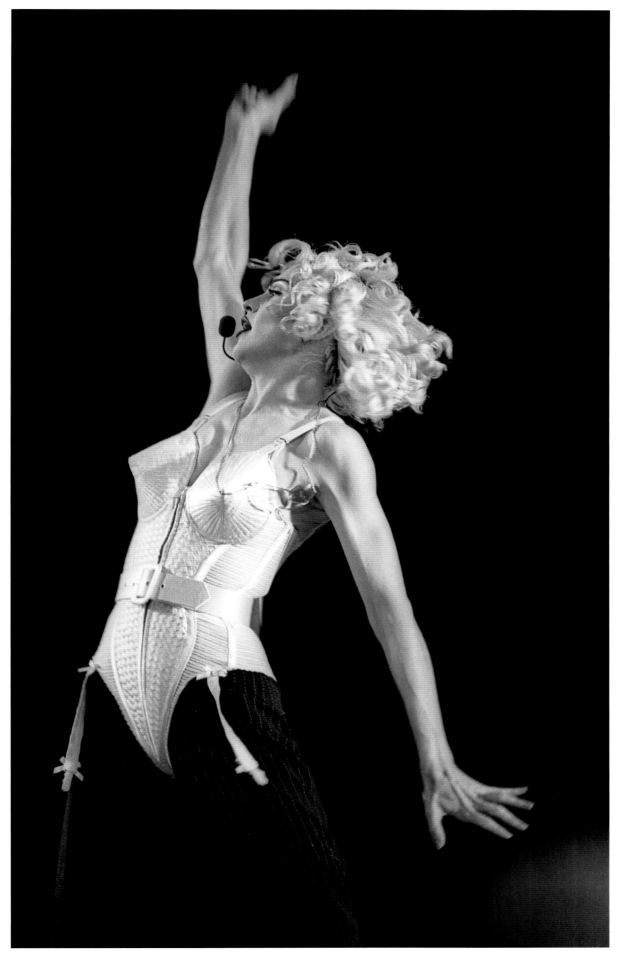

MADONNA
LADY MADONNA
An image change a day will not keep the media away, and maybe that's the point. What an amazing career she has had. This is from the Blonde Ambition tour, the white corset was a nightmare to shoot exposure-wise, pardon the pun!

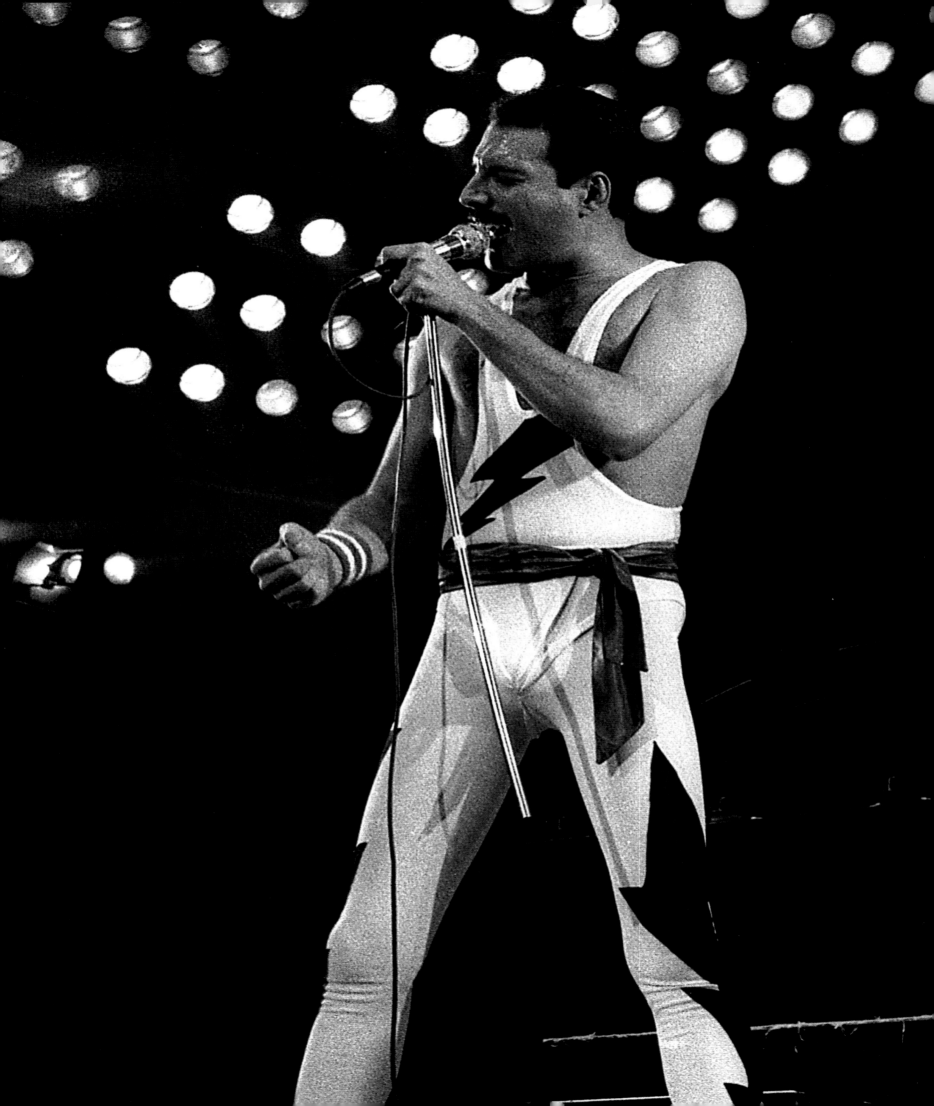

QUEEN

Without doubt the greatest frontman I have ever witnessed; half rock'n'roll, half vaudeville, there will only ever be one Freddie. Imagine a would-be manager going into the record company with demos announcing that the band were heavy with hard rock leaning, singles six minutes long, with a lead singer prone to wearing leotards, drag, and with teeth to his chin, and a screaming raving ****, and naming the band Queen just in case you don't get it.
A&R men would run a mile.

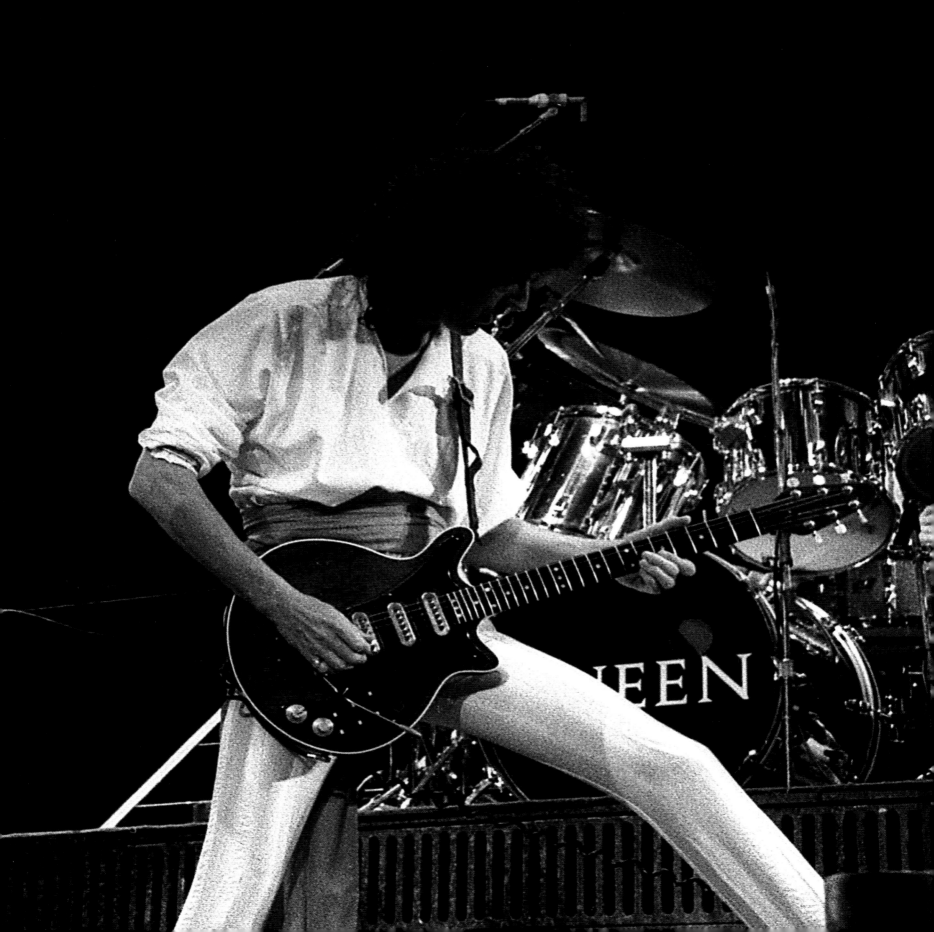

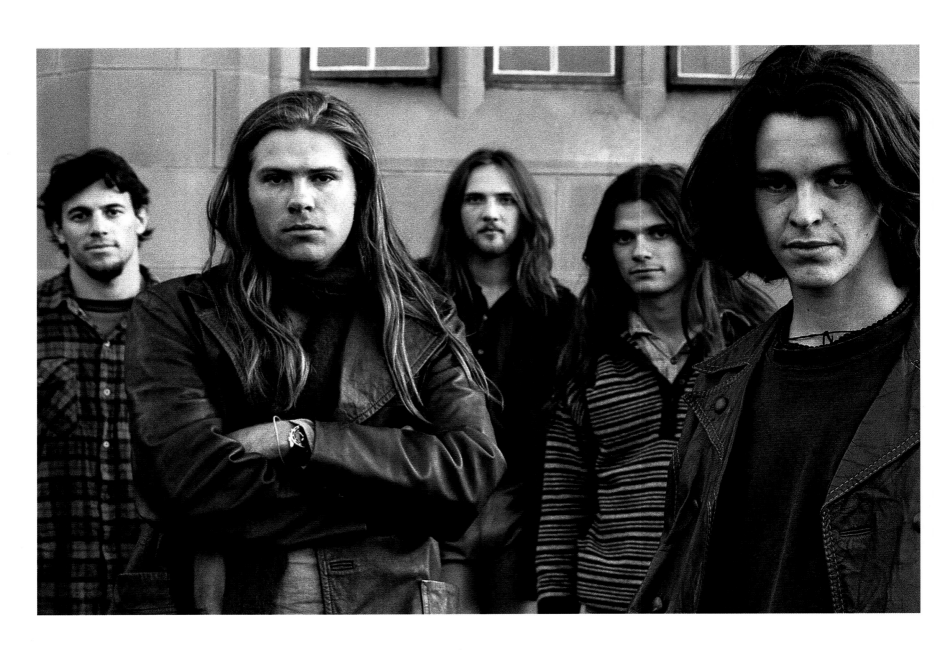

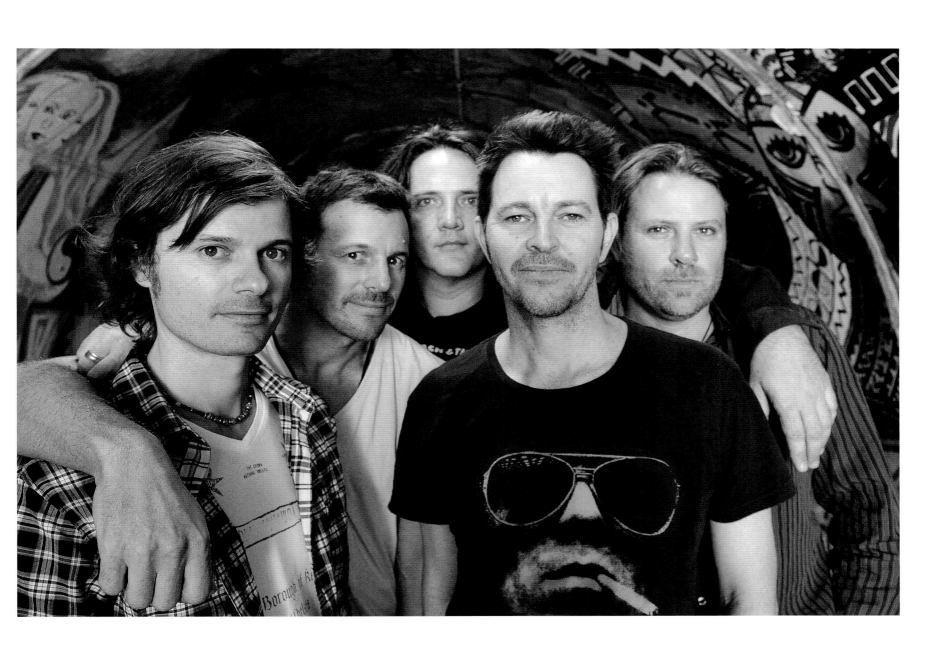

POWDERFINGER
PASSAGE OF TIME

Taken over twenty years apart, it shows the passage of time for Brisbane
band Powderfinger. The first, shot in the grounds of Sydney uni, was taken
before the band had a record deal. The second was taken in 2010 in Auckland,
New Zealand, before going on stage at the Big Day Out. The looks may have
changed but the guys are much the same. They've always been very obliging.
In fact, as a rock band, my main criticism would be that they've always been
way too nice!!! Good cricket and tennis players, too.

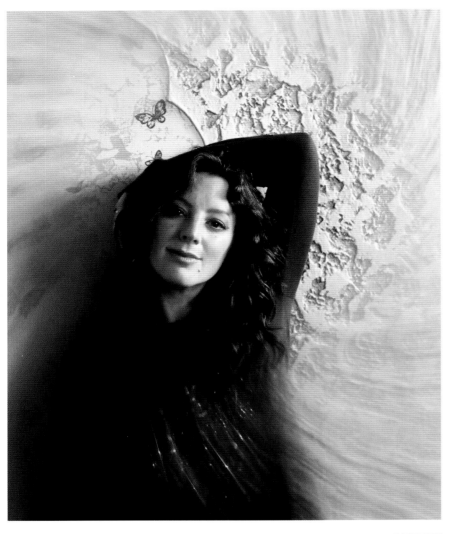
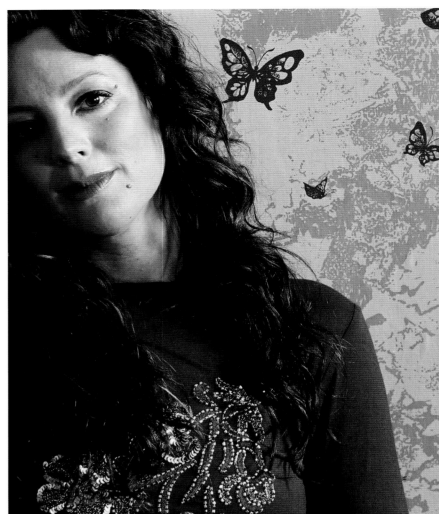
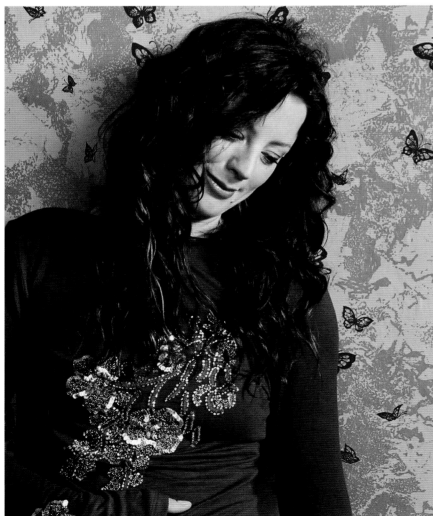
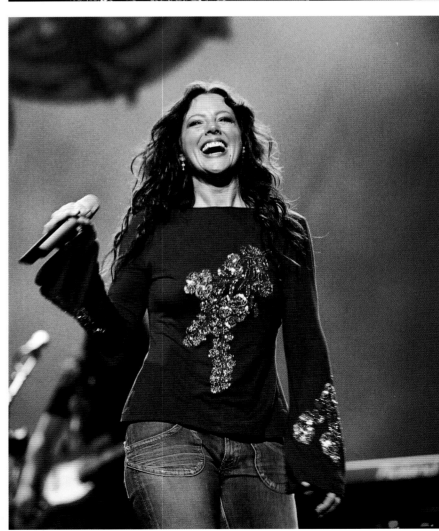

SARAH McLACHLAN
A TOILET IS A TOILET

Sarah McLachlan in 2004 on the Afterglow tour. I was flown up to Brisbane to photograph Sarah and the band in rehearsal. It's always great to meet the artist before the photos are taken, it helps in rapport and to put the subject at ease. Sarah and the band were very friendly and were excited they were staying at the same hotel as KISS. They took to playing KISS songs during rehearsal. I joked with Sarah that my idea was to photograph her in a toilet, hardly in keeping with her image, however the ladies toilet in the State Theatre where they were to play later in the week is the most beautiful toilet, possibly, in Australia. Known as the Butterfly Room, it couldn't be any more ornate. One of the most pleasurable tours I've been on, and I've become a huge fan of Sarah's music as a consequence. My wife thinks I'm in love with her.

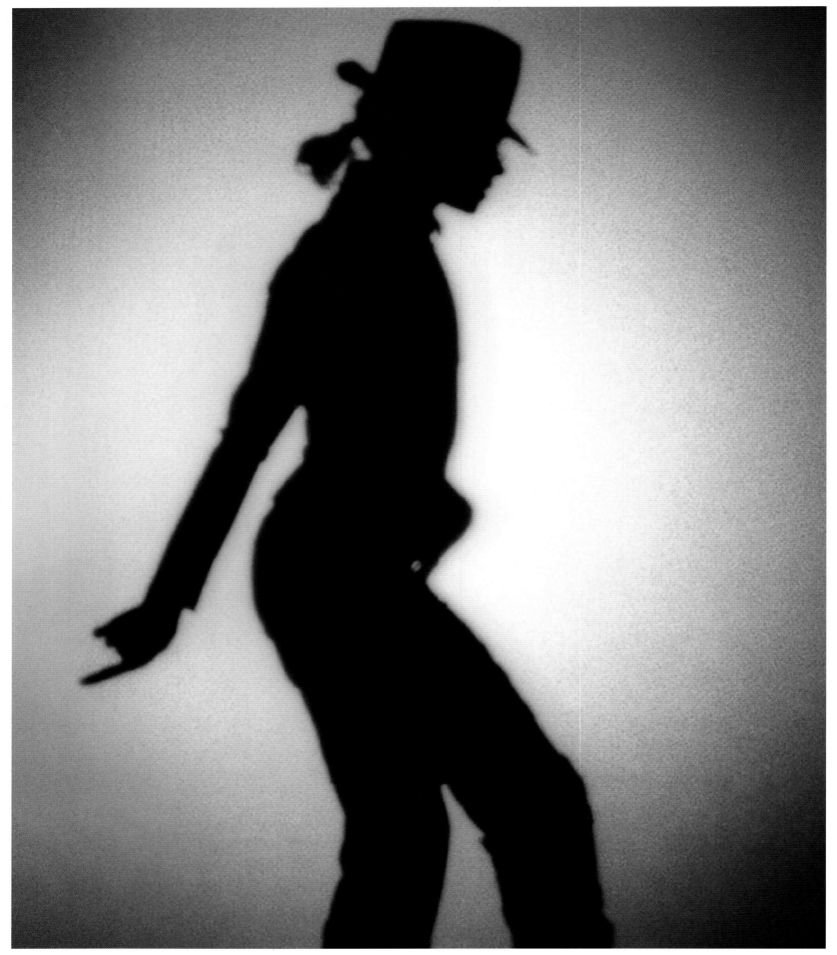

MICHAEL JACKSON
KING OF POP HAS LEFT THE BUILDING
Who would have thought that Michael Jackson could be as strange in death
as he was when alive? Whatever they say he really was the real deal on stage,
absolutely brilliant performer and he could write a tune. What a sad demise to
the most bizarre man in music.

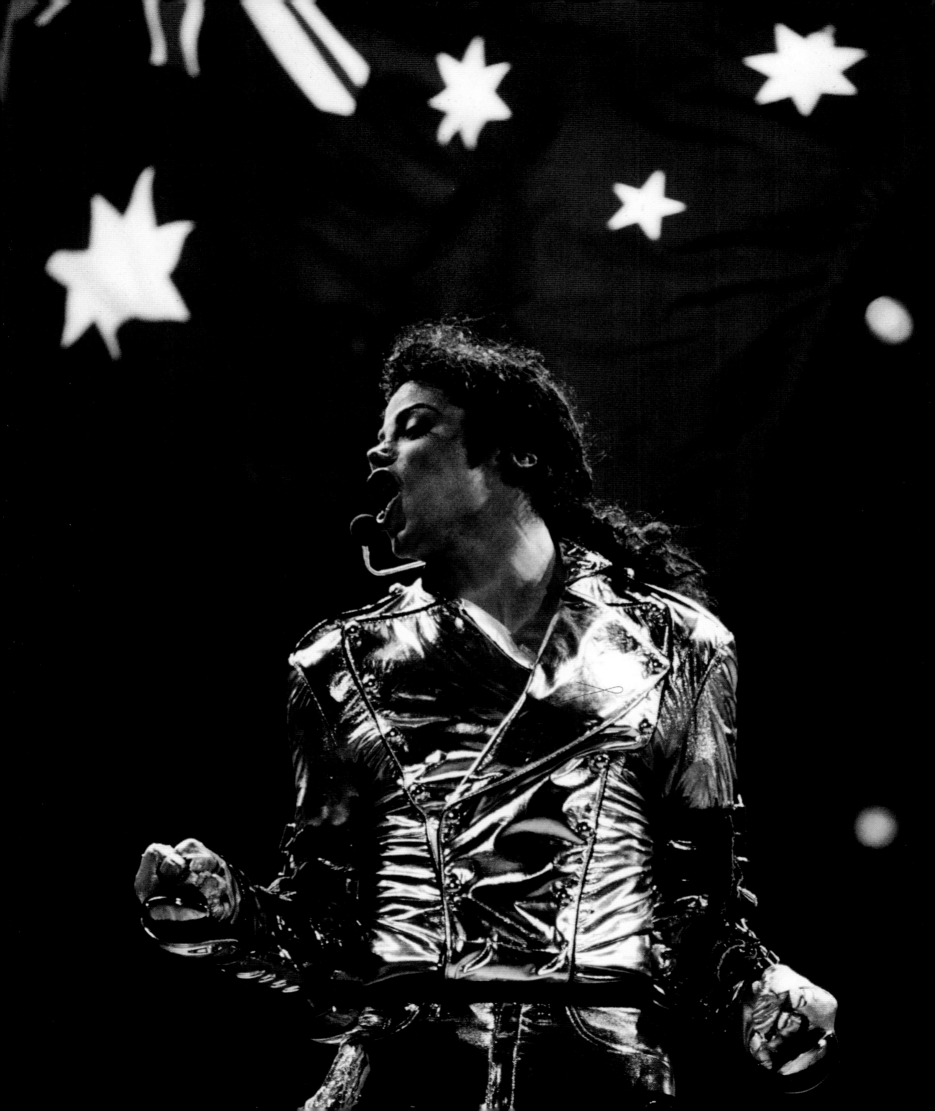

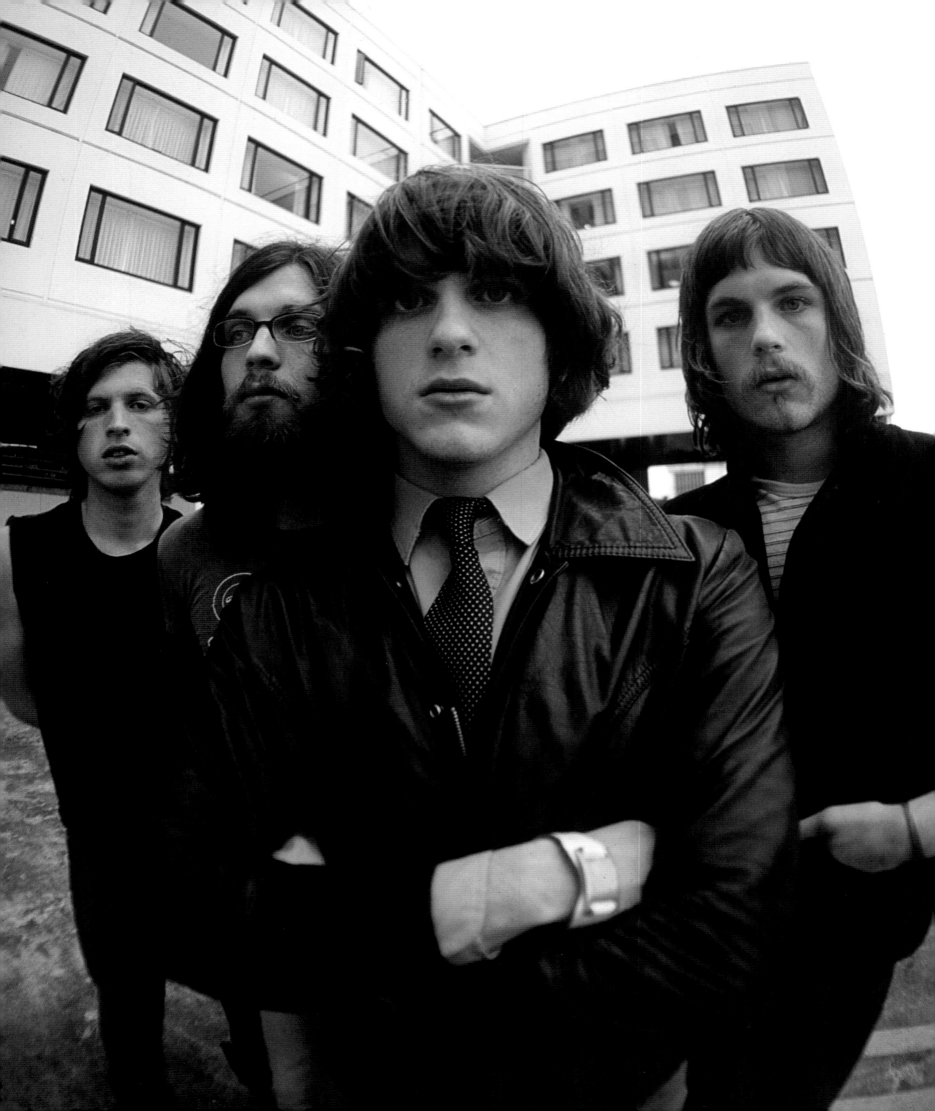

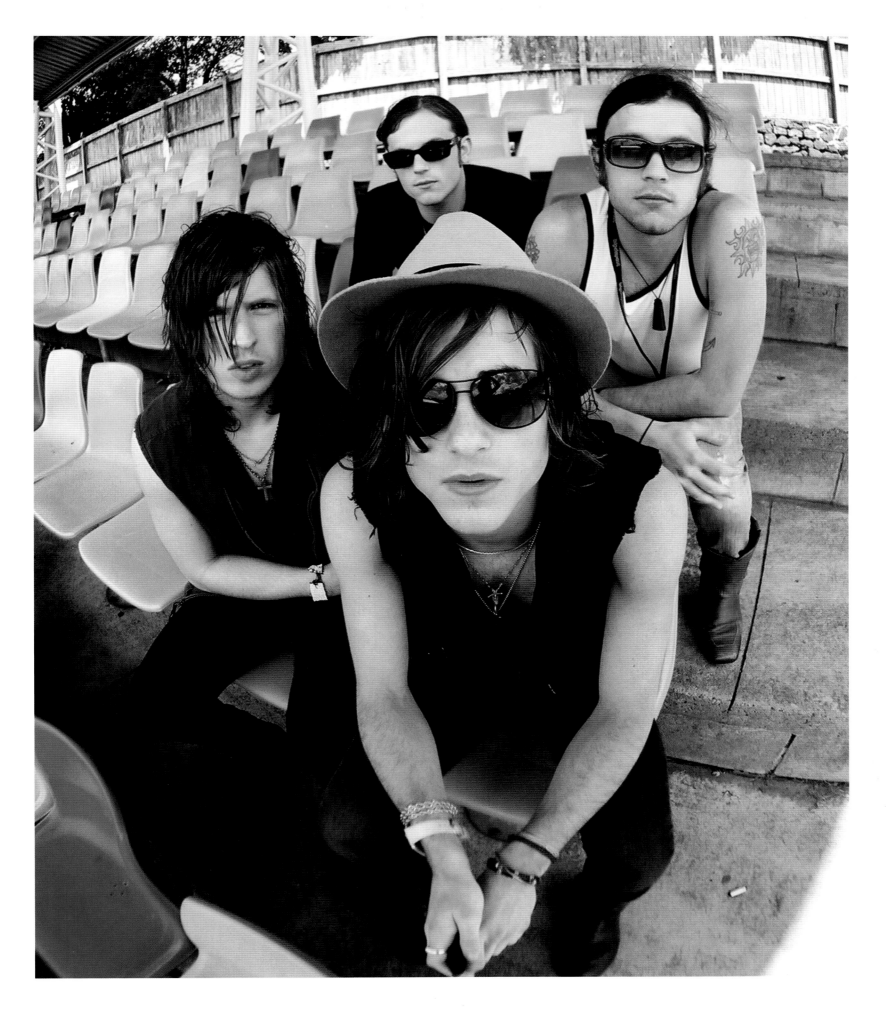

KINGS OF LEON
TIME AFTER TIME
Taken six years apart, from playing the side stage to the main stage of
the Big Day Out. I prefer the early eccentric look.

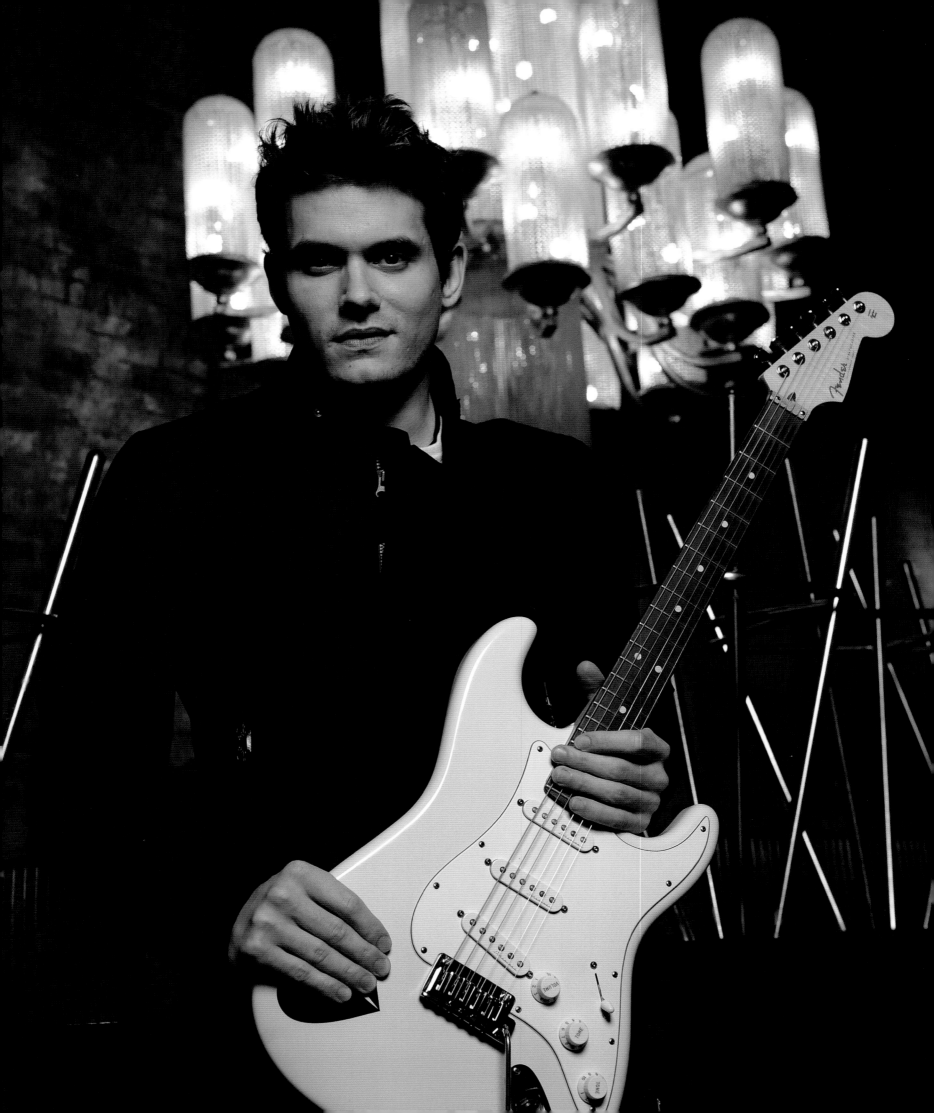

JOHN MAYER
DON'T MENTION HIS FRIEND

Only time I've been told not to mention something in a photo
session, so, consequently, Jennifer Aniston's name didn't come
up. Not sure how it would anyway. This was for a guitar magazine
cover and John complained he was uncomfortable holding the
guitar. Struck me as a strange thing for a guitar player to say.

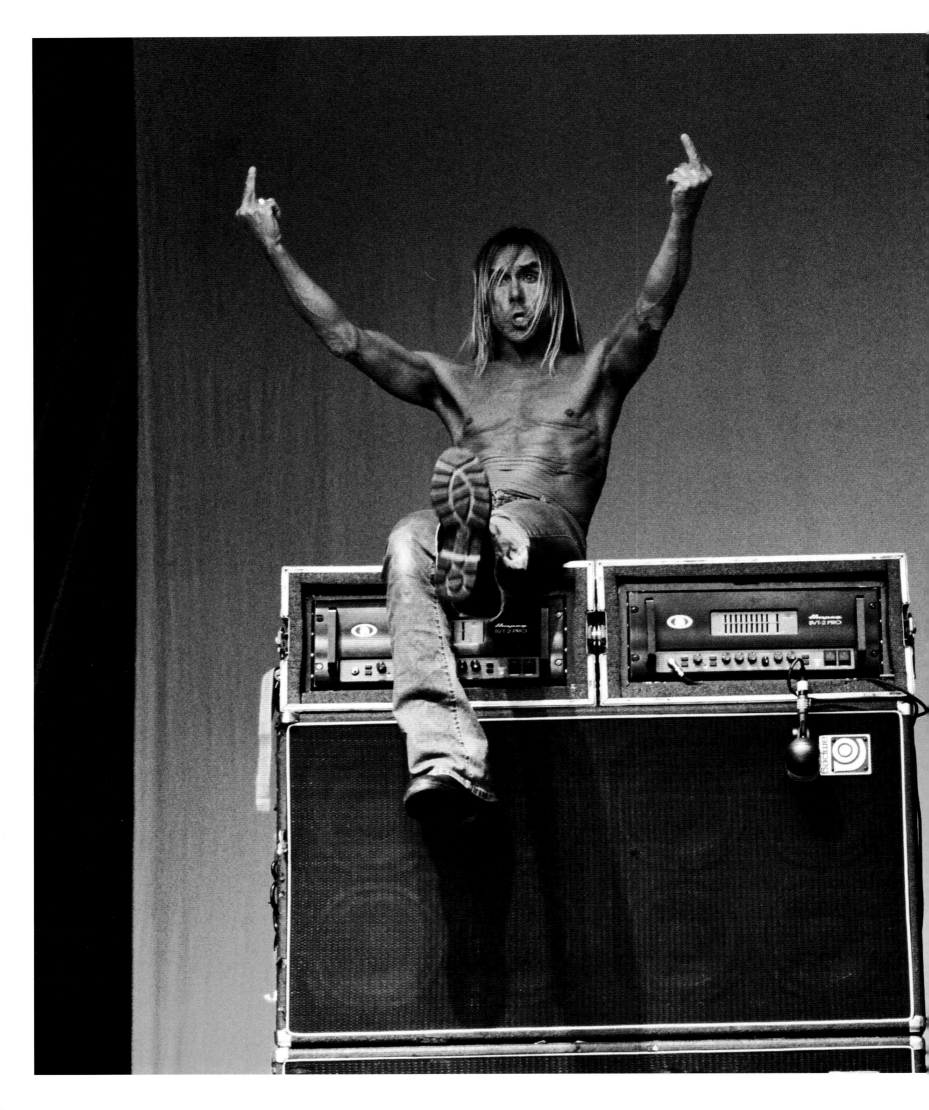

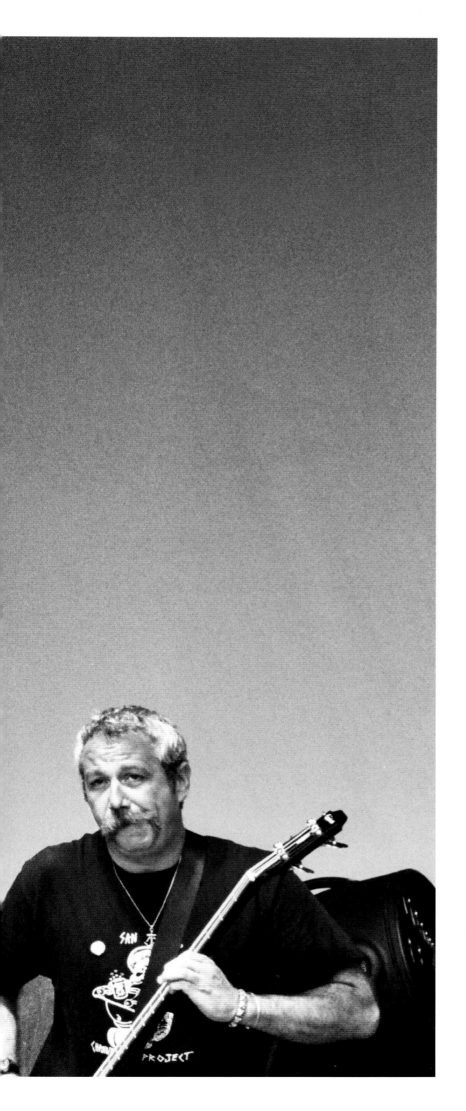

IGGY POP
MEET THE STOOGES
When the Stooges reformed in 2008 they came to Australia as a part of the travelling Big Day Out. Iggy was by then 59, yet he still managed to outperform – both in delivery and energy – bands on the bill that were half his age. He really wants to be your dog!

GUNS N' ROSES
HOW TO FUCK UP A CAREER

Shot low down on the bill at Monsters of Rock festival at Castle Donington,
UK, in 1988, this was the beginning of a great rock band's career but it all
went horribly wrong, splintering off into lesser versions and taking forever to
produce anything and then finally releasing poor efforts.
Possibly one of the great lost bands.

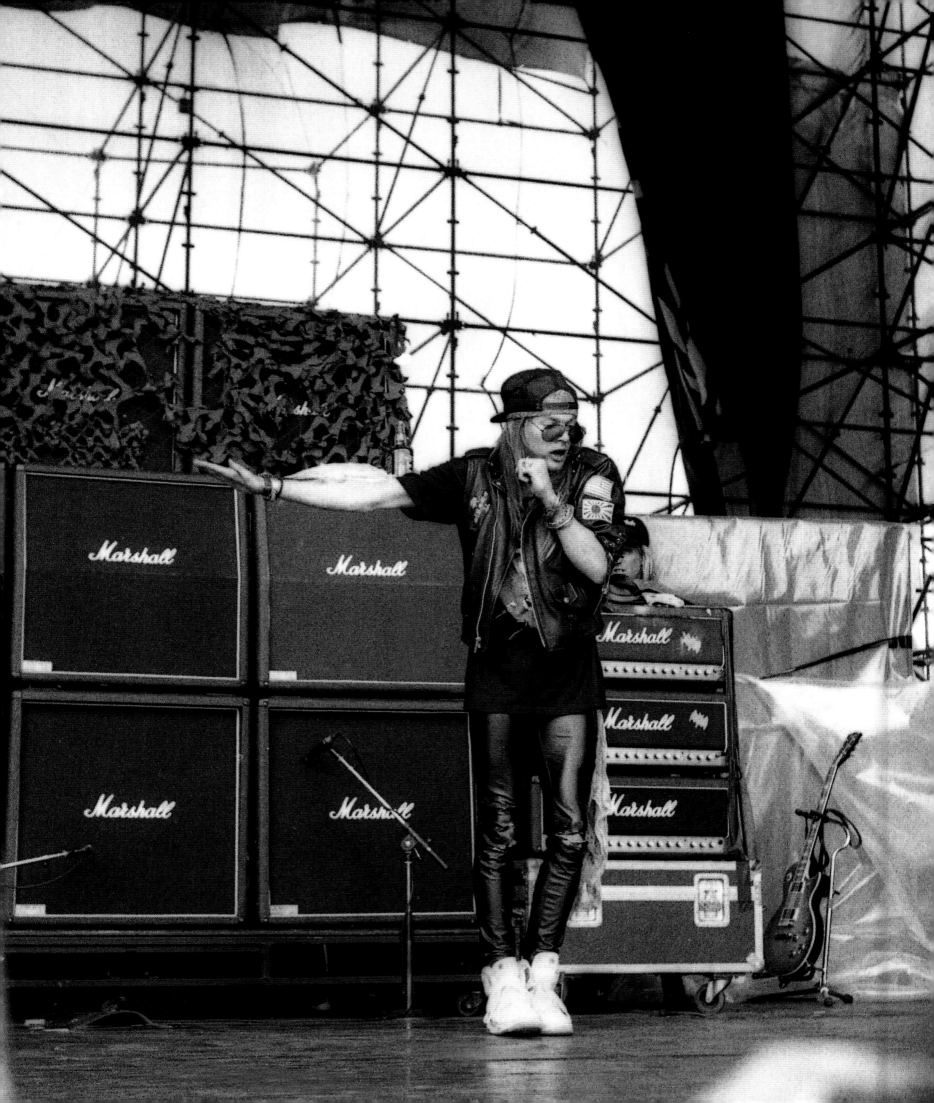

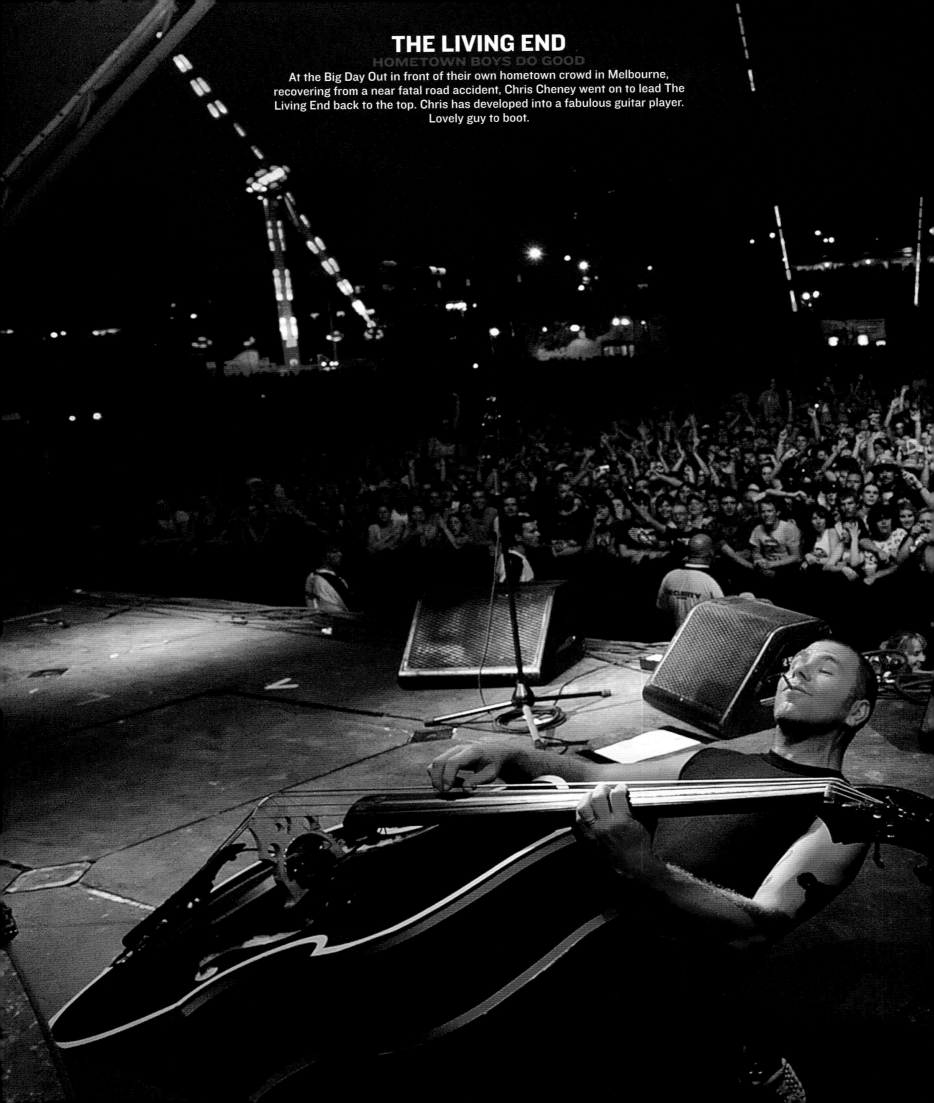

THE LIVING END
HOMETOWN BOYS DO GOOD
At the Big Day Out in front of their own hometown crowd in Melbourne, recovering from a near fatal road accident, Chris Cheney went on to lead The Living End back to the top. Chris has developed into a fabulous guitar player. Lovely guy to boot.

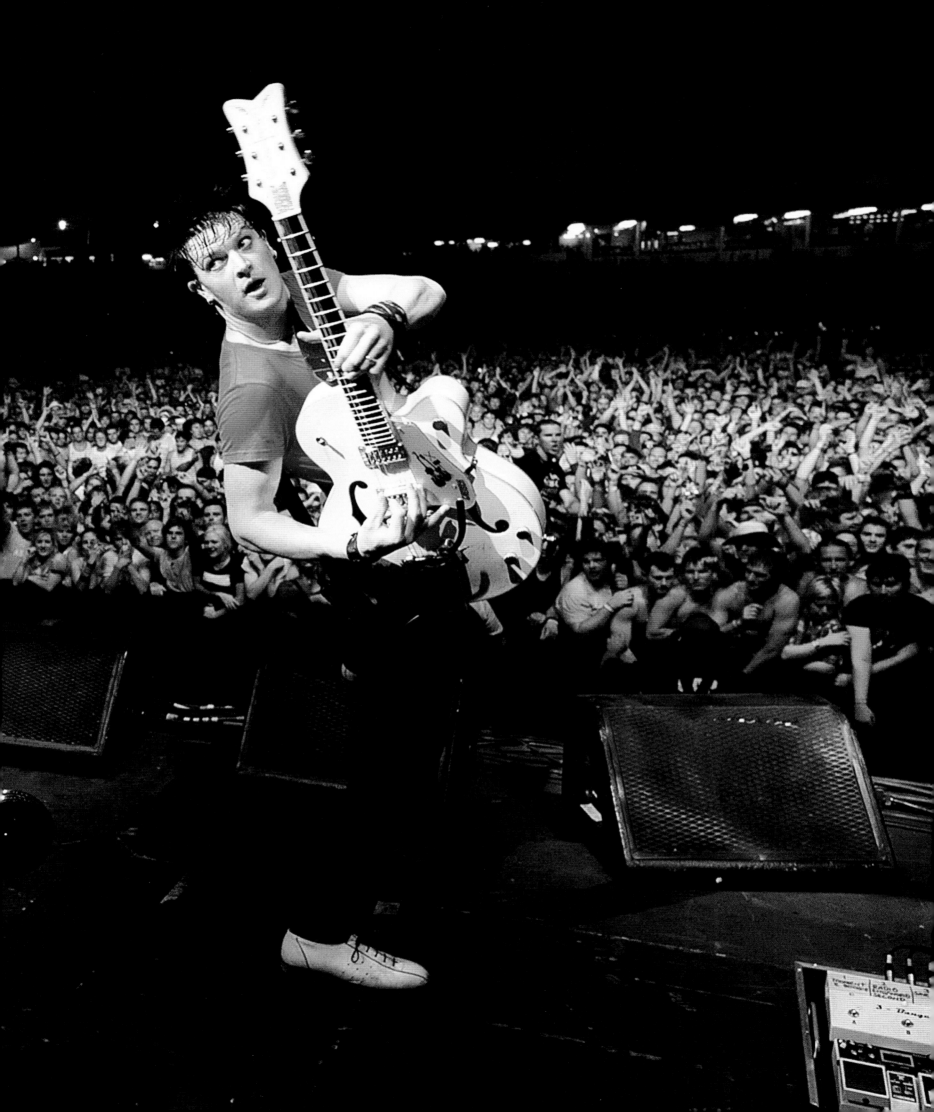

NATALIE BASSINGTHWAIGHTE
ROGUE TRADER

In the brave new world, personalities have so many careers often at the
neglect of another. Potentially a rock star, but side attractions seem to be
distracting her, shot on a video clip. Has a great look.

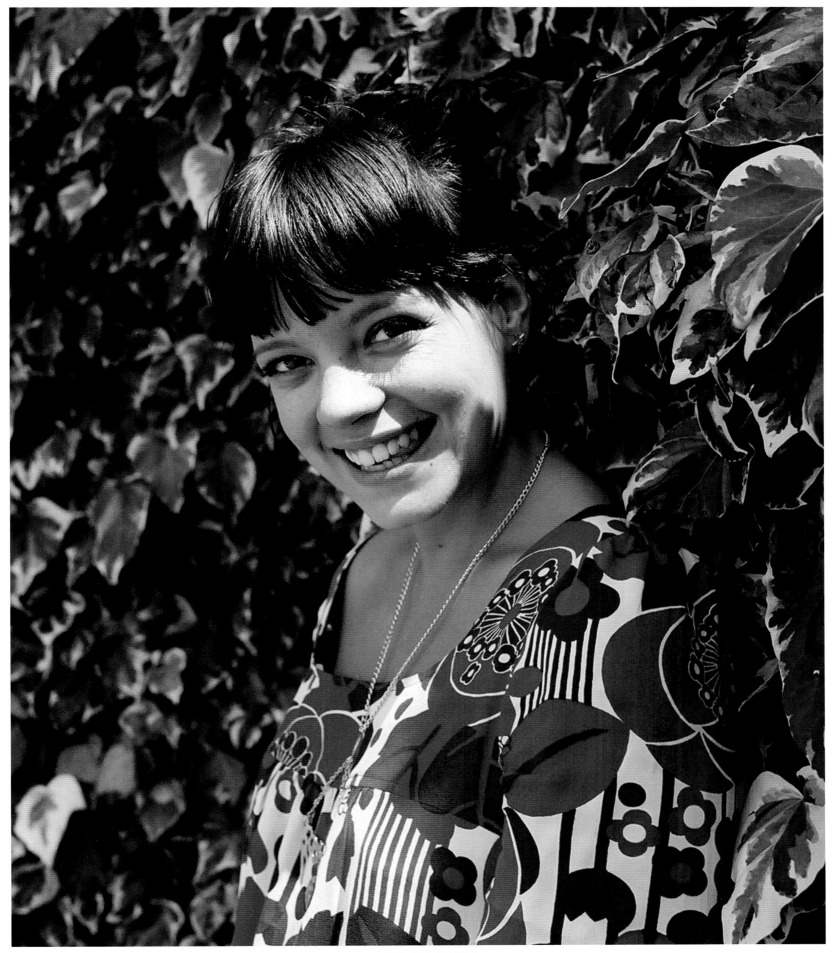

LILY ALLEN
A DIFFICULT LADY
Maybe, maybe not. Arriving with a fiery reputation, I found Lily to be very friendly and she smiled through the photo session. For whatever reasons, magazines always loved a serious look from the Cockney lady. Anyway, she smiled during my shoot and that was the photo I used for a front cover of *The Age*. So I spent a couple of days telling everybody how pleasant she was and then she goes and throws a glass in the general direction of Jet at an after show BDO party.

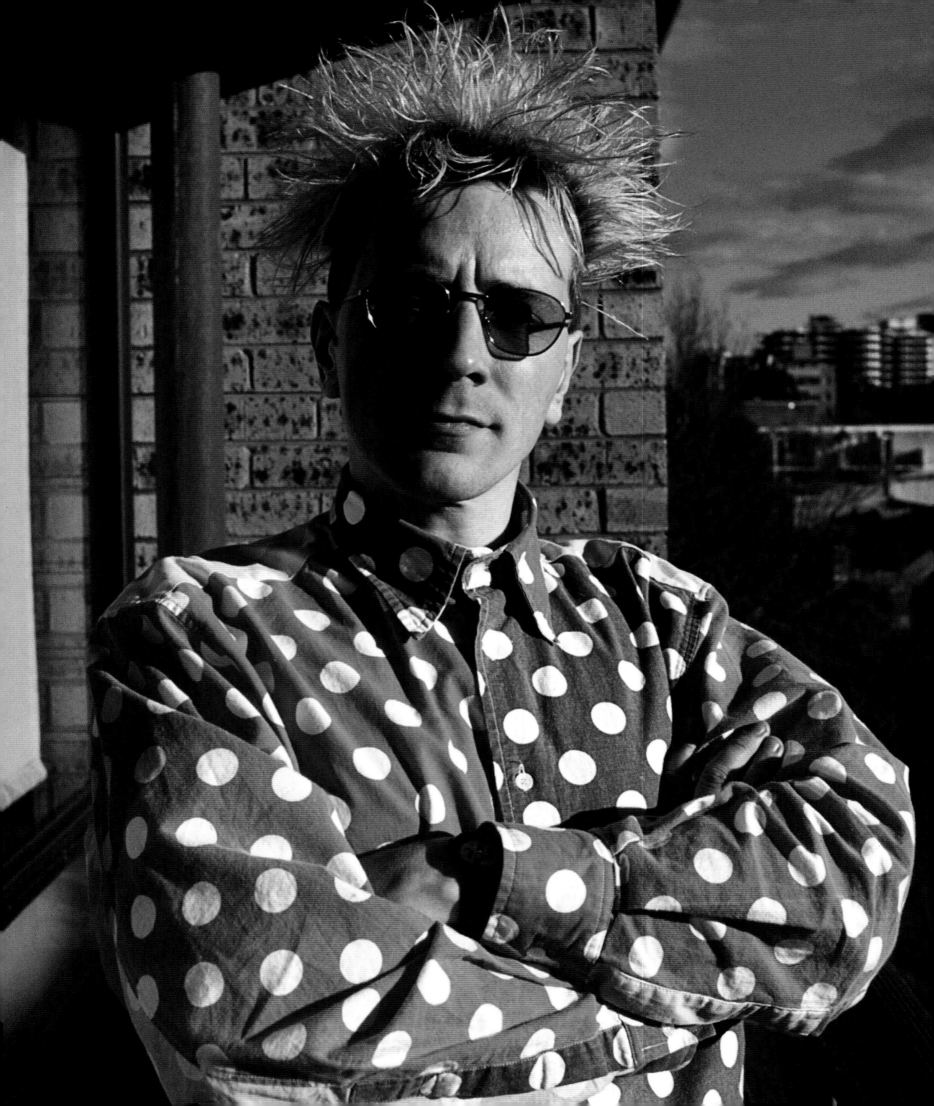

JOHNNY ROTTEN
SAINT SEX PISTOL
Taken at the Hordern Pavillion before stage barriers were introduced, so,
consequently, I had 10 punks on top of me whilst shooting, too much fun.
(*Left*) In session, Johnny is part antagonist, part clown. He loved the Mambo
shirt, it suited his personality.

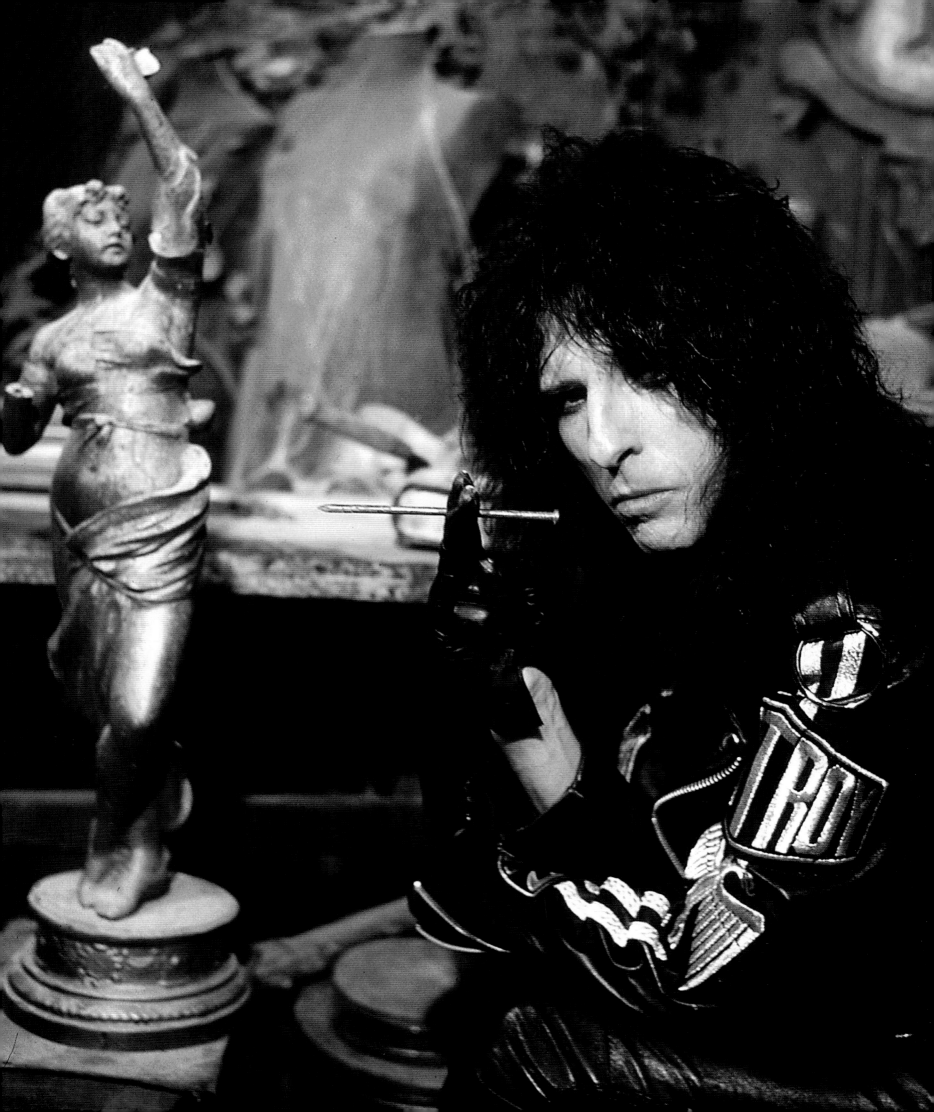

ALICE COOPER
SMOKING NAILS
Always refers to himself in the third person which can be disconcerting. Apparently Alice doesn't like to be photographed outside. I was shocked by his right wing political point of view. Plays golf – what is it with rock'n'roll and golf? It personally offends me.

MIKE PATTON
HAS THE FAITH
Irrelevant of what project he's on Mike Patton is one of the greats, smells of
charisma, once saw him perform an entire set wearing one stiletto, quiet and
unassuming in this photo that's the mystery of Mr Patton.

DON WALKER
CHISELSMITH
Cigar smoking songwriter from Cold Chisel. A lovely fellow with
a wicked sense of humour.

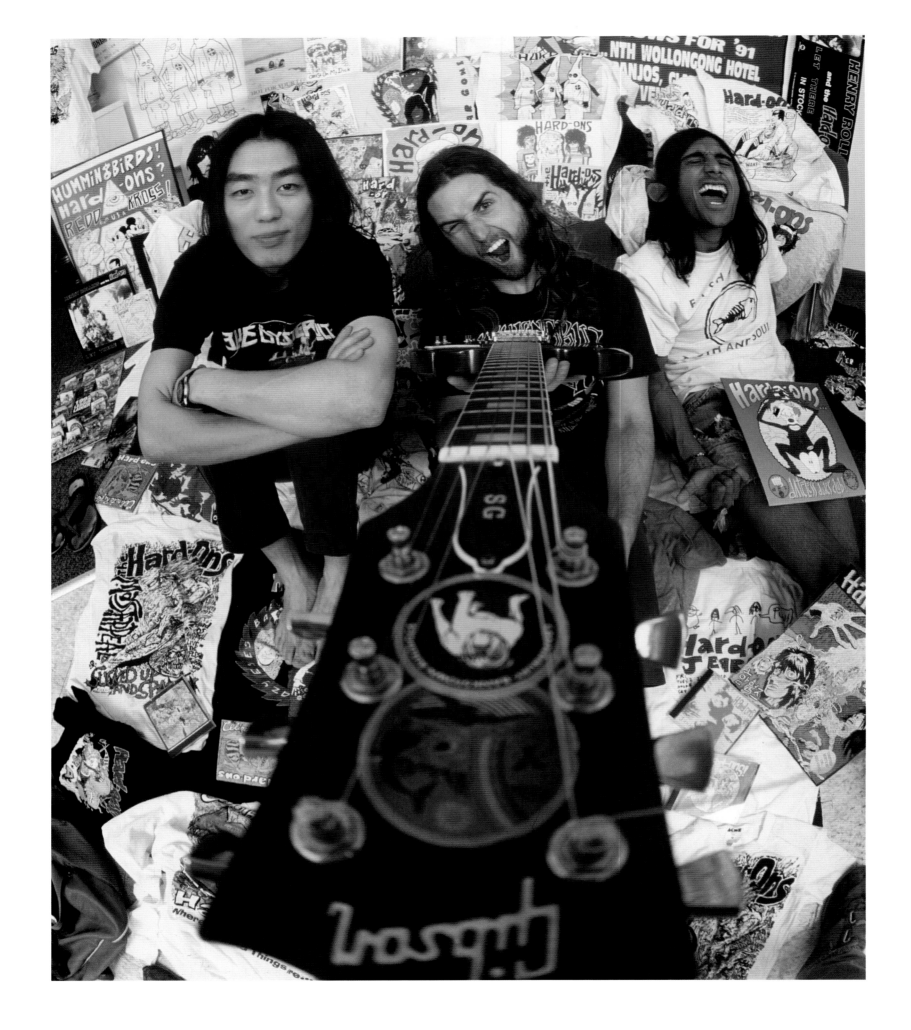

HARD-ONS
KINGS OF THE PUNKS
No nonsense punks, what you see is what you get.

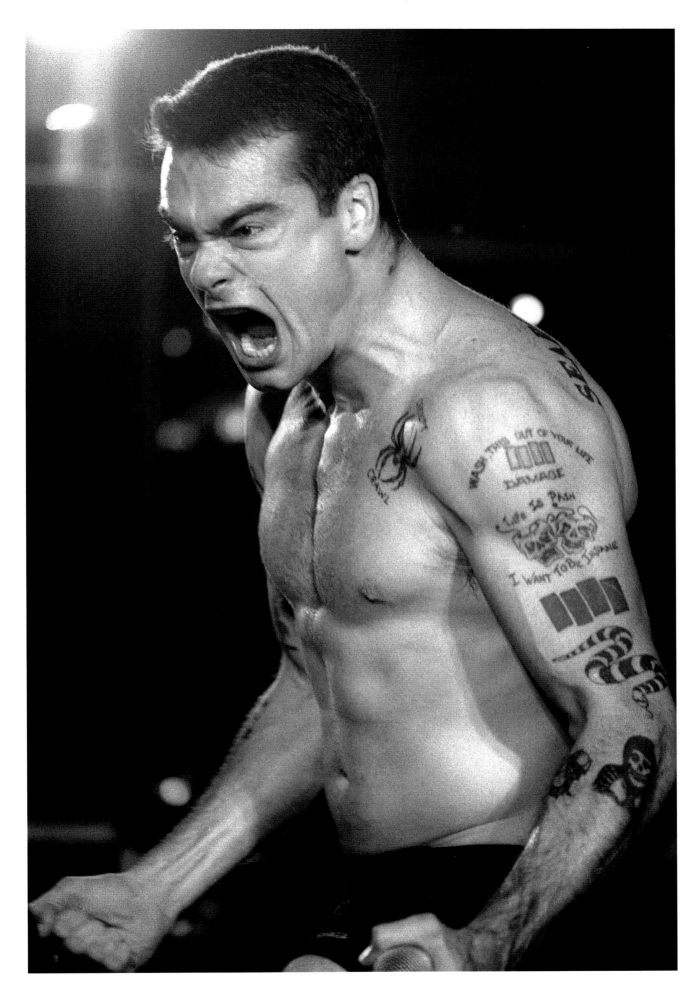

HENRY ROLLINS
HANK

The most instense performer you are ever likely to see. Best not to approach
Henry a good 15 minutes before showtime – he spends this time pumping
himself up to the intensity.

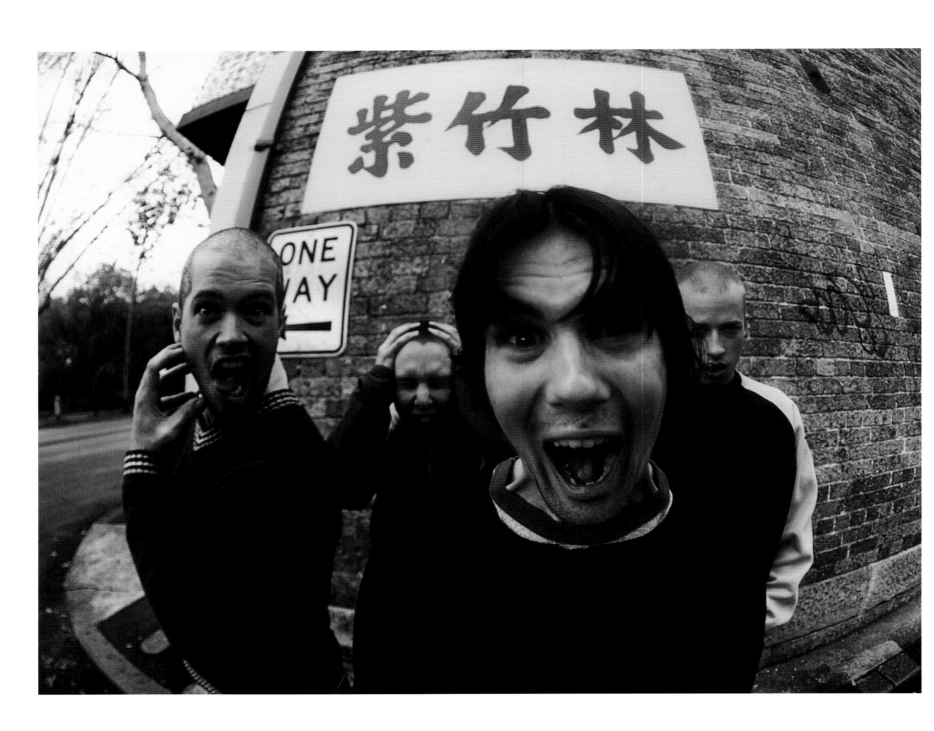

GRINSPOON
LISMORE'S FINEST

As a live act, this outfit gets tighter. They really do deliver on stage so it's ironical
that I put a session photo in rather than a live one. This was the first session of
many I've done, and was an extra picture at the end of the shoot. The studio was
next to a Buddhist temple in Surry Hills. Don't know why but I like it.

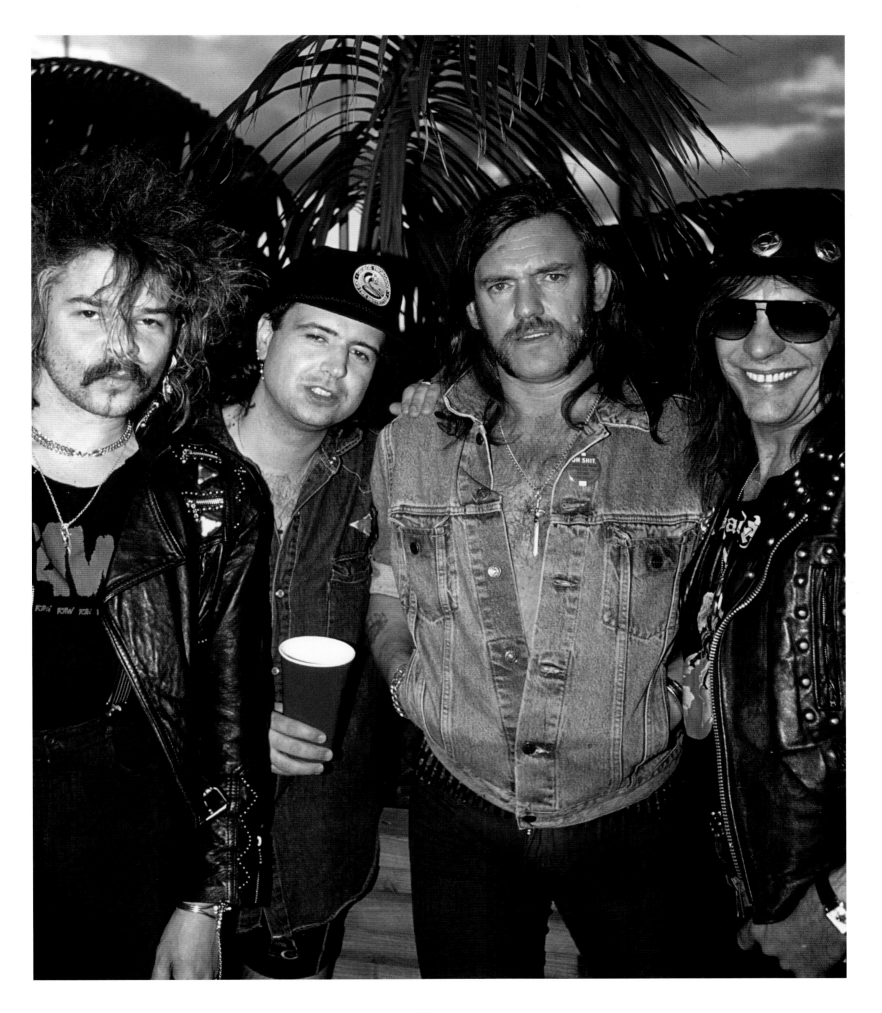

MOTÖRHEAD
LEMMY, ANIMAL AND THE BOYS
Not the biggest band in the world but hard to believe it by the amount of
Motörhead T-shirts you see on the streets around the world.

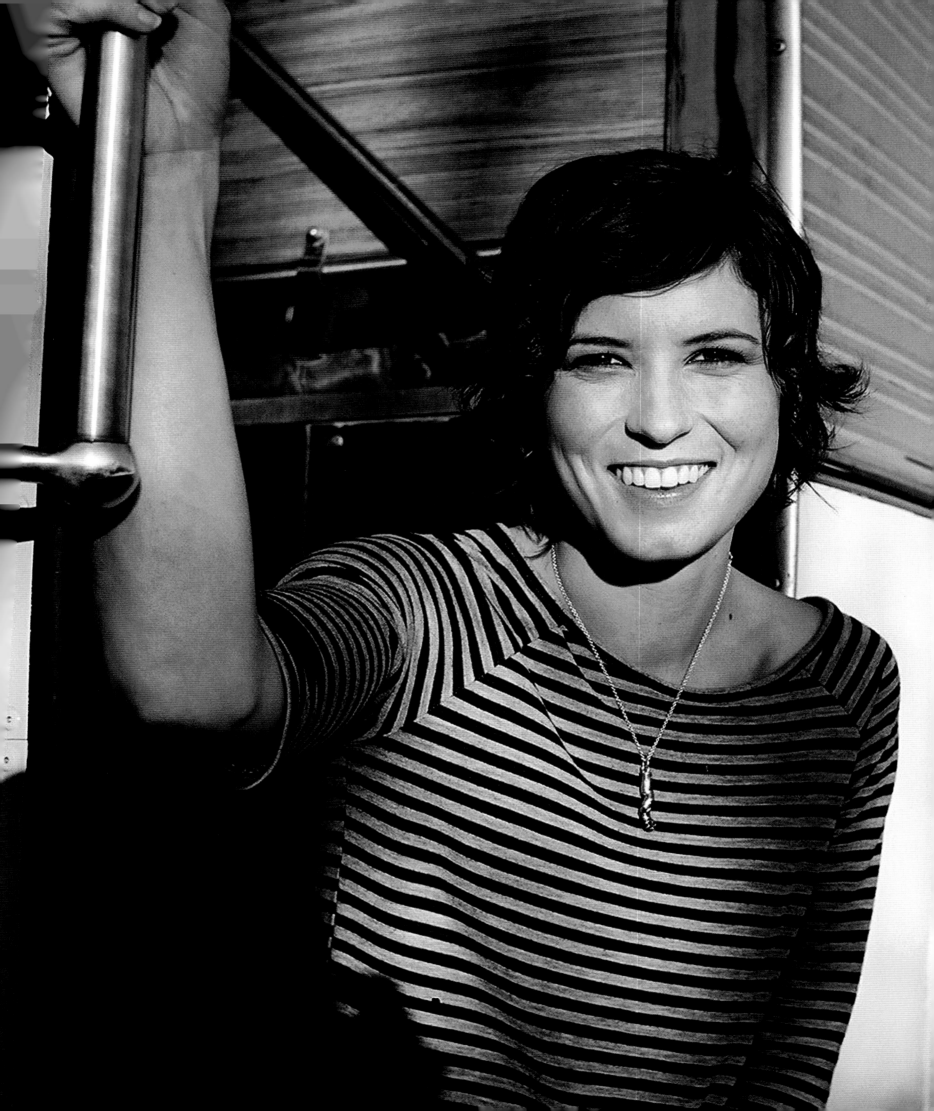

MISSY HIGGINS
A SMILE INSTEAD OF A SCAR
Love this photo, mainly because of the genuine smile. An easygoing star.

MARIANNE FAITHFULL
WHAT A WOMAN

Talk about having lived a life and a half. I was totally intimidated by her, and at the end of the session she casually mentioned she was running late for a lunch with Bob and Ron. Turned out it was Messrs Dylan and Wood.

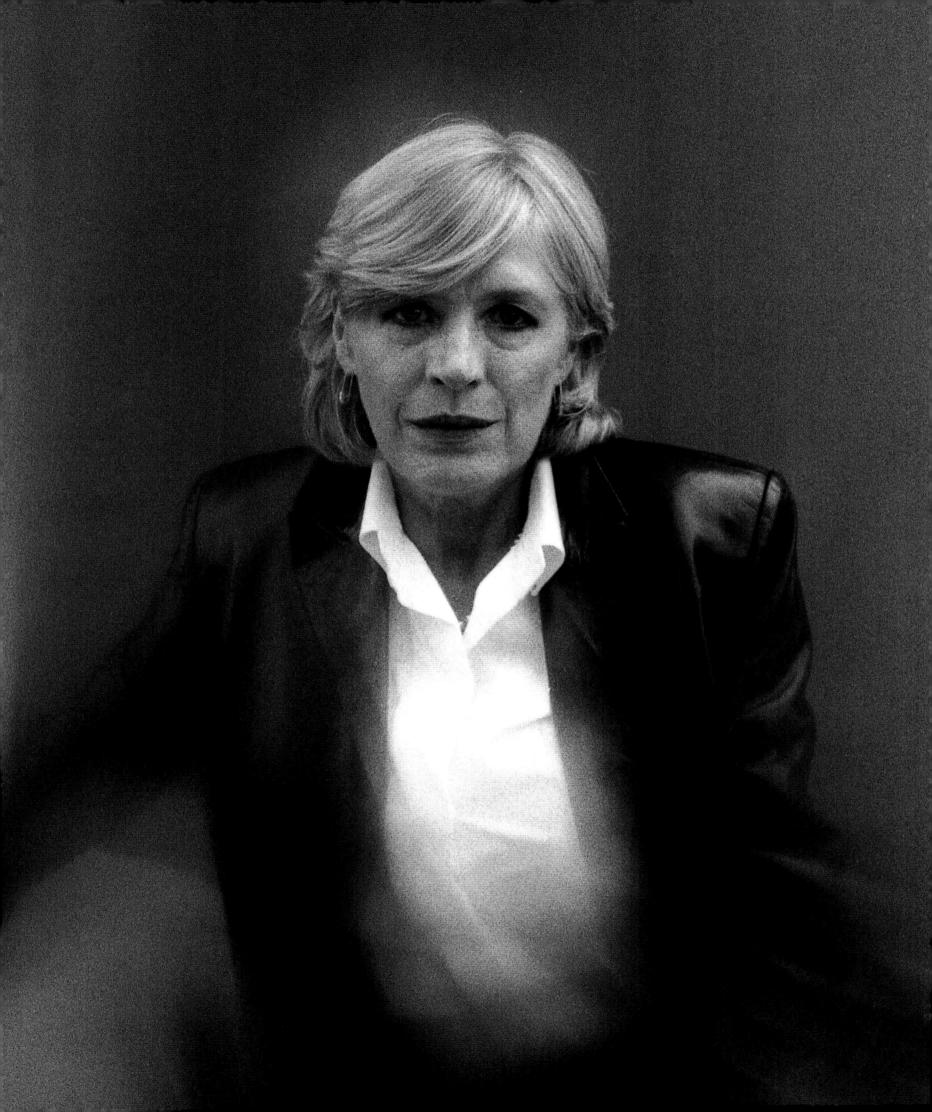

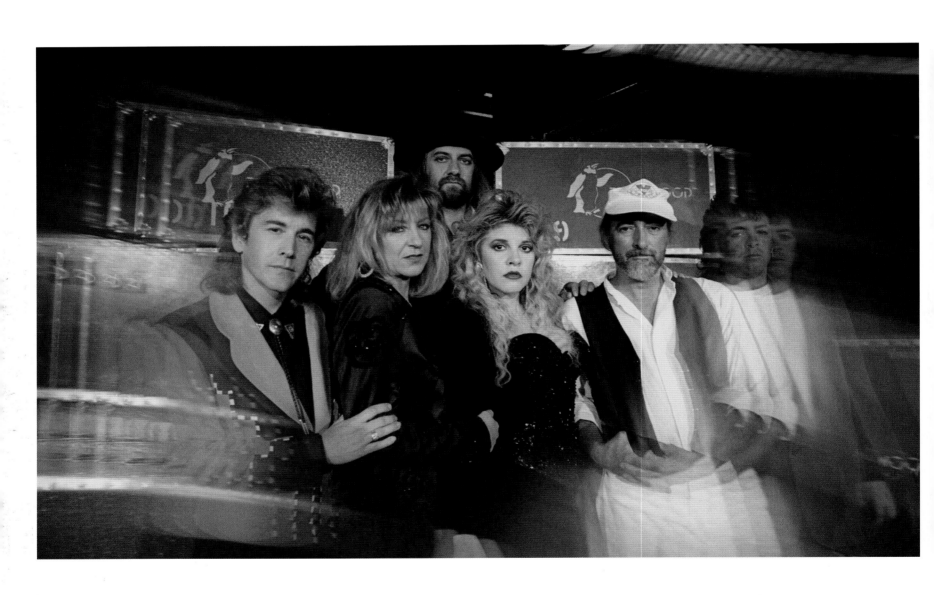

STEVIE NICKS
FROM PLANET ???

Toured with Fleetwood Mac in the mid 90s, and I have no idea what Stevie was on
about all the time. She had an alarming habit of singing happy birthday to me every
day. It wasn't my birthday. She often didn't seem to be aware of where she was.

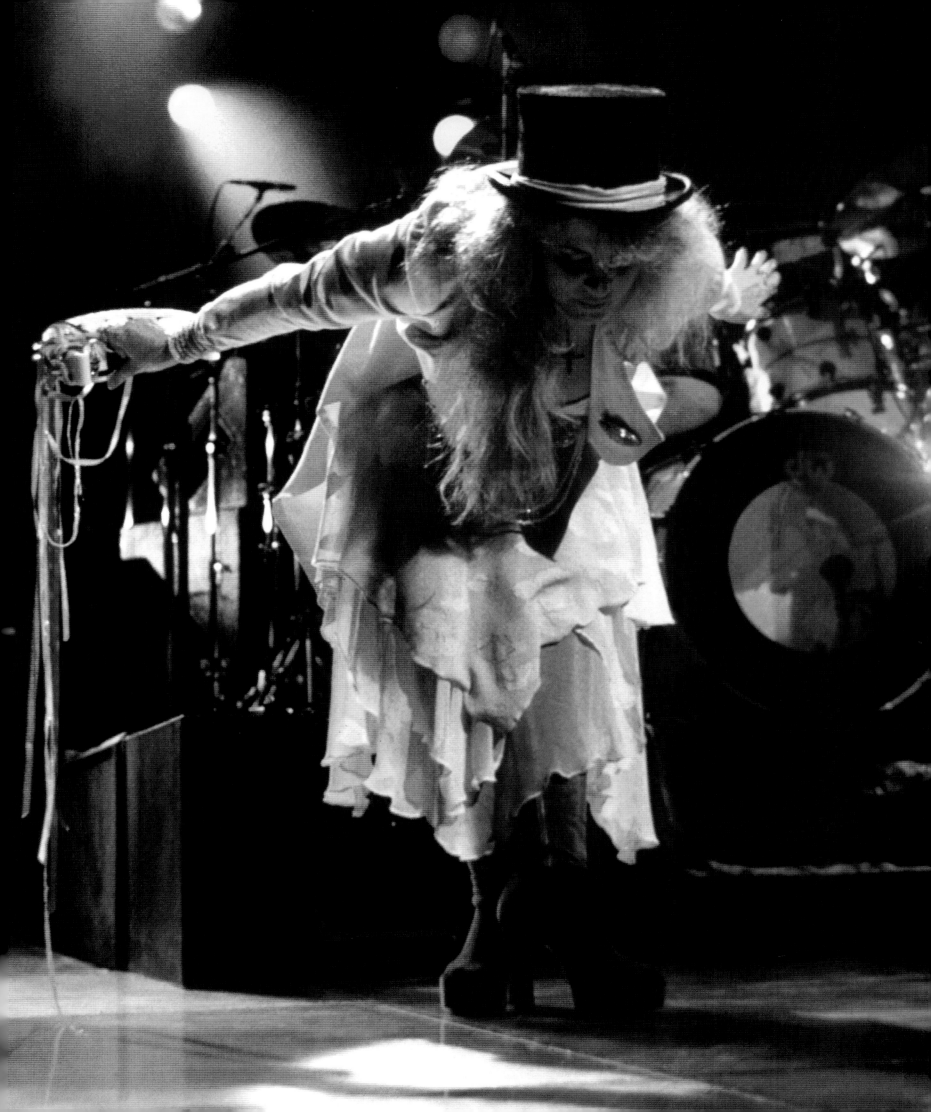

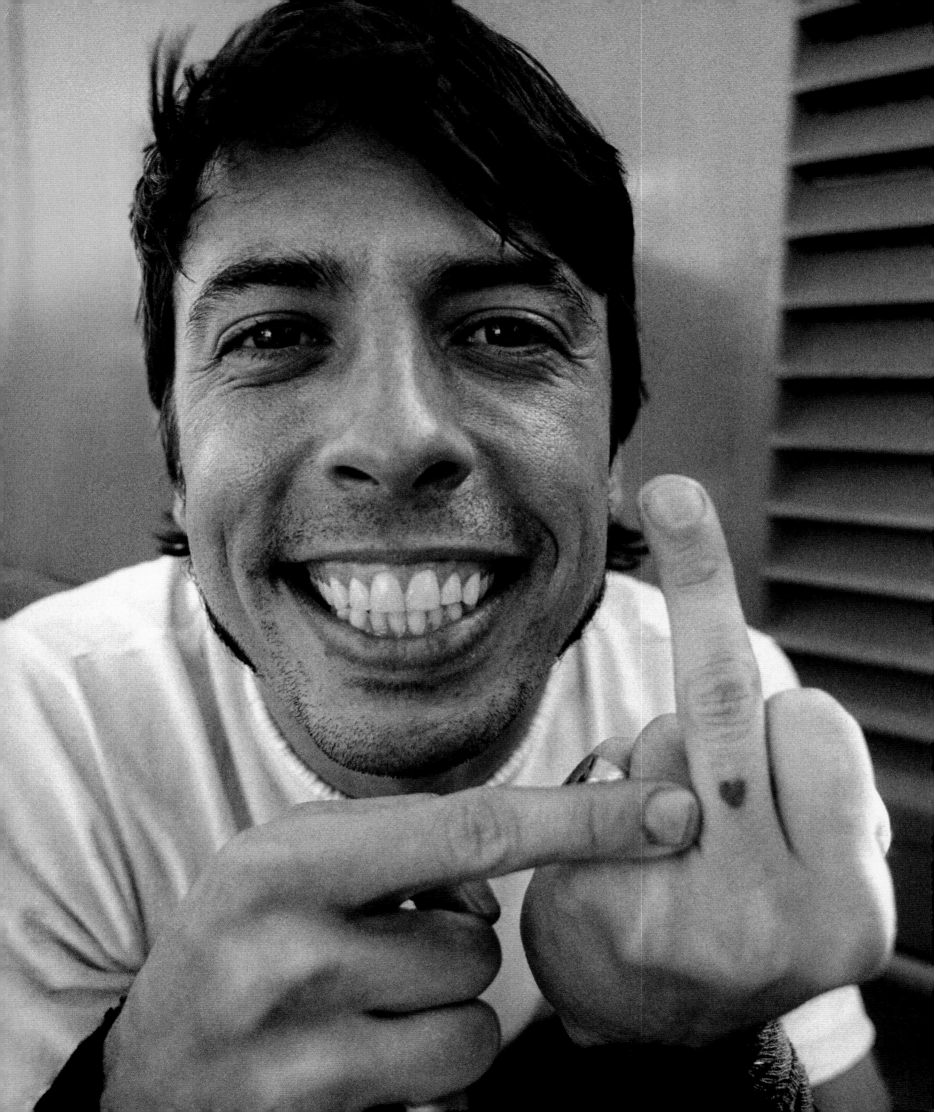

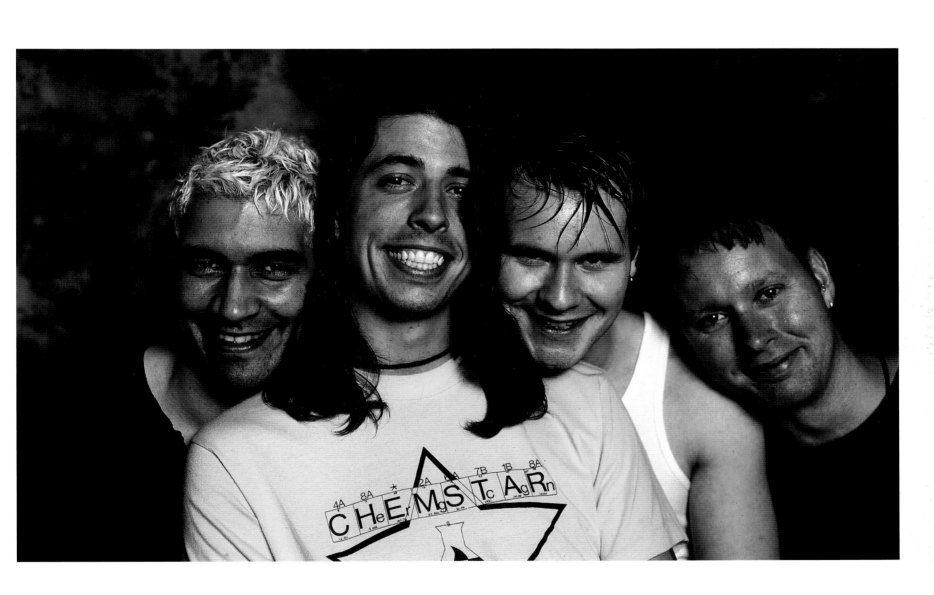

FOO FIGHTERS
NIRVANA TO FOO
Dave Grohl always comes across as one nice guy, probably
because he is. The band shoot was for a US publicity photo and
the solo for a metal magazine cover.

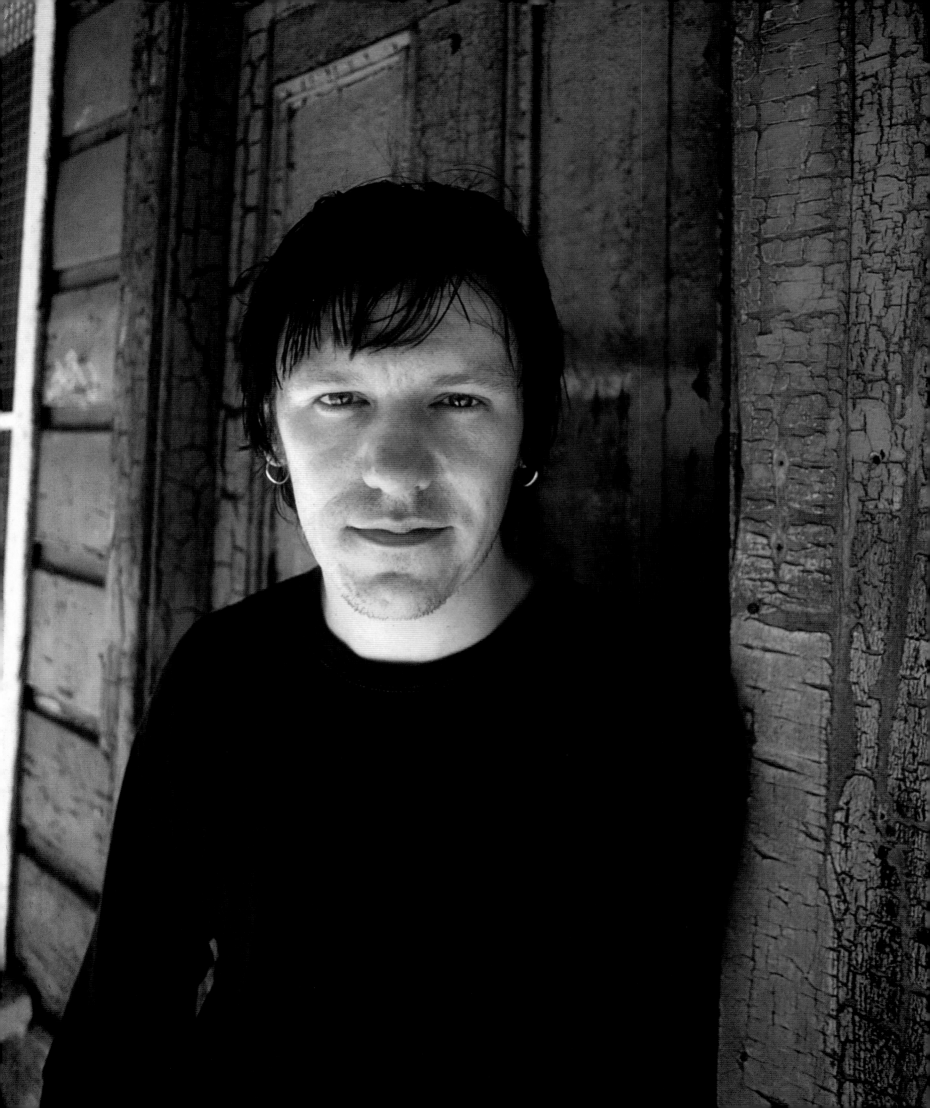

ELLIOT SMITH
HUGS AND KISSES
A great album, nominated for an Oscar and a bizarre suicide.
A strange character. Shot in the streets of Annandale.

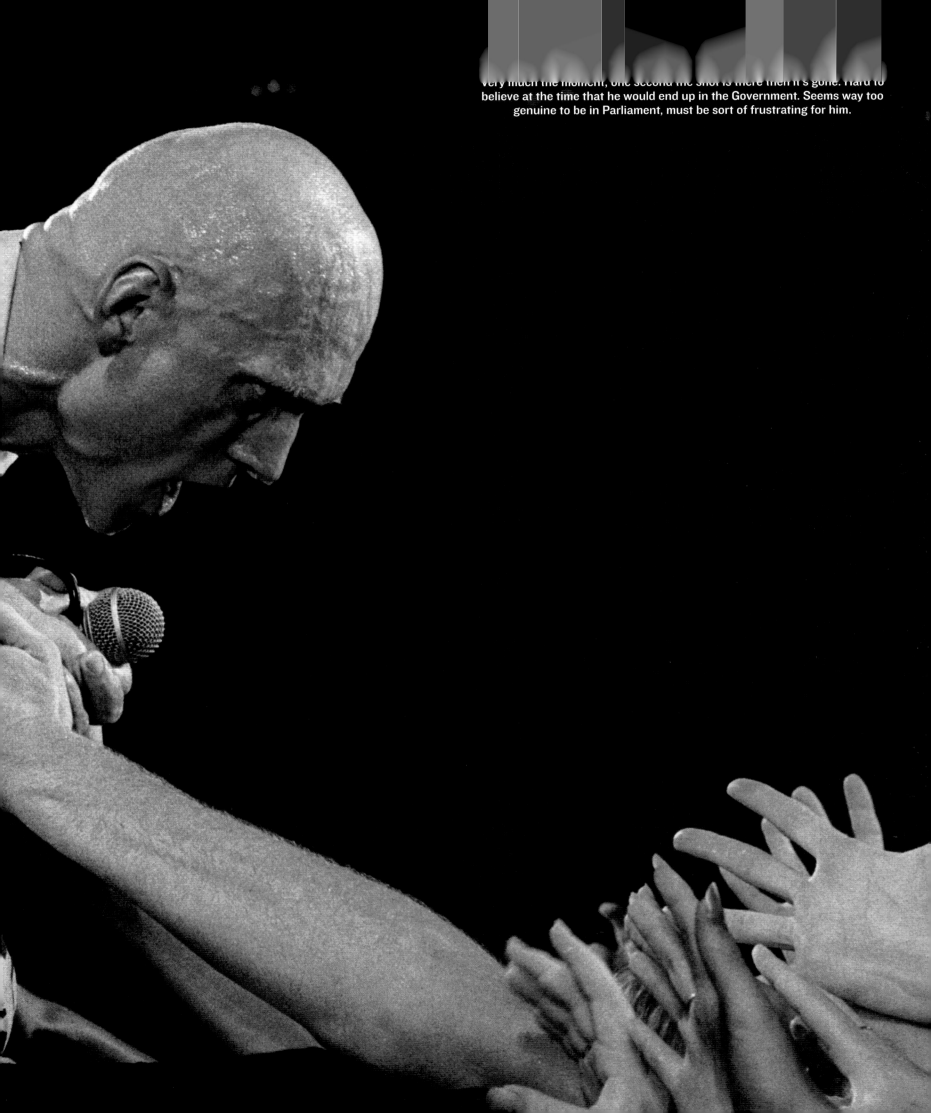

Very much the moment, one second the shot is there then it's gone. Hard to believe at the time that he would end up in the Government. Seems way too genuine to be in Parliament, must be sort of frustrating for him.

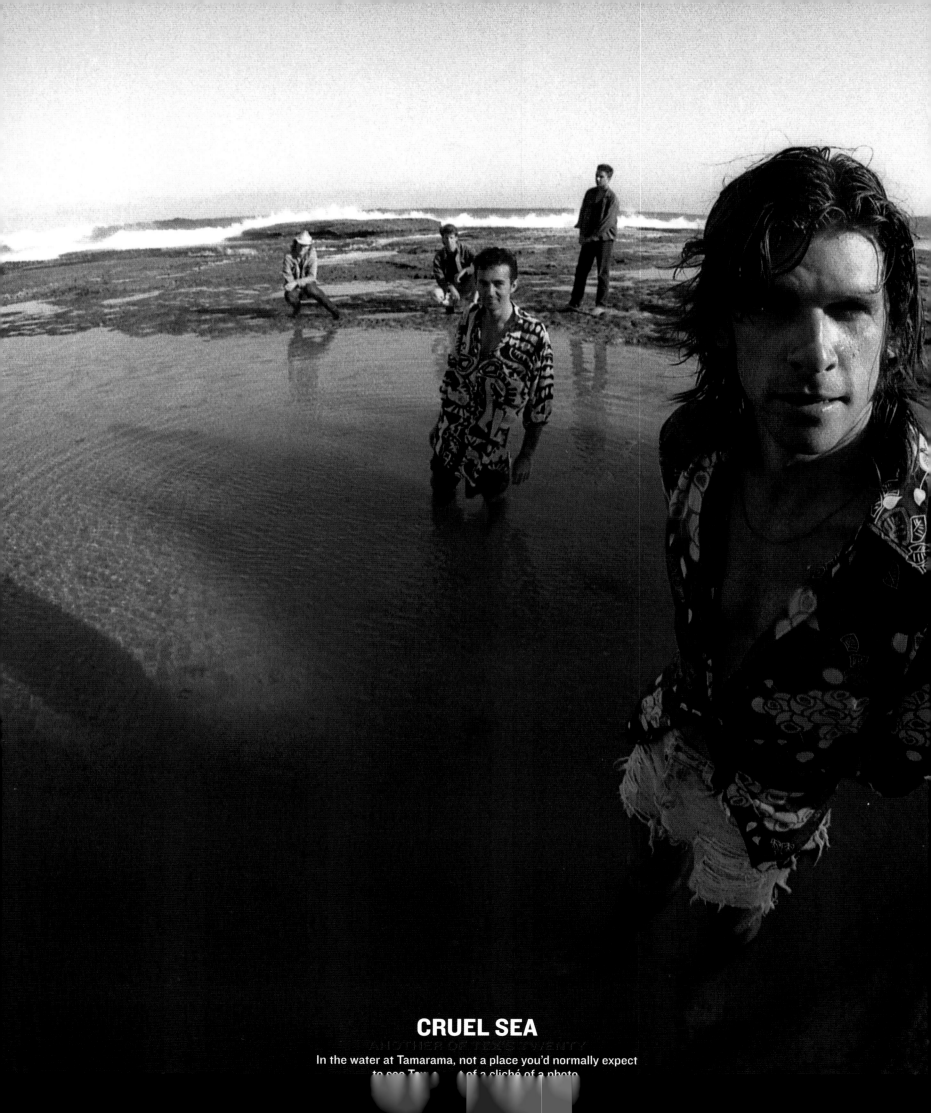

CRUEL SEA

In the water at Tamarama, not a place you'd normally expect
to see Tex, in a cliché of a photo.

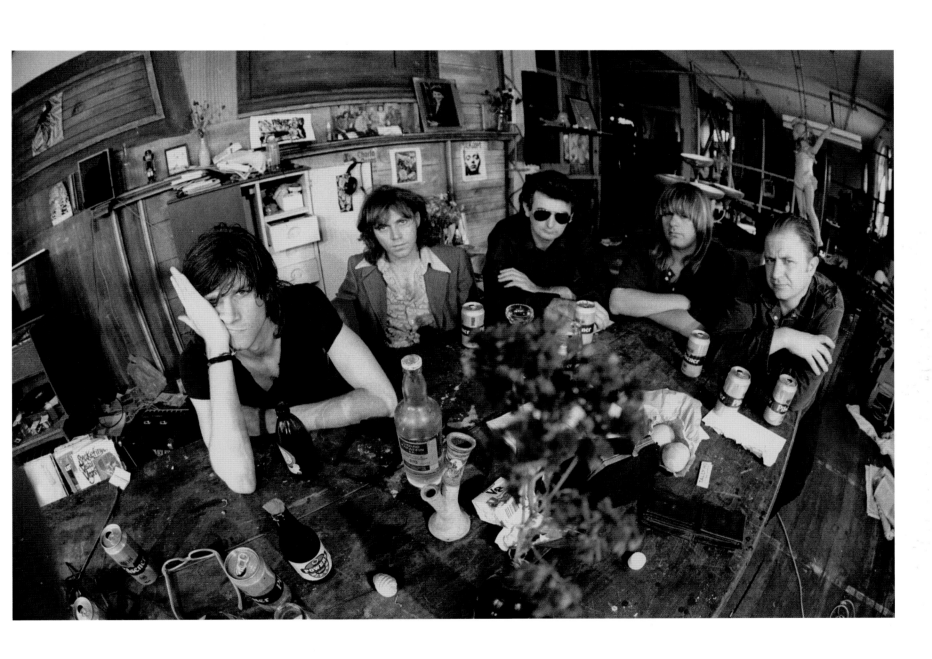

BEASTS OF BOURBON
ONE OF TEX'S TWENTY

On their night, one of the great bands of rock'n'roll. This is a happy accident
of a photo. While I was setting up the lights for a shoot the band were
having a band meeting. I just turned around, I shot, it worked.

MICHAEL HUTCHENCE

RIP

Rotten way to get a cover on *Rolling Stone* magazine.
As proud as I was to get this picture on the cover of
Rolling Stone, it was a very sad one, too.

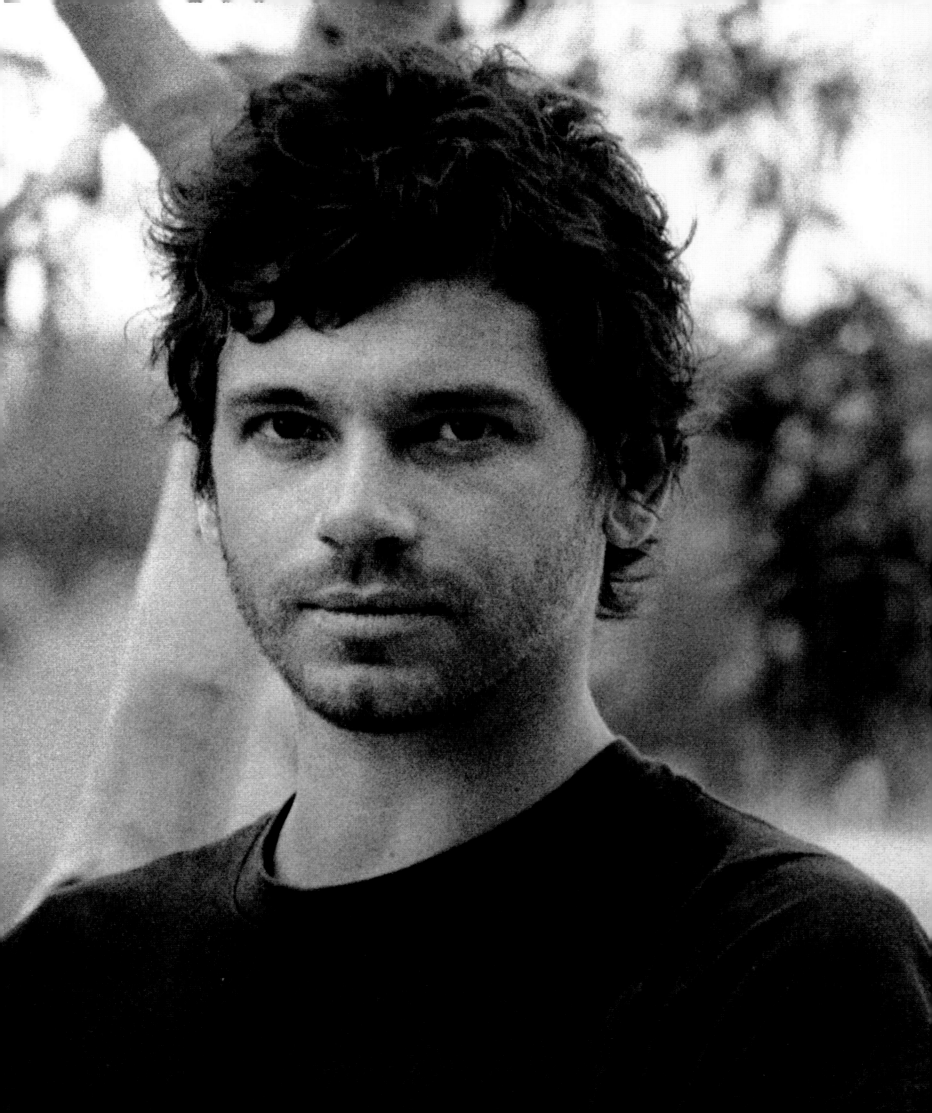

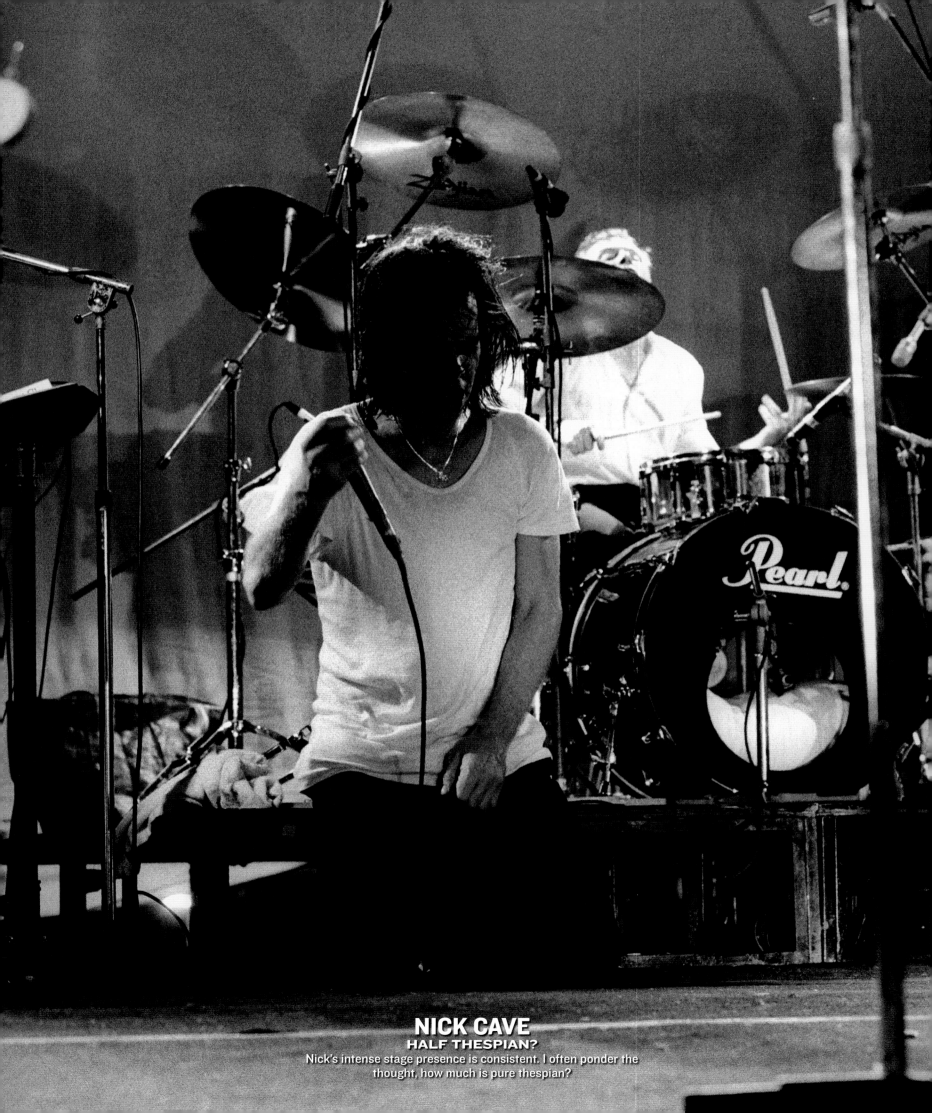

NICK CAVE
HALF THESPIAN?
Nick's intense stage presence is consistent. I often ponder the
thought, how much is pure thespian?

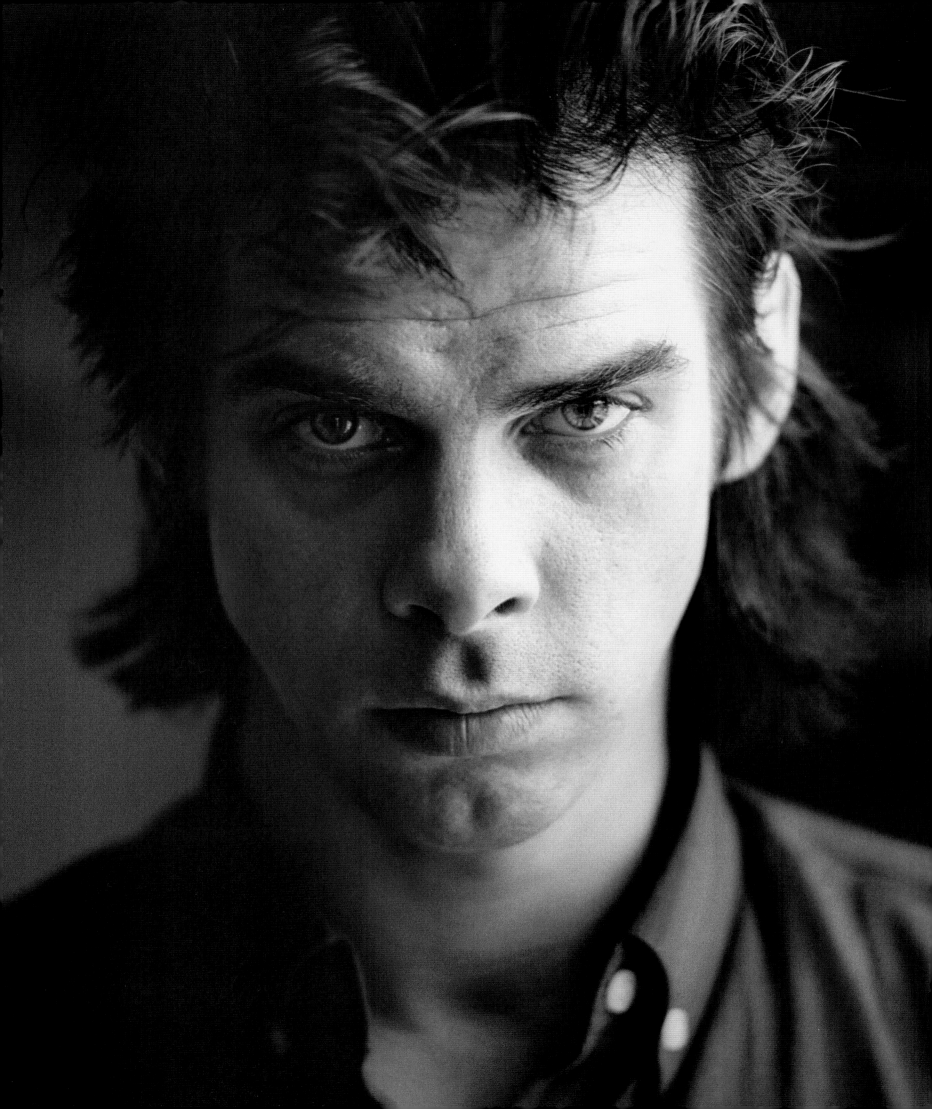

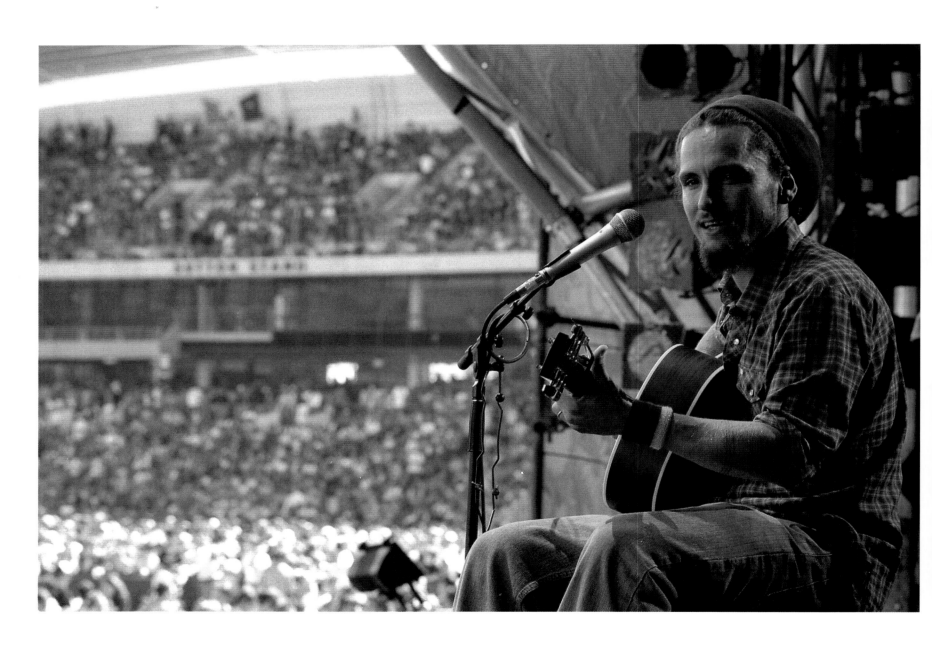

JOHN BUTLER
WITHOUT THE TRIO

The new breed of artist, no record company, no publisher, doesn't stop
John Butler from world wide tours and awards aplenty, like a giant cottage
industry, taken at the Big Day Out on the main stage, no other artist can
sit during the entire set and still compel the audience.

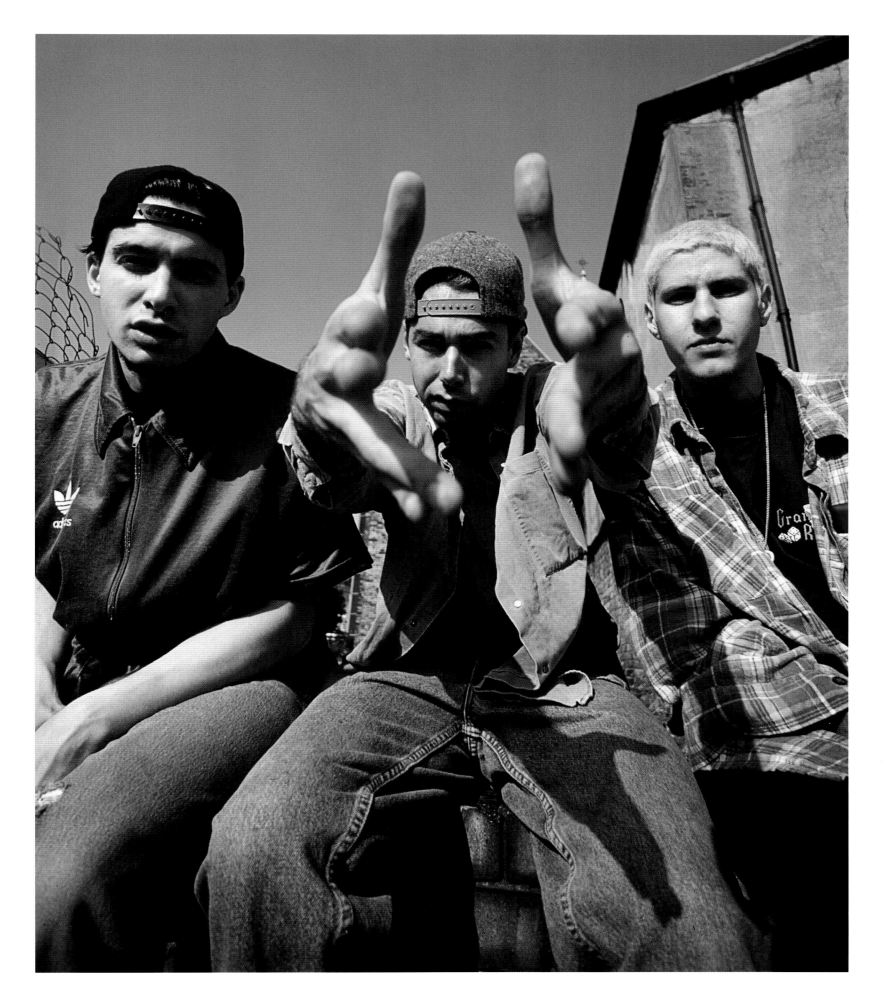

BEASTIE BOYS
WHAT TO SAY ABOUT THEM
My father always told me if you had nothing positive to say about someone say
nothing, so what I'd like to say about the Beastie Boys is ...

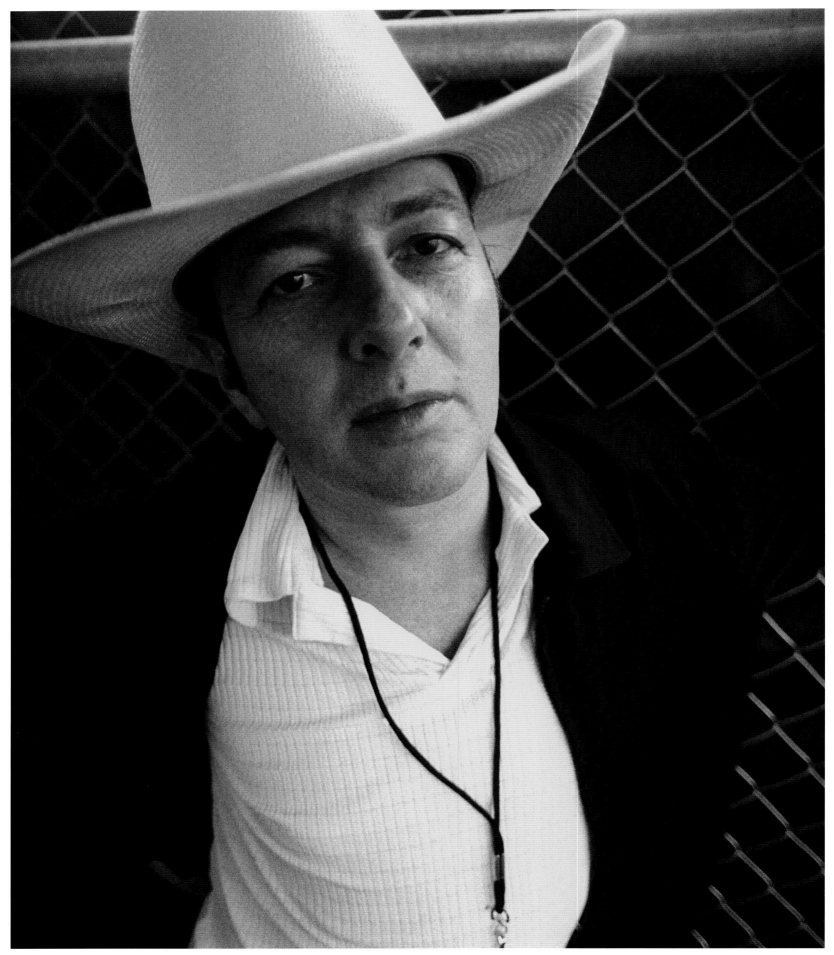

JOE STRUMMER
HALF A CLASH
Spent memorable moments touring with Joe on the Big Day Out. Surprisingly, our topic of conversation was gardening!! He loved it, and talked endlessly of his Somerset garden and was intrigued to know what Australian plants I had in my garden. Not the conversation I expected to have with Joe Strummer.

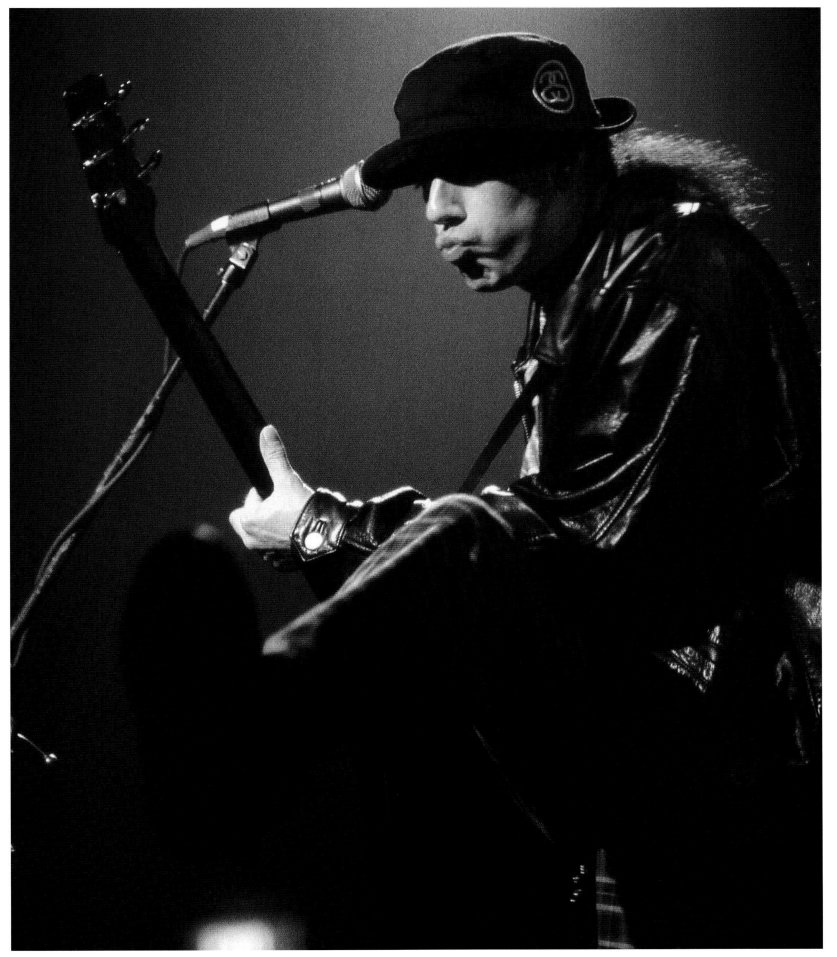

CLASH
JOE'N'MICK
My conversations with Joe and Mick were not what you'd expect: Joe was interested
in gardening and was curious about my Redfern garden whilst I spent hours grilling
Mick Jones about Pennie Smith, the photographer who shot "London Calling" a hero
of mine. The common thread between the three of us was the love of Mott the Hoople.

GO-BETWEENS
FINAL CURTAIN
Taken in their last year at the Homebake festival. I happened to be wandering around backstage when the curtain blew sideways to reveal the band onstage. Sort of love the image from behind the stage, and it feels right in a surreal way.

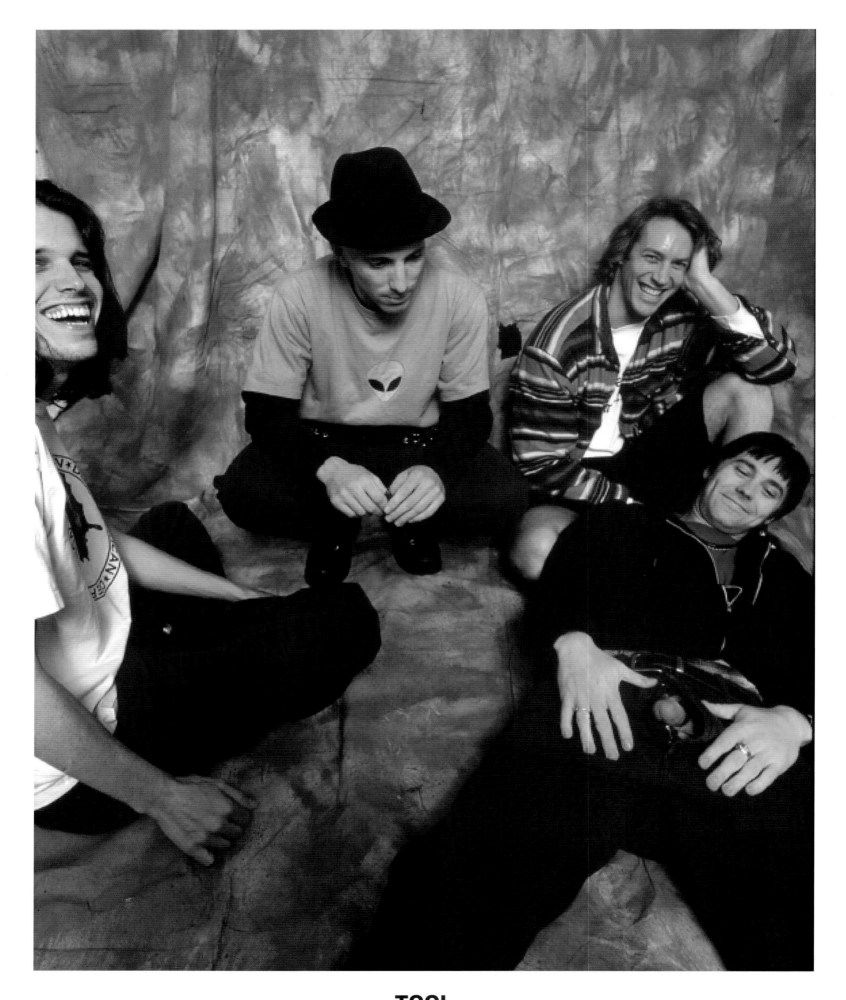

TOOL
A BETTER NAMED BAND I HAVEN'T SEEN
Nude photo's really aren't my thing , Ron Peno aside they all ended in disaster,
however in mid shoot Tool band member decided to show me his tool.
Sort of funny.

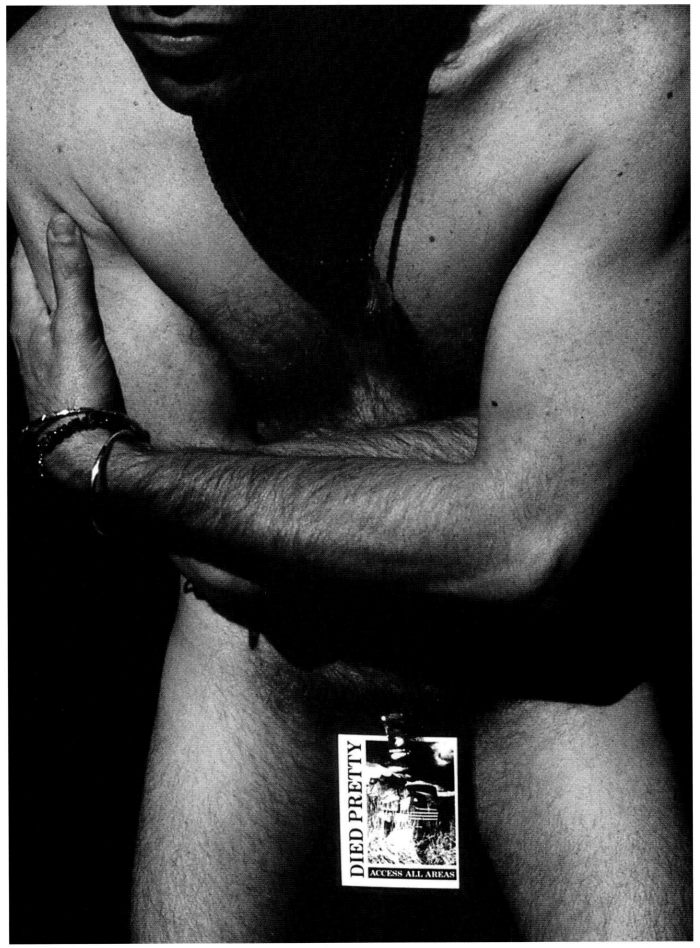

RON PENO DIED PRETTY
A NUDE IS A NUDE

My first published nude photo ended up being Ron Peno of Died Pretty, possibly the most unlikely nude. Whilst shooting in the Glebe bathroom of the then editor of *Rolling Stone*, the building supervisor came in to change a lightbulb. Not sure who got the biggest shock?

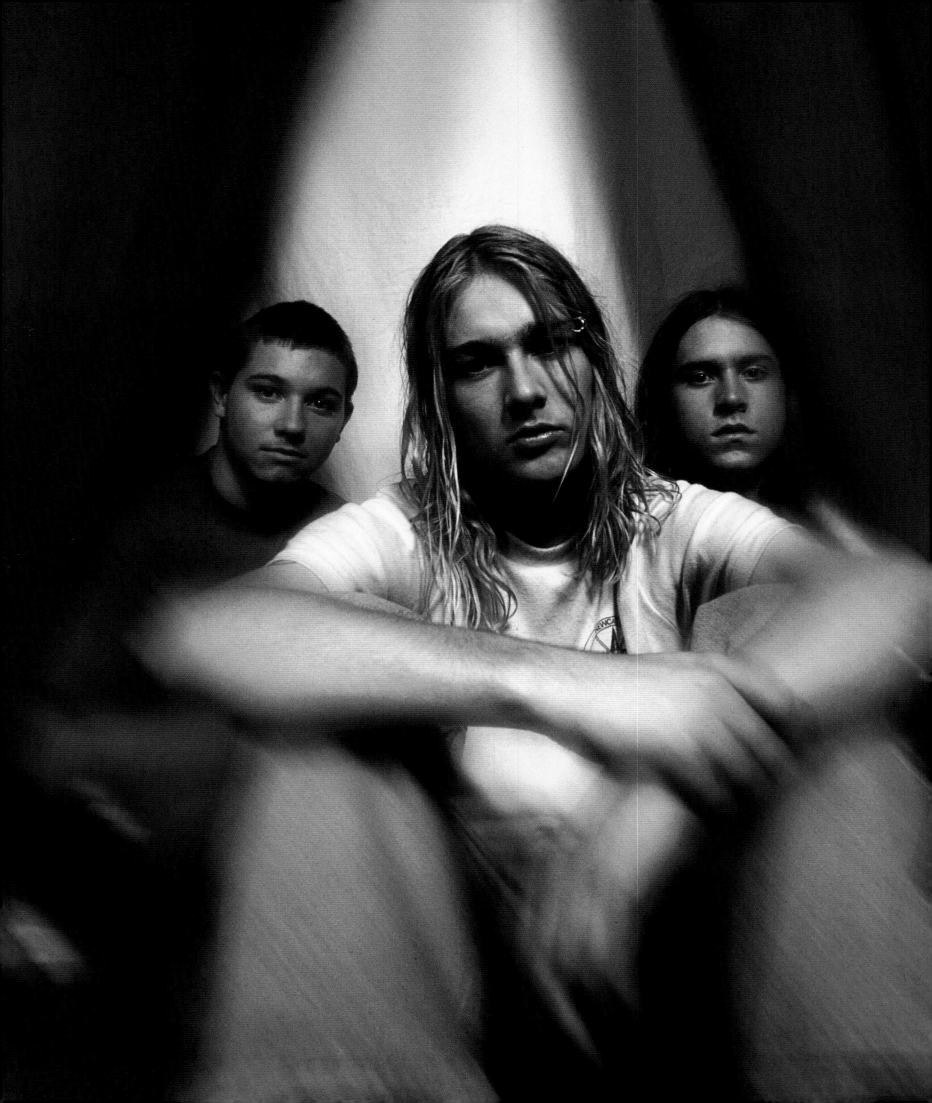

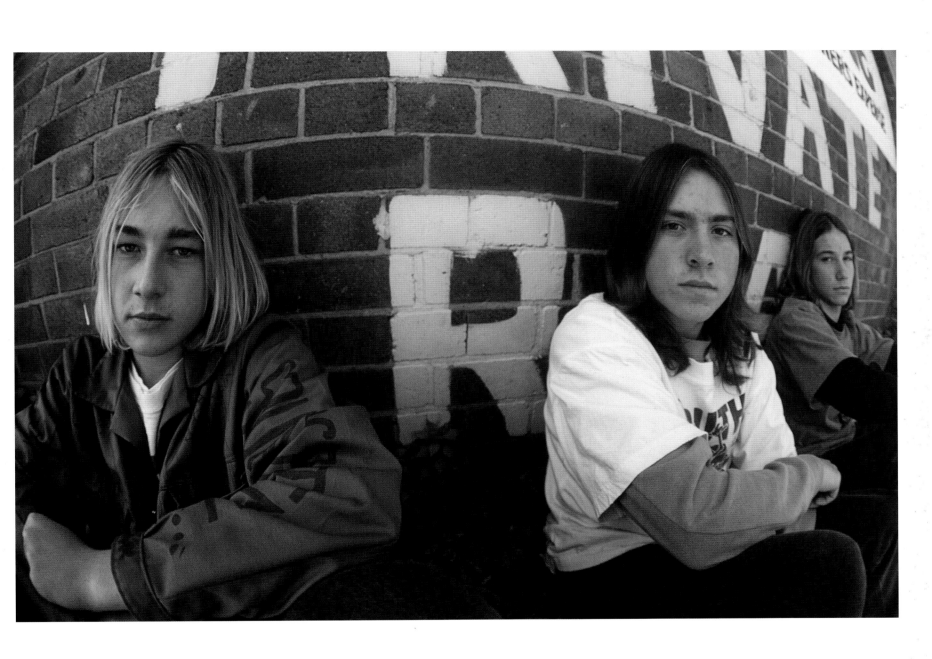

SILVERCHAIR
GROWING UP IN PUBLIC
It's hard to believe these guys are still in their twenties as I think of them as
veterans, but when you start so early (age I5 photo above) that's what happens.

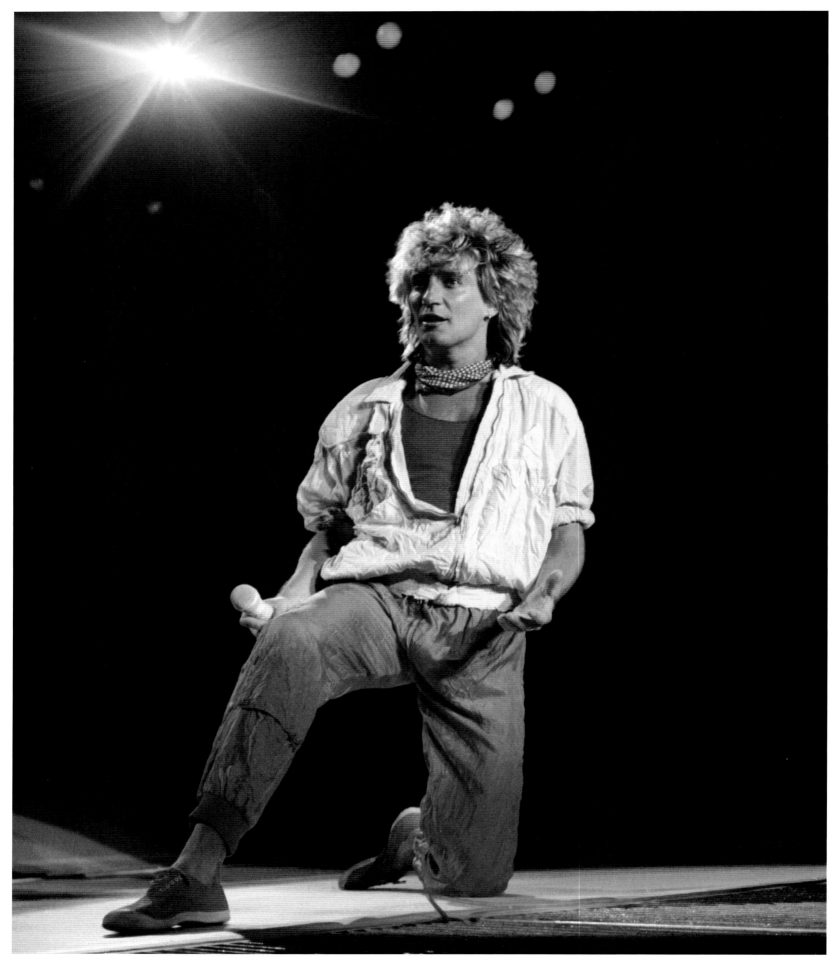

ROD STEWART
EVERY PICTURE TELLS A STORY
Named my first book after his album. I have in common with Rod a passionate
love of football and trains; believe it or not Rod made it on to a cover of a
model railway magazine showing off his train set. His early 70s output was as
good as it gets. His late 70s output goes very much in the opposite direction.

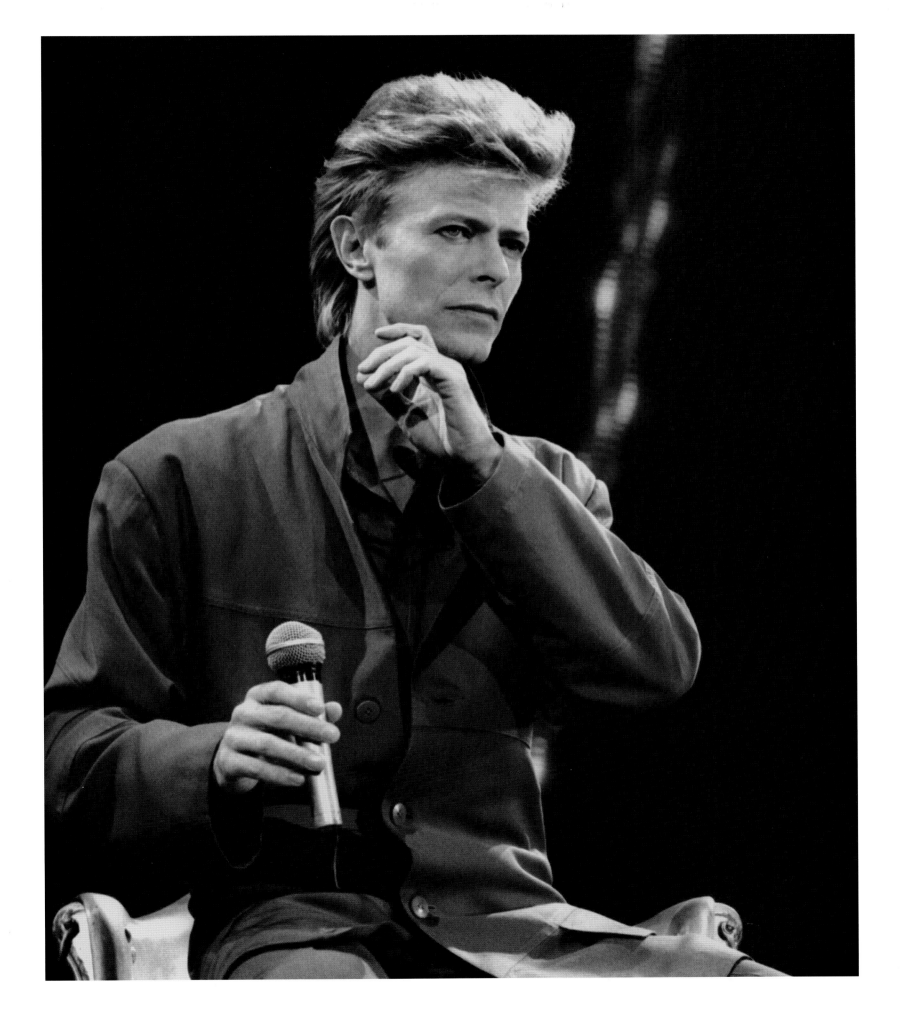

DAVID BOWIE
YOU CAN SMELL HIS CHARISMA
One of the most charismatic characters I've ever come across. Reeks of it.

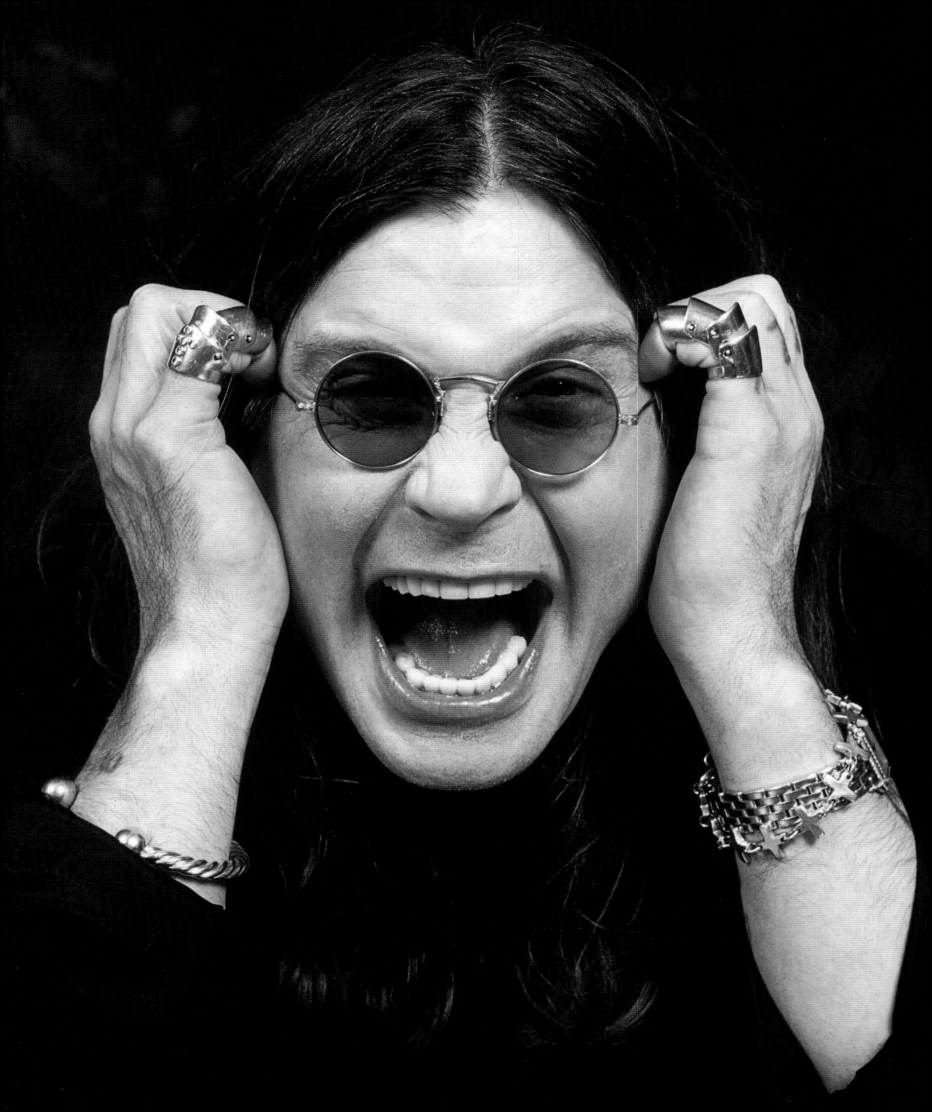

OZZY OSBOURNE
PRINCE OF DARKNESS

Ozzy doesn't look capable of doing a photo shoot when I met him in a hotel lobby, but as soon as you turn the camera on him he comes alive and gives you the Ozzy snarl. Funnily, when we set up the studio lights in his hotel room I asked if I could draw the curtains to use natural light. When I did Ozzy was gobsmacked to see a magnificent view of the Opera House and Harbour Bridge. He'd checked in 24 hours earlier and had never drawn the curtains. Priceless!!!

SOUNDGARDEN
HYDE PARK

Very early Soundgarden before they broke big. Kate Stewart (You am I's original manager) has great ears and told me well in advance that this band would be big and she thought Chris Cornell was hot. Funnily, I found Soundgarden's manager, the beautiful Susan Da Silva, just as hot. Not sure why I'm saying this, but there you go.

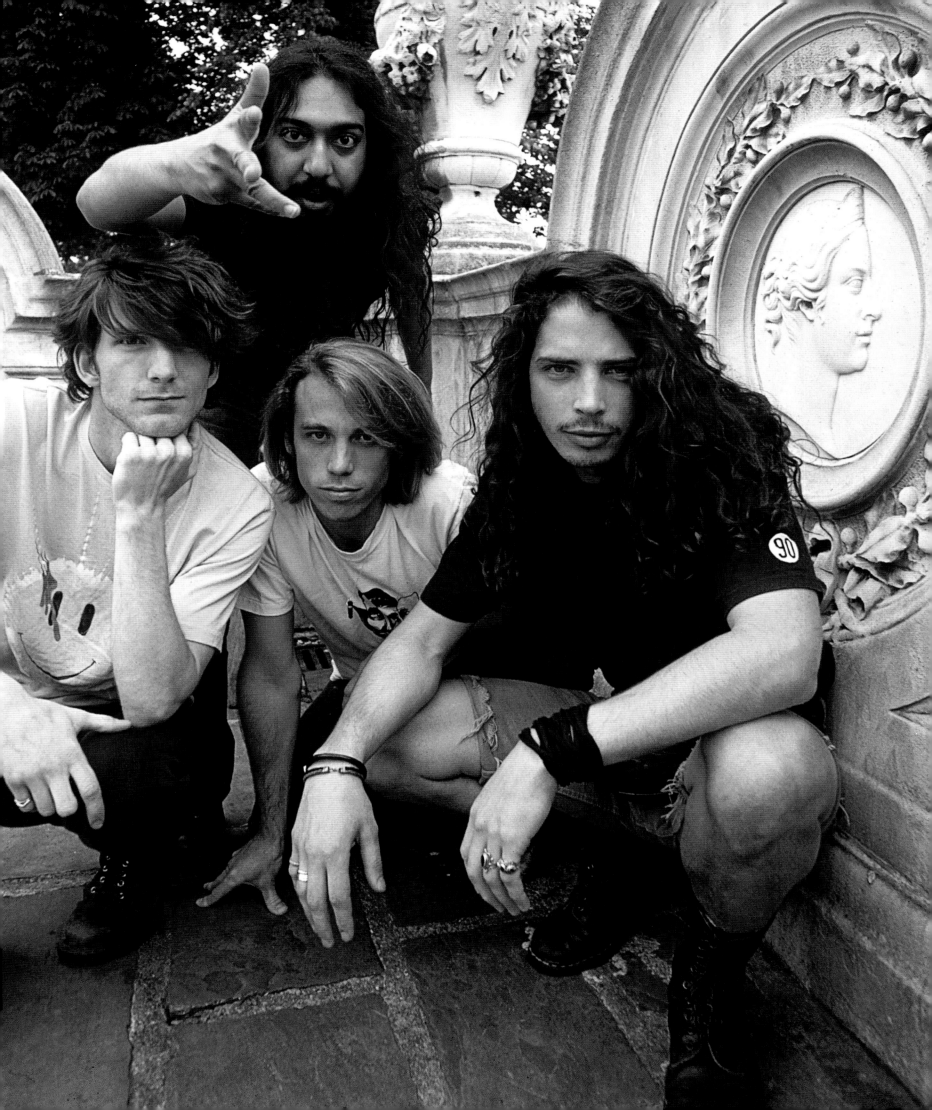

SUNNYBOYS
DISCONCERTING
Jeremy Oxley, without doubt, was an amazing talent but I always felt
slightly uncomfortable shooting him, I was never on his wavelength.

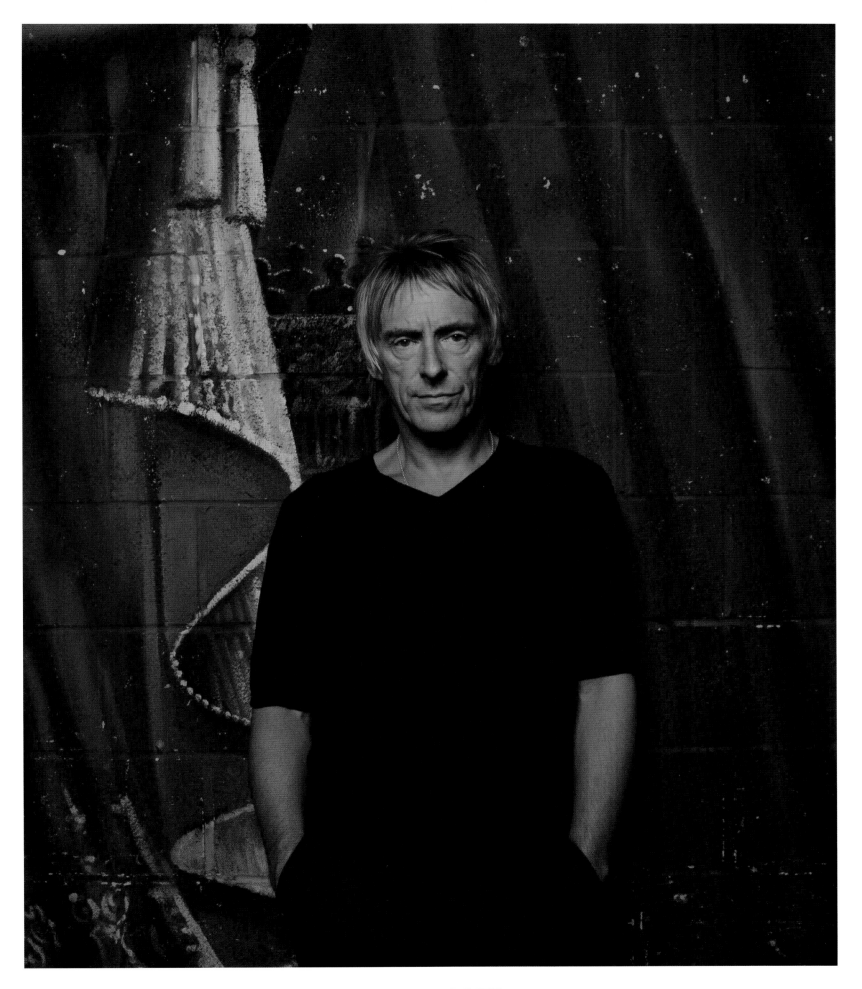

PAUL WELLER
GOING UNDERGROUND
The last photo taken for this book; UK musical icon, smiling in photos is not
his thing, doesn't take away from the man's musical output, The Jam, Style
Council to his present day solo career.

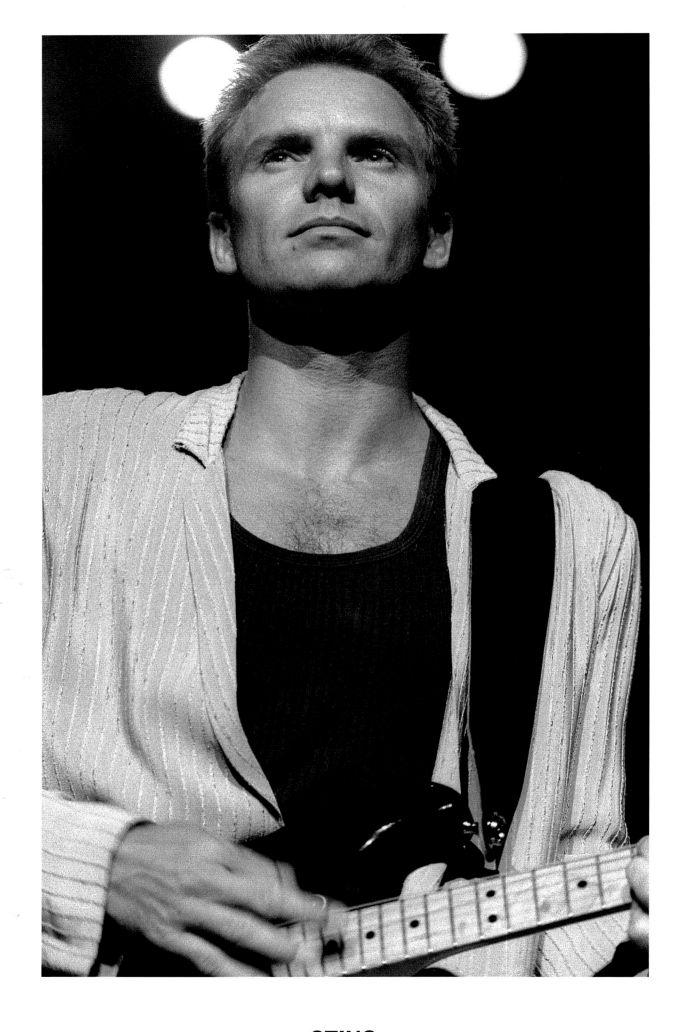

STING
EVENING ALL
PC makes good.

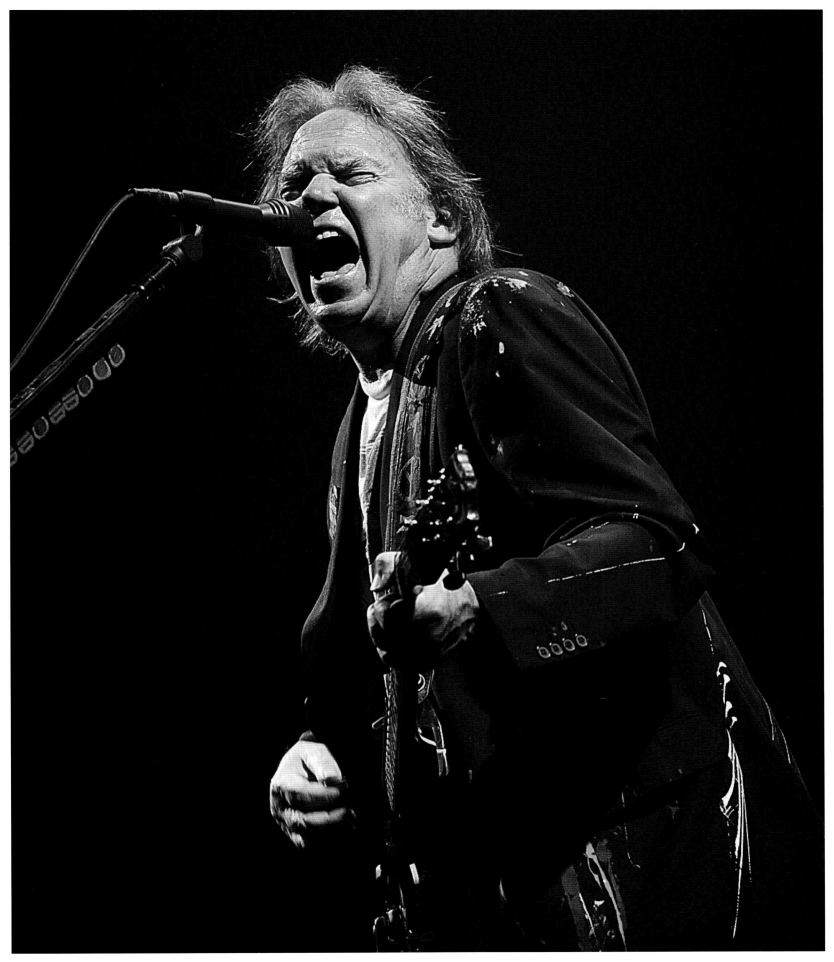

NEIL YOUNG
DEAD BUT NOT FORGIVEN
I can't believe how many of my friends hold Neil Young in such high esteem!!
Personally I haven't forgiven him for the lyric saying Johnny Rotten is dead but not
forgotten. Was it a metaphor or did he mean Sid Vicious?? Anyway, have to admit he
was pretty great as the headline act of the Big Day Out.

RED HOT CHILI PEPPERS
ADRENALINE PLUS

Power and physical presence from the get go on stage. Wild and funky.

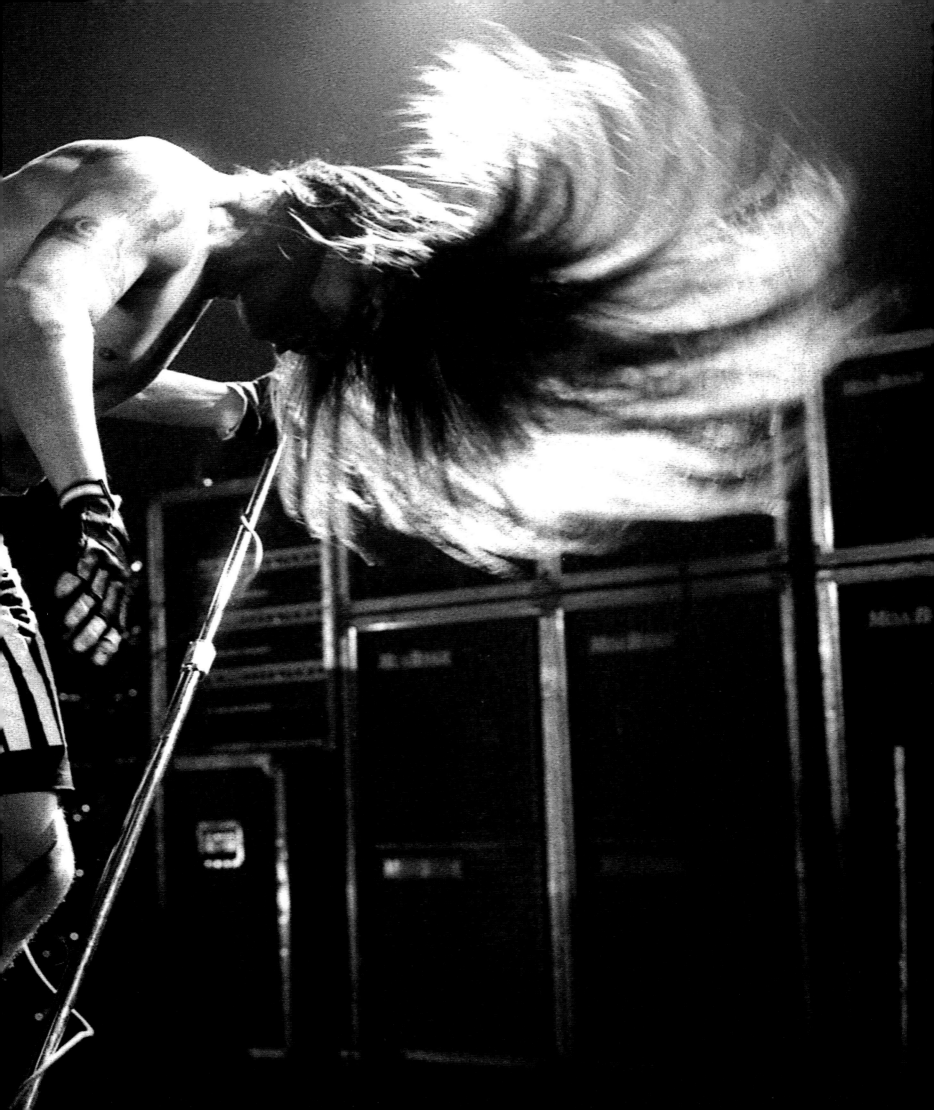

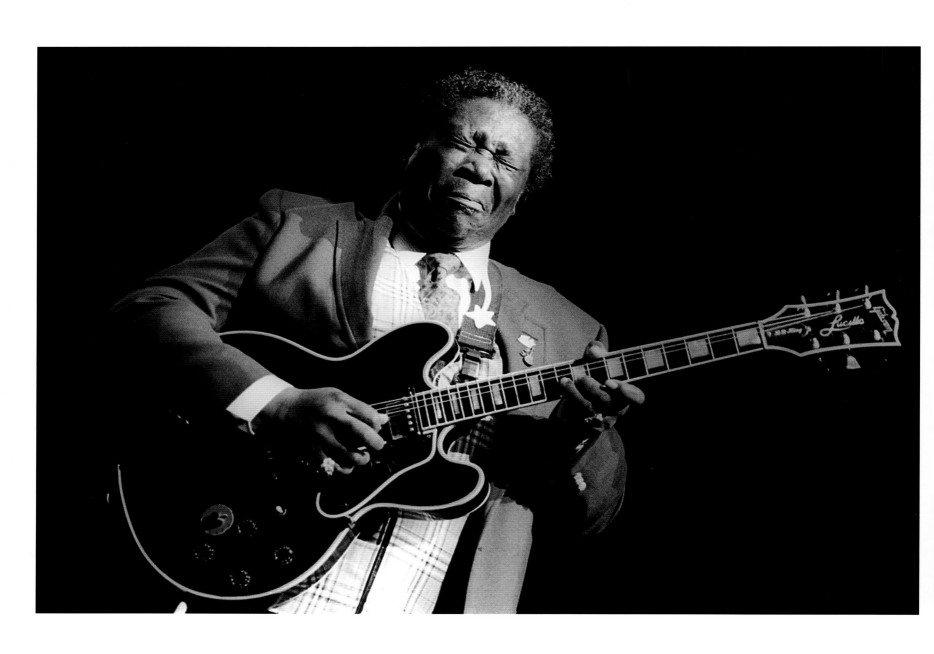

B.B. KING
WITH LUCILLE
This photo sells well with guitar magazines mainly due to the legendary Lucille
Gibson guitar. Taken during the Love Comes to Town U2 tour.

BOX THE JESUIT
MUCH MISSED GOOSE
Darlings of the inner city scene in the late 80s, they were always a joy to
photograph in an era where being dressed in black and looking miserable was
the vogue; their look was a blessing for a photographer.

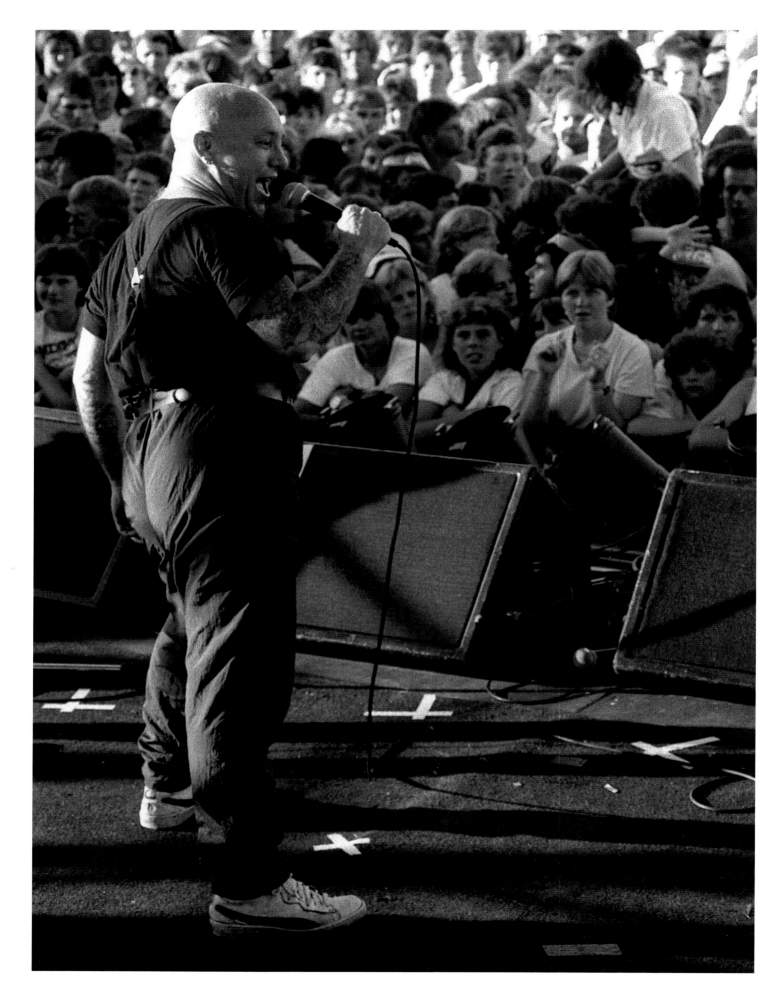

ROSE TATTOO
ROCK'N'ROLL OUTLAW
A band that commands respect from many overseas bands really should have
been more successful overseas themselves.

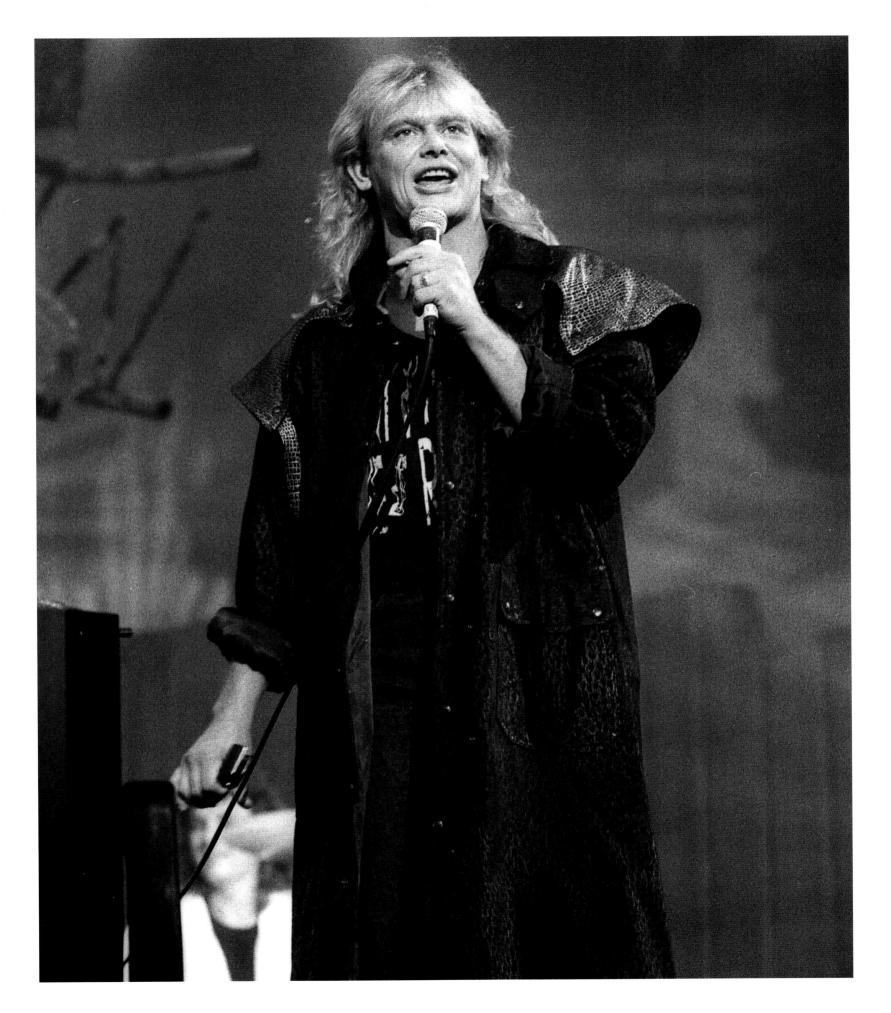

JOHN FARNHAM
DRY AS A BONE
You're the voice, from cleaning lady to Little River Band to his own voice, he
didn't really look back.

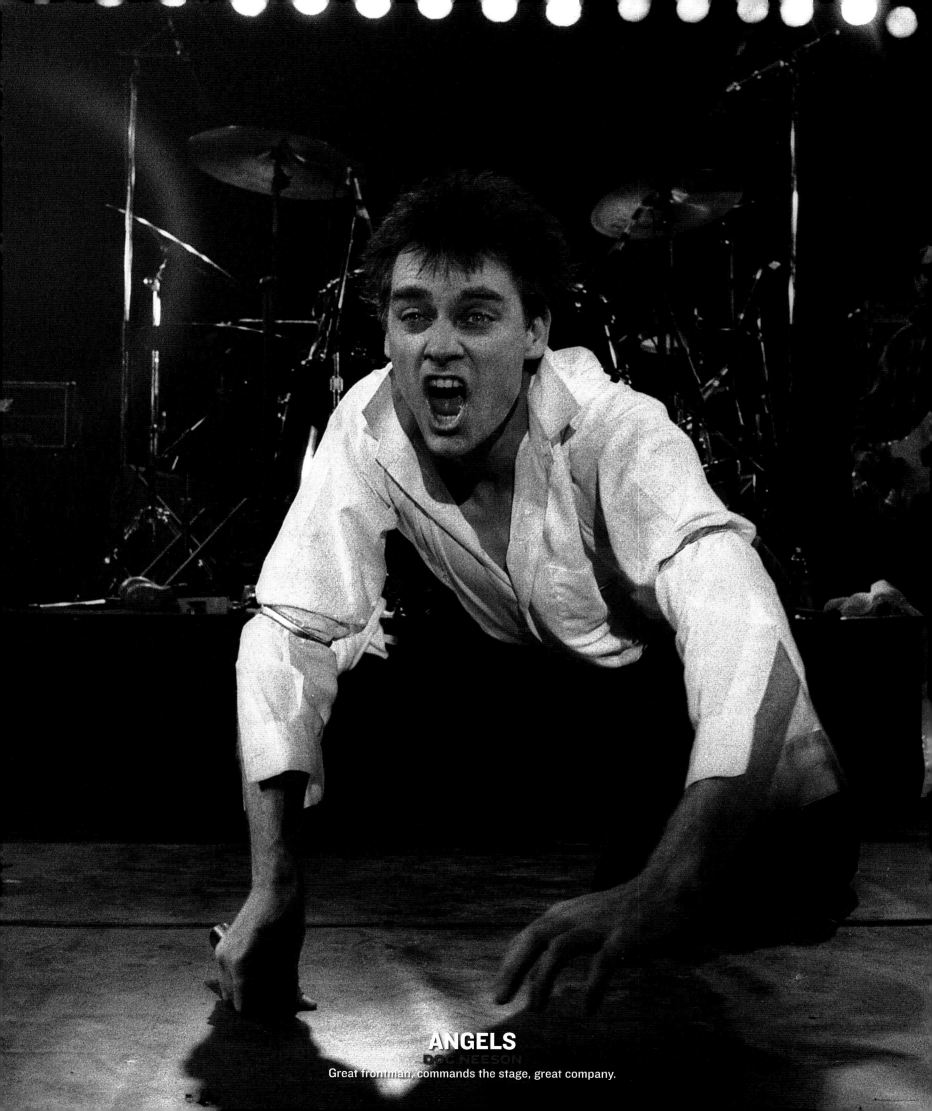

ANGELS
DOC NEESON
Great frontman, commands the stage, great company.

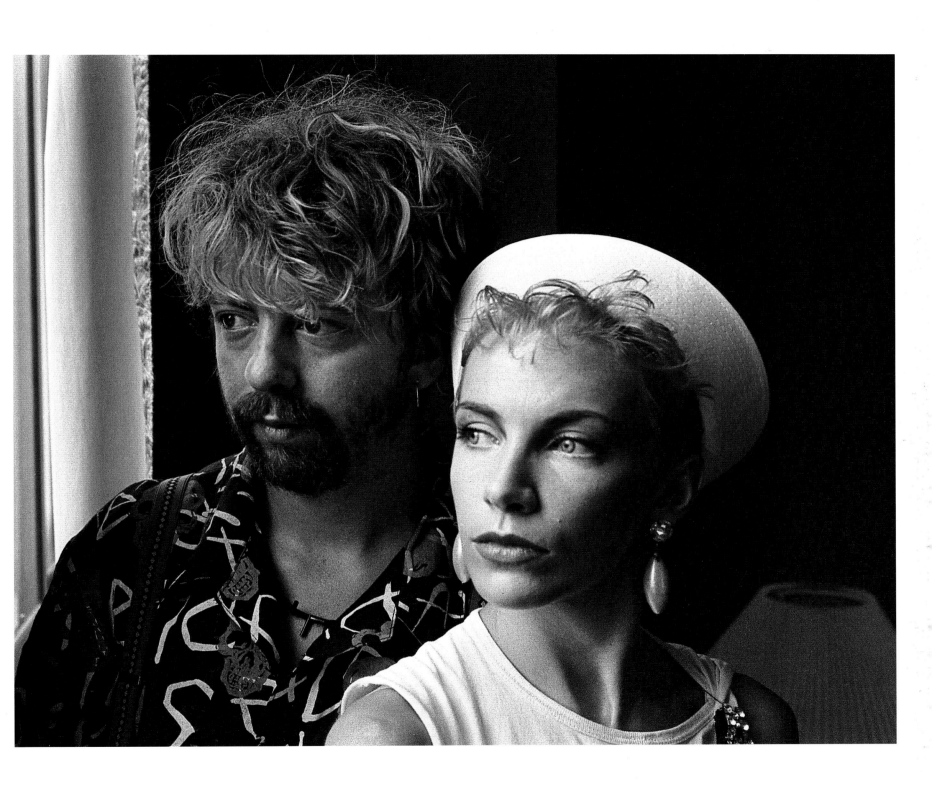

EURYTHMICS
MY DEBUT

As an up-coming and very green rock'n'roll photographer, this was my first international photo session. They were very kind and obliging. It was quite a thrill, I may have consumed a large quantity of alcohol as a result.

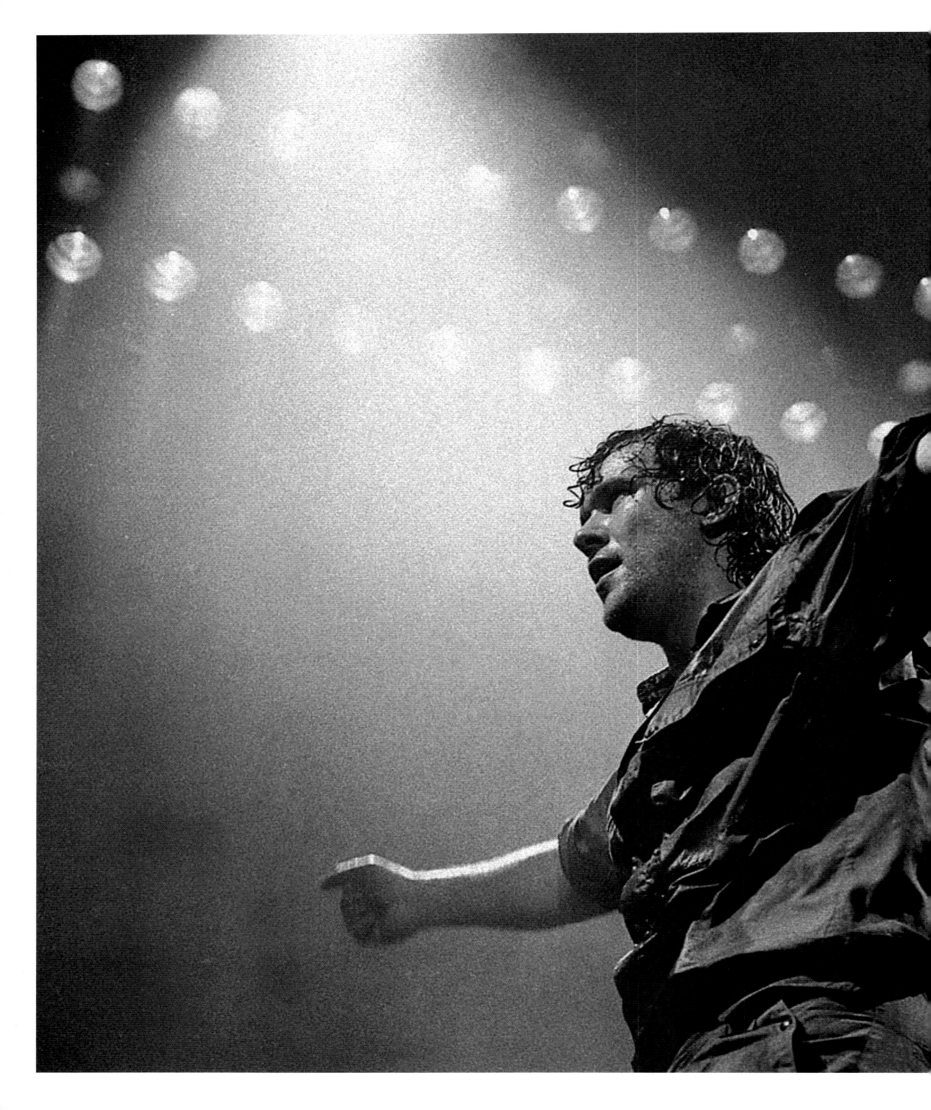

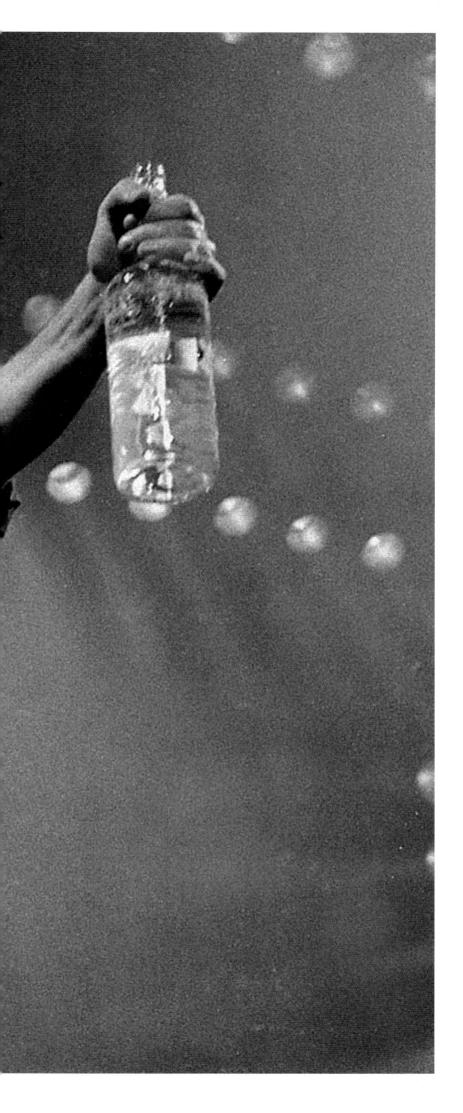

JIMMY BARNES
A VODKA TO GO
This picture became popular about 15 years after I took it, mainly because of the vodka bottle that became absent in later shows. Jimmy's tonsils must suffer when he's belting them out? Jimmy has truly become an Australian icon, amazing for such a young bloke: he's just two days younger than I.

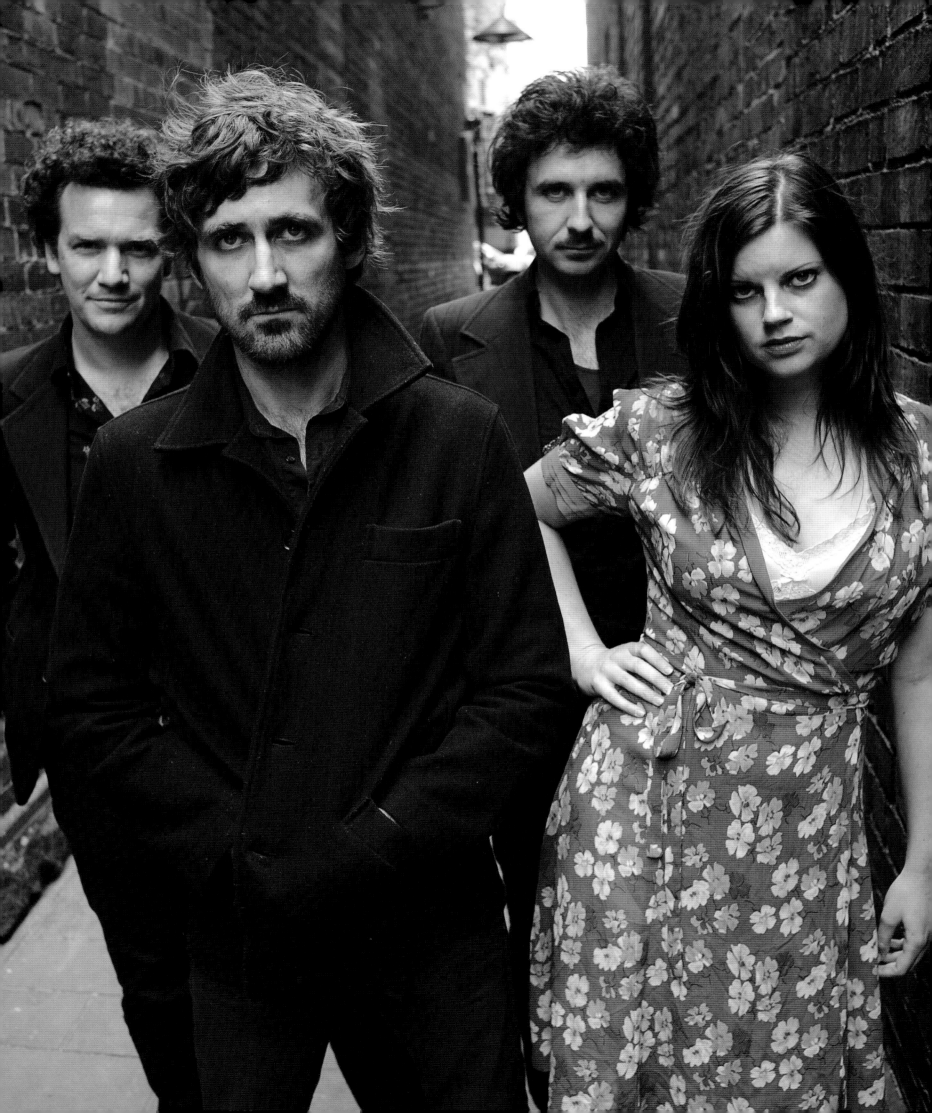

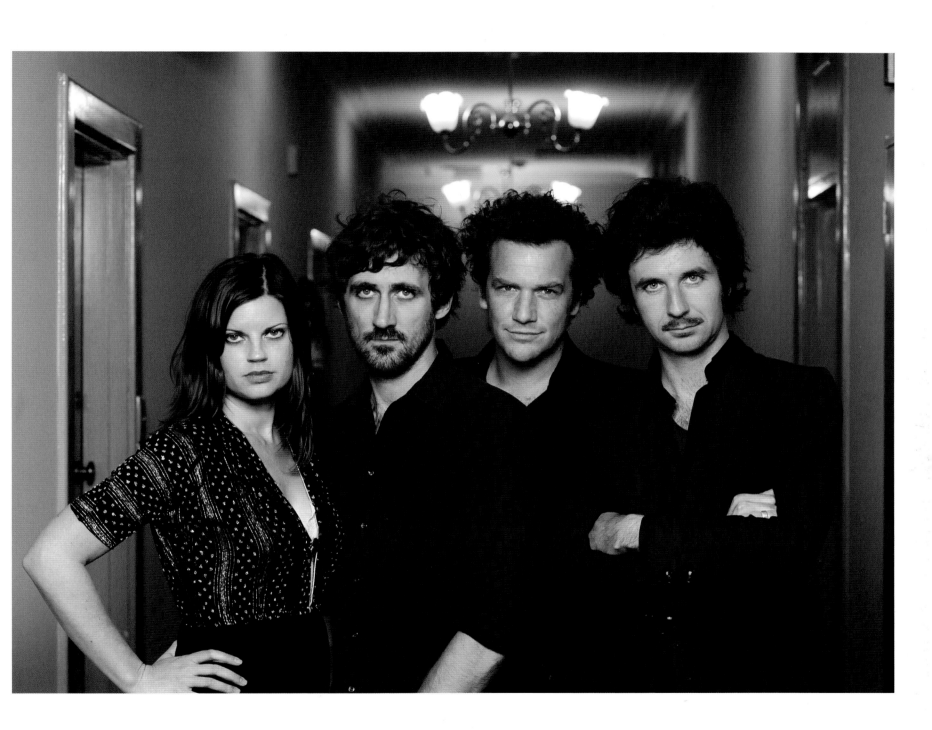

DRONES
COEN BROTHERS LOCATION

Shot in the corridor of the Hotel Windsor in Melbourne, I was trying to recreate
a Coen brothers film feel. Easy to work with, we went into the hotel back alley
to get a contrast. Very successful shoot that was done in just over an hour.
Love this band live.

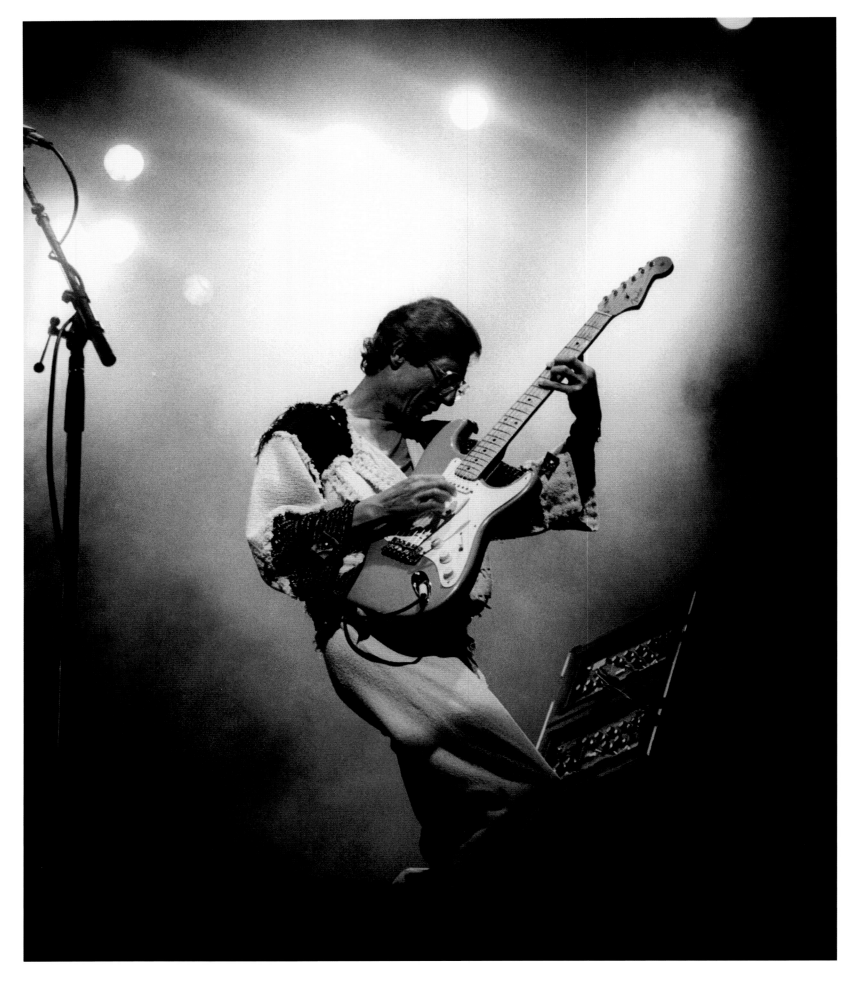

HANK MARVIN
SHADOW GUITARISTS
Strange as it might sound, Hank was the first guitarist to move
on stage with the shadow walk. He was fined by the musicians
union for his troubles, a much imitated guitar style.

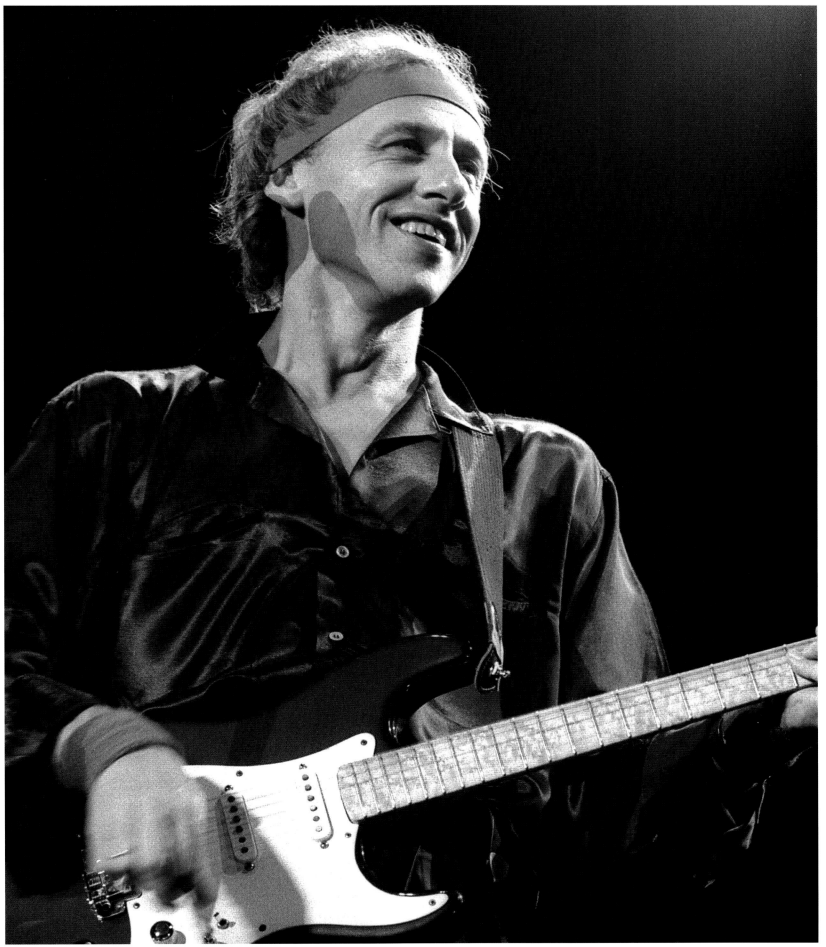

DIRE STRAITS
MONEY FOR NOTHING
Photographed on the incredible 1986 Brothers In Arms tour with a record breaking
24 night stand at the Sydney Entertainment Centre, rumour had it the band had to
buy property with the proceeds because there was too much money to take out of the
country in one go, money for nothing and your house for free?

HOODOO GURUS
BACK TO SCHOOL
I first witnessed the Hoodoo Gurus all the way back in the early
eighties at the Sydney trade union. They are still producing
fine albums to this day, and this was taken at the Oxford Arts
Factory in 2009. Tried to reproduce an old style school photo.

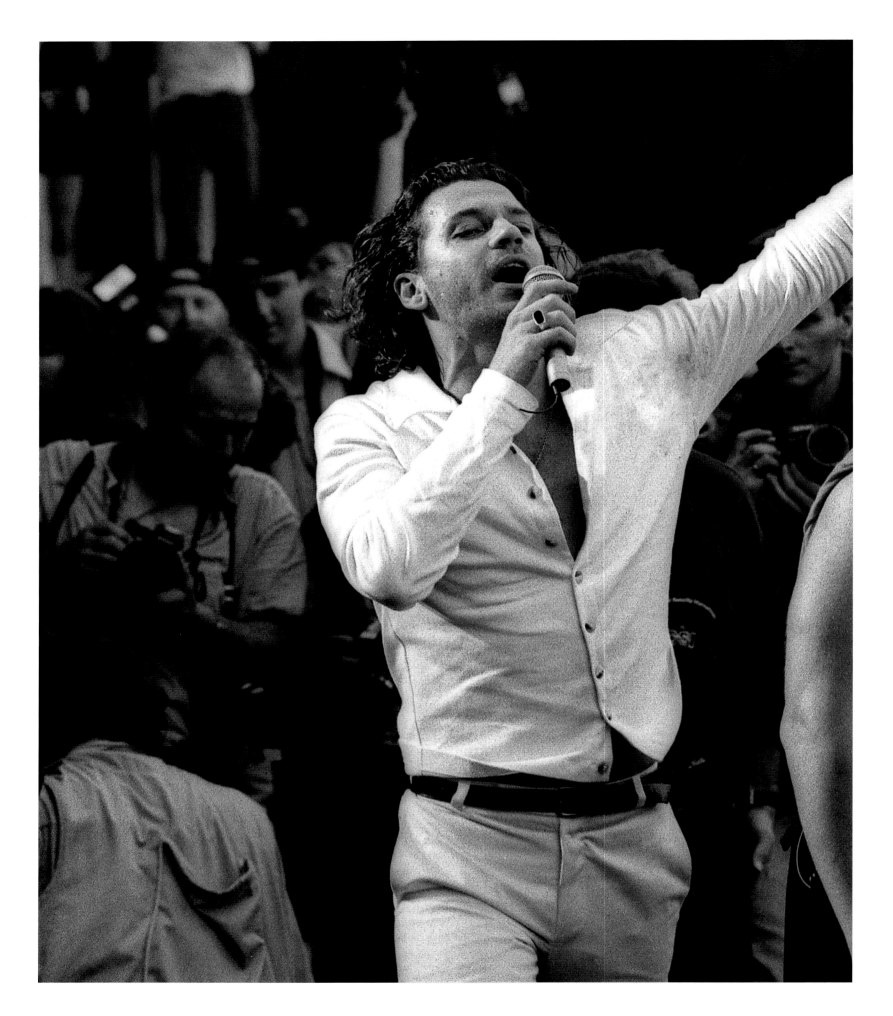

INXS
SHOULD REALLY STILL BE HERE
Gobsmacked when he passed away. Always great to shoot live,
a great mover, prowled the stage.

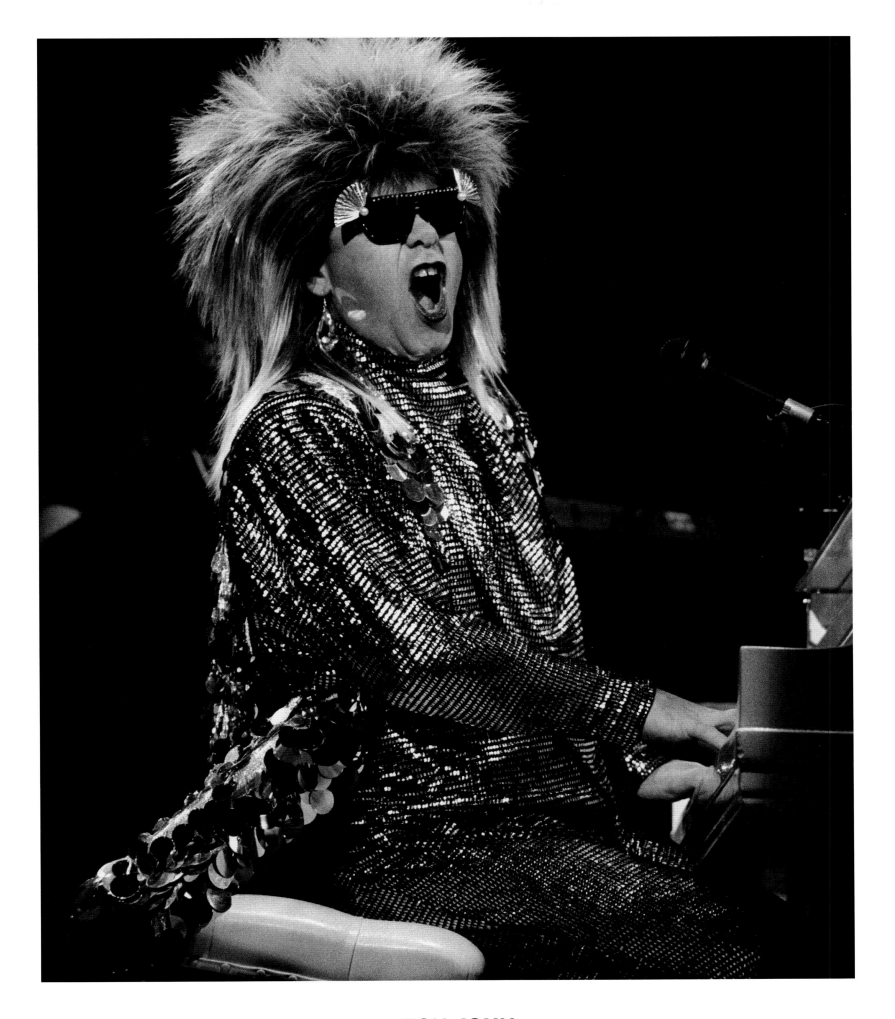

ELTON JOHN
REG DWIGHT MAKES GOOD
Taking his name from Long John Baldry, the name change was a good move. Was in a band with
Rod Stewart called Steampacket. Quite a character on stage but known for mood swings.

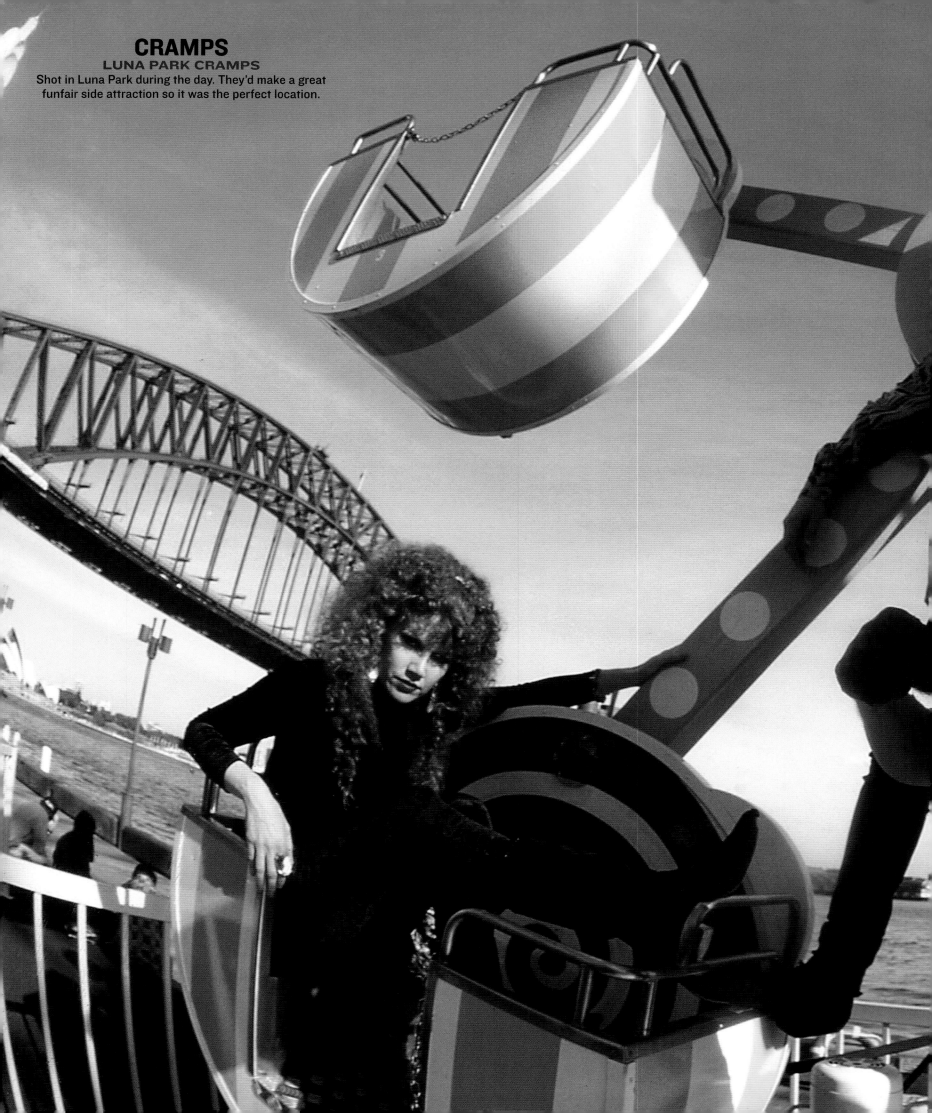

CRAMPS
LUNA PARK CRAMPS
Shot in Luna Park during the day. They'd make a great funfair side attraction so it was the perfect location.

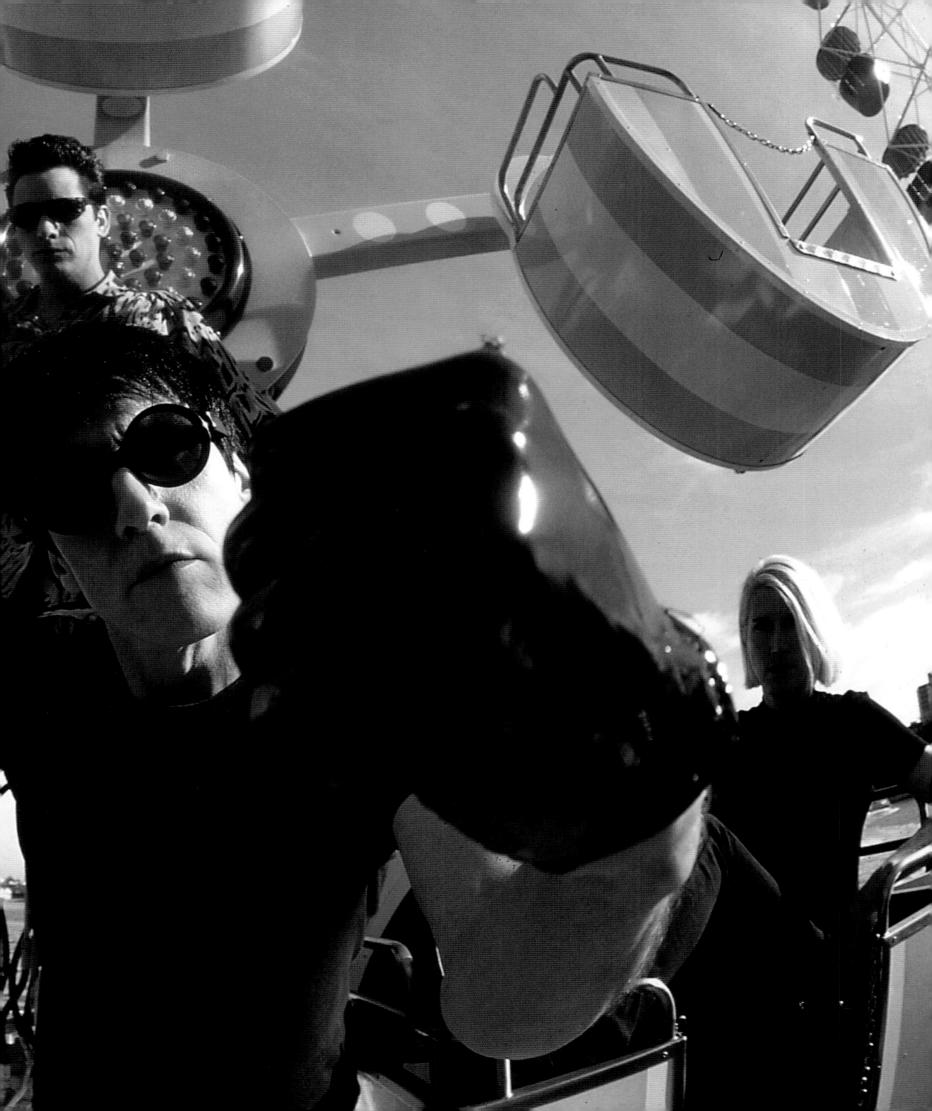

CLOUDS
A DAY IN THE PARK
I shot the Clouds many times for both the Australian and US record companies but this was taken when they were independent. Never felt I captured the essence of the band despite my love of 'em, love the debut EP, this was taken in Centennial Park and was an embarrassing shoot: when I asked the guitarist in the band to crouch down there was a strange silence. Unbeknown to me he had a wooden leg. Felt bad.

WAIFS
IN MY HOUSE
Taken on my railway seat in my home, another of the new breed of
independent artists that have forged a great career via the
hard road of gigging, love 'em.

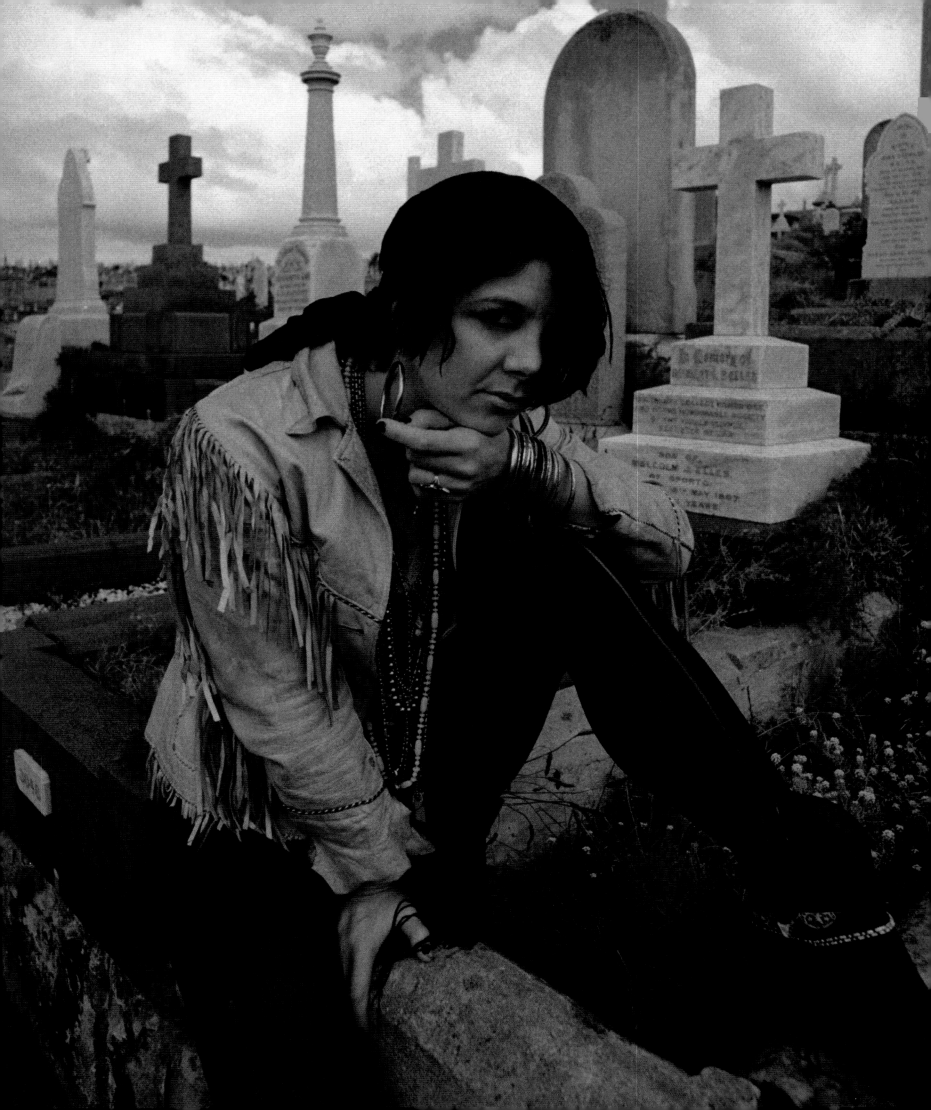

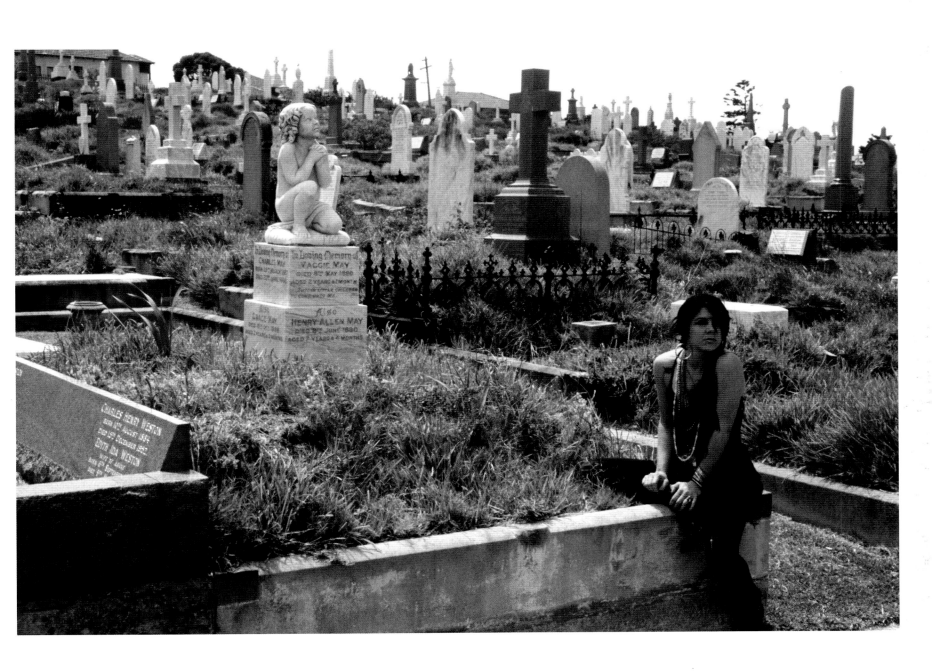

CONCRETE BLONDE
WINE IN A GRAVEYARD

Shot in Clovelly graveyard by the sea, we ended up shooting there on three
separate occasions and took a bottle of wine to enjoy the ambience. A picnic
in a graveyard with Johnette – great way to spend the day. We spent hours
looking for Banjo Paterson's grave. A really great band.

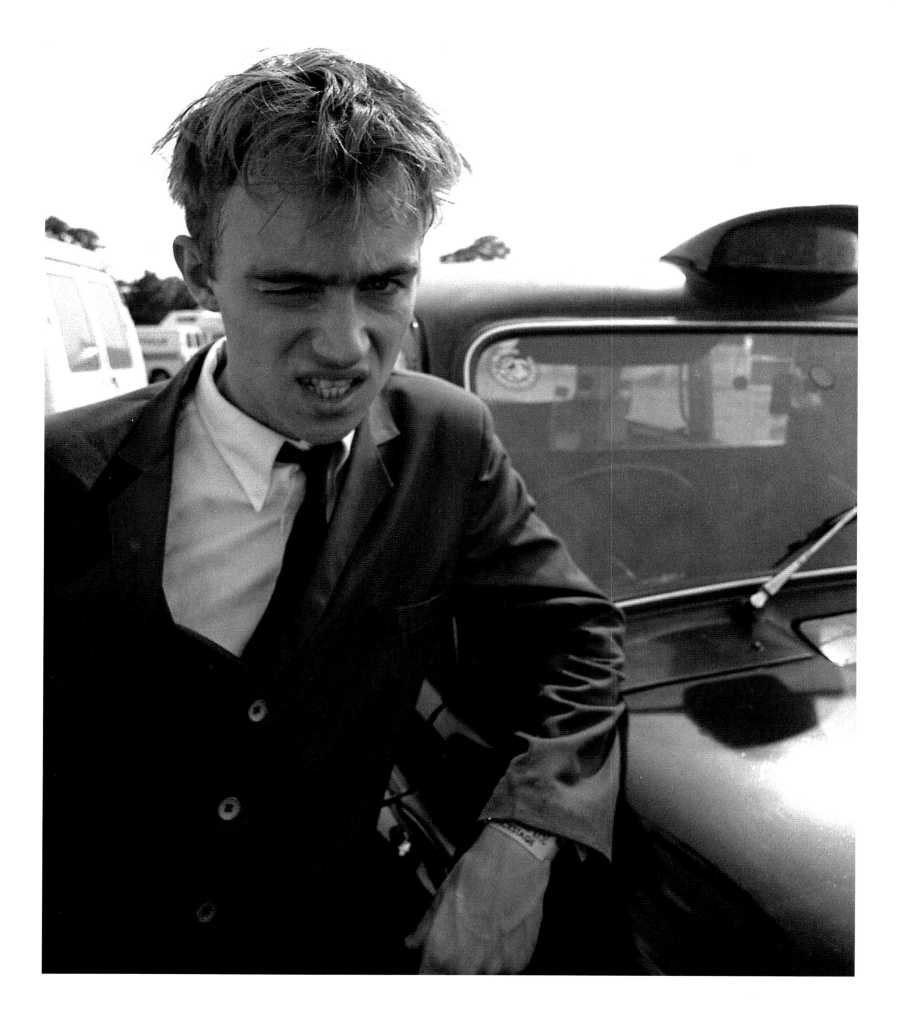

BLUR
TAXI!
Taken backstage at Glastonbury in Blur's very early days.

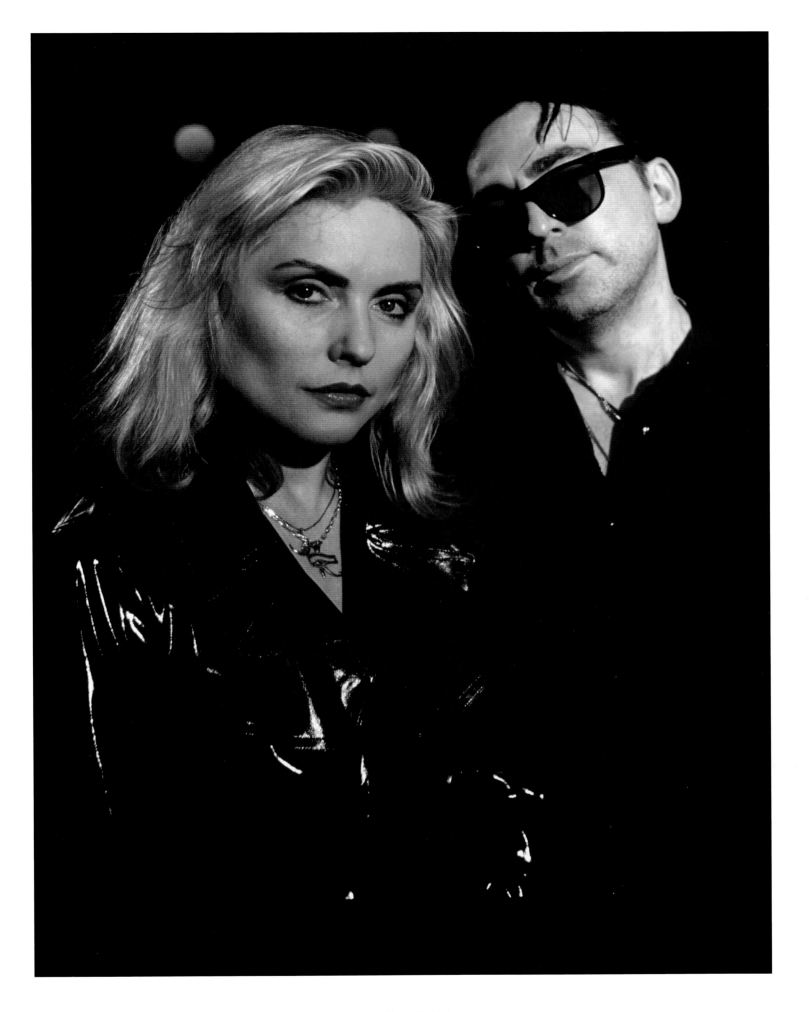

BLONDIE
LOOKING GREAT AT 48
Taken on her 48th birthday, apparently she hasn't spent a day in the sun.
Great skin, great songs.

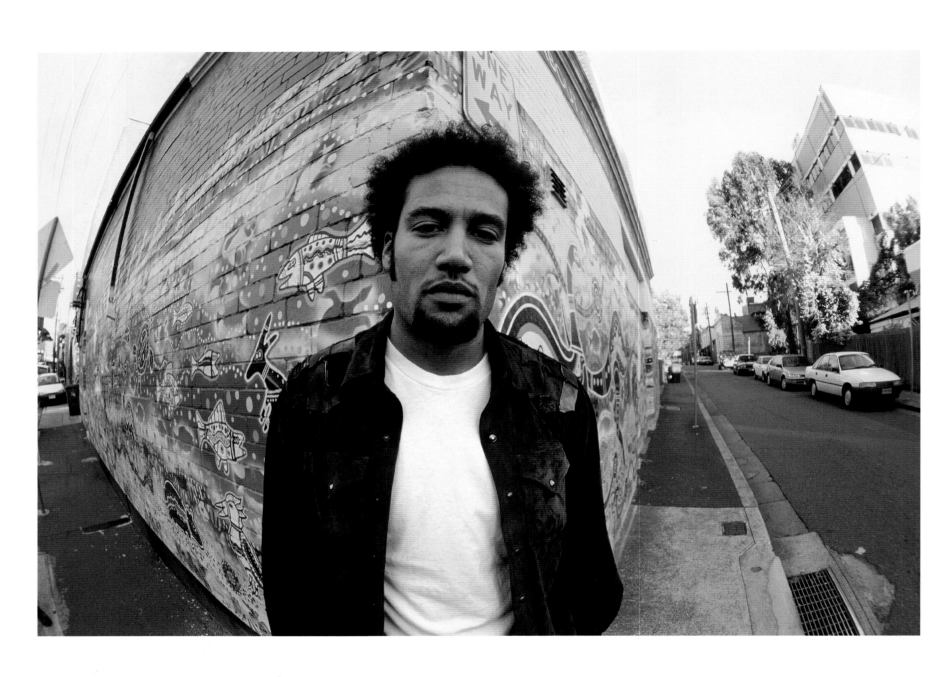

BEN HARPER
WHICH COUNTRY AM I IN?
Taken in the back streets of Newtown, he seemed unaware of which country
he was in. Lovely guy.

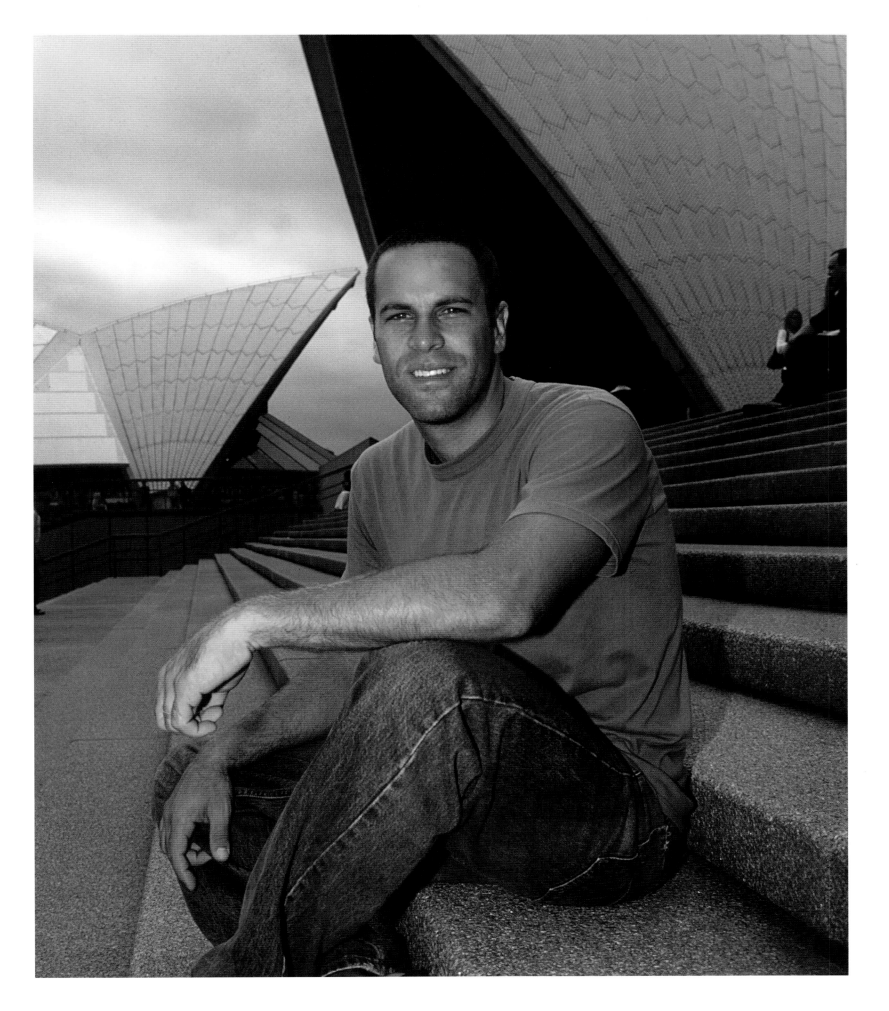

JACK JOHNSON
ANY MORE LAIDBACK HE'D BE ASLEEP
Laid back guy, he was very keen to get a picture of himself in front of the
Opera House. Why? For his mother.

DIRTY THREE
NEW YORK NEW YORK
Funny how everybody is embarrassed about being photographed in front of their own iconic images. No Sydney band in front of the Opera House, no Melbourne band on a tram. New York artists in Times Square? Never. Dirty Three in front of a Manhattan skyline? No problem.

R.E.M.
ATHENS TO SYDNEY
Ended up photographing Peter Buck's wedding and got to
sing with R.E.M. at the wedding reception. I did "Winchester
Cathedral" and found out that Frank Sinatra had a hit single with
it in the US. I knew the vaudeville Bonzo Dog Band version.

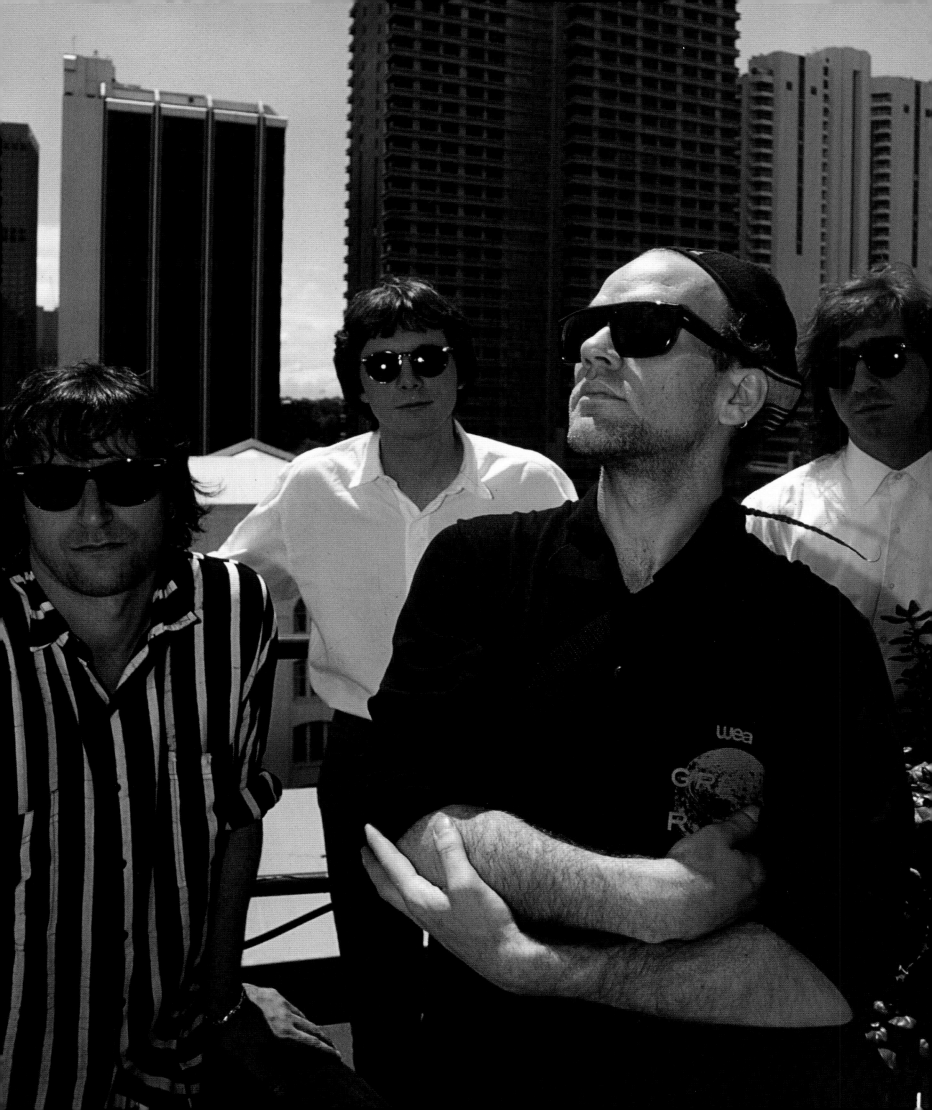

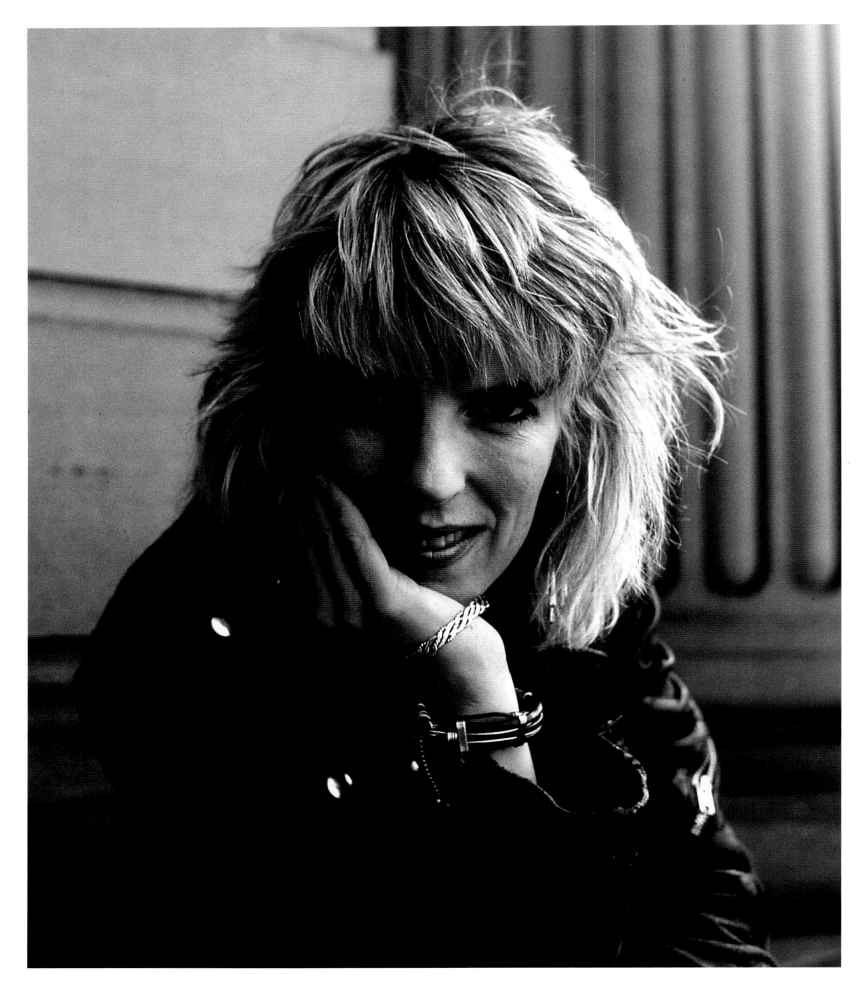

LUCINDA WILLIAMS
ESSENCE OF LUCY

One of my alltime favourite artists. Nervous having her photographs taken, as a performer she's like a bottle of red wine, gets better with age. Every album a gem. She's a lovely, if slightly mad, person.

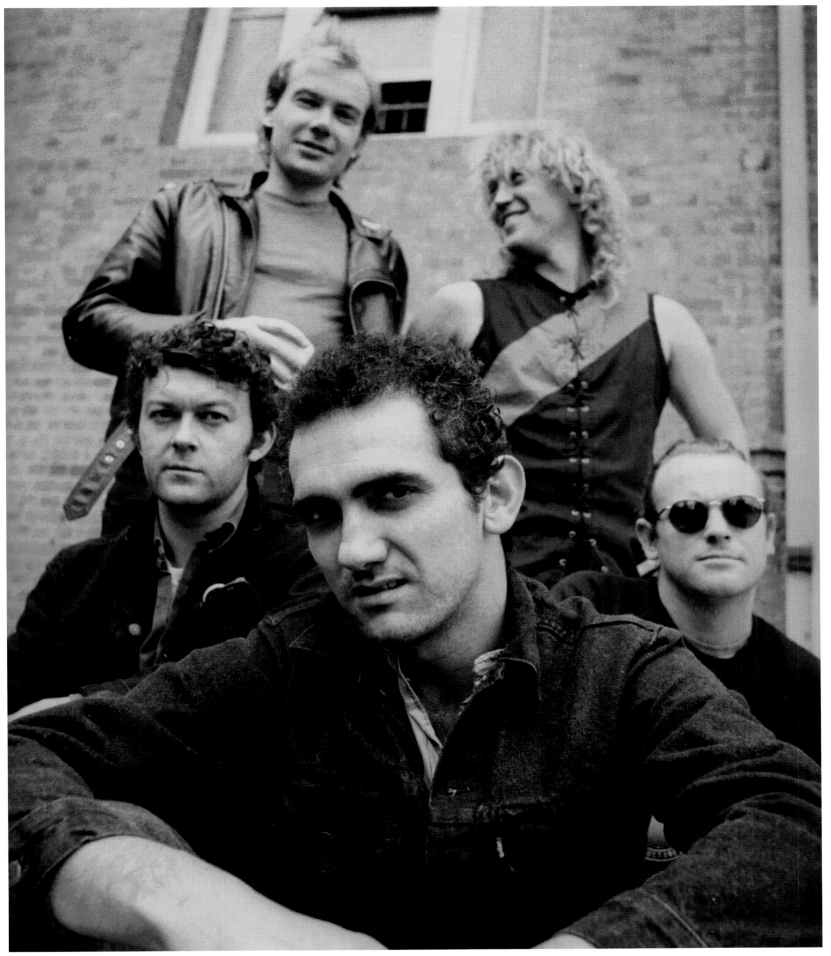

PAUL KELLY
MY QUEST
I have the uppermost respect for Paul Kelly and, more importantly, his songs
and I've never felt satisfied with any photos I've taken of him. I always think he
deserves better photos. Anyway, the quest continues. In the meantime, this is
the best and the first I took way back in the mid 80s with the Coloured Girls.

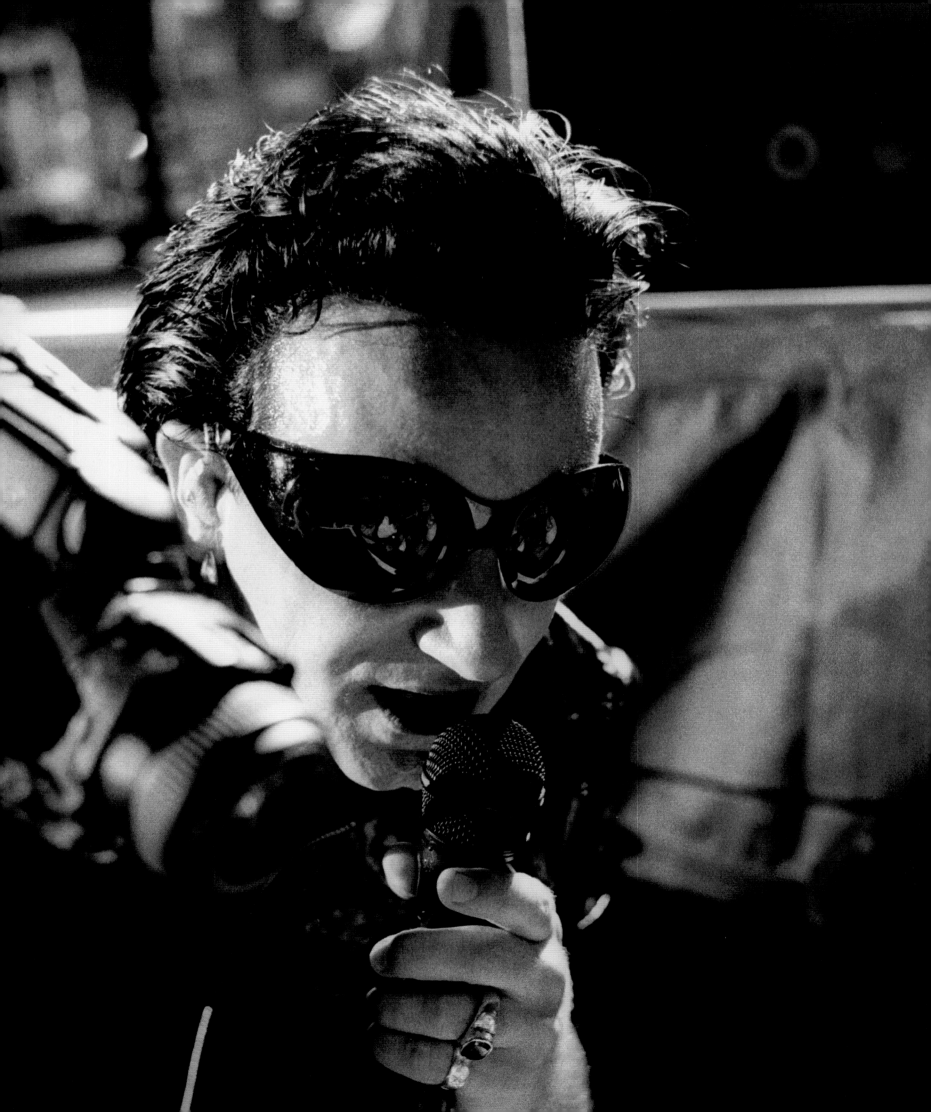

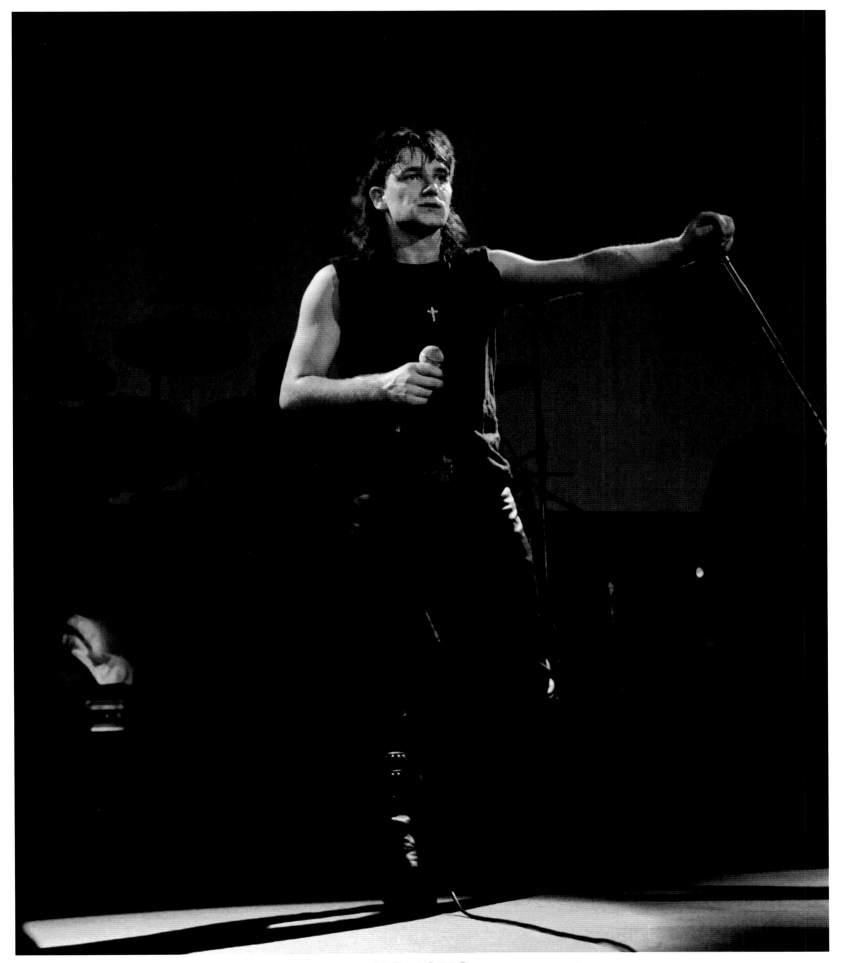

U2 BONO
WHO YOU LOOKING AT
Photographed in 1984 just before the band became world wide huge and Bono
became god. (*Left*) I'd worked out that Bono headed straight for the cutest
female photographer in the opening song. This night it was the talented Wendy
McDougall so I parked myself right next to her to get the shot.

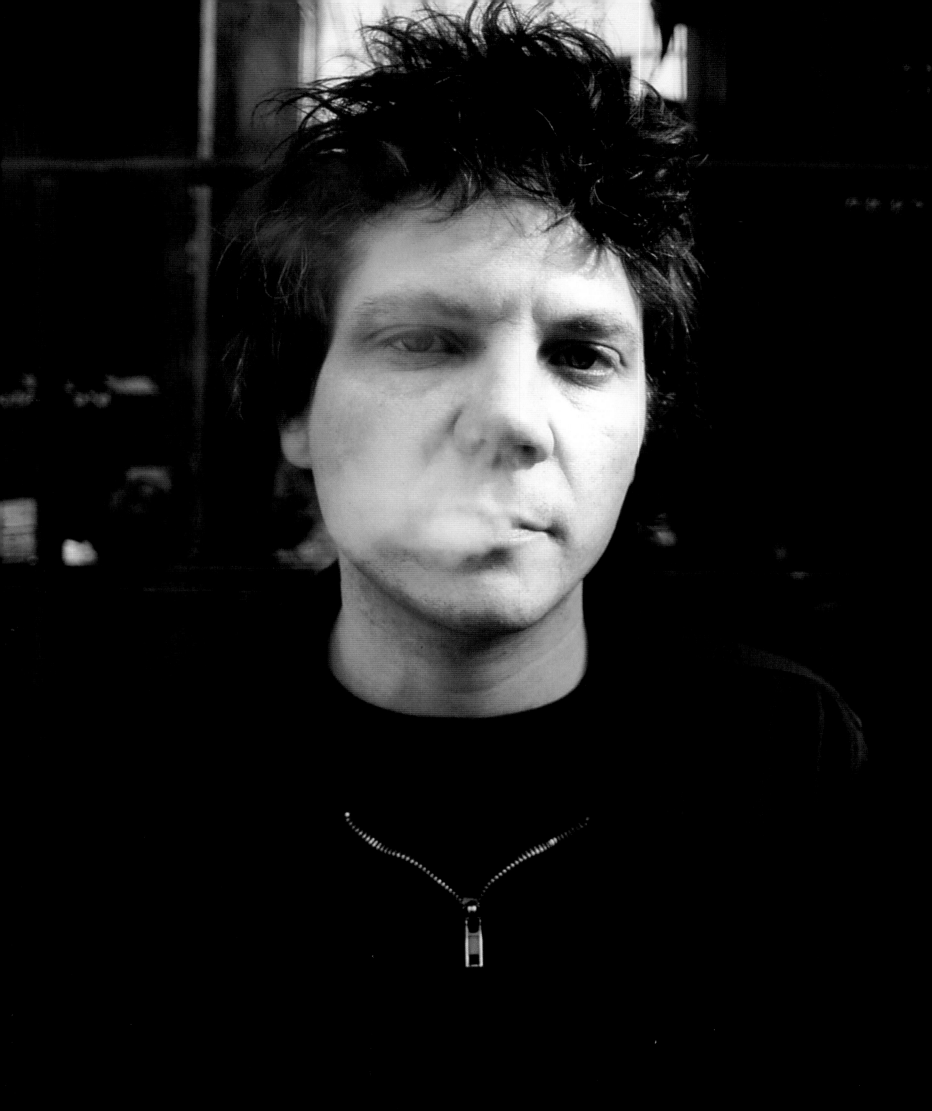

WILCO
JEFF'S BAND

Jeff Tweedy of Wilco. A casual shot often works best and after spending an hour in a photo session that had been thought through, I caught Jeff having a fag backstage and quickly took a couple of photos – and preferred them to the session. Go figure.

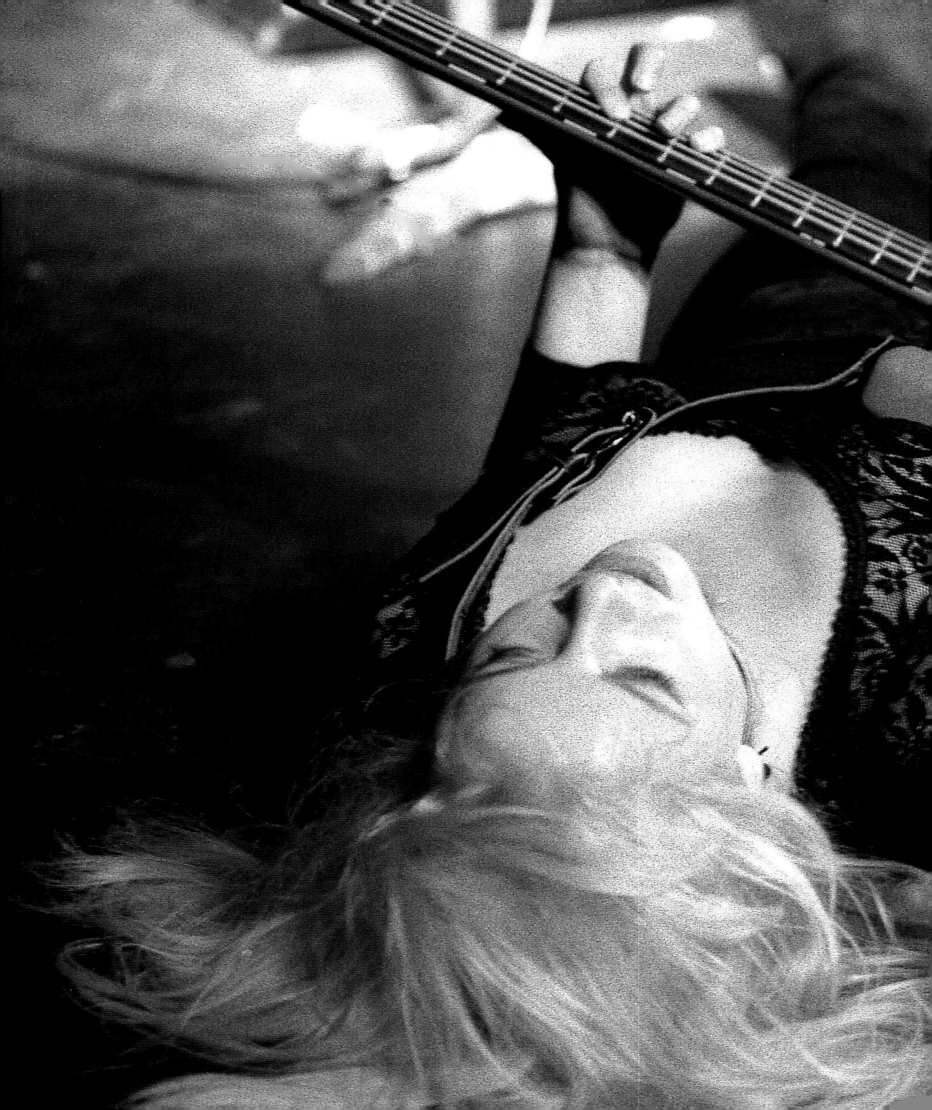

NUMBERS

ANNALISE ON THE

Loved this band and Annalise Morrow's fashion background always lent a great look on stage. Cheating really, because this is the latter Maybe Dolls, different name same band.

TEX PERKINS
TOO MANY BANDS SPOIL THE BROTH
First started photographing Tex in the late 80s. I believe at that point
he was in about 20 bands. Confusing?? Maybe, but brilliant on stage.
Women just seem to love him.

METALLICA
BLACK AND SIMPLE

Taken on Metallica's first Australian tour. At the height of big hair metal bands, Metallica were heavier and simpler. Black clothing and very much a white light show. Immense show.

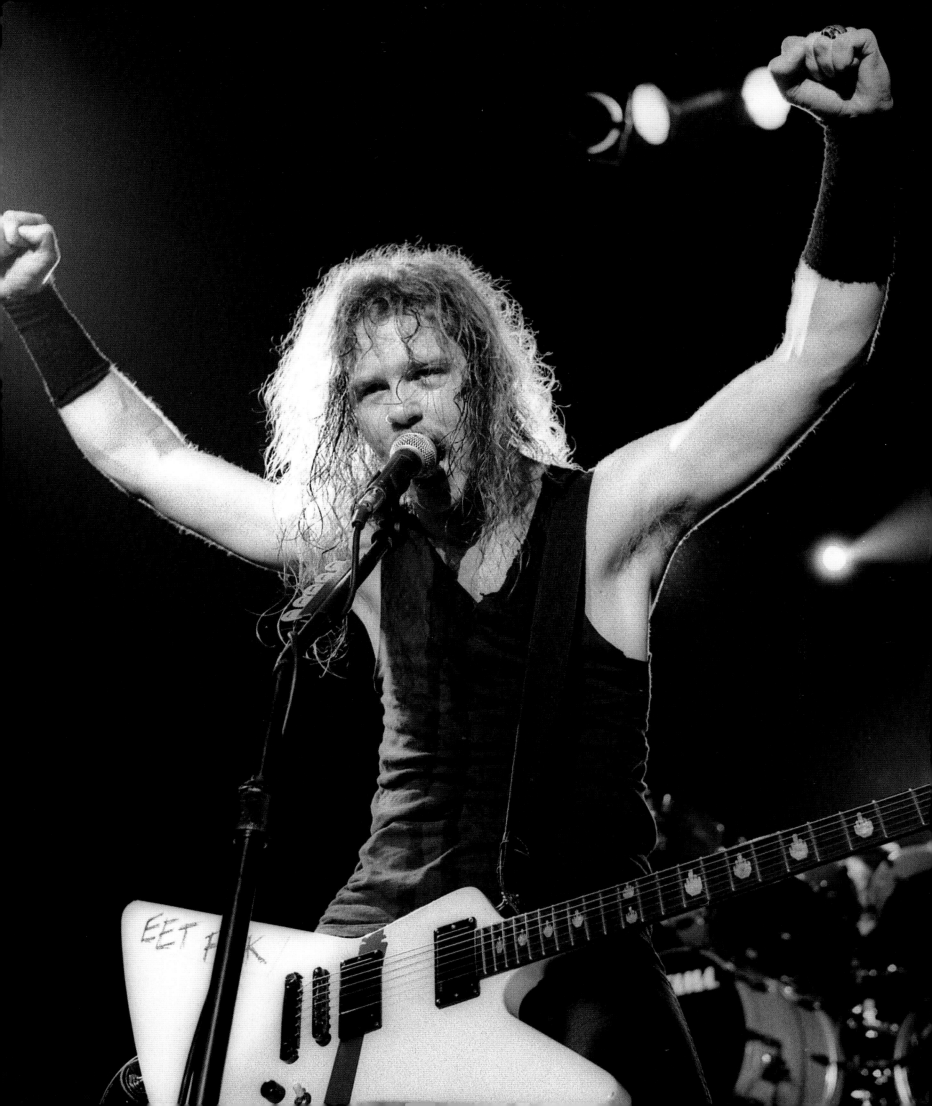

THE FALL
MARK E SMITH
Manchester's most belligerent frontman looking surprisingly sedate.

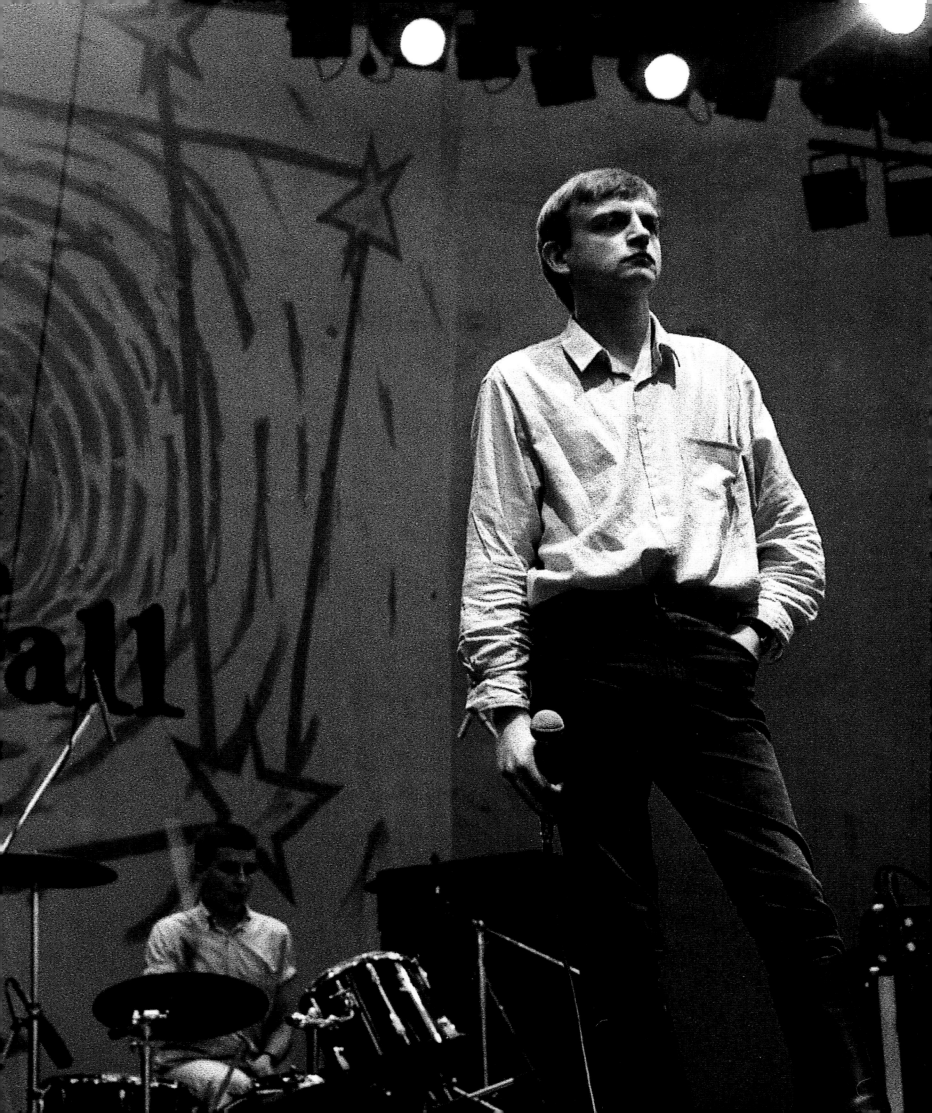

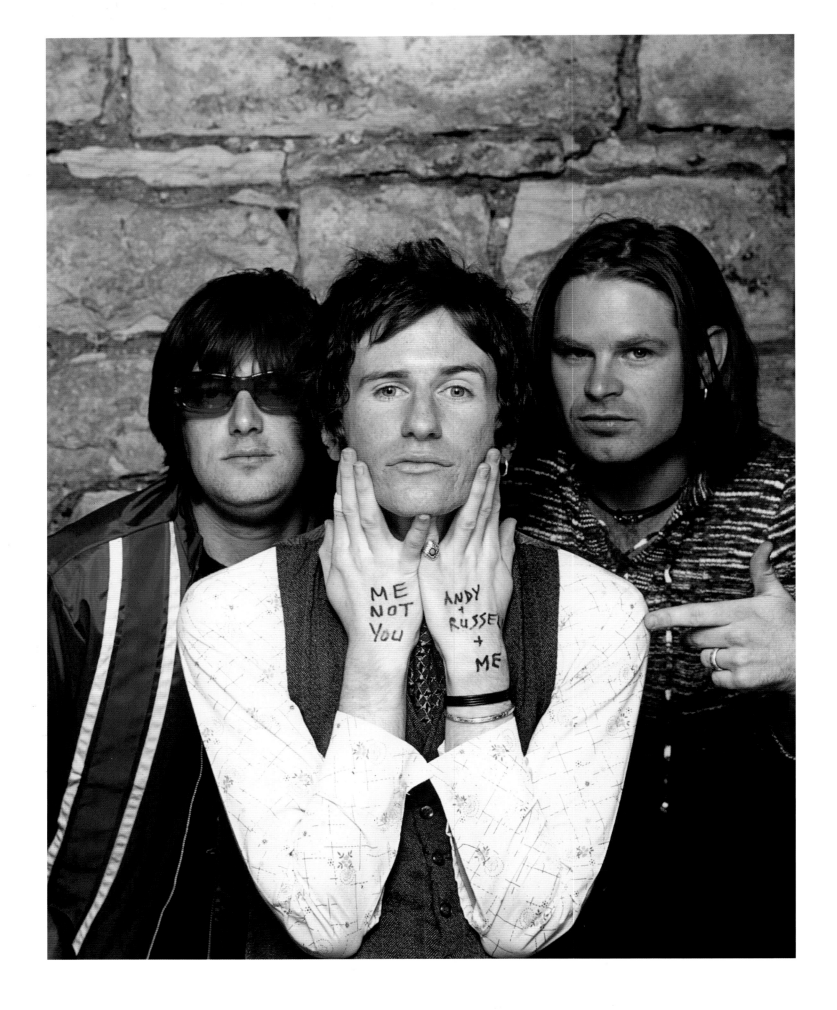

YOU AM I
THE GREATEST LOST AUSTRALIAN BAND
Great melodies, great lyrics, a genuine rock star out the front, influenced god
knows how many bands. Why oh why are they not bigger? Beats me.

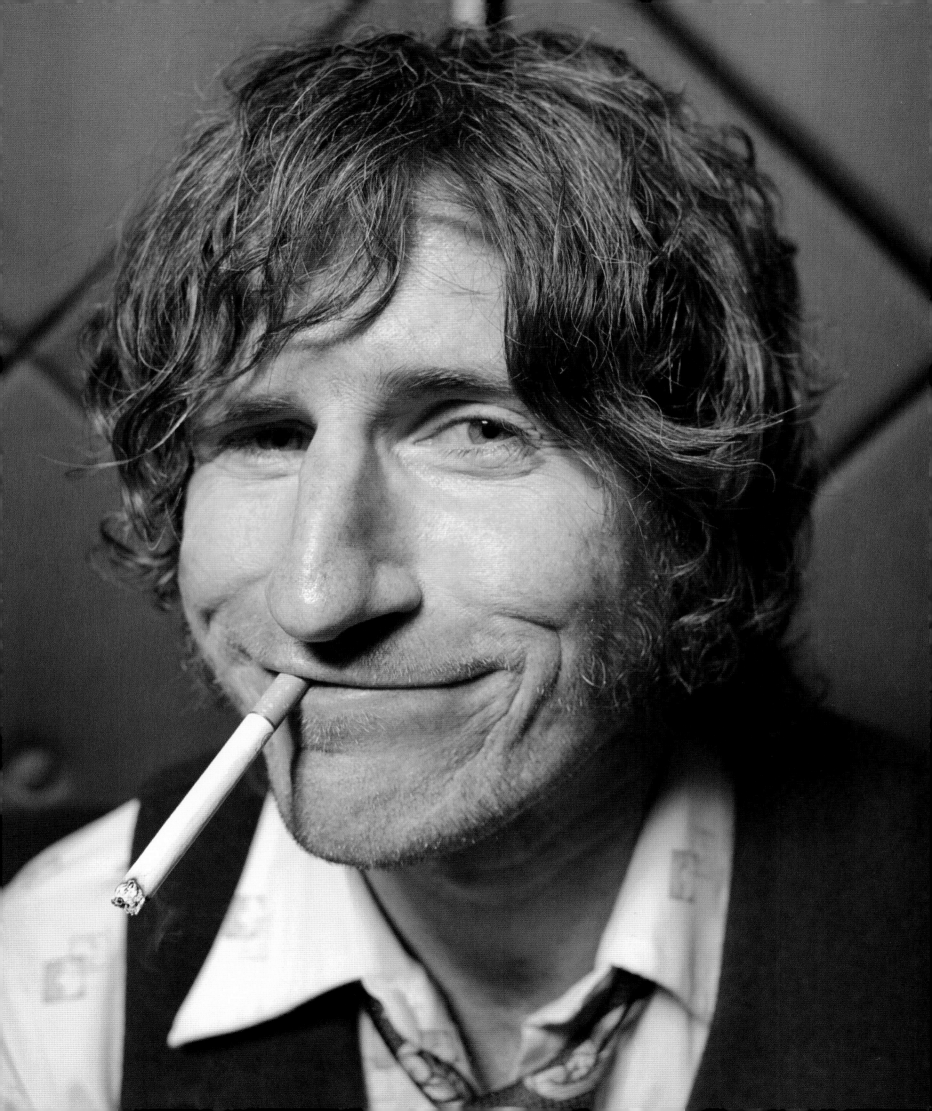

WHITE STRIPES
ROCK'N'ROLL MYTH
Rock'n'roll is built on myths and this couple sure knew how to
work the mystery angle. Husband and wife? Brother and sister?
Lovers? Who knows, who cares? Taken before they broke big time
at the Big Day Out where they were playing the side stage.

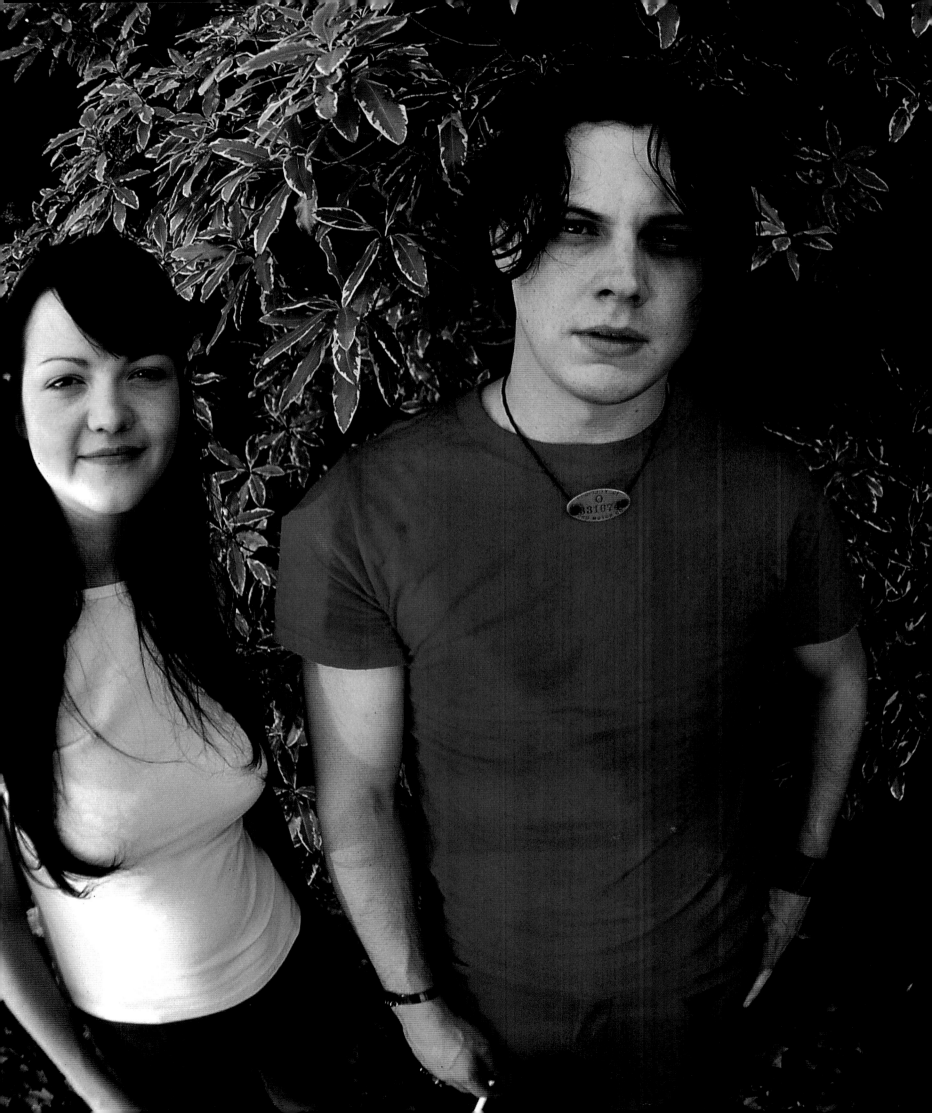

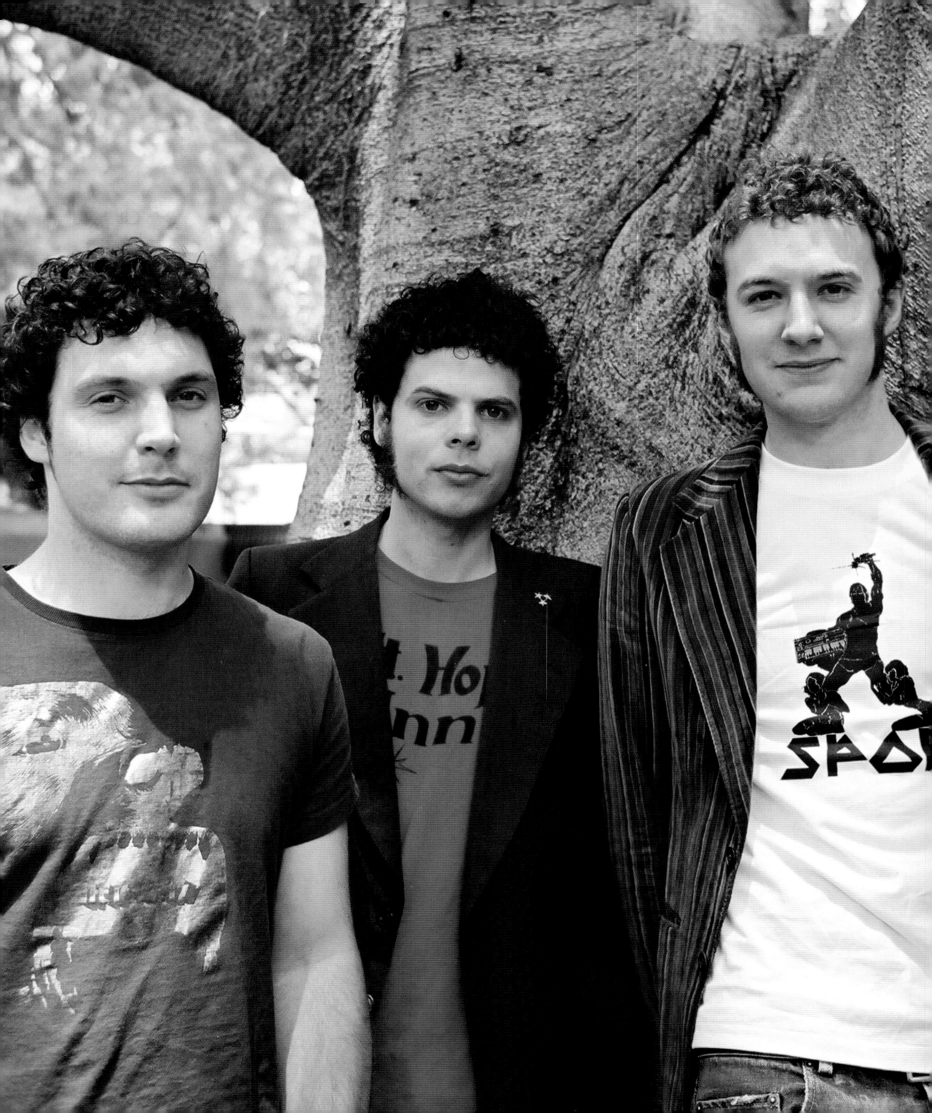

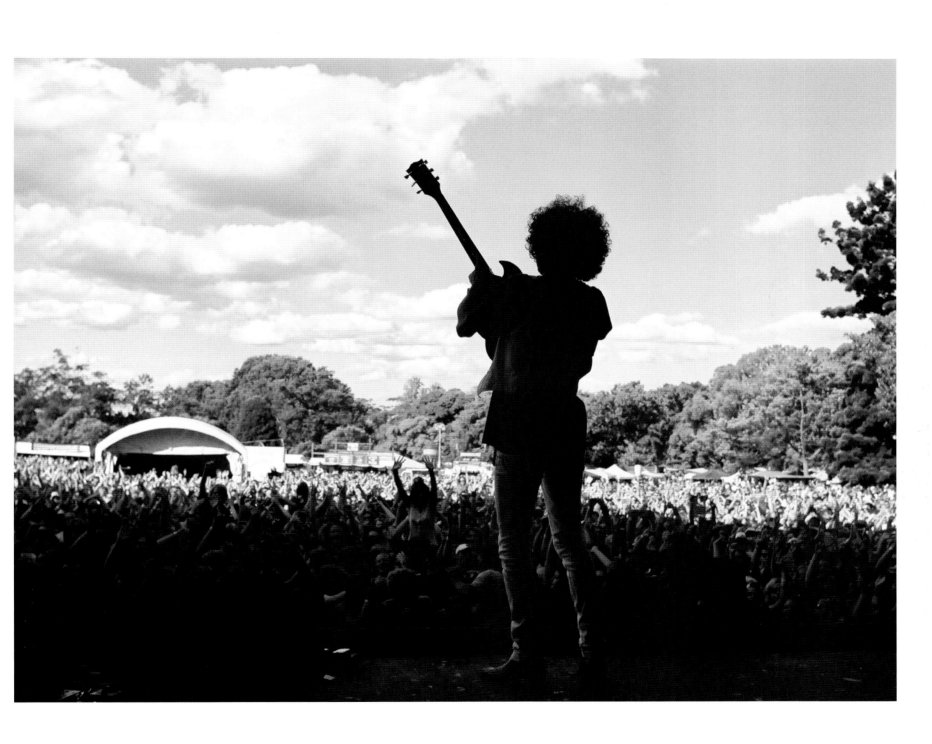

WOLFMOTHER
GUITAR HERO
It's always easy to get a guitar pose from frontman Andrew Stockdale.
Not many artists work in silhouette but Wolfmother do.
(*Left*) An early shot taken backstage at the Homebake festival.

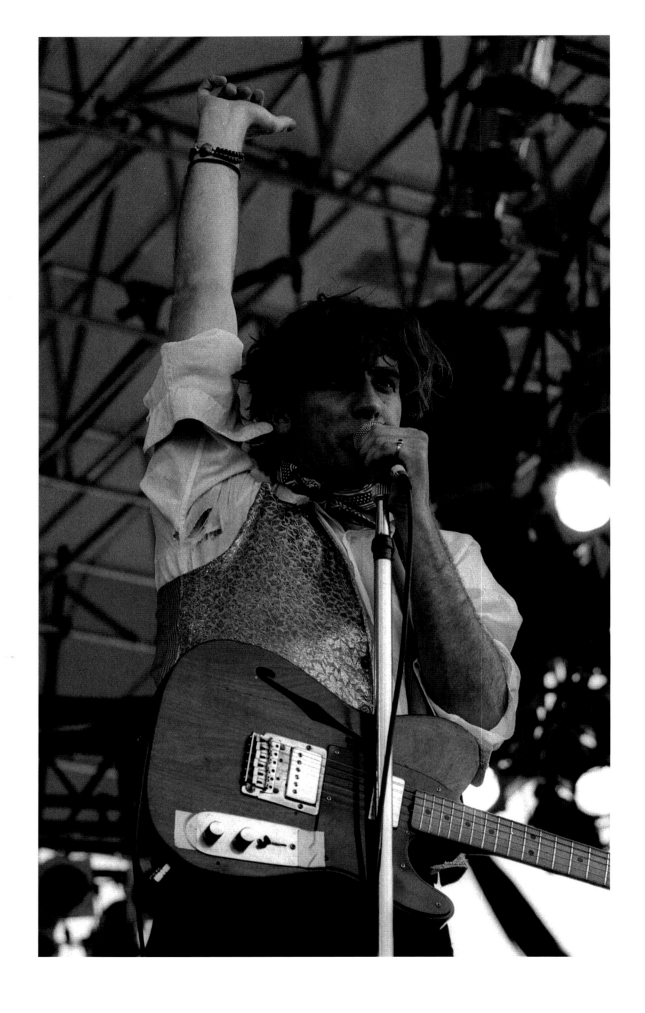

TRIFFIDS
WIDE OPEN ROAD
Shot at the Australian Made concerts supporting, amongst others, INXS.
Michael Hutchence, I gather, was a fan. Much missed.

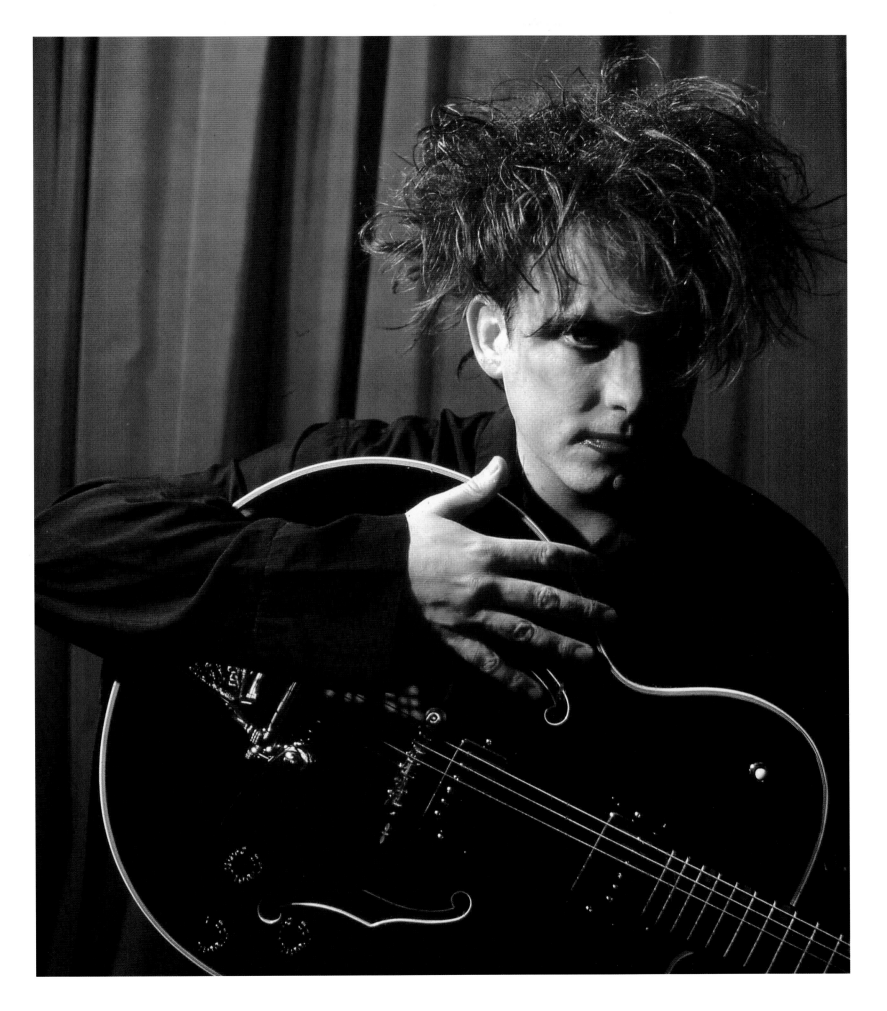

THE CURE
MAX FACTOR SPONSORSHIP
Cool cat Robert Smith was anything but cool. Visibly nervous having his
photo taken. Lovely guy, toured with his mum and dad in tow.

SAINTS
CHRIS AND ED
What an odd couple, yet their short output in the Saints has lasted the test
of time. Their solo careers have always been interesting, and they have very
contrasting styles musically. Also different to photograph.

PIXIES' FRANK BLACK
PIXIES' FRONT PERSON

Frank is not your average frontman. He really doesn't look the part, yet the
Pixies influenced a hell of a lot of bands. Now that they've finally reformed
they seem to do more business than when they originally existed.

RATCAT
DARLING OF THE INNER CITY
Darling of the indie inner city crowd to mainstream success in a frighteningly
short period of time, entertaining songs, so right for their time.

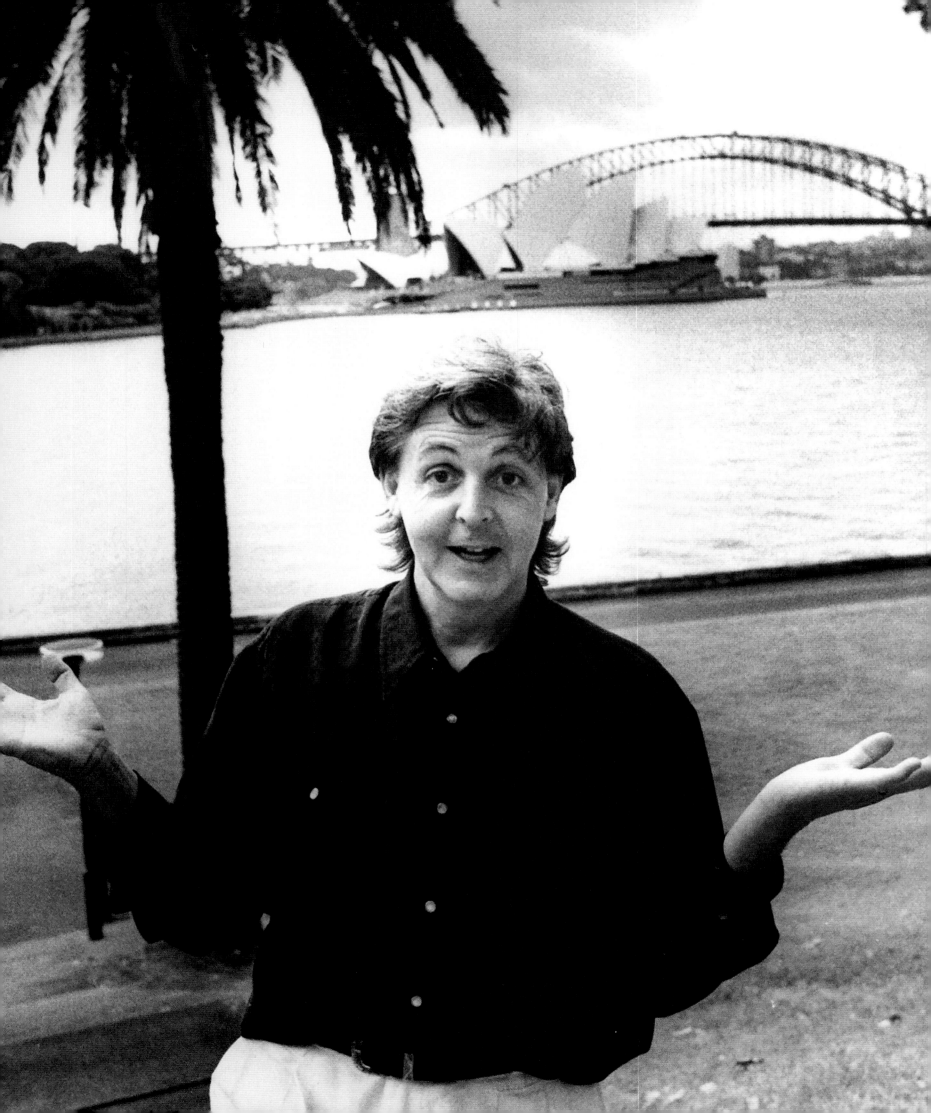

PAUL McCARTNEY
A BEATLE FOR GOD'S SAKE

Had to pinch myself to believe I was in the company of a real Beatle! Bloody brilliant, he and Linda couldn't have been more friendly. Great show and amazing the effect he had on every generation. When he went into Triple J radio station everybody from the CEO to the cleaning ladies wanted to meet him. Tended to wander off to the toilet a lot for a strange cigarette.

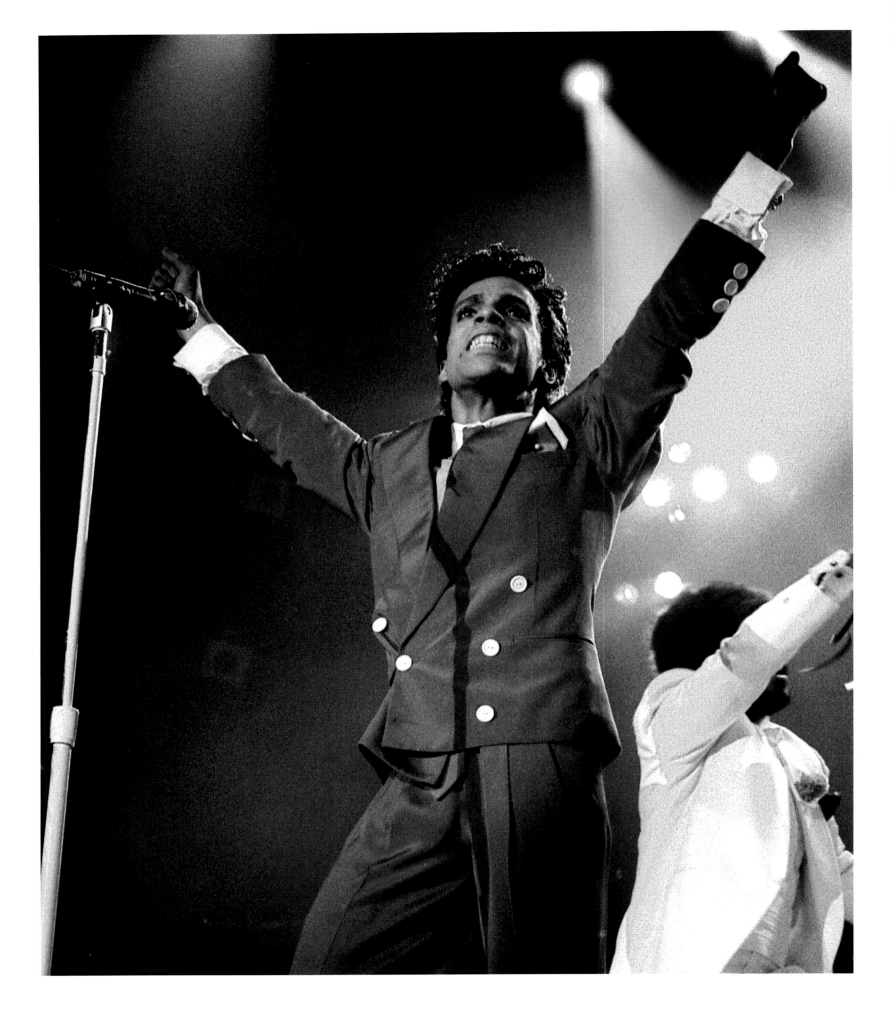

PRINCE
WHAT'S IN A NAME?
Symbol or artist formerly known as, without a doubt he's one of the greatest
performers, each tour has been awesome. Great mover.

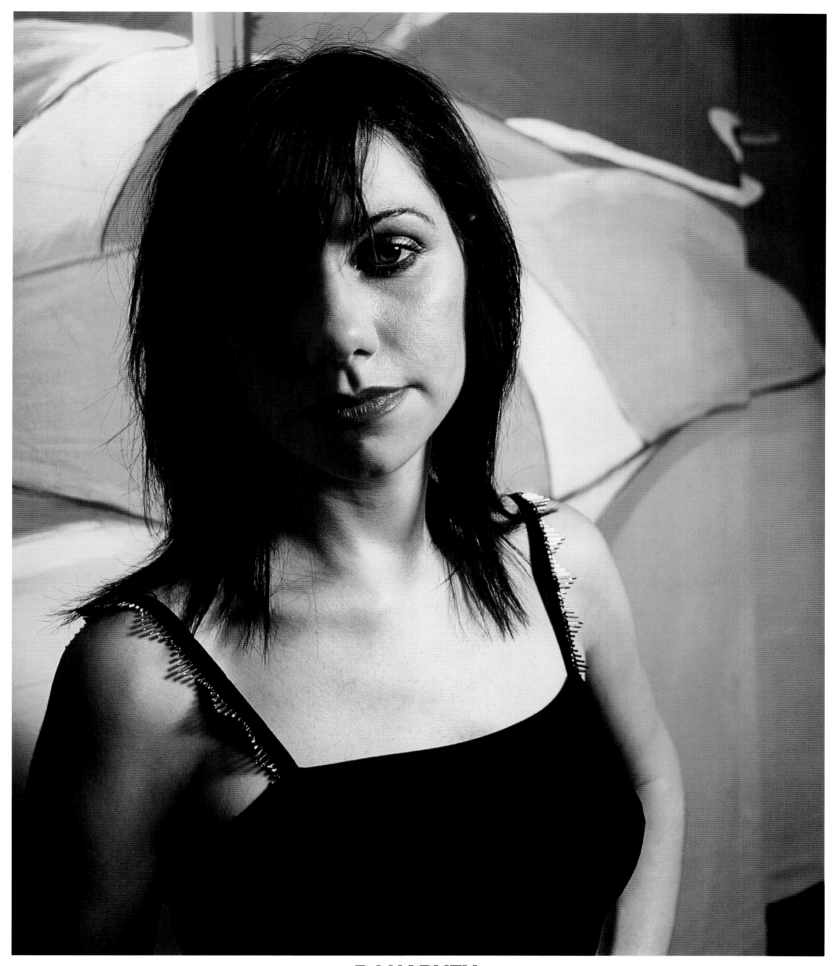

PJ HARVEY
MYSTERIOUS BEAUTY
Got to say it's an absolute pleasure to witness PJ either on stage or in a session.
One of the great performers with a mysterious beauty in as much as she's not the
greatest looking, but uses all her sassy and sensual being to produce one hell of a
sexy lady (badly explained but hopefully you get what I mean).

RAGE AGAINST THE MACHINE
MELBOURNE ALLEY

Spent three weeks organising this shoot with questions and answers going back and forth between myself and the band's management about what and where and why we were going to photograph the band. On the day of the shoot the band seemed oblivious to the previous bureaucracy, and would do anything I wanted. Ended up in an alley just around the corner from the hotel.

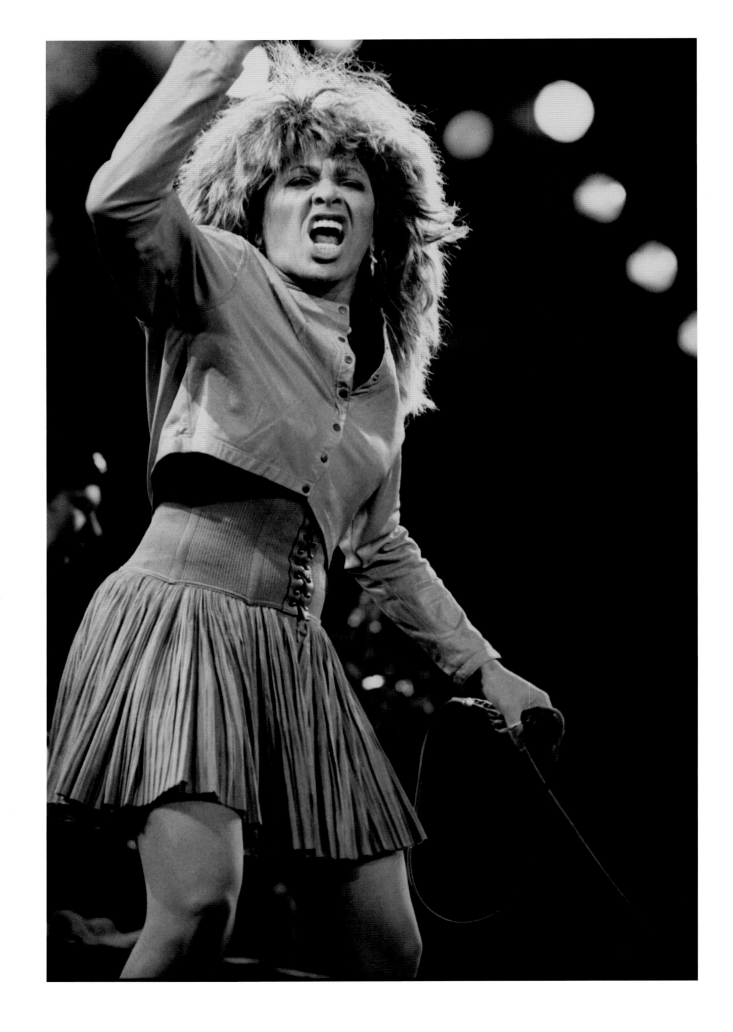

TINA TURNER
GRANDMA OF ROCK
Strange staggering mover on stage but entertaining.

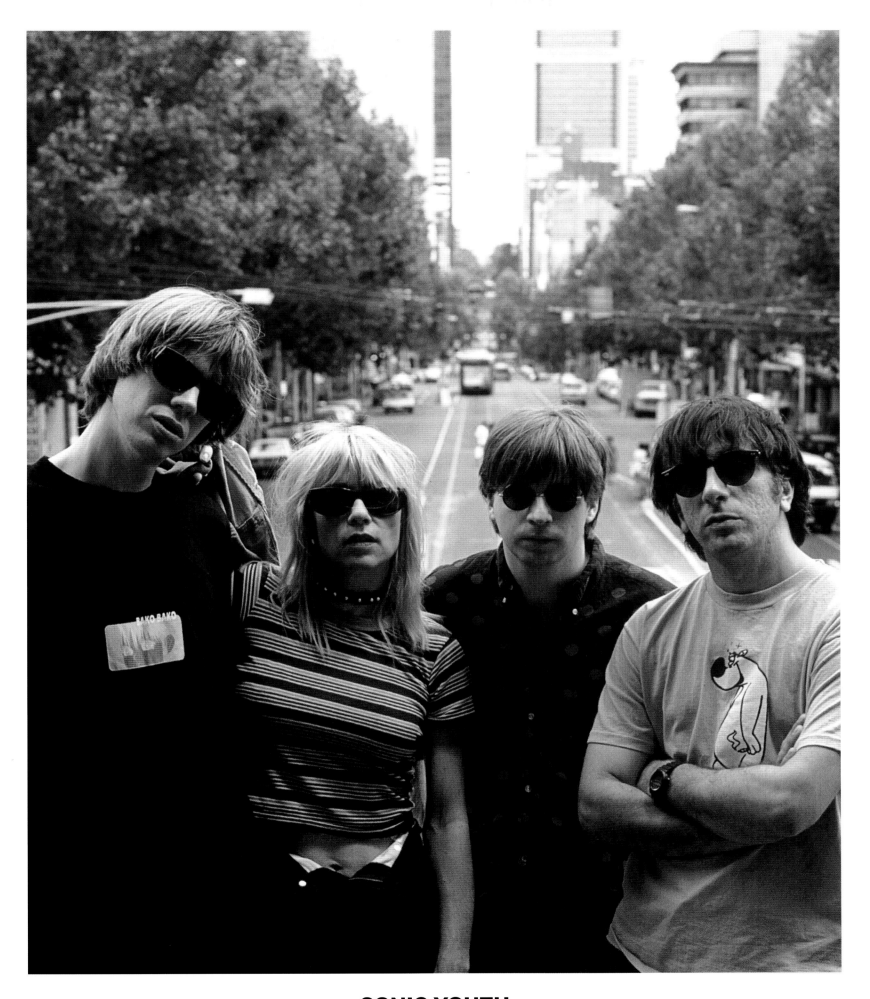

SONIC YOUTH
DOESN'T GET ANY COOLER
They really are the coolest band on earth. Kim Gordon is a hero to so many up and
coming female musicians. She had a great trick during photo session: as you got close
to her on went the shades, the further you got away they would be removed.

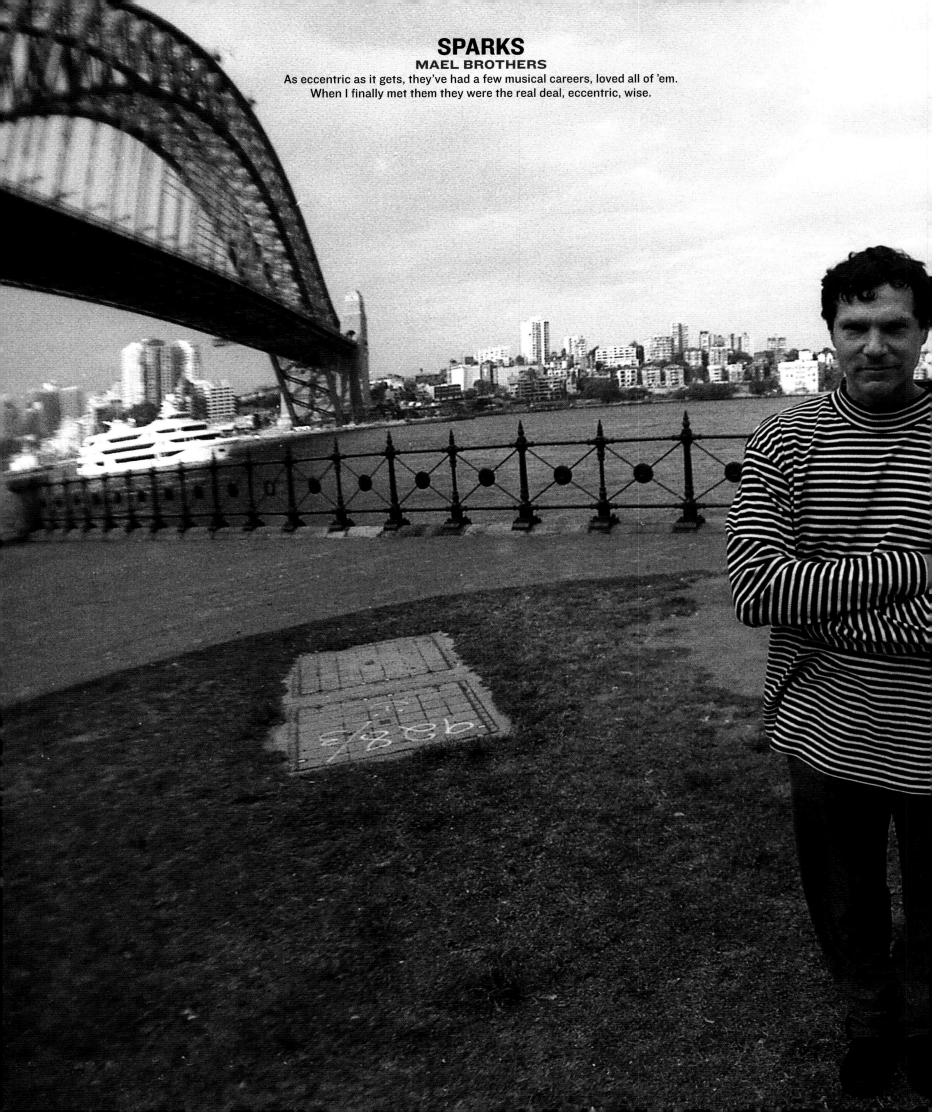

SPARKS
MAEL BROTHERS
As eccentric as it gets, they've had a few musical careers, loved all of 'em.
When I finally met them they were the real deal, eccentric, wise.

RICHARD THOMPSON
SHOOT OUT THE LIGHTS
Hell of a career spanning many decades from Fairport Convention to duo with
wife Linda, and a solo career. A wonderful guitarist and great songsmith.

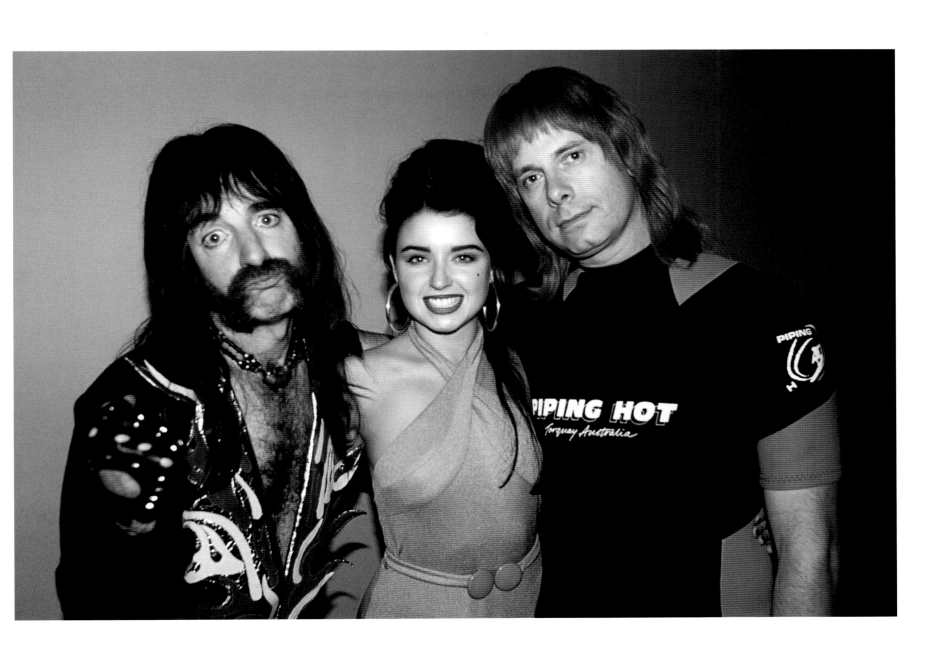

SPINAL TAP & DANNII MINOGUE
STRANGE COMBINATION
Spinal Tap came out to Australia for the ARIA awards and everyone, and I mean
everyone, wanted to have their photograph taken with them. I thought Dannii
was the least likely to be published but a metal magazine did. Too funny.

WHAM
I'M YOUR MAN
How did the public not see George's leanings?
Where is Andrew Ridgely now? Love George's
sense of humour sending the media and himself up
in both video and guest appearances on "Extras".

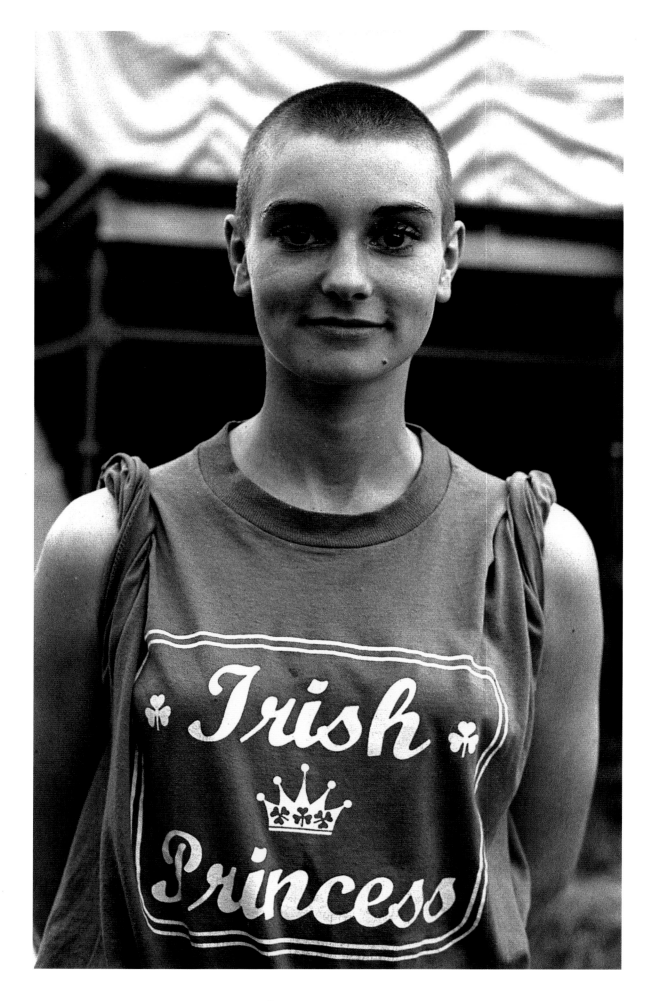

SINÉAD O'CONNOR
IRISH PRINCESS
Looking angelic backstage at Glastonbury, as opposed to the
Pope-picture-ripping devil on primetime American TV.

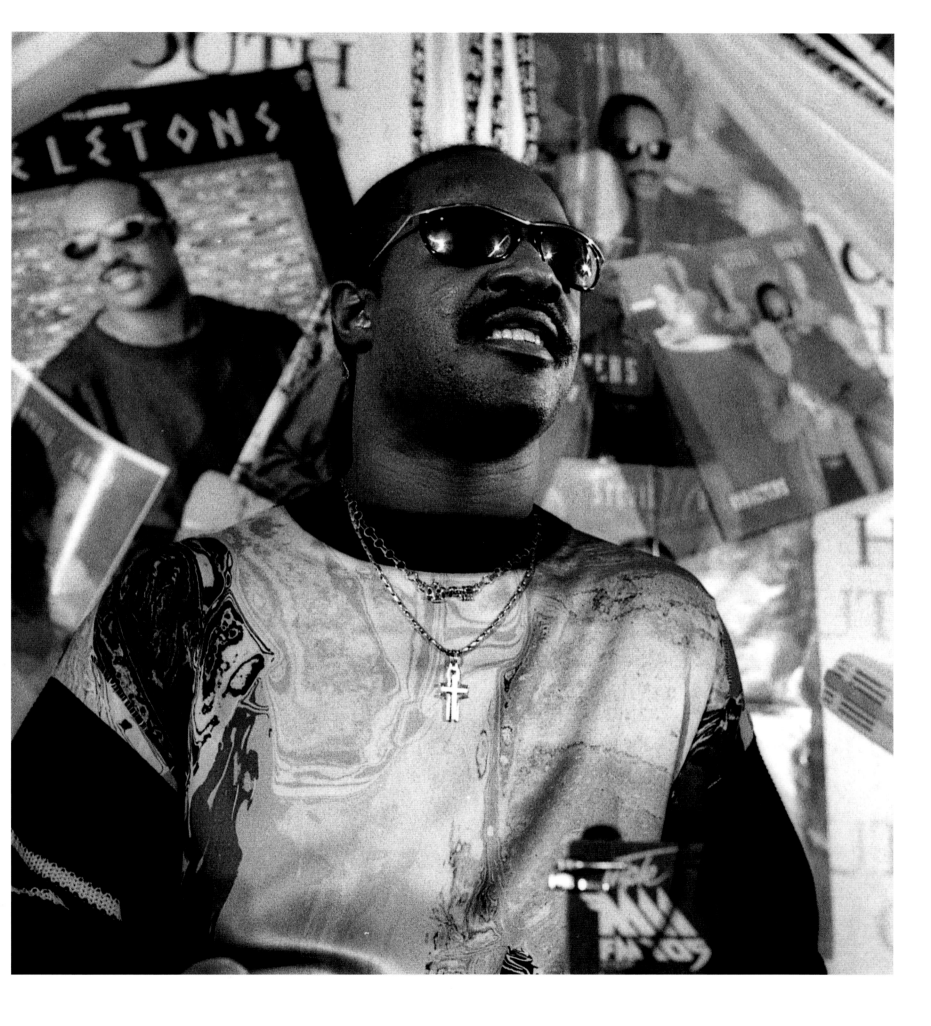

STEVIE WONDER
MASTERBLASTER
At a press conference at the Sebel, Sydney.

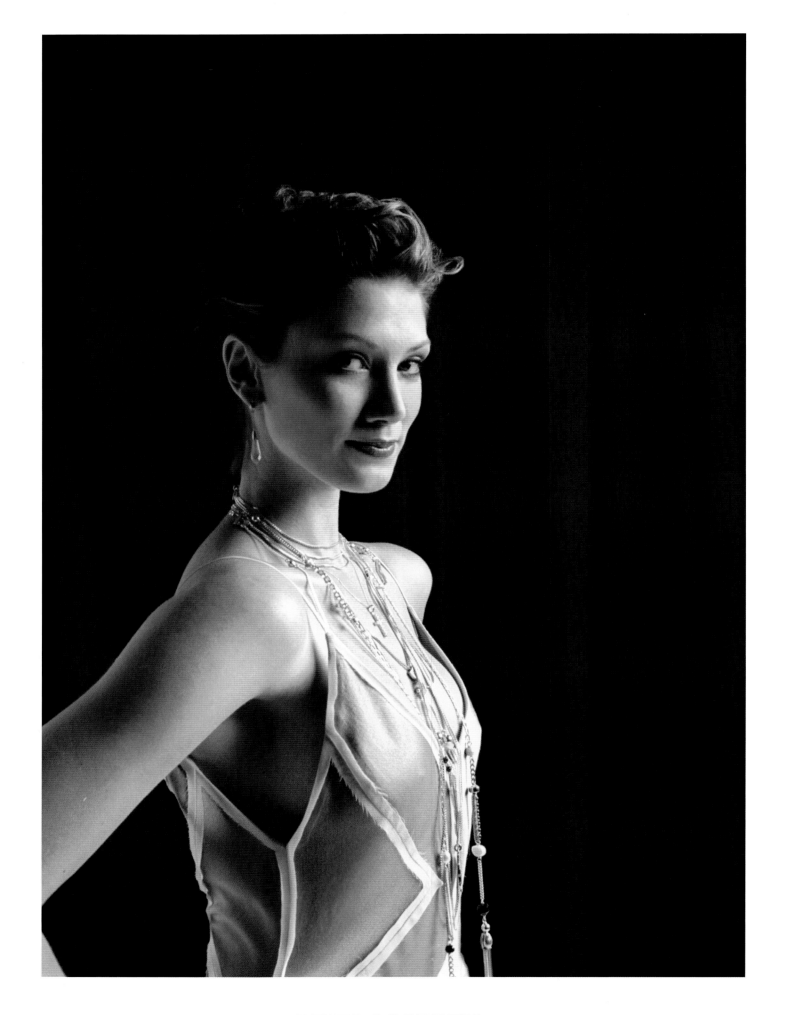

DELTA GOODREM
DELTA BABY
Taken backstage at the ARIAs in about 20 seconds flat. She just looks great
and it would be difficult to take a bad picture of her. Can't say I love her music.

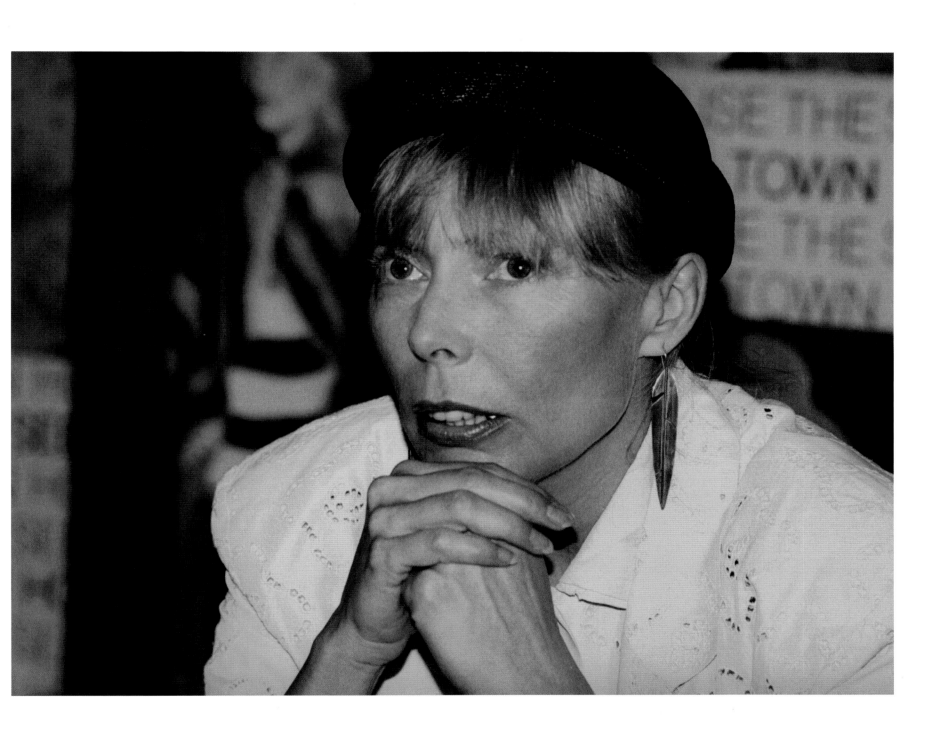

JONI MITCHELL
BLUE

Hated what she was wearing (a baggy white gown that was very unflattering)
and witnessed her 24 hours later performing in a beautiful blue velvet gown.
An amazing artist, she got her guitar from her hotel room and played three
songs for about half a dozen very privileged hacks.

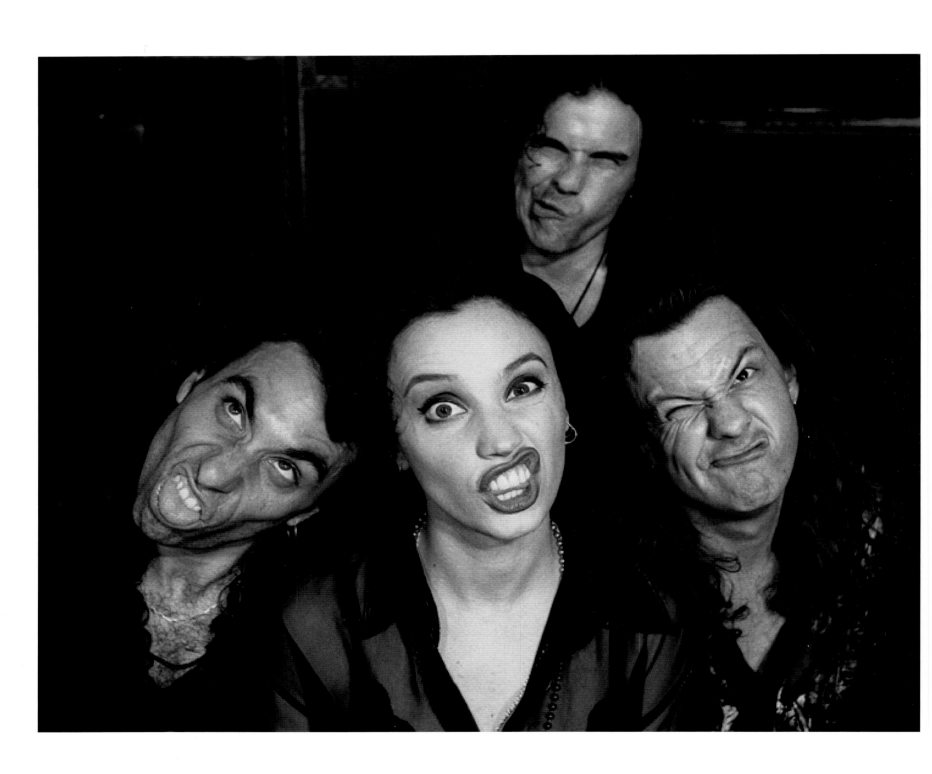

BABY ANIMALS
NOW THAT'S A LOOK
This frame was taken at the end of a session and has never been
published. Just love the spirit of Suzie and the boys and personally
this says a lot about them.

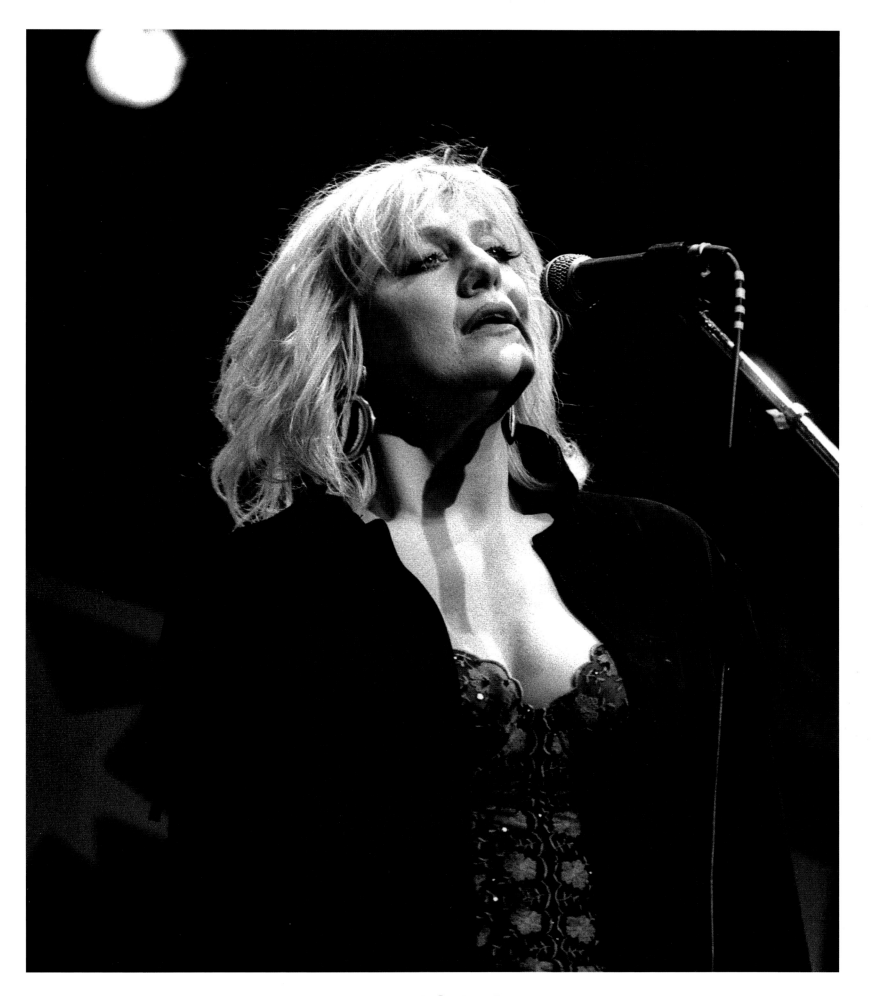

RENEE GEYER
HEADING IN THE RIGHT DIRECTION
Well maybe not in the right direction, despite her eccentricities there's
no denying this lady's vocals. Would highly recommend her gigs, this was
shot on the Australian leg of Live Aid.

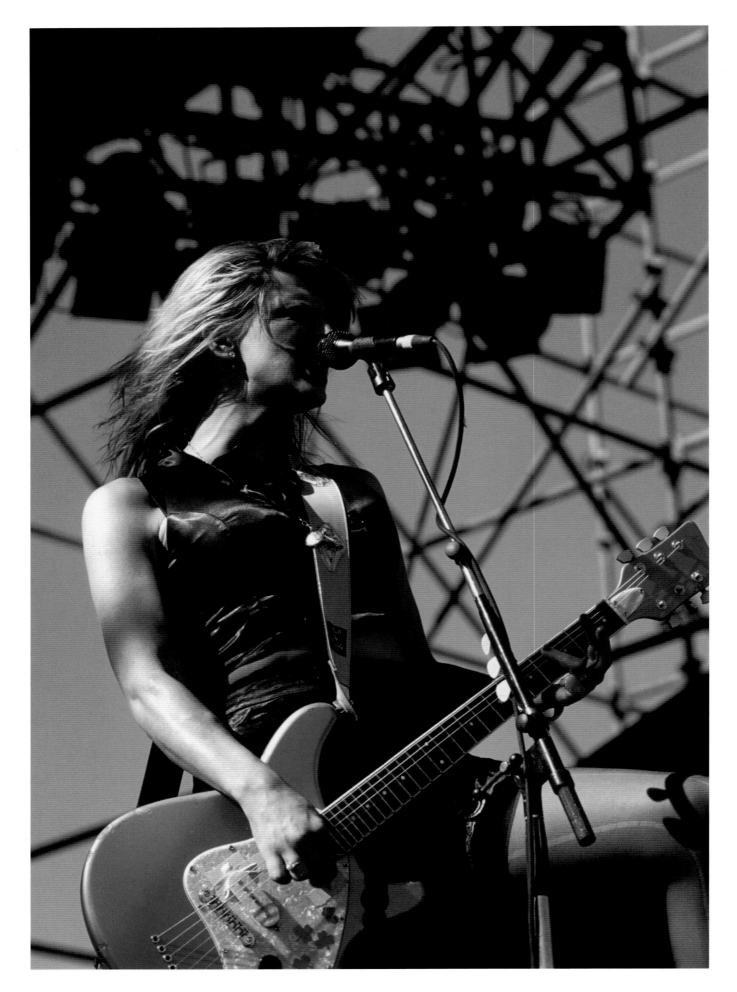

HOLE
KURT'S OTHER HALF
Bloody hell, genuine scary person. Nice as pie one minute, a screaming banshee
the next, with no logical reason for the change. Spent a Big Day Out tour
causing mayhem, too many stories to mention. My advice? Keep your distance.

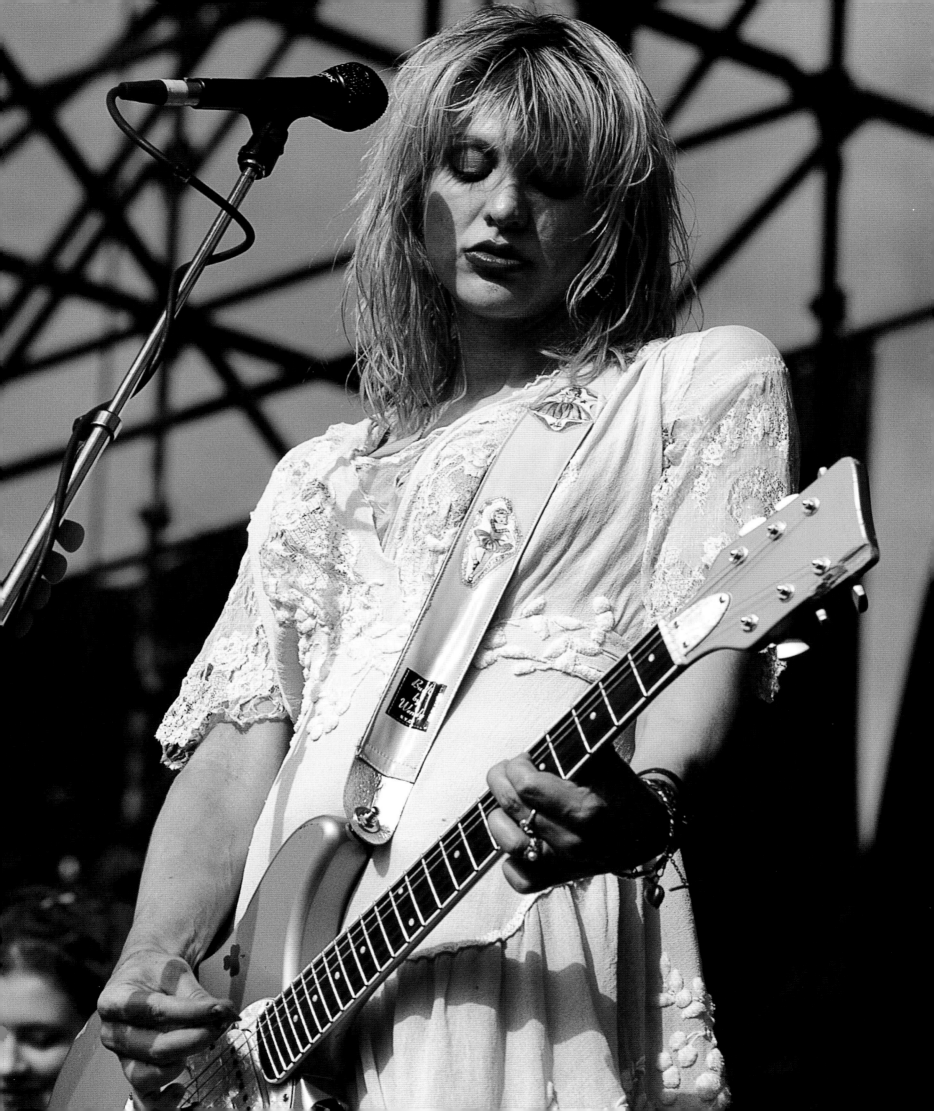

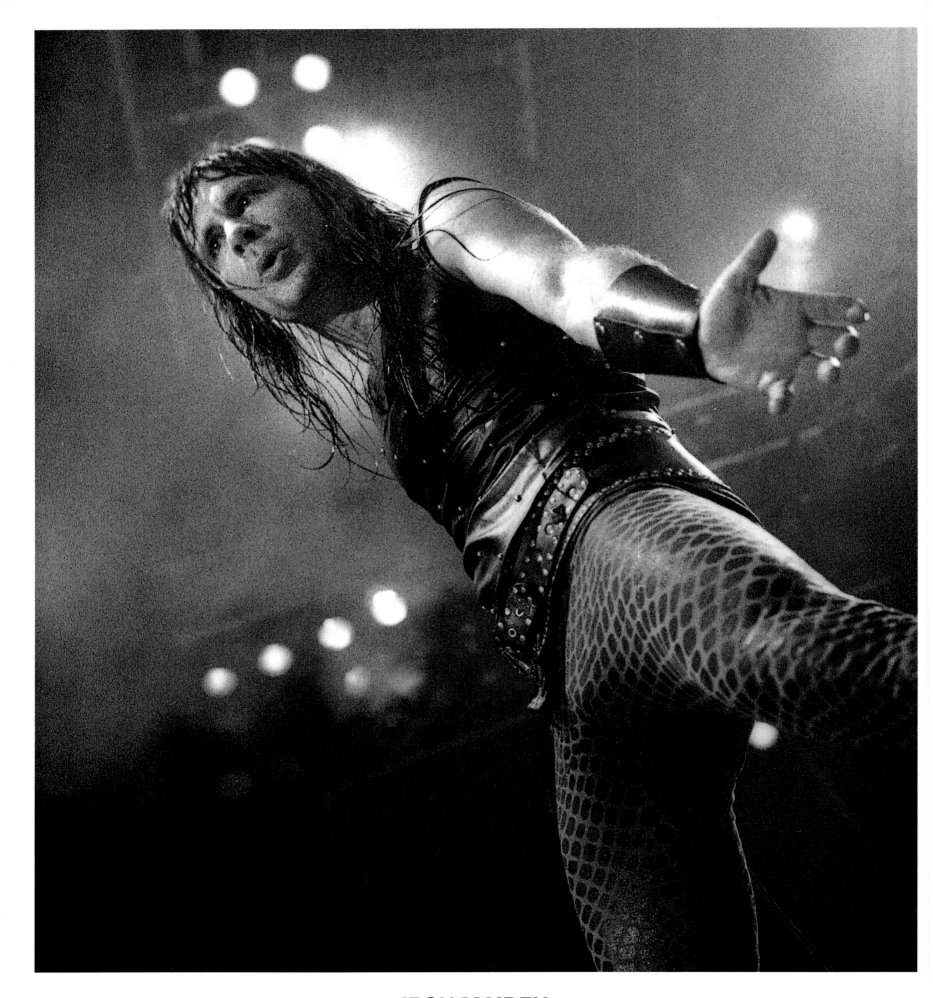

IRON MAIDEN
747 PILOT
Bruce Dickinson, the lead singer of Iron Maiden. Hard to believe
that, when not strutting his headbanging stuff on stage, Bruce is a
747 pilot and an Olympic grade fencer.

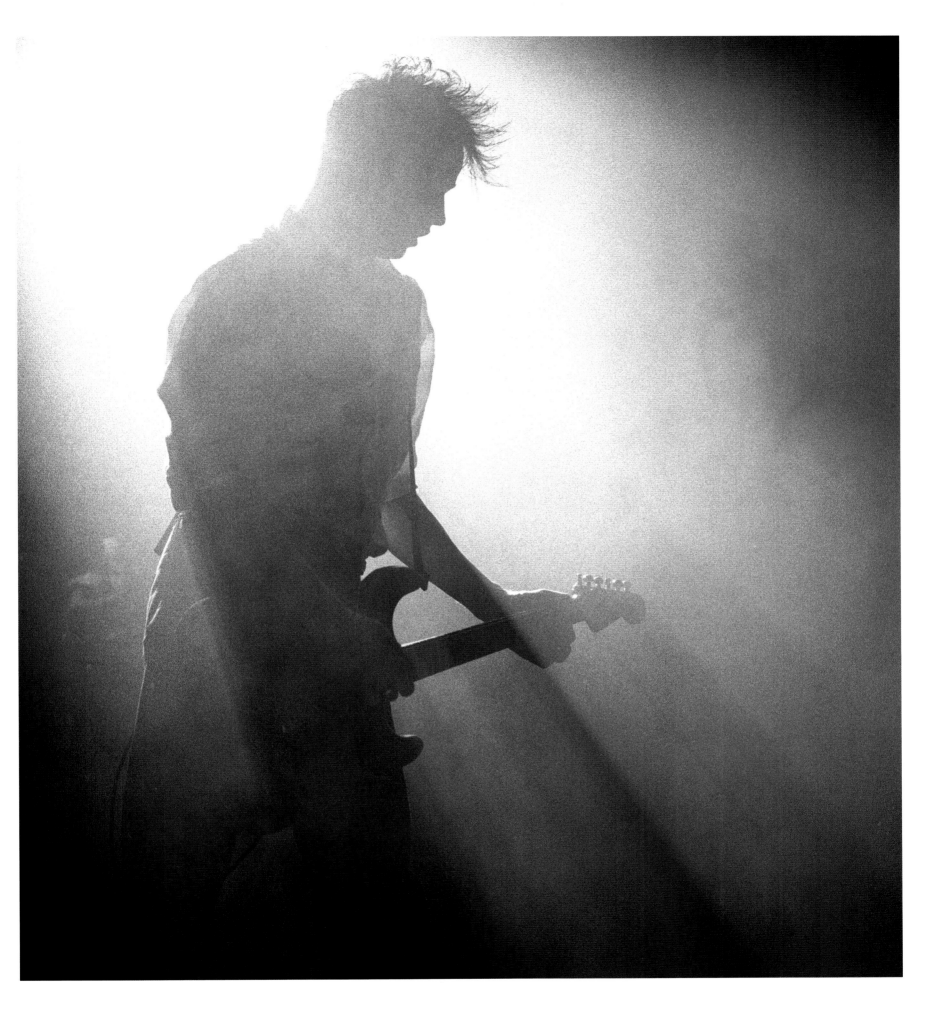

DIESEL
WHAT'S IN A NAME
From the Injectors to Mark Lizotte and back to Diesel. Great guitar work
and had a real groove going. Produces fine albums on a regular basis.

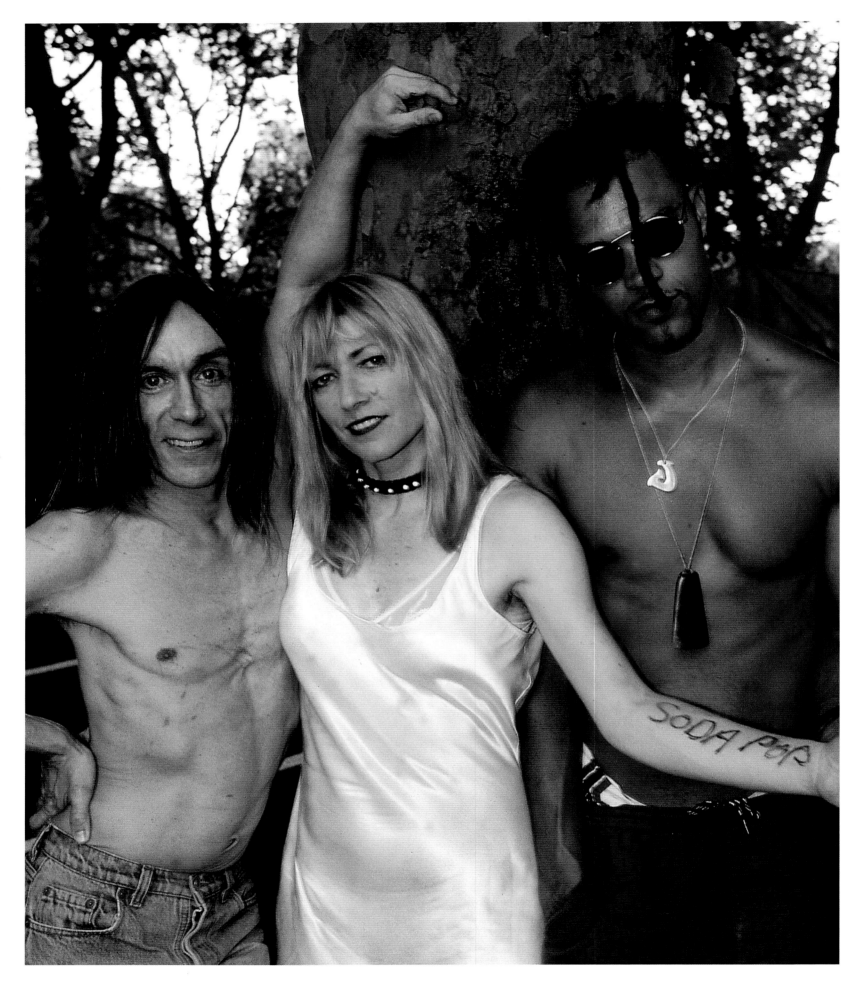

IGGY, KIM & MICHAEL
MELODY MAKER

Taken for the cover of UK music magazine *Melody Maker* on the first touring Big Day Out in Adelaide 1994.
Very exciting tour and the combination of Iggy Pop, Kim Gordon and Michael Franti was pretty special.
Taken immediately after Iggy and Kim had left the stage.

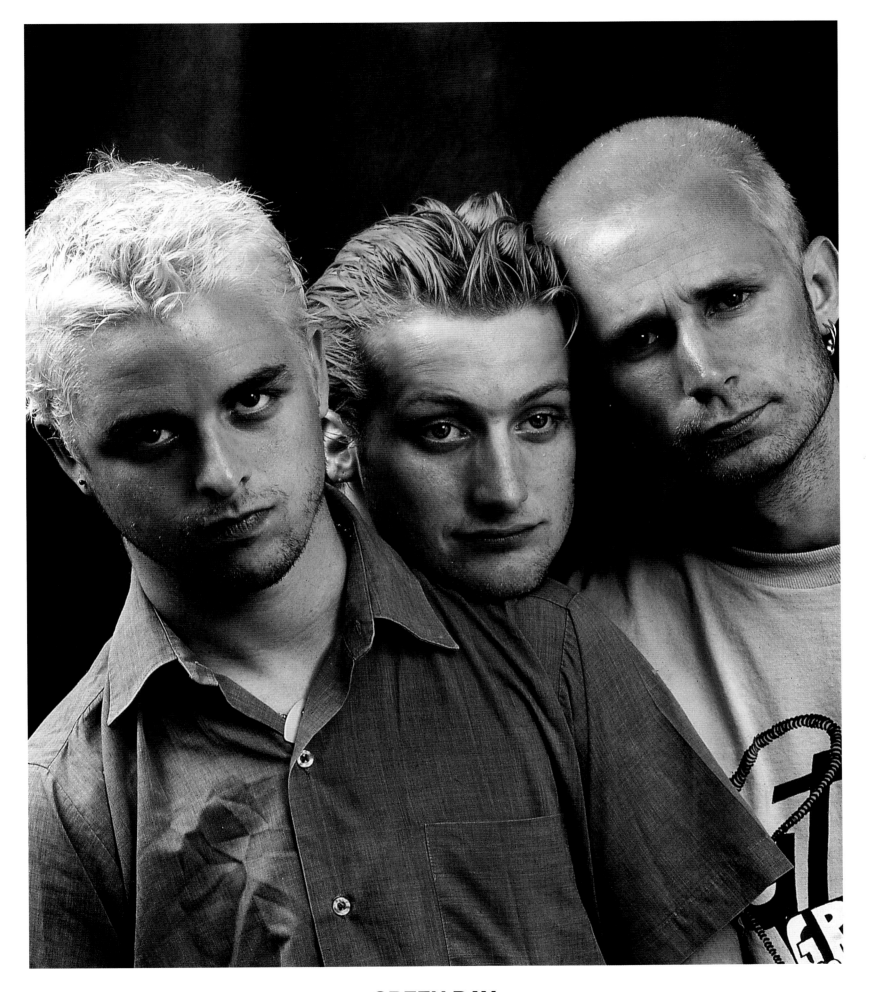

GREEN DAY
HAVIN' THE TIME OF THEIR LIVES

Punk band that ended up in a stadium, that in itself is wrong. A pleasure to work with, they have no problem
hamming it up for the camera. Taken in the blinding heat of a Brisbane summer. They were suffering from
sun burn, and it didn't help that the hair colour was bright and the faces red. On the other hand, perfect.

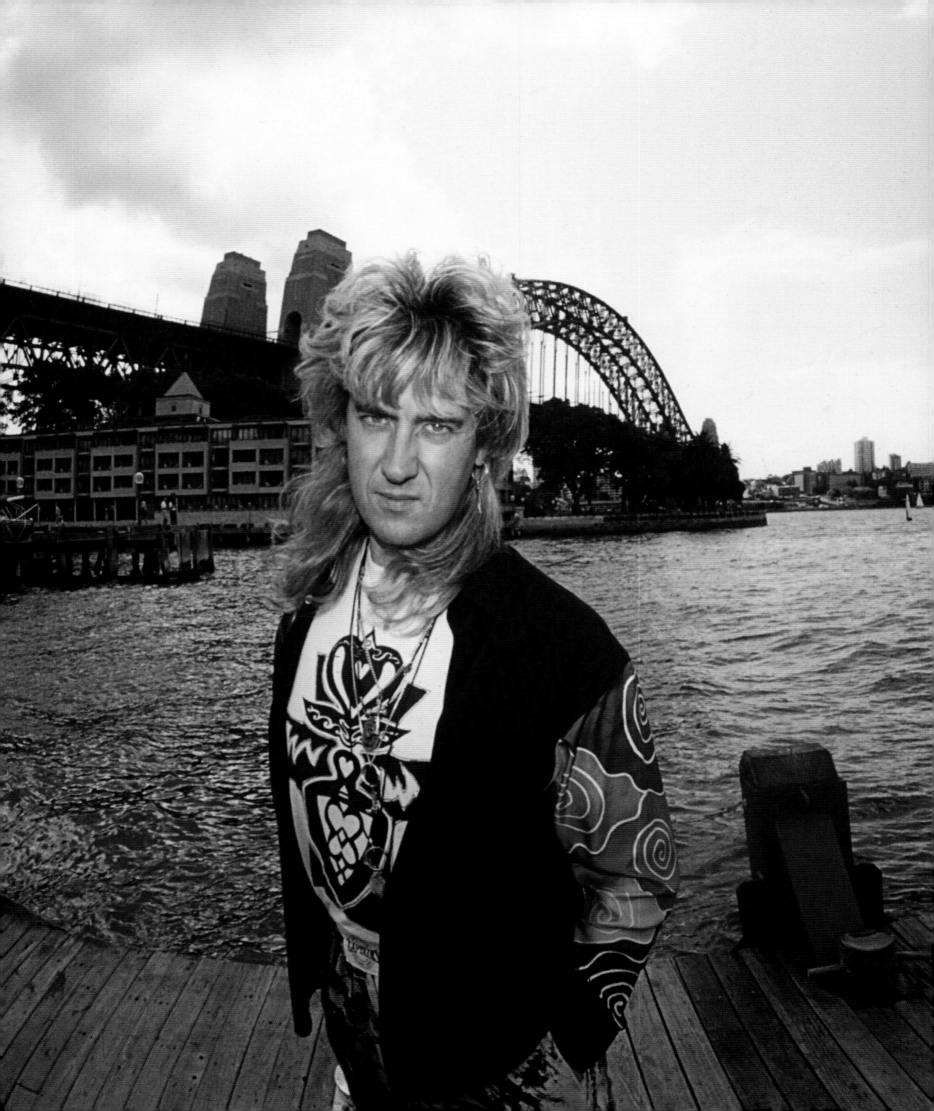

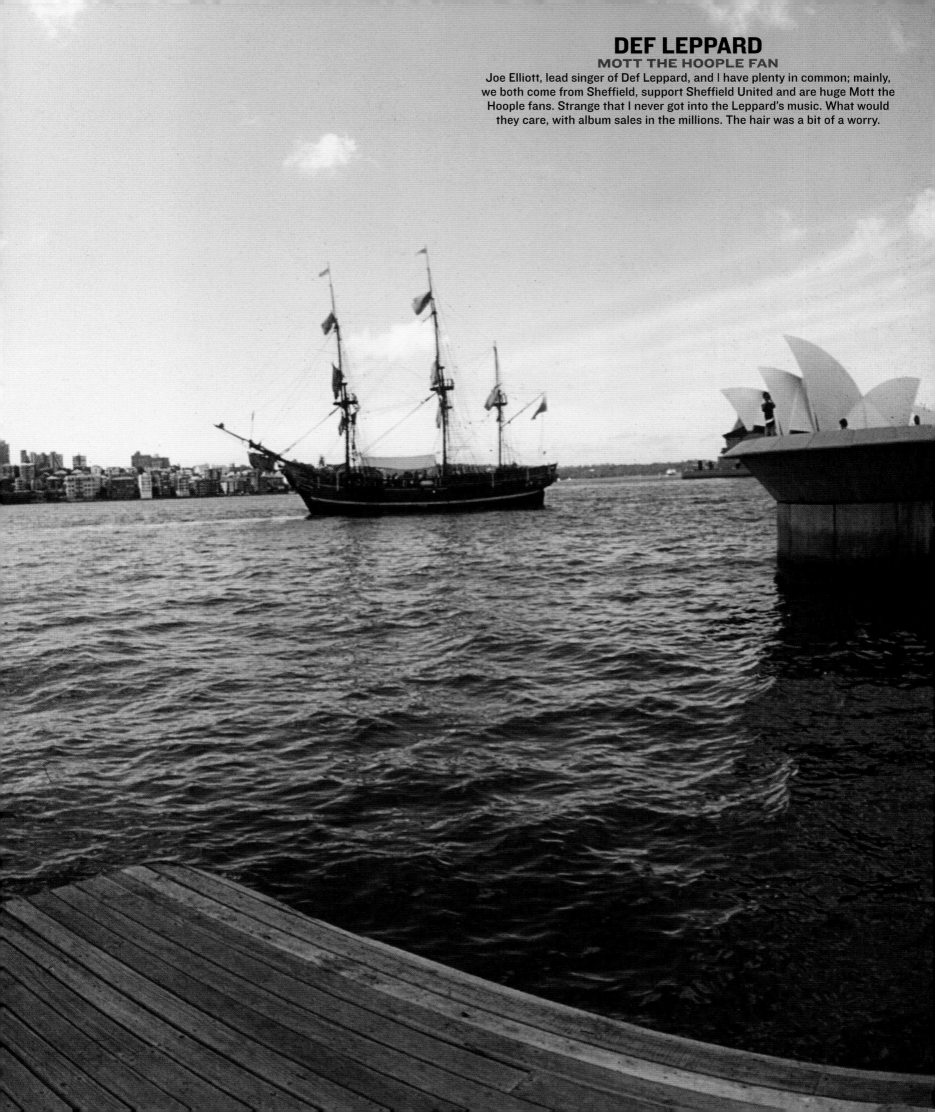

DEF LEPPARD
MOTT THE HOOPLE FAN
Joe Elliott, lead singer of Def Leppard, and I have plenty in common; mainly, we both come from Sheffield, support Sheffield United and are huge Mott the Hoople fans. Strange that I never got into the Leppard's music. What would they care, with album sales in the millions. The hair was a bit of a worry.

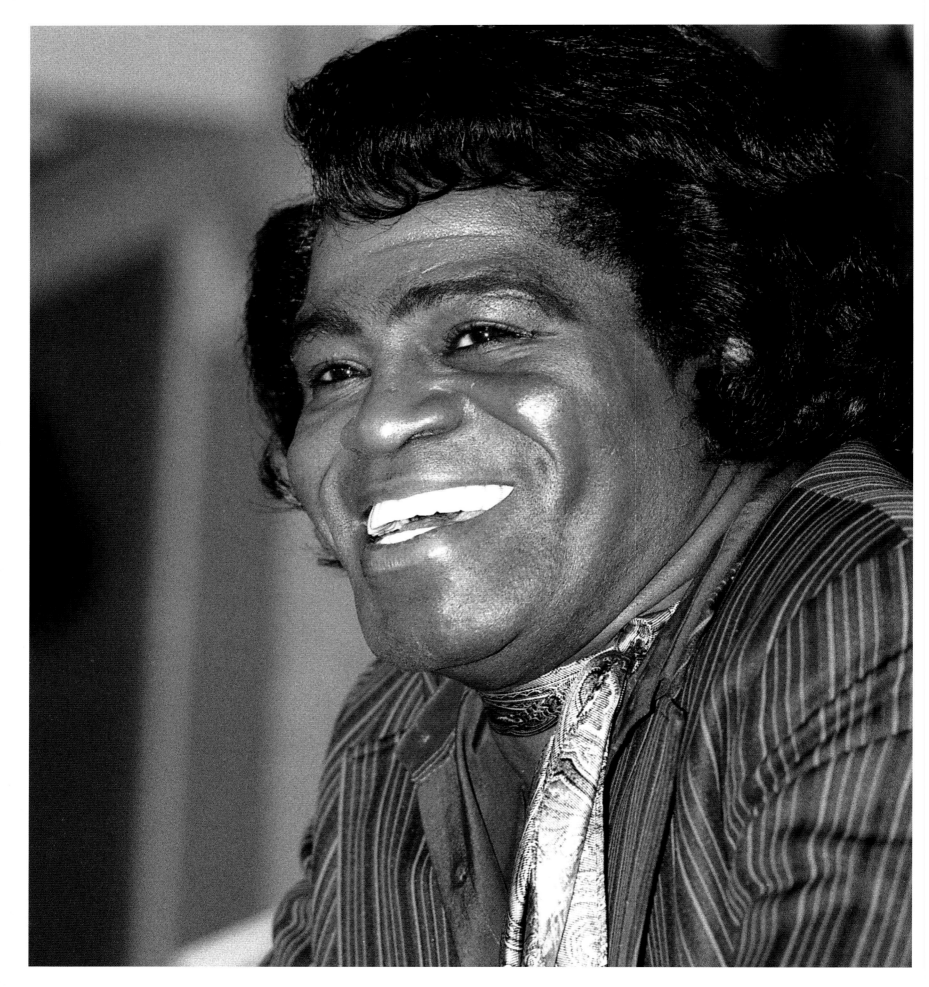

JAMES BROWN
JAMES BROWN, JAMES BROWN, JAMES BROWN
One of the biggest egos I've ever come across. Chanted his own name more than 100 times
during the concert. This is at a press conference at the much missed Sebel Townhouse
Hotel, the home away from home for overseas rock stars. The teeth are amazing.

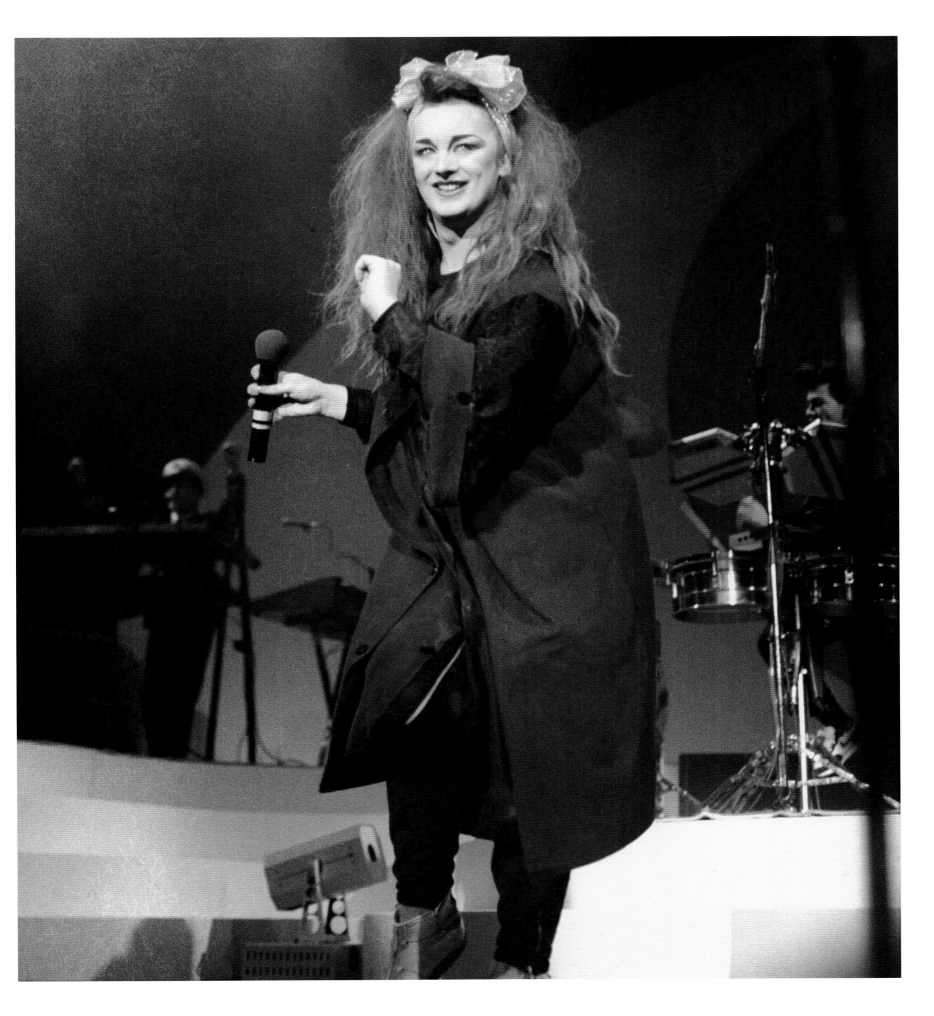

CULTURE CLUB
BOY GEORGE
First experience of teen worshipping, screaming was the order the day. It was
all downhill from here for George.

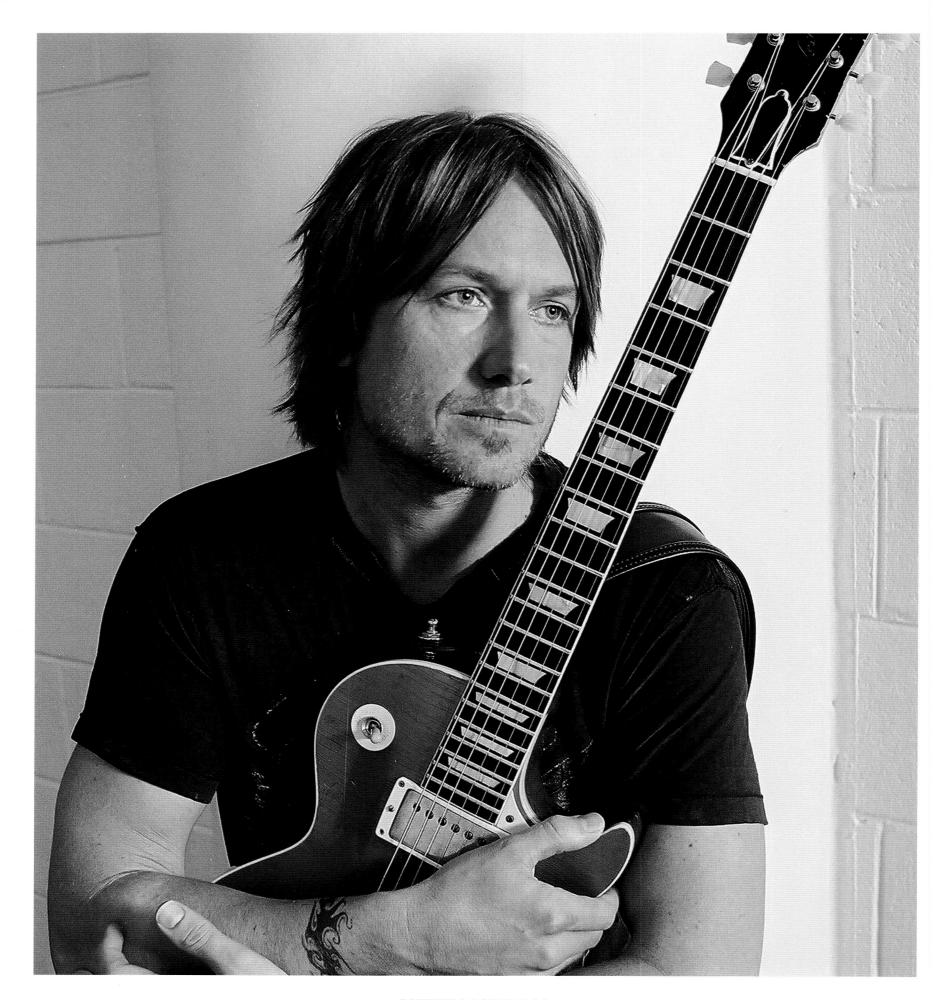

KEITH URBAN
BIG ACROSS THE POND

Taken on his 2008 tour after giving up substances, I opened up with the comment, "I could kill a beer" in his dressing room that was very dry. Oops. Huge career in the US that is not quite replicated back home. Doesn't seem unduly concerned. Who would?

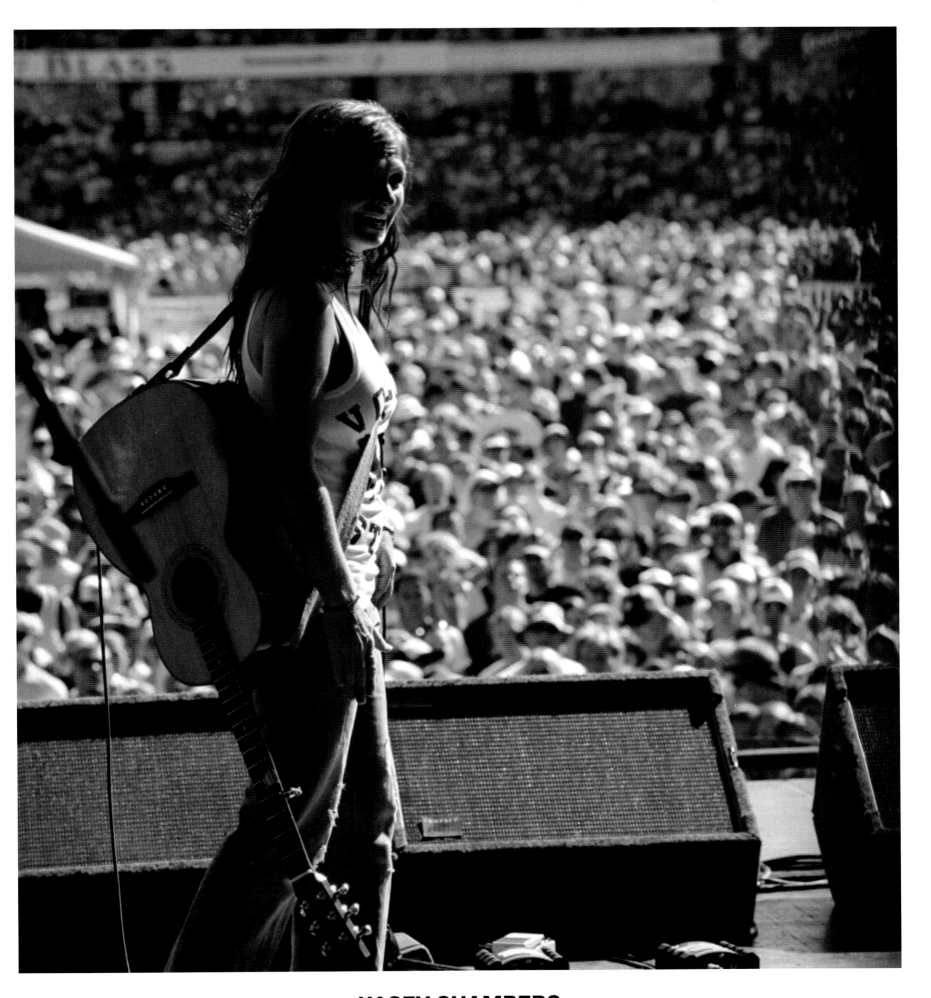

KASEY CHAMBERS
KEEP IT IN THE FAMILY

First photographed Kasey in the Dead Ringer band, including brother, mum and dad. When she went solo we received one of the best songwriters in the country. She's got the best smile in the business. She seems so wee amongst the packed SCG for the wonderful Wave Aid concerts.

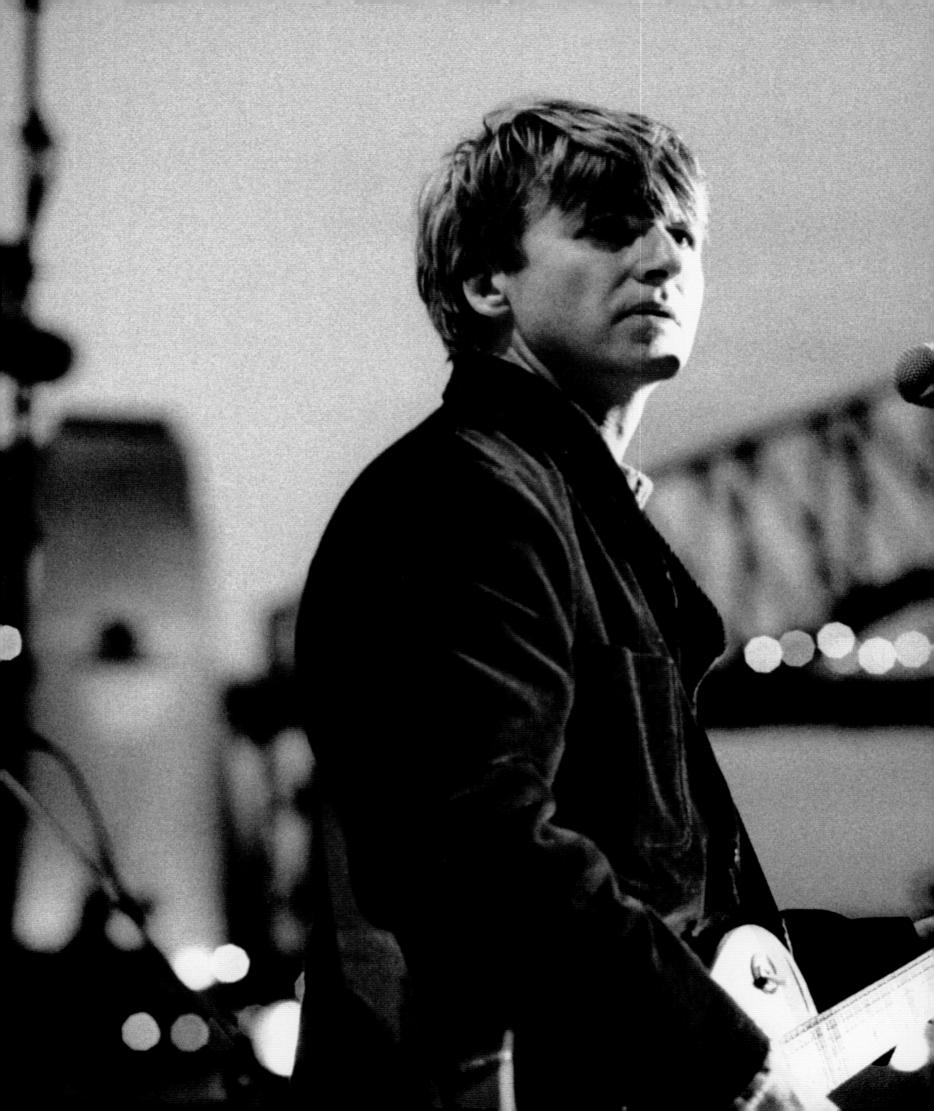

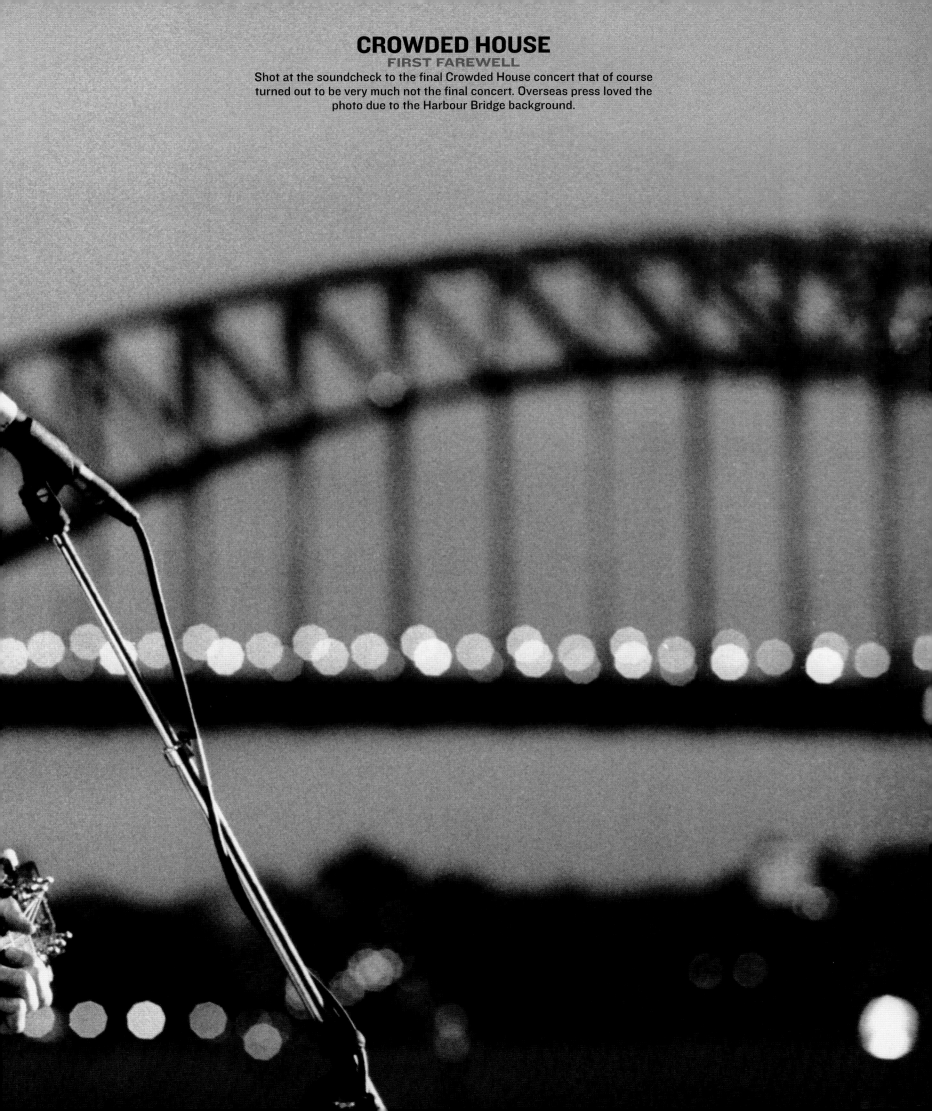

CROWDED HOUSE
FIRST FAREWELL
Shot at the soundcheck to the final Crowded House concert that of course
turned out to be very much not the final concert. Overseas press loved the
photo due to the Harbour Bridge background.

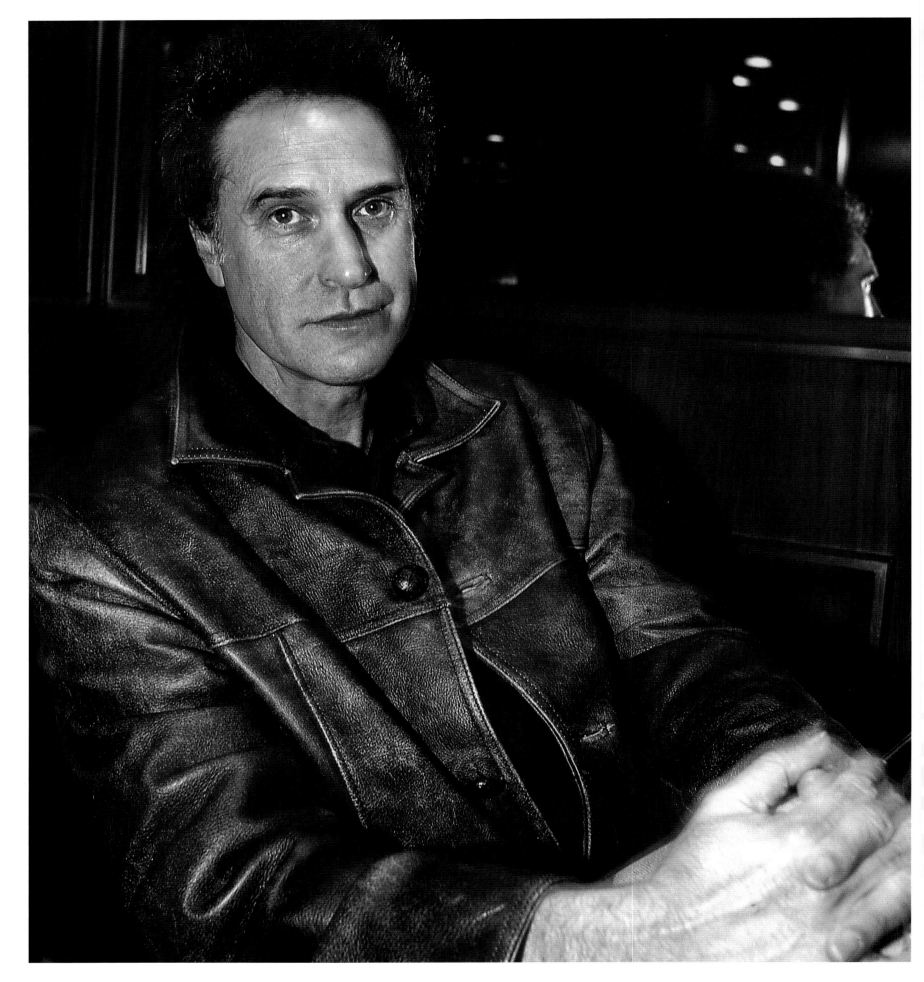

KINKS' RAY DAVIES
CHAMPION OF THE VILLAGE GREEN PRESERVATION SOCIETY
Ray Davies was very self effacing and unassuming yet he must be the most highly respected songwriter amongst his peers. You am I frontman Tim Rogers assisted me on this shoot for a chance to meeet his idol. We both spent a wonderful afternoon at his soundcheck.

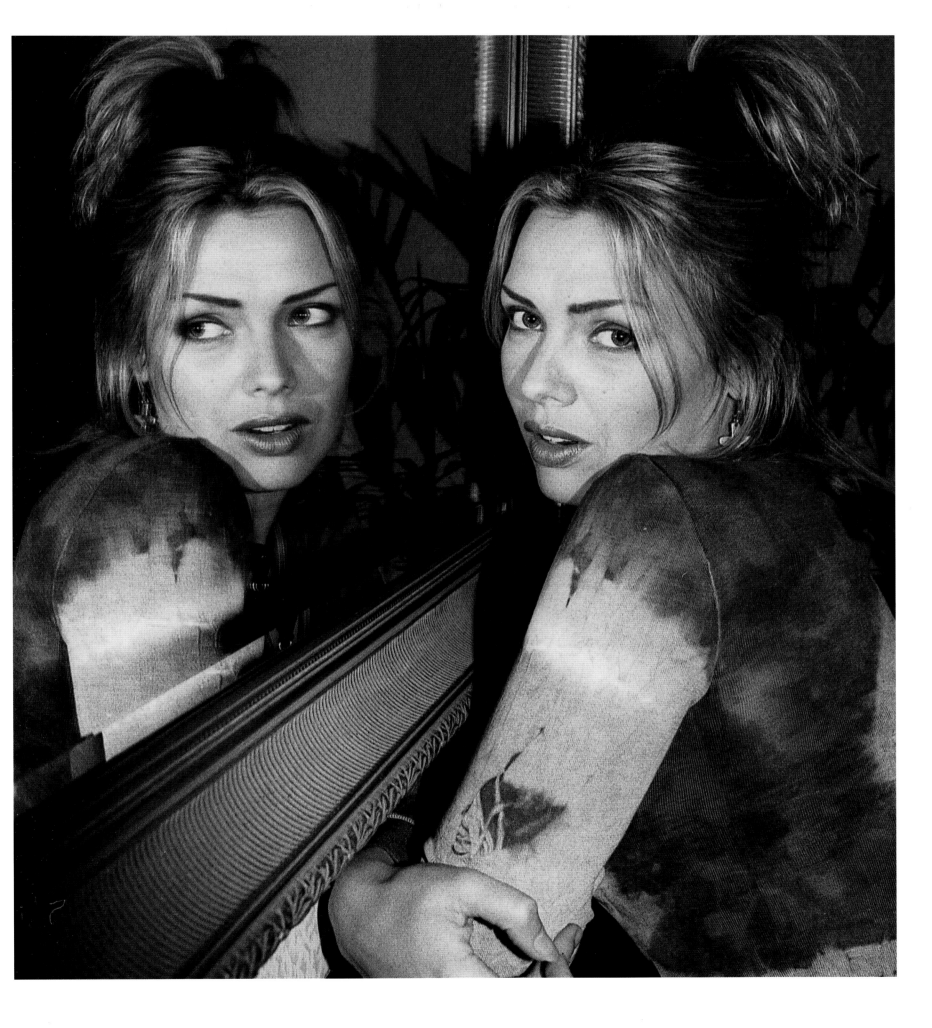

KIM WILDE
KIDS IN THE GARDEN
Lovely lady, ended up running a landscape gardening business.

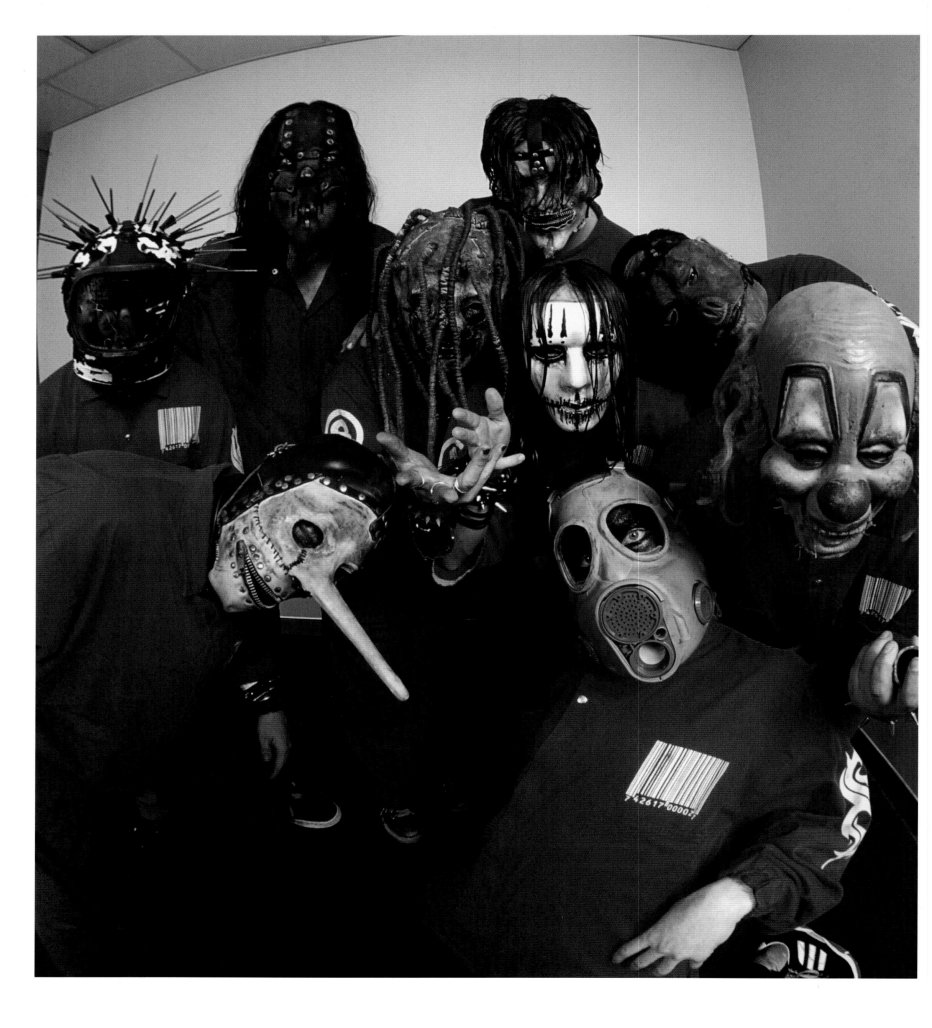

SLIPKNOT
WHAT YOU SEE IS WHAT YOU GET
Photographer's dream. I mean, look at 'em.

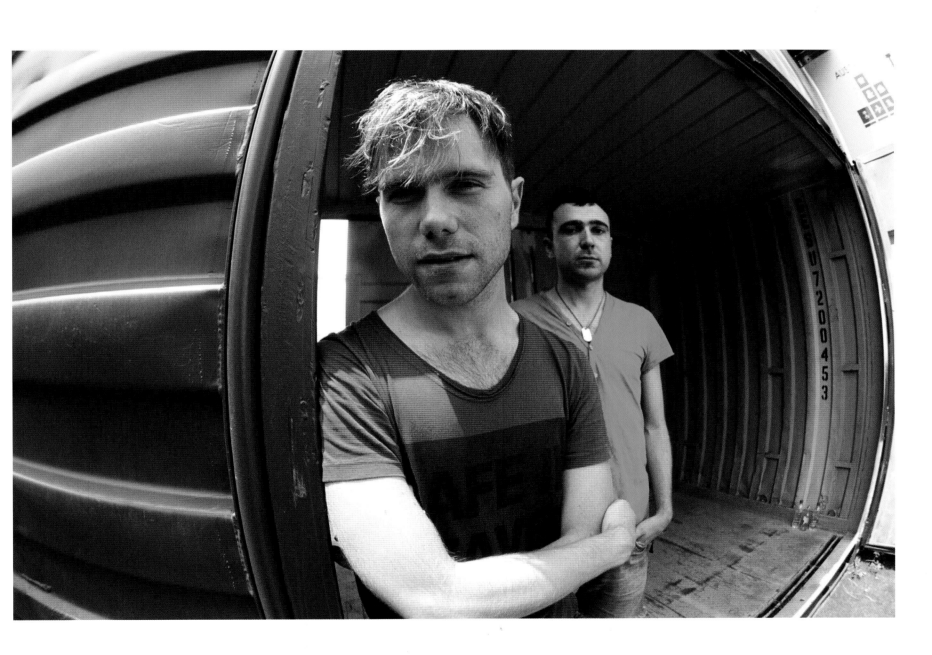

PRESETS
SO VERY WRONG
This photo couldn't be any more wrong. It totally doesn't fit their image or what
they are about, fish eye, unstyled, in a freight container, wrong, wrong, wrong,
that's why I love it. P.S. unpublished till now.

MARILYN MANSON
LIFE OF BRIAN
Introducing himself as Brian and presenting a box of various
contact lenses in different colours, he couldn't have been a nicer
guy. Don't look like any Brian I've ever known.

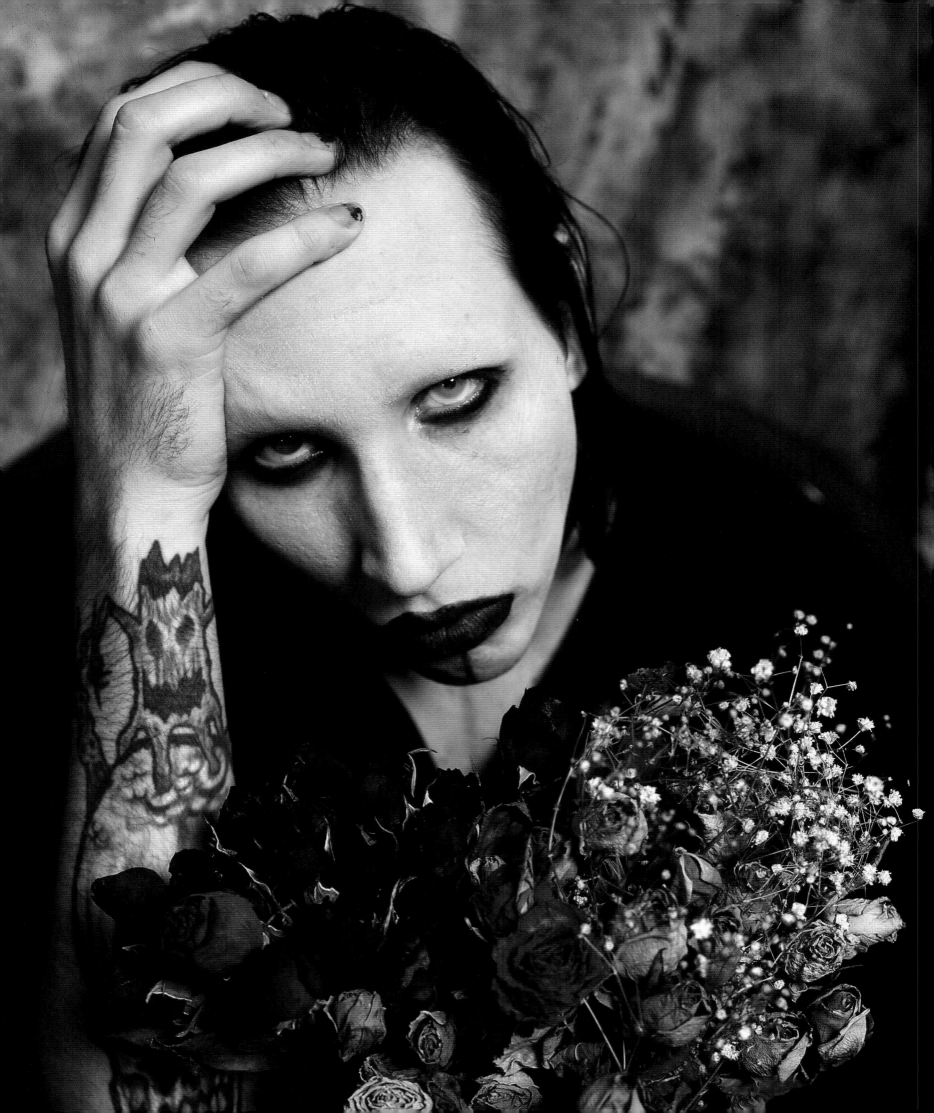

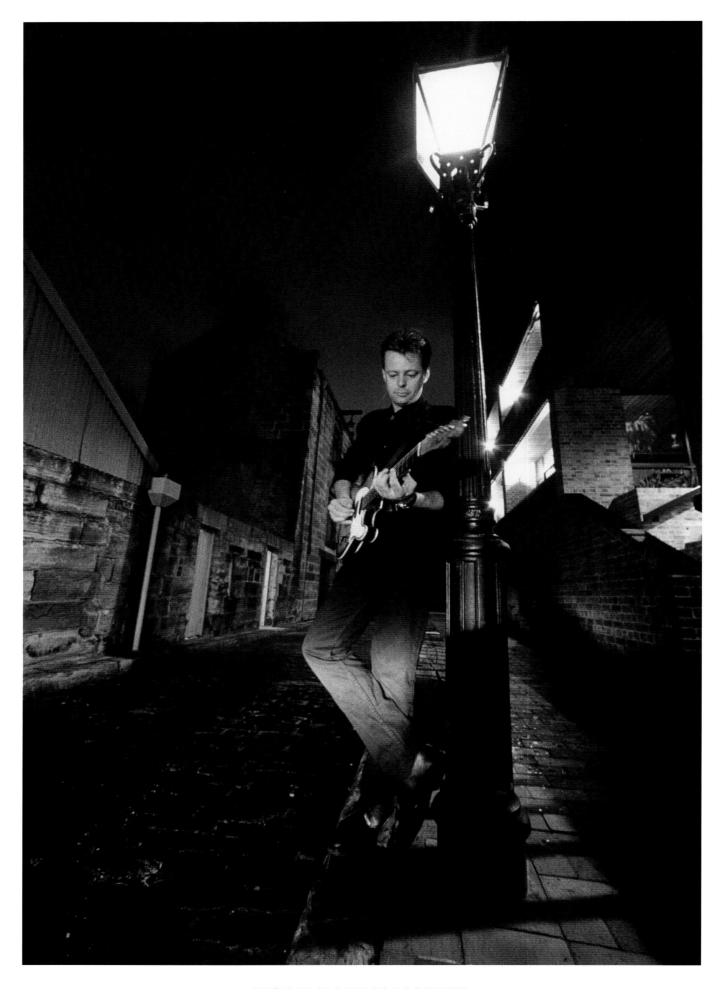

TOMMY EMMANUEL
STREETS OF OUR TOWN
Shot in The Rocks, Sydney. The record company hated the photo but, luckily
for me, Tommy liked it, so it was used and went on to be nominated for Album
Cover of the Year ARIA-wise.

RICHARD CLAPTON
RICHARD OF THE AVENUE
Shot in the back streets of Ultimo. An enigma of sorts, a great body of work.

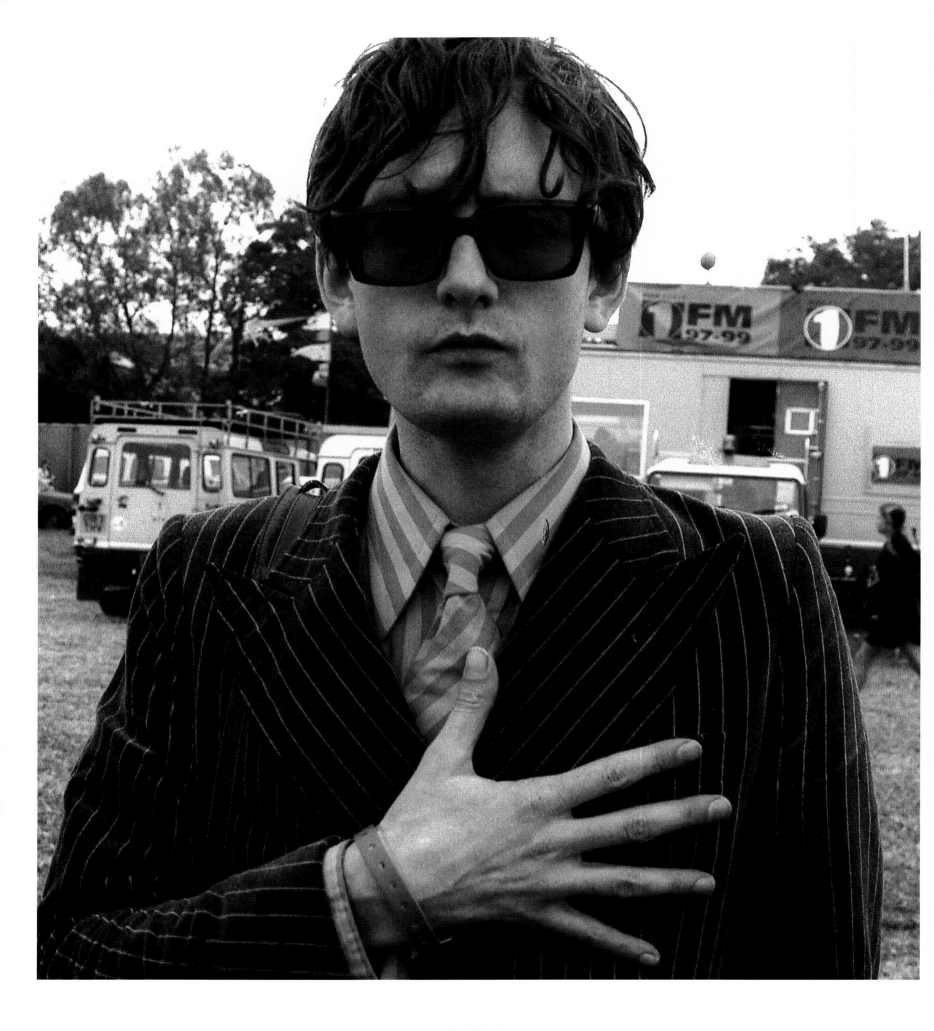

PULP
SHEFFIELD LAD MADE GOOD
Jarvis Cocker, an eccentric gentleman from my home town Sheffield.

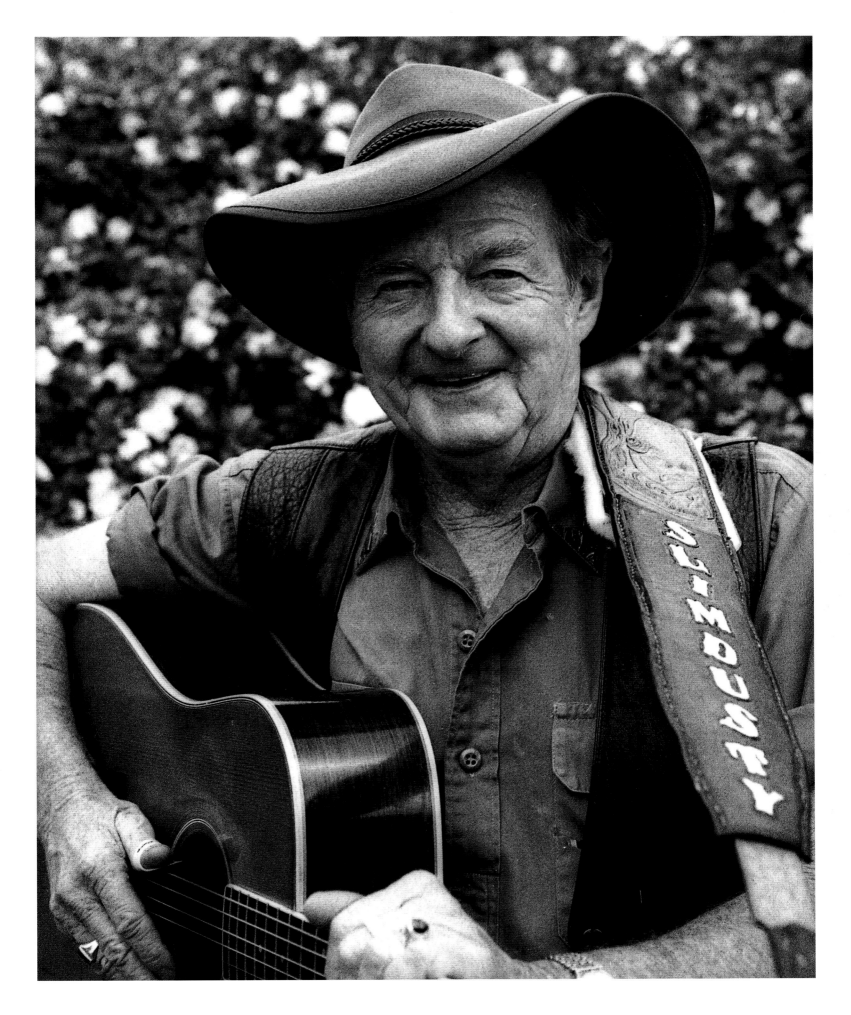

SLIM DUSTY
KING OF COUNTRY
Australia's first number one hit single in the UK, way back in the 50s with
"Pub with no beer".

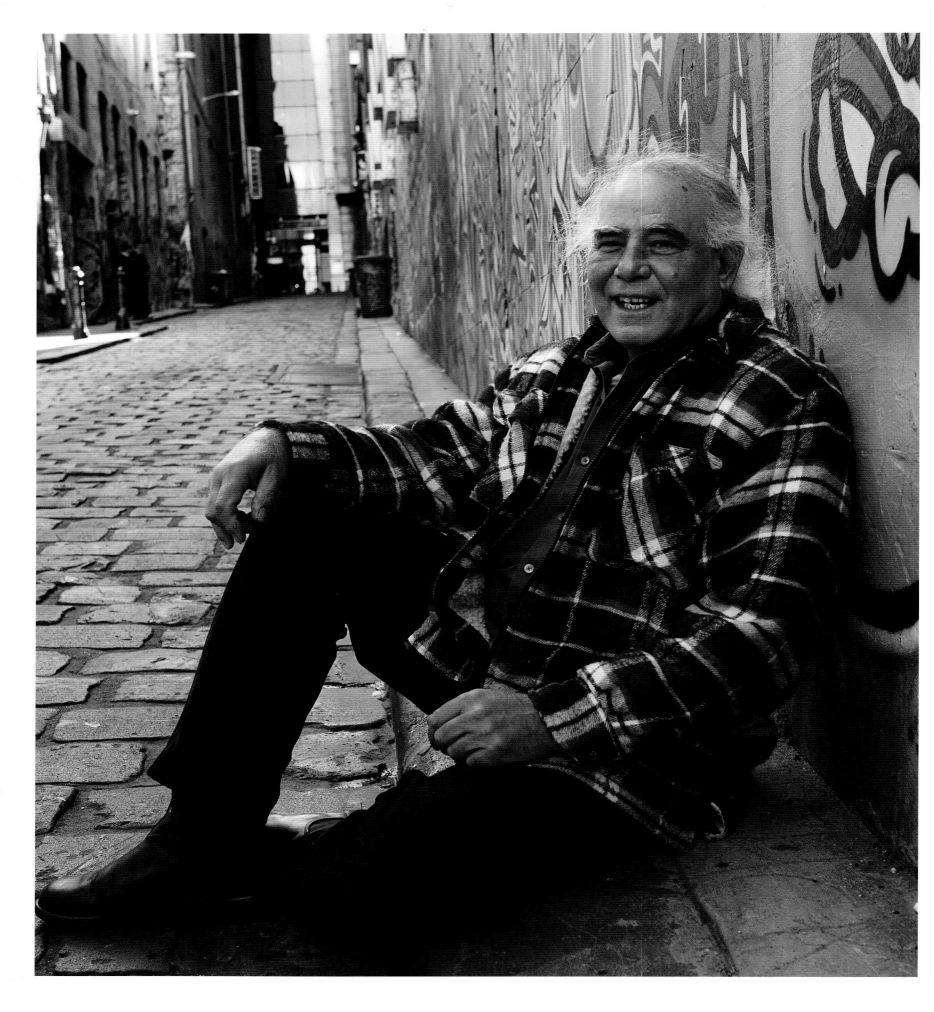

KEV CARMODY
BLACK DYLAN
Someone described Kev as the black Dylan, and I cannot argue with that. His
"Cannot buy my soul" tour was inspirational. A great lyricist.

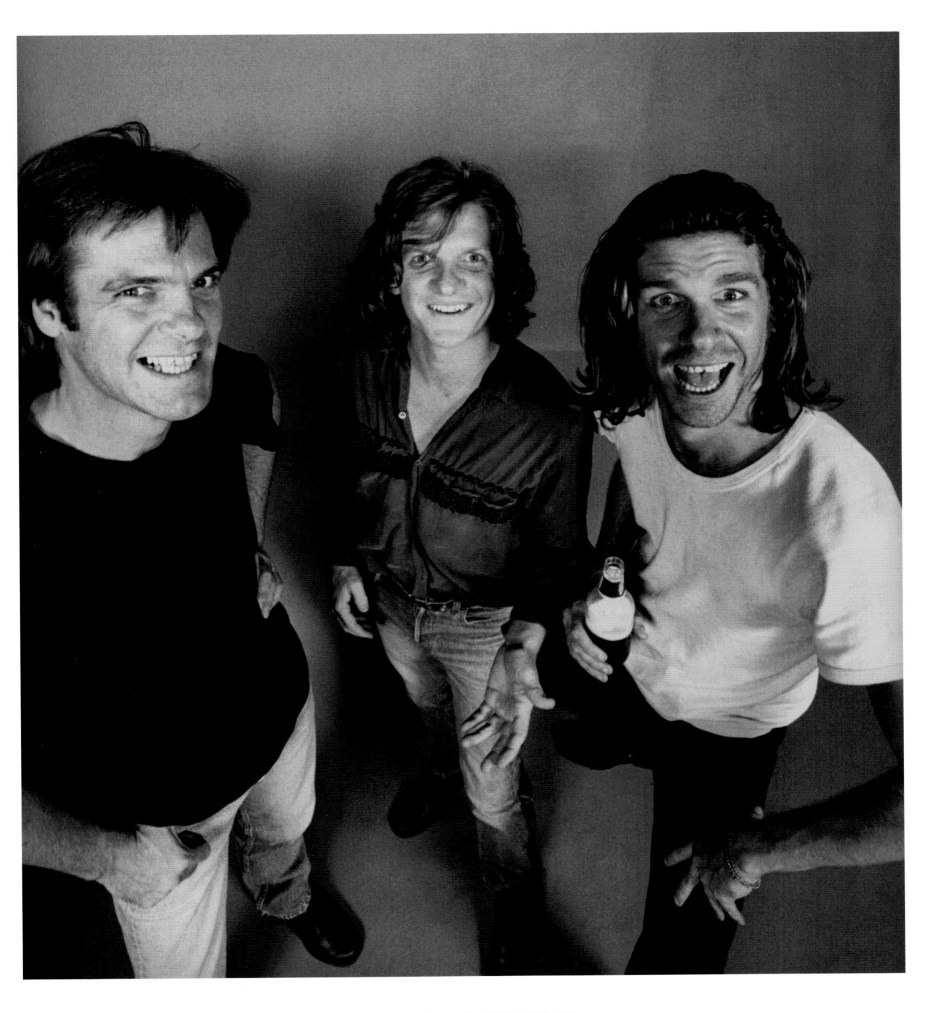

TEX, DON & CHARLIE
THE ODD TRIO
Love this photo because none of them are known for smiling in photos.
A genuine smile has to be just that. Love their albums.

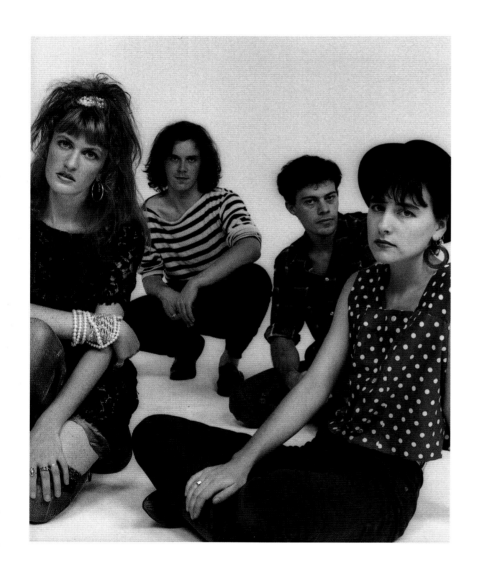
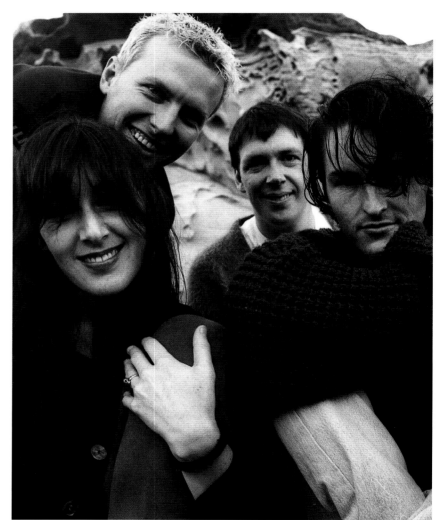

HUMMINGBIRDS, FALLING JOYS, HONEYS & KILLJOYS
FOUR BANDS THAT I BASICALLY USED TO BECOME A BETTER SESSION PHOTGRAPHER

In the late eighties I was very raw as a photographer and possibly intimidated by bands. I had to learn to take charge of the proceedings whilst still listening to bands' ideas. To these 4 bands i'm eternally grateful for allowing me to progress, not to mention I loved their music and company.

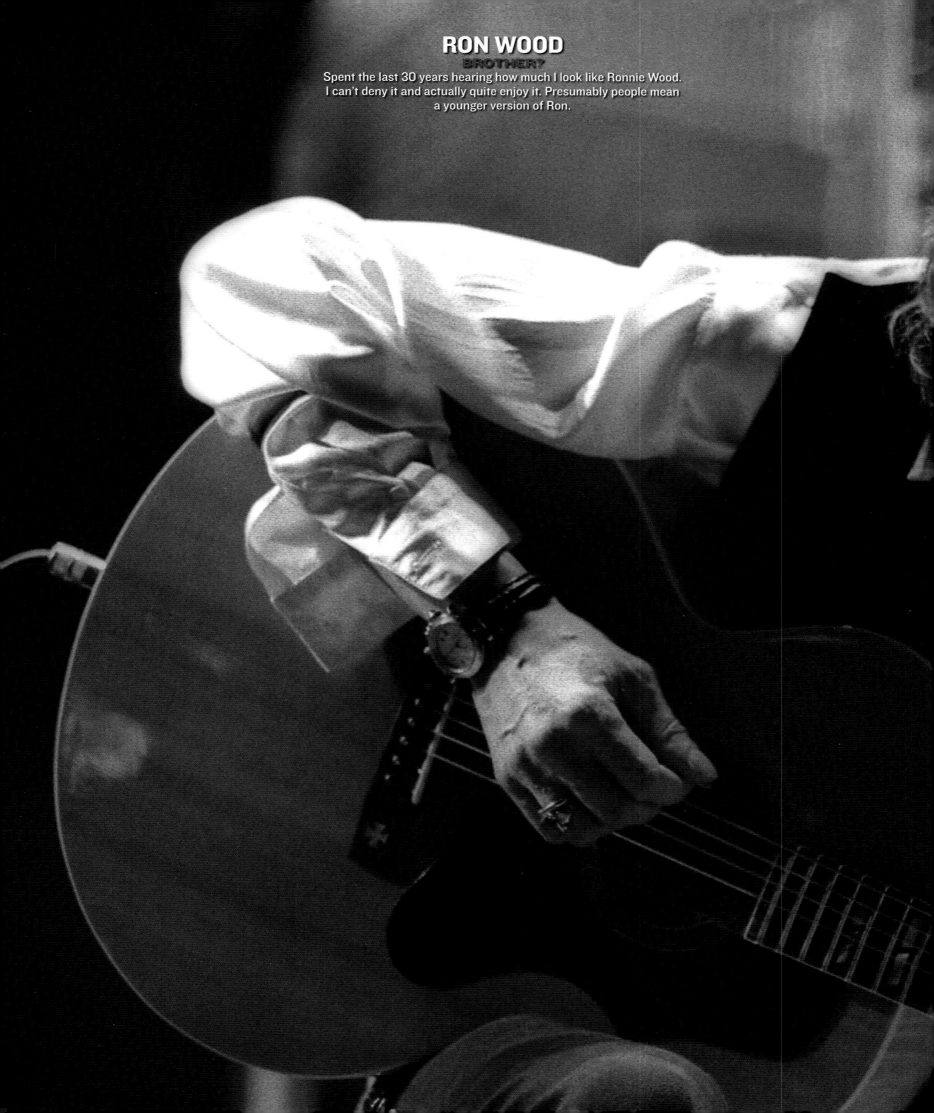

RON WOOD
BROTHER?
Spent the last 30 years hearing how much I look like Ronnie Wood.
I can't deny it and actually quite enjoy it. Presumably people mean
a younger version of Ron.

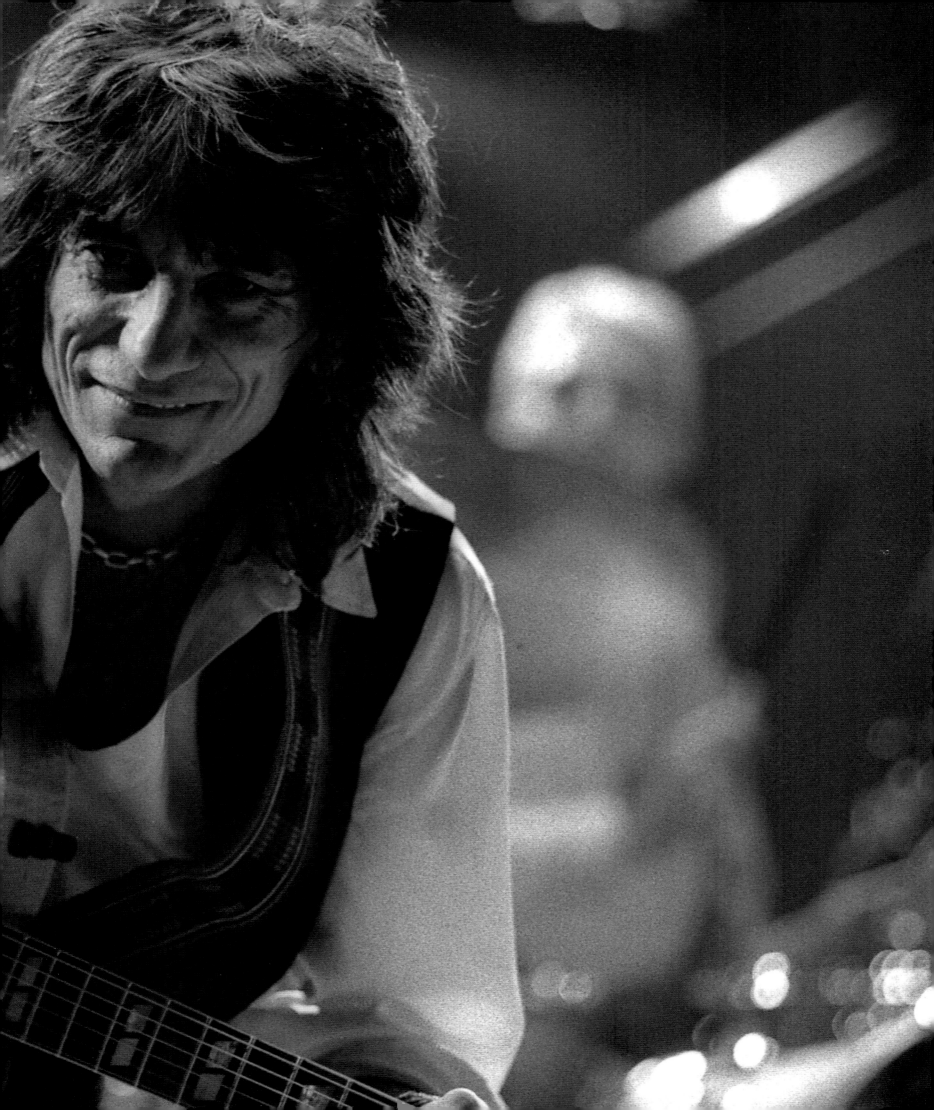

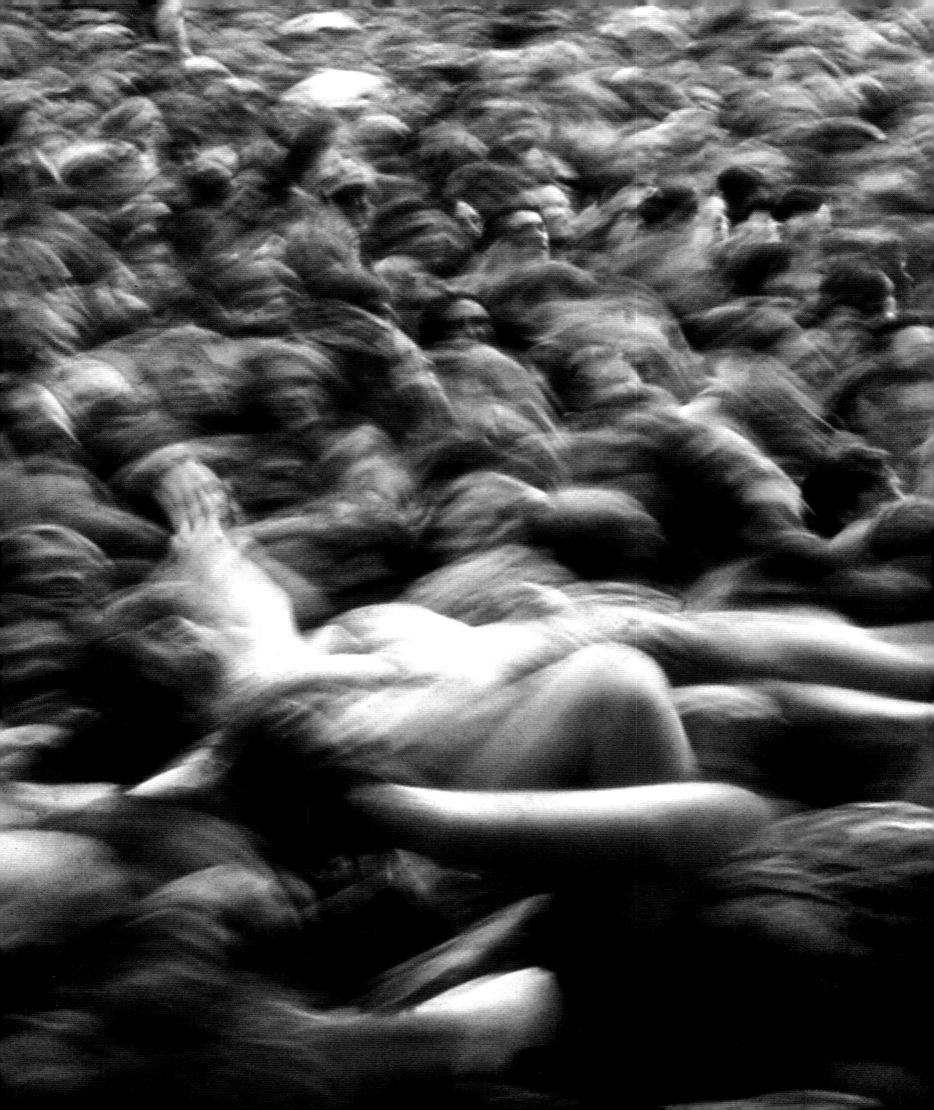

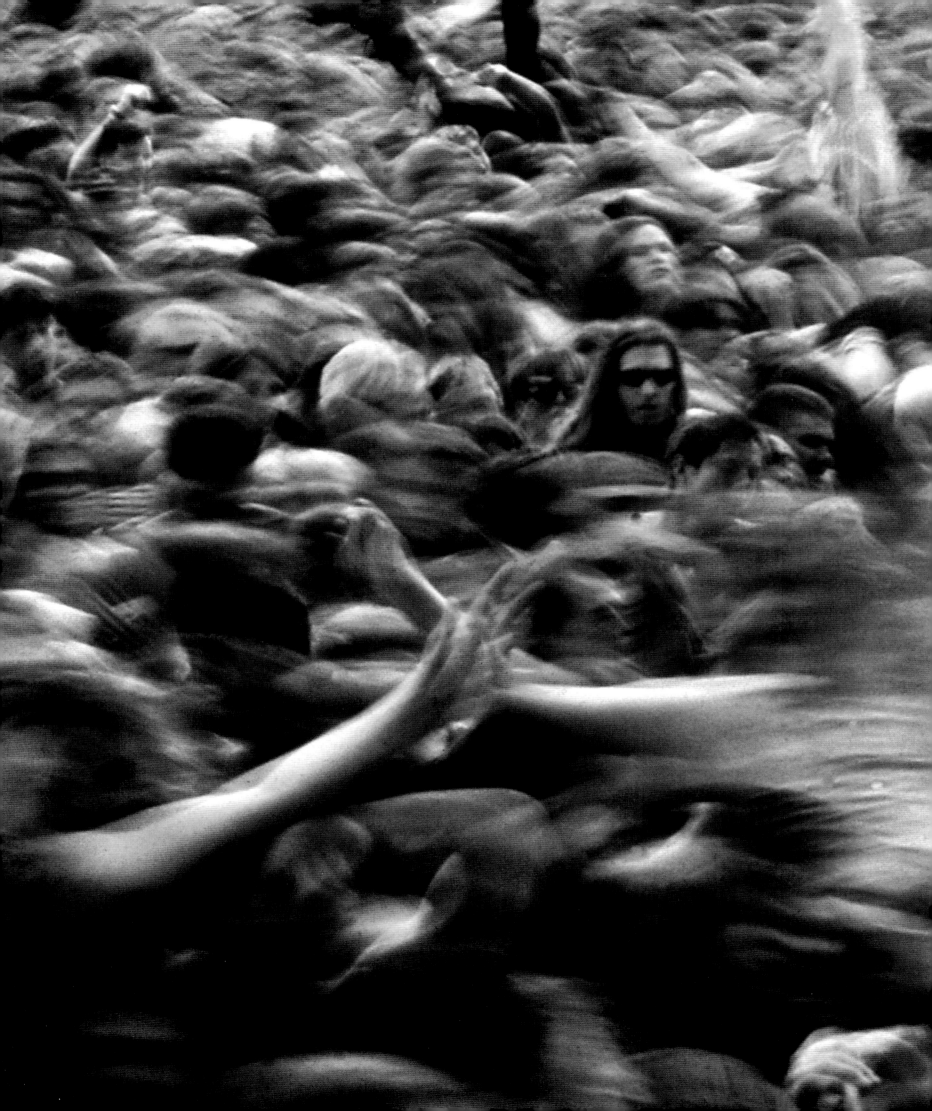

THANK YOU
There is of course so many people to thank, in fact everybody
I've come across in the industry but most of all I'd like to thank
Joe Ferrara without whom this book wouldn't have happened
and to my wife Libby xxxx

DEDICATIONS
Love And Best Wishes The Families Moulds, Mott,
Bossingham, Langford, Walker, Sharpe and Ross.

A Rockpool book
Published by Rockpool Publishing
24 Constitution Road, Dulwich Hill, NSW 2203, Australia
www.rockpoolpublishing.com.au

First published (privately) 2010
This revised and updated edition published by Rockpool Publishing 2011
© Tony Mott 2010–2011

ROCK'N'ROLL PHOTOGRAPHY IS THE NEW TRAINSPOTTING / Tony Mott
ISBN: 978 1 921878 01 5 (pbk.)
Photography
Cataloguing-in-Publication entry is available from the National Library of
Australia http://catalogue.nla.gov.au/

For information about legal deposit and government deposit, please
contact the Legal Deposit Unit on (02) 6262 1312 or email
legaldep@nla.gov.au
Information about legal deposit can be found on the Library's website
http://www.nla.gov.au/services/ldeposit.html

Art Director Joe Ferrara
Imaging Specialist Jonathan Griffiths

Printed and bound by 1010 Printing in China
10 9 8 7 6 5 4 3 2 1

ROCKPOOL
PUBLISHING